ENGLISH PRE-RAPHAELITISM
and Its Reception in America
in the Nineteenth Century

ENGLISH PRE-RAPHAELITISM
and Its Reception in America
in the Nineteenth Century

Susan P. Casteras

RUTHERFORD • MADISON • TEANECK
FAIRLEIGH DICKINSON UNIVERSITY PRESS
LONDON AND TORONTO: ASSOCIATED UNIVERSITY PRESSES

Associated University Presses
440 Forsgate Drive
Cranbury, NJ 08512

Associated University Presses
25 Sicilian Avenue
London WC1A 2QH, England

Associated University Presses
P.O. Box 488, Port Credit
Mississauga, Ontario
Canada L5G 4M2

The paper used in this publication meets the requirements
of the American National Standard for Permanence of Paper
for Printed Library materials Z39.48-1984.

Library of Congress Cataloging-in-Publication Data

Casteras, Susan P.
 English Pre-Raphaelitism and its reception in
America in the nineteenth century.

Bibliography: p.
 Includes index.
 1. Preraphaelitism—England—Public opinion.
2. Painting, English—Public opinion. 3. Painting,
Modern—19th century—England—Public opinion.
4. Public opinion—United States. I. Title.
ND467.5.P7C37 1990 759.2 87-46421
ISBN 0-8386-3328-5 (alk. paper)

Printed in the United States of America

for Eric, my best friend and muse

Contents

Illustrations

Preface

WHILE MODERN SCHOLARSHIP ON THE PRE-RAPHAELITE BROTHERHOOD HAS PRODUCED NUMEROUS IMPORtant articles and publications, there has been virtually nothing written about the reputation that this revolutionary band of painters earned in America during the nineteenth century. Indeed, probably the sole scholarly precedent on this topic in the past twenty years was my essay on the 1857–58 exhibition of English art in America, published in *The New Path: Ruskin and the American Pre-Raphaelites* catalogue from the Brooklyn Museum exhibition of 1985.

There is thus almost an utter vacuum of information on the Brotherhood and their impact in this regard; as a result, this book was conceived as a remedy to this gap in the literature of Pre-Raphaelitism. Beginning with an examination of the kind of reception Ruskin's works received in the United States—the only aspect of the book which has hitherto been analyzed—the first chapter explores Ruskin's influence in general along with the pertinent writings and beliefs of his American followers and friends. In the latter category were Harvard professor and collector Charles Eliot Norton, William James Stillman (editor of the leading art journal, the *Crayon*), and critic and connoisseur James Jackson Jarves. The interrelationships among these three men are also investigated, for each one played an important role in the dissemination of Ruskinian and Pre-Raphaelite doctrine.

As early as 1851 the *Literary World*, for example, commented on how the "earnestness, faithful work, and promise of future excellence" of the Pre-Raphaelite Brotherhood "enlist Mr. Ruskin's advocacy" and also how "these painters delight in a minute and somewhat rigid reproduction of Nature, and a disregard of the technicalities of the drawing-master." Chapter 2 examines how Americans defined and categorized the tenets of Pre-Raphaelitism in the 1850s particularly, including analysis of the alleged flaws of stiffness, eccentricity, and ugliness in the figures, traits a correspondent to the *Crayon* in 1855 called "a certain hardness and rigidity of forms and a want of grace which made their pictures seem little less than grotesque. . . . The labored study gives a rigidity and awkwardness which is painful. . . ." Moreover, the supposedly harsh color and strange stylistic characteristics of such compositions (which *Dwight's Journal of Music*, for example, in 1858 likened to the strange tattooing customs of Fiji Islands inhabitants) are also considered.

The next chapter outlines in considerable detail the monumental 1857–58 exhibition of British art that traveled to three American cities and unleashed a flood of controversy and debate about Pre-Raphaelitism. A typical reaction was that of the *New York Times*, which remarked that there were "some of the finest pictures of the pre-Raphaelites" on display but nonetheless lamented

that "there is none, we regret to say, from the head of the school, Millais." The central portion of the text devotes individual chapters to the reception that works of the key members of the group—John Everett Millais, William Holman Hunt, and Dante Gabriel Rossetti—received from contemporary American critics and journalists. The approach within these sections mixes analysis with chronology, providing the reader with an unfolding or evolving sense of how these artists were viewed during the decades after 1850. Moreover, specific paintings such as *A Huguenot* or *The Light of the World,* both of which were famous and exerted a definite impact on American art criticism and artists, are also extensively discussed. For most Victorian scholars the list of works that were exhibited in America—as well as the particular reactions they evoked in the pages of the *Crayon,* the *New York Times,* the *Boston Daily Courier,* and other periodicals— will provide totally new and revealing information and documentation about this hitherto neglected aspect of Pre-Raphaelitism. Relevant reviews from lesser known magazines such as the *Round Table,* the *Art Amateur,* the *Aldine,* and the *New Path* are cited at some length in these chapters, partly to give the reader a fuller sense of critical perspective and also to offer English readers exposure to opinions in sources that are unavailable even in the British Library. In all these chapters accompanying photographs illustrate some of the renowned images revered on both sides of the Atlantic—notably Millais's *The Rescue,* Hunt's *Eve of St. Agnes,* or Rossetti's *Found*—as well as some of the more obscure pictures by Arthur Hughes and Ford Madox Brown, for example, which were seen, reviewed, and sometimes even purchased by Americans. Changing patterns of critical perception between 1855–1900 of the great Pre-Raphaelite triumvirate—how their reputations waned or altered in the public consciousness—thus emerge and provide an interesting counterpoint to English developments in art criticism of the Brotherhood.

Finally, the concluding chapter chronicles the only aspect of this subject that has hitherto been assessed in any depth (in the 1985 catalogue, *The New Path,* mentioned earlier)—namely, the Brotherhood's "spiritual offspring" in American art of the period and the mixture of support and hostility that these "rebels" received from critics and viewers. As George Curtis, editor of *Harper's Magazine* noted in 1866 about this phenomenon, "The Pre-Raphaelite doctrines, as they were called, were for a long time merely theoretically and doubtfully entertained in this country, and our own exhibitions showed little sign of the prevalence of influence of the spirit of the P.R.B., the Pre-Raphaelite Brethren." The change in spirit was due largely to the impact of members of the Society for the Advancement of Truth in Art and their paintings, for it was this organization that turned to the Pre-Raphaelite Brotherhood as its direct model and inspiration. Accordingly, there is an emphasis upon these artists and on significant exhibitions of their art in New York and at Yale, with selected works by Charles Moore, J. W. Hill, J. H. Hill, and Thomas C. Farrer mentioned or reproduced in order to reinforce the pictorial interconnections with their English counterparts in the years 1855–70. The images and subjects of these mostly native artists also underscore the effect that theories of realism espoused by Ruskin and practiced by the Pre-Raphaelites had upon American aesthetics in general, for the American transformation of Ruskinianism and Pre-Raphaelitism resulted in a kind of hybrid pictorial realism that was both derivative and unique. The resulting differences are underscored by examination of both figural and landscape borrowings from Pre-Raphaelitism, with the latter the predominant mode for American artists. The popularity of "flirting" with Pre-Raphaelitism is also considered, particularly in terms of artists like John LaFarge and Elihu Vedder, who briefly showed inspiration from the English brethren.

In terms of acknowledgments, I wish first to express my gratitude for the year-long fellowship I received in 1983–84 from the American Council for Learned Societies, under a project funded by the National Endowment for the Humanities. I am, moreover, very grateful to various individuals who offered information and encouragement to this project, especially Millais scholar Malcolm Warner, Hunt scholar Judith Bronkhurst, and American art expert

William H. Gerdts. The writings of Roger B. Stein, Linda Ferber, and Kathleen Foster were also very useful to my work, and Elizabeth Fahlman, Barbara Dayer Gallati, Rowland Elzea, and Lucy Oakley also were helpful. In the course of my research I also learned much from art history students working in this area, particularly May Brawley Hill and Margaret Favretti, and I thank them along with my colleagues for their assistance and insight.

Another debt of thanks is due the many museums that have allowed me to reproduce their paintings in this book, and this list includes above all my own institution, the Yale Center for British Art, as well as the Tate Gallery, the Ashmolean Museum, the Birmingham City Museum and Art Gallery, the Walker Art Gallery, the National Gallery of Victoria, the Manchester City Art Gallery, the Fitzwilliam Museum, the Guildhall Art Gallery, the Delaware Art Museum, the Brooklyn Museum, the Fogg Art Museum of Harvard University, the New York Historical Society, the Princeton Art Museum, the Pierpont Morgan Library, the Yale University Art Gallery, the Art Institute of Chicago, the Southampton Art Gallery, the Walters Art Gallery, the Vassar College Art Gallery, the Calderdale Museums Service, the Manchester City Art Gallery, the Lady Lever Art Gallery, the Oldham City Art Gallery, the Leeds City Art Gallery, the Provost and Fellows of Eton College, the British Museum, the Russell-Cotes Art Gallery, the Metropolitan Museum of Art, the Beinecke Rare Book and Manuscript Library, and the Boston Museum of Fine Arts. I also thank the Yale University Library for allowing me to quote material in its manuscripts and archives collections. In addition, Sotheby's, Christie's, and Hirschl & Adler also graciously granted me permission to reproduce works of art previously in their sales rooms. Private collectors who generously permitted me to illustrate their pictures include Mr. and Mrs. Wilbur L. Ross, Jr., The Makins Collection, Christopher Wood, and Jo Ann and Julian Ganz, to all of whom I am indebted for their cooperation.

On a personal level, I am very grateful to my husband, Eric Schnapper, for his continuing support and patience throughout this massive undertaking, and it is to him that this book is dedicated. Once again I thank my son John Paul for his forbearance while I worked at the library and at the computer; at times he would have preferred me to frolic with him outdoors.

ENGLISH PRE-RAPHAELITISM
and Its Reception in America
in the Nineteenth Century

1

Ruskin, His Champions, and His Challengers: William James Stillman, James Jackson Jarves, and Charles Eliot Norton

RUSKIN'S IMPORTANCE TO AMERICAN THOUGHT, ART, AND THE CRAFT MOVEMENT IS BETTER DOCUMENTED than any other aspect of the impact of English art in the nineteenth century, for his writings enjoyed incredible popularity and fame in this country. As the leading modern historian on this subject has shown, Ruskin's blend of art, morality, and nature appealed to audiences in the United States as much as the originality or power of his writings, mostly because American Transcendentalism in particular had, earlier in the century, paved the way for Ruskin's brand of nature worship.[1] In 1847 the Wiley firm in New York was the first American company to publish *Modern Painters*, and by the end of the century the book had gone through scores of re-issues. The number of reviews of this publication during the same period was also overwhelming, and a typical positive one (although some reached almost a fever pitch of ecstatic apostrophe) appeared in the pages of the *Knickerbocker, or New-York Monthly Magazine* in 1847. The "Literary Notices" column confirmed that at that point the author's name was " . . . not yet known to the public, at least in this country." Nonetheless, Ruskin was perceived as a vigorous and inno-vative thinker, "a close observer . . . and a fearless expounder of the truth. . . ." Mourning only his seemingly extravagant "adoration" of J. M. W. Turner, the critic approved of how Ruskin "scorns to be tied down to the conventional opinions. . . . In short, the work is one which will not only delight and instruct the artist, but the poet, the philosopher, and every lover of the works of God."[2] Such unbridled enthusiasm continued in other periodicals like the *Literary World*, which saluted *Modern Painters* as a "rich, persuasive, and liberal" landmark publication that would define a new era in art and would rescue it from the doldrums into which it had allegedly fallen.[3] Ruskinian terms soon invaded the columns of this journal and others in the late 1840s, and as Ruskin's name rapidly became a virtual household world among the intel-ligent reading public, some writers began to warn readers of the dangers of becoming too enamored of his tenets; for example, *Putnam's Monthly Magazine* urged people in the mid-1850s against too "wild" and wholesale an acceptance of his beliefs.

Notwithstanding the other accolades he received, it was in the fledgling art journal called the *Crayon*, however, that Ruskin was venerated in almost religious terms as a prophet spreading a

new aesthetic gospel. In terms of the reception of his writings overall, the editors of the *Crayon* maintained in 1855 that his works "found a warmer greeting from the American public than from the English, owing to the greater freedom from prejudice in matters of Art, and a fuller sympathy with his enthusiasm and his earnestness of spirit. His ideas have here found a virgin soil in which to germinate—a national mind on which Nature has a strong hold, and which as of yet is ignorant in the main of the marvels of Art, or of the distinctions between artists and schools. We believe it will scarcely be possible that any Art should arise here of which Ruskin and his ideas should not be a large component."[4] The *Crayon's* assertions were both rather jingoistic and an overstatement of Ruskin's effect, but he himself agreed with this assessment of the fertile ground his writings found in America (in contrast to the harsh opposition his works often received in Britain) and wrote to the editors in March of 1855, "I have much to thank America for—heartier appreciation and a better understanding of what I am and mean, than I have ever met in England. Nothing gives me greater pleasure than the thought of being of use to an American. . . ."[5] Even after the pro-Pre-Raphaelite and Ruskinian supporter William Stillman left as an editor of the *Crayon*, the magazine continued to refer to Ruskin and to print lengthy excerpts from *Modern Painters, The Stones of Venice,* and other works. Yet the journal was not totally blind to his shortcomings, at various times remarking on his sometimes contradictory or inconsistent theories, his pedantic and hyperbolic tendencies, and his frustrating ambiguities as a writer.

In addition to the occasional swipes taken at Ruskin by the *Crayon* and later the Pre-Raphaelite-inspired *New Path* in the early 1860s, there was a decidedly negative strain of criticism that also co-existed with the praise. A typical protestation was registered in the pages of *Dwight's Journal of Music* in 1858, the author touching on a sore point concerning Ruskin's critical myopia vis-à-vis Pre-Raphaelitism when he remonstrated, "A few years ago, Mr. Ruskin, the most ardent and strong-eyed explorer the world has ever seen, discovered that Art was only rightly to be seen from a nutshell. He accordingly procured one of ample dimensions, fitted up its interior to suit his convention, mounting therein a powerful periscopic lens, and commenced his explorations."[6] Other journalsts also lambasted Ruskin's writings, Franklin Dexter of the *North American Review* fearing that *Modern Painters* could increase American arrogance and idolization of the new at the cost of belittling the past and the art of the Old Masters.[7] However, whether vociferously for or against his tenets, nearly all American critics agreed that Ruskin's theories had galvanized the state of public interest in art, and that this in itself was a great achievement and advance.

There was also some scrutiny of Ruskin as an artist, not just a theorist, even before his watercolor of *Study of a Block of Gneiss* (fig. 1, now retitled) was included in the 1857–58 exhibition, although not necessary in the best of circumstances. In this respect Ruskin was vulnerable to attack and ridicule, for even the *Crayon* in May 1855 mentioned an inferior, indeed "feeble," watercolor that hung in New York "in the dark room of the Academy gallery, and which attracts the wondering attention of many people."[8] The editors rightly claimed, however, that this work misrepresented Ruskin's talent, reprinting his own explanation that this was a juvenile drawing that had been sold or given by a servant to an American visitor without the artist's knowledge or permission. However, perhaps the pejorative reaction to this example of juvenilia was prophetic, for when Ruskin's highly detailed painting of "scriptural geology," essentially a portrait of a rock, finally came to American shores, it fared rather poorly. *Study of a Block of Gneiss* became the butt of jokes, and Brownlee Brown for the *Independent*, for example, pronounced the watercolor "laborious" and lacking in breadth.[9] Reviewers generally seemed to appreciate Ruskin's philosophies more than his abilities as a painter; support of his beliefs was perhaps greatest during the 1850s and 1860s.

It should also be pointed out that after the Civil War Ruskin's reputation suffered in America due to his pro-south sentiments. The *New York Times*, for example, in 1867 cited the En-

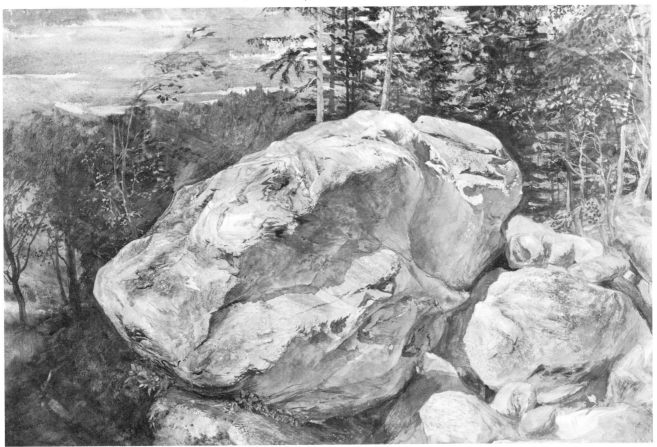

Figure 1. John Ruskin, *A Fragment of the Alps*, ca. 1854–56. Watercolor and gouache over graphite on cream wove paper. *(Courtesy of the Harvard University Art Museum, Fogg Art Museum. Gift of Samuel Sachs.)*

glishman's belief that true art could not flourish amidst the "barbarous manner" of the North. This irked the reviewer, who "never supposed him to be deliberately advising an artist, who had come to him for assistance and direction, to pursue the wrong and false way in art, because, forsooth, the people who were to buy his pictures had not followed Mr. Ruskin's ideas of political right." He even linked Ruskin's views on the degradation of American art with the cause of Pre-Raphaelitism:

> Mr. Ruskin may not be wholly to blame in this matter. The disciples of the Pre-Raphaelites in this country, an insignificant and unpopular clique, have filled his ears with dolorous complaints of their own want of success, arguing, from their failure to sell their pictures, the total depravity of artistic sentiment among Americans. . . . Their complaints accord with his own notions of a Democratic and Republican people, and he seizes the opportunity to reiterate his ill-expressed contempt for a self-governing nation. . . . One would suppose that our very debasement would be an argument in favor of giving us the highest art, that what to us is dark might be through his instrumentality illumined. But as he thinks otherwise, and as our people seem to be obstinately blind to the merits of the few Pre-Raphaelites in this country, we fear we must stand condemned to remain in our native ignorance. . . .all because Mr. Ruskin did not approve of the war for the Union![10]

Yet Ruskin's pre- and post-war influence was nonetheless formidable. William Stillman, initially an ardent fan of Ruskin, wrote in 1860 that for him (and perhaps, in different ways, for other prominent nineteenth-century Americans like Nathaniel Hawthorne, Ralph Waldo Emer-

son, Walt Whitman, and Henry David Thoreau, who were all acquainted with *Modern Painters*)
Ruskin's books provided an apocalyptic experience: "The first volume of *Modern Painters* was, as
everybody will remember, one of the sensation-books of the time and fell upon the public
opinion of the day like a thunderbolt from the clear sky. Denying, and in many instances
overthrowing the received canons of criticism, and defying all the accepted authorities in it, the
author excited the liveliest astonishment and the bitterest hostility of the professional critics,
and at once divided the world of art."[11]

On a personal level, Ruskin's creed definitely affected Stillman's development as a young
painter, the American later recalling that he had read *Modern Painters* while studying with
Frederic Edwin Church: "Like many others, . . . I received from it a stimulus to nature
worship. . . ."[12] As a result, Stillman's paintings of the late 1840s and early 1850s reflected
Ruskinian notions of truth to nature, and in late 1849 Stillman left for England, meeting Ruskin
the next year in a gallery where both men were looking at paintings by J. M. W. Turner. The two
shared many conversations on religion and art and even traveled together, their early friend-
ship based on shared attitudes towards morality as well as to art.

In the 1850 Royal Academy exhibition the work that introduced Stillman to Pre-Raphaelite
painting was John Everett Millais's *Christ in the Carpenter's Shop* (fig. 2), and Stillman later
claimed that "the scrupulous conscientiousness" of this picture "chimed with my Puritan
education."[13] Upon his return to America, Stillman continued as a Ruskinian advocate, produc-
ing various studies like *June on the Mohawk* and *The Mountain Brook* which were exhibited at the
National Academy of Design and earned him the sobriquet of an "American Pre-Raphaelite,"
the first native painter to be described as such.[14] On a subsequent trip to London in 1853 it was

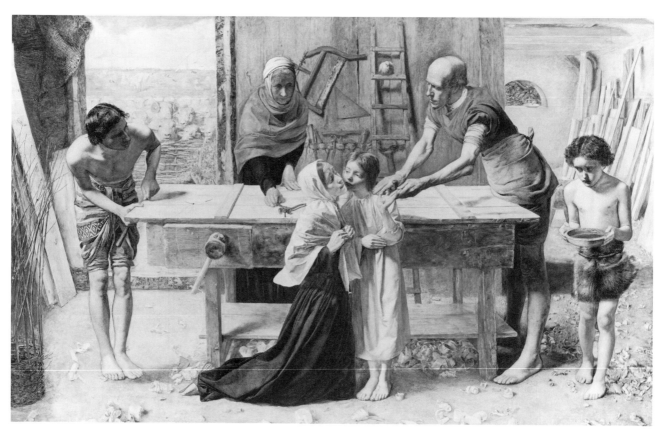

Figure 2. John Everett Millais, *Christ in the House of His Parents*, 1849. Oil on canvas, 34 × 55 inches. (*Courtesy of the Tate Gallery.*)

Figure 3. John Everett Millais, *The Proscribed Royalist*. Engraving with stipple engraving by W. H. Simmons after the 1853 original, 30 × 25½ inches. (plate size). *(Private collection.)*

again a canvas by Millais—*The Proscribed Royalist* (fig. 3) in the Academy—that incorporated "a treatment of landscape which should be mainly foreground, such as I particularly delighted in."[15] This Pre-Raphaelite canvas and its emphasis on foreground detail directly inspired Stillman's (now lost) picture entitled *The Forest Spring*. This composition was exhibited at the National Academy of Design in 1854 and was hailed in *Putnam's Monthly Magazine* for its novel qualities as " . . . a marvelous piece of greenery, . . . a little clear spring of water, whose unruffled surface reflects objects like a mirror; and the mosses, leaves, flowers, and grasses are painted with wonderful delicacy and accuracy."[16] Moreover, the naturalistic scene was characterized as Pre-Raphaelite in appearance, although this particular critic had little idea of what that appellation meant: "We have heard it called a pre-Raphaelite picture; but we should like to learn what pre-Raphaelite artist ever attempted any thing in this style."

At about the same time Stillman became Fine Arts editor of the *Evening Post* and soon met in Cambridge major literary and scholarly figures such as Henry Wadsworth Longfellow, Ralph Waldo Emerson, and Charles Eliot Norton, all of whom knew Ruskin's works. The poet James Russell Lowell had introduced Stillman to Norton, and the two connoisseurs both joined the Adirondack Club and began corresponding as early as June of 1855. Norton's early impressions of his new friend were quite positive, and he remarked that Stillman " . . . interests me greatly. I have never known anyone more earnest and faithful in his desire and search for spiritual improvement."[17]

The inaugural issue of the *Crayon* was published in January of 1855, with John Durand and Stillman as co-editors. Stillman had been partly inspired to undertake this enterprise because of *Modern Painters,* and he felt that his Ruskinian sympathies were appropriate qualifications in tune with the general endorsement of Ruskin and his credo, writing that "The art-loving public was full of Ruskinian enthusiasm, and what strength I had shown was in that vein. . . . The success of 'The Crayon' was immediate, though, from a largely journalistic point of view, it was, no doubt, somewhat crude and puerile. It had a considerable public, sympathetic with its sentimental vein, readers of Ruskin and lovers of pure nature—a circle the larger, perhaps, for the incomplete state of art education in our community."[18]

Stillman accordingly wrote many of the editorials and articles during his two-year stint at this rather quixotic enterprise and lost few opportunities to expound his interpretations of Ruskinian dogma. In an early issue Stillman made his indebtedness to Ruskin explicit to readers, and countless subsequent columns like "Duty in Art" echoed Ruskinian principles on the almost divine role of the artist in apprehending nature. Although Stillman had trouble resolving some of the more convoluted or ambivalent aspects of Ruskin's theories, he nonetheless was quite influenced by many of the Englishman's ideas and conveyed these rather stridently in his writings before he resigned as editor in the summer of 1856 due to health reasons. Moreover, he dared to assess both English Pre-Raphaelite and American paintings (the term "Pre-Raphaelite" itself occasionally bestowed as a compliment upon native painters like Frederic Edwin Church) according to Ruskinian criteria. However, after Stillman left the *Crayon,* the Brotherhood and its artistic activities received noticeably less attention and endorsement, and by about 1860 American "brethren" were similarly less likely to be favorably singled out for their Pre-Raphaelite tendencies. While Stillman had worked to create guidelines for the development of American landscape painting, his success was ultimately limited and, even with the considerable impact of the *Crayon,* he was unable to make American audiences fully receptive to or ardent about the transplantation of Pre-Raphaelitism to this country.

After his departure from the periodical, Stillman went to the Adirondack Mountains and other pastoral locations to return to his easel, continuing to paint landscapes (or, more precisely, intimate corners of nature minutely rendered) in a Pre-Raphaelite mode. In 1859 he was again in London, where he finally met members of the Brotherhood and also spent time with Ruskin. He also entertained visits from fellow artists Dante Rossetti, Frederic Leighton, Millais, Val Prinsep, and George P. Boyce. In 1860 Stillman even sent two canvases to the Society of British Artists, both landscapes presumably executed in a (modified American) Pre-Raphaelite style.[19] Stillman also toyed with the idea of sending a figure painting he had worked on previously in America, a composition entitled *The Bed of Ferns,* to the Royal Academy. This was, according to Stillman's own description, a scene of a dead hunter and buck depicted " . . . on a perpendicular ledge of granite, about twenty feet high, mosses and ferns clinging in its crevices, overhanging a level space covered with a heavy growth of luxuriant fern. . . ."[20] Apparently Ruskin advised Stillman to paint out the two bodies, an action that Dante Gabriel Rossetti deemed absolutely disastrous. Stillman remembered of the entire disaster that "My reverence for Ruskin's opinion was such that I made no hesitation in painting out the central motive of the picture. . . . When Rossetti called again, he asked me, with a look of dismay, what I had done to my picture." Rossetti "walked out of the room in a rage" and exclaimed, " 'you have spoiled your picture!' " Perhaps it was due to Ruskin's ill-advised suggestion that the canvas was "accepted but not hung for want of room" at the Academy that year.[21] Understandably upset by the unnecessary effacement and ruin of his picture, Stillman personally destroyed *The Bed of Ferns* in a fire.

Stillman and Ruskin went to Switzerland together in the summer of 1860, but the trip proved fatal to their relationship, the American ultimately resentful of his mentor's overbearing criticism of his painting techniques. As a result of pressure from Ruskin to redo his painting of

alpine roses " . . . growing luxuriantly against a huge granite boulder" in even greater detail, Stillman became frustrated, developed eye trouble, and burned this canvas, too. More significant, however, was his permanent disenchantment with Ruskin because of these incidents and his decision to abandon painting entirely. Stillman's demoralization was undoubtedly evident to Charles Eliot Norton, who received a letter from him stating that Ruskin was " . . . fundamentally wrong on all practical questions and his advice and direction the worst thing a young artist can have."[22] Moreover, Stillman personally blamed Ruskin for the end of his artistic career, bitterly complaining to his friend that "Ruskin had dragged me from my old methods, and given me none to replace them. I lost my faith in myself, and in him as a guide of art."

By 1860 Ruskin had lost Stillman as an adherent, but there were other Americans who still endorsed his writings and even tried to emulate them. The foremost of these was James Jackson Jarves, whom the *North American Review* in 1855 regarded as trying to do for Americans what Ruskin had done to educate his countrymen.[23] Indeed, in 1855 Jarves met Ruskin, and his first book in particular is rife with Ruskinian terminology and theory. Jarves, however, was a cultural missionary in his native land, a man who both wrote a great deal about art and also formed one of the first collections of early Italian (or genuinely pre-Raphael) paintings in the New World. Jarves felt his collection, and indeed all art, would both teach and delight audiences as well as improve them in a moral way. Many of his concepts were quite advanced for his time, but he met with measures of both acceptance and resistance to his plans for elevating American taste and consciousness of the higher, more spiritual potential of the fine arts.

As Stillman himself pointed out in the *Crayon* in 1855 in his review of Jarves's *Art-Hints: Architecture, Painting, Sculpture*, the first book-length study of art by an American, this publication significantly borrowed from Ruskin above all and as such qualified overall as " . . . little else than dilute adaptations of Ruskin."[24] Jarves maintained that the Pre-Raphaelites were " . . . imitators rather than creators. In their zeal for prototypes they not only seek to revive their motives, but they perpetuate their errors; consequently we find faults of design, hardness of outline, weakness of tint, inharmonious combinations of color, beside the general mysticism or its opposite overtelling of the story. . . ." In addition, Jarves disagreed about the need for pictorial symbolism in modern art, believing that the Pre-Raphaelites mistook "their relationship to the age in seeking to carry back its intellect to a time when mere symbolism or pictorial writing best embodied its instruction. We are now beyond that, books being the best agents for the conveyance of abstract ideas; consequently, artists, who, like Hunt, represent the Saviour as the Light of the World by a lantern in His hand, only make the idea contemptible and themselves ridiculous."[25] Stillman found the book to be pretentious "rubbish" that revealed the "positive blindness" of the author, who in his subsequent publication irately referred to what he deemed the unjust review of the *Crayon*. Jarves thus wrote that: "The only case of attack on 'Art-Hints' by distorted interpretation and invective ridicule was on the part of the late 'Crayon,' edited by the artists Stillman and Durand, whose unfairness elicited from Mr. Ruskin a letter to me, in which he says: 'Your book seems to me very good and useful in many ways. I was sorry—very heartily—for the general tone of the review in the "Crayon." ' "[26]

As one modern historian has pointed out, rather than being gratified at finding an articulate American ally, the *Crayon* (or, more probably, Stillman) lashed out at Jarves, mostly because he dared to stray from the Ruskinian path and to suggest the "traitorous" idea that American artists should turn to European art—not to themselves or their own environment—for inspiration.[27] The rivalry may well have been personal, and it was certainly sometimes heated between the two Ruskinian disciples.

Jarves dedicated his next book, *Art Studies* (1860), to Charles Eliot Norton, making several references to what he perceived as the limitations of Pre-Raphaelitism. Accordingly, he wrote that "The miscalled Pre-Raphaelites of our time, exaggerating the law of fidelity in parts, and

losing sight of the broader principle of effect by which particulars are absorbed into larger masses, protrude upon the sight with microscopic clearness the near and the distant, delineating the tiniest flower in a wide landscape, of which, in nature, it would form, at their point of sight, but an uncertain Trick of color. . . ."[28]

Although in 1865 Jarves became a member of the New Path Association (partly to continue the publication of the radical and pro-Pre-Raphaelite *New Path*), he had not been exempt from an earlier attack upon *Art Studies* in the pages of the *New Path*. Charles Moore, the author of an 1863 article entitled "Fallacies of the Present School," quoted Jarves frequently, acknowledging some faults in the nascent school but nonetheless decrying Jarves's failure to comprehend the moral truth of Pre-Raphaelitism. Accordingly, the author wrote in thundering tones of the "unintelligent censure" found in *Art Studies:* "Such works as Mr. J. speaks of, in which 'all things are equally indicated, foregrounds, and backgrounds, and middle distance alike distinct and defined,' are either mimicries by shallow men of what they do not understand, or else the awkward work of students. It would be no more absurd to judge principles of religion by the tenets of individual professors, than to judge principles of art by the works of men who do not know what they are about."[29] Furthermore, Moore penned with great conviction his opinion that "This criticism of Mr. Jarves shows that his mind is so soaked in conventional doctrines, that his perception of the nobler works of God is secondary to them. Who cannot see that this state of mind is opposed to all true growth? Must not reverence, humility, and love of God and nature be at the root of all art that can flourish? And must not that art which is inspired by vanity and ostentation sink to the ground?" In addition, Moore clearly used this opportunity to justify the beliefs of the American followers of the Pre-Raphaelites, reminding readers that "Naturalism is not *all* we believe in, but we know it must come first. . . . We are called by some 'weak mockers of Ruskin,' and it is said that our principles are not born of original conviction. . . . By the mercy of God, Ruskin has been sent to open our eyes and loose the seals of darkness. He has shown us the truth and we thank him and give God the glory; and the truth once clearly shown becomes ours if we will receive it."

Probably as a result of such sharp words in the *New Path* and elsewhere, Jarves changed his mind somewhat and in *The Art-Idea* of 1864 slightly tempered his hitherto totally abrasive remarks about the Pre-Raphaelites. While he might not have known much about Pre-Raphaelitism in 1855, he should have been well-informed on the subject nine years later. Nonetheless, Jarves's references to the Brotherhood remained rather hostile, real invective evident in his opinion that Pre-Raphaelitism " . . . in little hands degenerates . . . into trite pettiness and wearisome literalness, from a tendency to subordinate great laws to lesser, and to exalt the common and integumental above the intellectual and spiritual. They also forget that nature, their teacher, invariably in the landscape hints at more than she discloses. . . ." At best, his comments paid only a "left-handed" compliment mixed in with his censure, and his reservations were laced with considerable invective: "So far, therefore, as Pre-Raphaelitism robs art of her poetry in order to give the literal facts of nature, it may subserve exact science by way of illustration, but it subverts noble art. And, then, nature will not disclose herself with microscopic realism to the naked eye. . . ." Although he stated that the Pre-Raphaelites " . . . to a great degree lost their own individuality or consciousness in their zeal for rigid representation," he allowed with seeming reluctance that Pre-Raphaelitism united " . . . Turnerian breadth and freedom to its legitimate spirituality of vision and scientific accuracy" and thus "offers a possibility of progress as exhaustless as the pure and noble aspirations which are or should be the basis of its theory of paintings. We estimate it not so much by what it has accomplished, even in the hands of Millais, Hunt, or Dante Rossetti, as by what it professes to be."[30] Reviewers of the *Art-Idea* often perceived his debt to Ruskin yet adjudged him inferior in innumerable ways. The *Round Table* critic, for example, chastised Jarves for his alarming ignorance of contemporary British art, moaning that "We can find no mention of Leighton, Hook, or Arthur Hughes, and no analysis or criticism of Millais, Hunt, or Dante G. Rossetti.

Mr. Jarves is manifestly more acquainted with the works of French than of English painters."[31]

By the time *Art Thoughts* was published in 1869, Jarves finally devoted more attention to Pre-Raphaelitism in particular, although he still chafed under the attack of earlier critics about his prejudices in this regard and again mentioned this in his foreword. Citing an apparent difficulty (not entirely credible) of seeing original works by the Pre-Raphaelites in England, Jarves acknowledged that English art—not only French—had something valuable to offer American artists: "American amateurs would do a salutary thing were they to temper their eagerness for French subjects with the wholesomer motives and more sincere treatment of English painters. Millais, Holman and William Hunt, D. Rosetti [sic], and Leighton, to name but few, deserve to be better known abroad." Moreover, he admitted that these men all " . . . paint brilliantly and with signal ability and versatility. Their training is robust, their choice alike free from the commonplace, and the transcendent-idea or conventional grand, while their treatment both of great or little motives, whether altogether to our fancy or not, begets respect for its honesty and acuteness."[32]

In addition, nearly a page of text was devoted to the three key members of the Brotherhood, Jarves subscribing to the notion that Millais, Hunt, and Rossetti were " . . . the originators and 'forlorn hope' of this renovating movement, which they made successful as much by sheer pluck, perseverance and consistency as by a high view of art itself and indomitable talent; returning year after year in the Academy exhibitions with their accurately executed and carefully considered pictures, until they overcame prejudices and took by storm the position of the older painters in the estimation of the critics." Alluding perhaps to his own unspoken rivalry and "petty jealousies" with Stillman, Jarves managed to shed his previous distaste for the Brotherhood and commended Millais and Hunt as "conscientious masters of rare ability and great knowledge. . . . Their range of fancy and motives is as wide as their general cultivation and acute observation. Any type which they select is certain to be well treated in relation to itself as art, and not for hasty gains and transient sensations. They keep in mind that the main office of a painter is to paint, teaching being secondary. This rigid adherence to the first principle of aesthetics, joined to a high-minded comprehension of the moral and intellectual aspects of art, imparts to the English school of which they are the acknowledged chiefs, a more elevated, if somewhat restricted, character than elsewhere obtains." Nonetheless, many reviewers continued to lambaste Jarves for his beliefs, seizing upon his opinions on modern art and thus somewhat overlooking his wisdom on other artistic matters.

If nothing else, Jarves's career as an art writer and the condemnation he endured for his negative judgments of Pre-Raphaelitism underscored how pervasive and important Ruskinian thought had become to American culture. Although by the mid-1860s only a handful of real Pre-Raphaelite paintings had actually been seen in America, many reviewers—undoubtedly influenced by the fervor of the *Crayon*—expected at least some degree of approval of this inventive strain of British naturalism. Jarves's books reached a wide audience, and while espousing the potentially great destiny of the American arts and the viewing public, they also revealed how susceptible to criticism personal reactions to Pre-Raphaelitism could be.

While there were some bad feelings between Jarves and Stillman, just the opposite was true between Jarves and Charles Eliot Norton (whom Stillman had also known well.) Norton and Jarves went to Europe together in 1855, but their friendship was seemingly never as close as that of Norton and Ruskin, who nonetheless corresponded with both men. As a young man Norton wrote *Notes on Travel and Study in Italy*, a book that not only revealed the influence of Jarves's *Art-Hints*, but also was infused with the Ruskinian aesthetic, both men's thoughts clearly refracted (and—to some critics—distorted) through an American perspective.[33]

Norton—who in 1875 became a Professor of the History of Art at Harvard University, a teaching role for which he is best known today—as a youth experienced hero worship of Ruskin when he saw him from afar at a London party in 1850. The two did not meet until 1855, and the next year a real friendship—which lasted until Ruskin's death in 1900—began to evolve. Norton

even had his first view of Pre-Raphaelite drawings in Ruskin's home, where his mentor introduced the American to numerous members of his circle. The two also went together to the 1857 Russell Place exhibition in London of Pre-Raphaelite paintings. It was on that occasion that, according to Norton himself, he became deeply interested in the work of Rossetti (see chapter 6 for additional details on his relationship with this artist). Norton purchased several works by Rossetti and his wife Elizabeth Siddall and was very patient with Rossetti's procrastinations. The two corresponded even when Norton returned to America, Rossetti writing rather candidly (if wistfully) to his friend in Cambridge: "Your 'Shady Hill' is a tempting address, where one would wish to be. . . . I find no shady hill or vale, thought, in these places and pursuits. . . . It seems all glare and change, and nothing well done."[34]

In addition to the link with Ruskin, Norton also knew and liked Stillman, applauding the latter's efforts to elevate American cultural standards in the *Crayon*. Norton even contributed some pieces to the art journal, initially on his travels in India and subsequently on his love of Italian art. These letters to the *Crayon* appeared sporadically in 1856 and later formed the basis of Norton's *Notes on Travel and Study in Italy*. Perhaps even more importantly, when bankruptcy and extinction loomed for the *Crayon* in 1855, Norton wrote to the eminent American poet James Russell Lowell, who sent a new poem for the journal to print.[35] He also expressed to his fellow Bostonian his fear that the loss of the *Crayon* would be a serious one for the state of American art, but fortunately, the periodical was able to survive these early trials. On a personal level, Norton's fealty to Stillman proved quite genuine, and in 1859, for example, he recommended Stillman as an artist to his friend Mrs. Gaskell, the famous English novelist.[36]

Norton not only befriended Stillman and the original members of the Pre-Raphaelite circle; he also supported their efforts by buying some of their works. For example, in the 1892 exhibition of British Pre-Raphaelite art in Philadelphia, the catalogue listed him as the owner of several works by Rossetti and his comrades. These included the Rossetti watercolors of *Beatrice Meeting Dante at a Marriage Feast, Denies Him Her Salutation* and *The Chapel Before the Lists* (fig. 4); in addition, photographs owned by the professor of Rossetti's *Hesterna Rosa* and *How They Met Themselves* were also on display. (Three works by Burne-Jones, watercolors of *Angels* and *Sibyl* and a pencil drawing of *The Romaunt of the Rose* were also exhibited in this show.) In later years, a similarly strong loyalty to Ruskin was evidenced by Norton's 1880 book entitled *Historical Studies of Church-Building in the Middle Ages*, a work deeply imbued with distillations of Ruskinian concepts. He was also supportive of Ruskin throughout his later, emotionally troubled years, bringing a collection of Ruskin drawings to New York and Boston for exhibition in 1879 and—in the 1890s—securing an American copyright of Ruskin's works for the author. Overall, he thus proved instrumental in diverse ways in the dissemination of Ruskinianism: in his writings, his teaching, his support of Stillman and the *Crayon*, and even his assistance of Jarves (whose collection of Italian primitives he futilely tried to secure for a museum in Boston.)

In addition, Norton was an important teacher, although he was occasionally to be "crucified" by Harvard undergraduates for his advocacy of Pre-Raphaelitism.[37] The student newspaper the *Crimson*, for example, pilloried Norton and his fine arts course in 1875 for its doctrinaire espousal of Pre-Raphaelitism, "set forth to me who elected the course much as the story of Daniel in the lion's den might be told to an infant class of a Sabbath school. Its reality was not to be questioned; the moral was to be drawn, not for discussion, but that it might be blindly and implicitly followed."[38] Fine Arts I was accordingly best "reserved for those who of their own free will wish to devote themselves solely to Pre-Raphaelitism," for those who "had pinned their faith to Ruskin" alone, but not for those who wanted a more catholic approach to art. Norton's singlemindedness resulted, at least in the scathing tones of the *Crimson* reporter, in students who would gain "the same relative knowledge of art that a caterpillar has of geography." Nonetheless, Norton's teachings influenced at least one influential art critic of the next generation, Henry James, who in 1869 had been introduced in London by his Harvard mentor to the giants of the movement—Ruskin, Rossetti, and Morris. James was to offer some of the

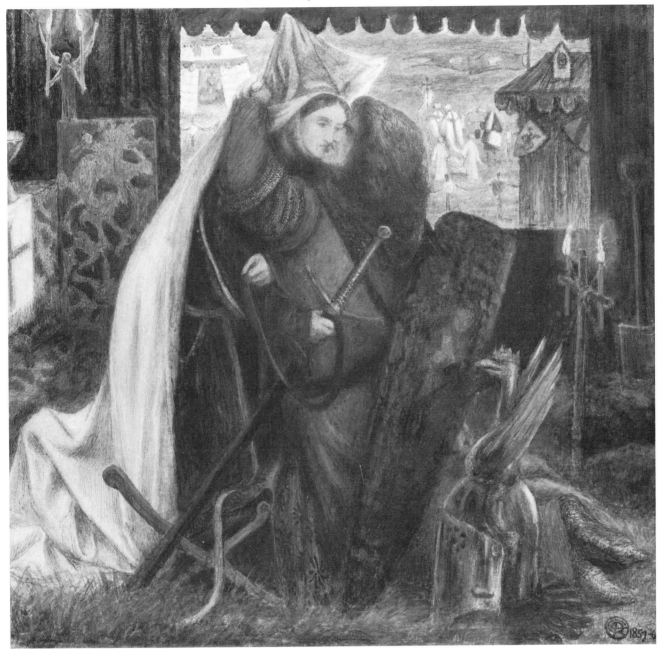

Figure 4. Dante Gabriel Rossetti, *The Chapel before the Lists*, 1857–64. Watercolor, 15½ × 16¼ inches. *(Courtesy of the Tate Gallery.)*

most perspicacious insight on Pre-Raphaelitism, commenting in 1876 in his dispatch for the *New York Times* on the differences between this kind of English art and the phenomenon of Impressionism, " . . . The divergence in method between the English Pre-Raphaelites and this little group is especially striking, and very characteristic of the moral differences of the French and English races. When the English realists 'went in' . . . for hard truth and stern fact, an irresistible instinct of righteousness caused them to try and purchase forgiveness for their infidelity to the old more or less moral proprieties and conventionalities, by an exquisite, patient, virtuous manipulation—by being above all things laborious."[39]

Thus, these men—Ruskin (from the other side of the Atlantic Ocean) and his "acolytes" Stillman, Jarves, and Norton—effected a small but significant revolution in the spread of

Ruskinian doctrines on American soil. Without their proselytizing efforts and sincere commitment, Pre-Raphaelitism in the abstract (and in the way of actual paintings) would have remained a foreign enigma without champions—or perhaps even without detractors—to help shape the future direction of American art and aesthetics.

2

The Stiff, the Eccentric, and the Ugly: General Responses to Pre-Raphaelitism

The *real* Pre-Raphaelites, our readers will agree, . . . are those who invented the name and applied it to themselves—the only school of artists that ever were so self-styled. What this school was, and where located, and whence arising, we shall show. But first it should be stated that, so far as we know, there never has been a Pre-Raphaelite picture painted by any American artist: there has never been a Pre-Raphaelite picture in any exhibition of the Academy of Design, except on one occasion, nor elsewhere in New York at all, except in the exhibitions of British Art in 1859 and 1860. There is no modern school of art so little known in this country as this. There is no European school of art which has so few followers in this country. There is no modern school of art of such strongly marked and individual character, and so impossible to be confounded with others.[1]

This was the pronouncement (mistaken in its citation of the years when british art was first exhibited in New York) issued in an 1865 article on Pre-Raphaelitism in the *Nation*, a statement that revealed a great deal about critical and public perception of this kind of art in America. Not only did the author indicate how little known the Pre-Raphaelites were both as artists and proponents of a specific creed, but he also specifically named the year " . . . 1850 that we first hear of the Pre-Raphaelites." While this date was only an approximate one, it proved to be a fairly accurate index of how awareness of these contemporary painters and the issues about naturalism which they raised began and then grew in that decade. Americans may have initially learned of Pre-Raphaelitism through Ruskin's writings, but there were also other sources that focused on this phenomenon and subjected it to continual debate, investigation, and inquiry.

Even before the *Crayon* championed Pre-Raphaelitism and the 1857–58 proposal was organized for American spectators, there was evidence of other native interest in this type of contemporary British painting. Ruskin's pamphlet entitled *Pre-Raphaelitism* was published in New York in 1851, and among the evaluations of this was one that appeared in the Boston-based periodical the *North American Review*. Ruskin's defense of these artists, who went to nature and carried out the faithful representation of real objects just as he had exhorted them to do at the end of *Modern Painters*, was sympathetically discussed, even though the general

subject was described as in a rather unstable state and "now making some noise and exciting a good deal of ridicule."[2] Mostly Ruskin's own prose was reprinted, but there was also some attempt to judge his novel opinions: "By the very constitution of his mind, he is the advocate, . . . believing that a tame and slavish adherence to the traditions of the schools is the great incubus upon modern art, and that an earnest study of nature is the great remedy, he strives with all his soul to inculcate this deep study and fond imitation of nature upon the artists of his time." There was no real discussion of the art or of Pre-Raphaelitism per se, however, the unnamed author preferring to leave " . . . the soundness of his creed to be discussed by Art Journals and Royal Academies." (It should be remembered, however, that until about the middle of the nineteenth century, American art criticism was mostly piecemeal, a mixture of biographical data with simple descriptions or commentaries of content.[3] This situation altered with the founding of the *Crayon* in particular, and the phenomenon of Pre-Raphaelitism decidedly helped to hone the analytical skills of reviewers and was part of the increasing interest in the formal aspects of art and in aesthetic philosophies.)

Aside from Ruskin's pamphlet and critical reactions to it, it was not until about 1855, once again in the pages of the *Crayon,* that the subject of Pre-Raphaelitism began to heat up and to be brought to the attention of Americans both with some noticeable regularity and also with clearly growing levels of passionate conviction for or against it. Of course, it was possible that some interested Americans could have read about this topic in the pages of British periodicals like *Fraser's Magazine,* for example, which in 1856 published a lengthy piece entitled "Pre-Raphaelitism from Different Points of View."[4] But in American terms, it was the *Crayon* that provided the most extensive coverage of the Pre-Raphaelites, beginning in the early issues and continuing to the end. However, even the supportive editor Stillman initially wavered in his enthusiasm for Pre-Raphaelitism. In a reply of March 1855 to a reader's query, the editors found fault with Pre-Raphaelite technique and with the hard-edged and elaborate details, viewing Pre-Raphaelite canvases essentially as belonging to a "preliminary" phase of art. Accordingly, Stillman wrote that "The true definition of Pre-Raphaelitism then, is that it is a phase of Art preliminary to the attainment of the ideal of truth and beauty—not desirable in itself and for itself, but as a condition of Art, preparatory to something most desirable. . . ."[5] Not long afterwards he took a more positive stance, stating that he considered Pre-Raphaelite art a good model for Americans to follow, arguing that "detail is not the end of Art, but it is the means of it—as indispensable to it as the knowledge of our letters to learning to write."[6]

Beyond Stillman's sometimes contradictory advocacy of the new creed, it was the contributions of William Michael Rossetti as foreign correspondent to the *Crayon* from April 1855 through January 1857 that proved to be the turning point for that magazine's elucidations of Pre-Raphaelitism. In spite of his obvious biases on behalf of the Brotherhood, Rossetti gave readers a fairly accurate appraisal of the art and events happening in Britain, providing Americans with a great deal of information and insight even before the first English Pre-Raphaelite canvases were seen on American shores.

Nonetheless, although the tenor of support was mostly positive in the *Crayon,* there were lapses and fluctuations in the reactions expressed in its pages. In an article published in the March 1856 issue of the *Crayon,* for example, the comments about Pre-Raphaelitism were surprisingly caustic, far less positive than later remarks offered by Stephens, Rossetti, or Stillman himself. There were references made both to the Germanic (Overbeckian) origins of the movement and to what was perceived as the underlying "Catholic" spirit of the subject matter. While there was some recognition of the noble aims of the Pre-Raphaelites, there was also criticism of their "exclusive means", the author urging that " . . . The P.R.B. . . . search beyond the narrow confines of one age and country."[7]

In addition, the *Crayon* ran a five-part series of articles in 1856 on "The Two Pre-Raphaelitisms" which, while focusing mostly on such Italian artists as Giotto, Ghirlandaio, and

Masaccio, also outlined the careers of their modern English descendants. The Pre-Raphaelite band of seven was described as having "striven to reinstate the art of painting in its proper nobility of position", and the works of Hunt, Millais, Rossetti, and Woolner were all extensively chronicled for readers. Aside from the description of their careers, however, this series did not deal with really evaluating the group until the last essay, which appeared in March 1858. While acknowledging the merit of many of their canvases, the author demurred from the task of defining Pre-Raphaelitism and was satisfied instead with setting a few analogies before his readers. However, there was a degree of lashing out against the rigidity of Pre-Raphaelite doctrines, the writer insisting "We do not pretend to prophetic acumen, nor to take the responsibility of saying that English Pre-Raphaelitism will or will not rule the universe of Art. Truth will certainly prevail, but we do not believe that it will prevail in Art, at the expense of Beauty." Moreover, there was some quibbling over the notion whether the Brotherhood was capable of forging their own category of "sectarian distinctions." "A work of art is not a mere intellectual construction, to be accepted on account of its ingenious symbolism, or for mechanical polish. . . . When Pre-Raphaelites paint good pictures, it is not because they paint in accordance with the principles of their sect, but because they are artists in feeling, and possess adequate executive ability to place that feeling before us."[8]

Besides the accounts of the artists' careers available in such articles, an equally significant concern involved current observations on both the assets and the shortcomings of this group, as the 1858 comments indicated. The early piece on "The English Pre-Raphaelites," for example, enumerated the supposed anatomical absurdities of the creed—namely, the "strange quaintness, stiffness, and gratuitous deformity" which proved to be such vulnerable areas for attack in America as well as in England and France.[9] Many English critics pronounced the faces of Pre-Raphaelite figures to be ungainly and ugly, while the postures or gestures were constantly described as ungainly, exaggerated, and strained. The *Times* reviewer in 1851, for example, recoiled at the tendency to seize upon "the minute *accidents* of the subject, including, or rather seeking out, every excess of sharpness and deformity."[10] This complaint about the supposed awkwardness and angularity of the figures was commonly shared by Americans as well, who were similarly taken aback by the seemingly ungraceful physiognomic and phrenological effects in art that resulted from the Pre-Raphaelites' empirical observations of real, not ideal, people and poses.[11] *Dwight's Journal of Music,* for example, lamented in a general way that the Pre-Raphaelite painters, "instead of being naive. . . . are only awkward . . . not warm or genial but uncouth. . . ."[12] To that writer the tenets upheld by the Brotherhood were due to Ruskin's "magnifying glass" distortions, and the results were eccentricity and a technique with a "prevailing dryness, unhealthy coldness of flesh tones, and want of tone and freshness. . . ." Even William Stillman was reproached for having given a lecture in which his "eulogy of Pre-Raphaelitism" supposedly embraced an unhealthy "worship of ugliness and deformity."[13]

A rather poignant defense of some of these deficiencies was proffered by a New York critic for the *Evening Post,* who asserted that painters in this category " . . . have been most misunderstood and misrepresented. The absurd notion that pre-Raphaelitism is stiffness and ugliness or, as a most sapient critic not half as wise as clever, states it in one of our contemporaries [from the *New York Times*], 'the wish to make a penance of every picture and of every penance at once a spiritual pleasure and a spiritual profit. . . .' That a certain stiffness and constraint characteristic of most of the pre-Raphaelite pictures is very true, but from no intention on the part of the painters, and the true reason of it lies in this—that when a man whose powers of execution are slight, either from inexperience or otherwise, sets earnestly to paint an object, his very earnestness and intensity beget an awkwardness and heaviness of expression which will make the (otherwise) best drawn figure graceless. . . . The pre-Raphaelists are in this course of study—most of them in the beginning of it—and their 'stiffness' is the result of earnest thought and uncompromising intention struggling with feeble hands. Understanding this, if any would

still wish them to be more facile, at the loss of meaning and earnestness, . . . such can have no possible sympathy with pre-Raphaelitism, either in its present training or its future triumph. The artists of the pre-Raphaelite Brotherhood are unfortunate in one respect, that they must display their art in its incompleteness to those who have no capacity to perceive purpose through incompletion. . . ."[14]

Another aspect often mentioned was the novel and even revolutionary character of this kind of art, a quality which sometimes pleased Americans and at other times dismayed the more tradition-bound writers who still supported the eighteenth-century tenets of Sir Joshua Reynolds. Editor Stillman wrote in "The Hope of Art" 1855 issue that the Pre-Raphaelites heralded the "start of a new reform, a new phase in art, their reverence for nature serving as the hope for all future art."[15] A few years later, in 1858, the *Crayon* expanded its remarks by stating that "Pre-Raphaelitism [had] sprung up to put down Royal Academy-ism. Pre-Raphaelitism is a species of Puritan reform against the cavalier pretension of Royal Academy-isms."[16] In a similar way, the *Evening Post* in the same year described the Brotherhood as " . . . an association of like-minded men banded against opposition rather than agreed on conventionalism."[17] The *Atlantic Monthly* concurred, admitting in a grudging way that that this was "an absolutely revolutionary movement and must, therefore, be rejected by the English mind when seen as such—and this all the more certainly and speedily because Ruskin with his imaginative enthusiasm has raised it to a higher position than it really deserves at present."[18] The same writer also remonstrated, "To suppose that a revolution so complete as this could take place without a bitter opposition would be an hypothesis without any justification in the world's experience. . . ." To him, Americans were more receptive than their British counterparts, whose " . . . conservatism has built its strongest batteries in the way of invading reform. For the moment, the English mind, bending in a surprised deference to the stormy assault of the enthusiasts of the new school, [was] partly carried away by its characteristic admiration of the heroism of their attack and their fiery eloquence of their champion. . . ." Furthermore, the *Boston Daily Courier* realized that Pre-Raphaelite works were truly iconoclastic in their aims, for they "not only deny boldly some of the most important canons in the European aesthetic code of the last three centuries, but they originate many new problems in art, and revive some principles forgotten since Giotto and Angelico."[19]

However, chaos could also accompany revolution, and this was true in terms of the confusion that prevailed about the battle cry of "Pre-Raphaelitism" itself. In his first letter as a correspondent to the *Crayon,* for example, William Rossetti attempted in 1855 to dispel some of the misconceptions about Pre-Raphaelitism, not defining the movement but instead differentiating the distinct forms or phases it took in art. At the lowest end of the scale he placed mere transcription of nature, and at the highest "a faith in Nature . . . involving that sincerity of thought which shall always invent something." Pre-Raphaelite art was thus elevated from a descriptive mode to a "condition of the mind" that embraced both "truth of feeling and truth of fact."[20]

By 1858 the Boston periodical entitled the *Christian Register* suggested that the word "Pre-Raphaelitism" connoted as much enigma as the term " . . . transcendentalist [had] a few years ago. It seems to mean a literal adherence to nature in color and form with a touch of symbolism and mystery. . . . The Pre-Raphaelite . . . with the fine conception burning in his brain, waits patiently to elaborate the tresses hair by hair, to compare tints in the flesh, proportions in the figure; and when he reaches the flowers must rush out under the sky with spectacles and note-book, and inventory each line on the petals, each pollen-grain on the anthers, each swelling stem and bud and leaf and vein, and transfer them to his canvas."[21] A similar effort to pin down the term—and yet a more antagonistic opinion protesting its perplexing ambiguities—was expressed in the *Crayon* by a London correspondent in a column of June 1859: "There has been a good deal of discussion about Pre-Raphaelitism, a thing of which most people appear to

entertain rather vague and unintelligible notions, and which each of its votaries, as a matter of course, interprets after his own fashion; and it must be admitted that the interpretations of some of them are very curious documents." The writer not only wailed about the alleged ugliness of the creed; he also assailed the mechanical reproductive aspects of Pre-Raphaelitism, the prismatic palette, and even the mystifying effect the choice of subject matter had upon viewers: "We have, accordingly, in all our public exhibitions, a sprinkling of most singular and grotesque things, which are paraded under the title of studies from nature, experiments, etc., and which entirely baffle poor uninitiated spectators. I fancy some of our young aspirants have adopted the practice of painting in spectacles composed of bits of colored glass, through which they see purple rivers and yellow rocks, and other prismatic marvels. . . . One thing is certain, that there is too often a sad lot of awkward, ugly-looking attempts, and I don't believe that anything ugly or disagreeable is a faithful rendering of nature, or that a faithful rendering can be obtained by dint of mechanic drudgery—an Art-heresy, which seems very much in fashion just now."[22]

The rampant multiplicity of meaning that Pre-Raphaelitism seemed to spawn was later examined by Russell Sturgis (a founder of the American counterpart to the Brotherhood), who wrote in an article devoted to the subject in the *Nation* in 1865 that Pre-Raphaelitism as a word " . . . has a definite and very exact meaning. but it is used as if it had twenty. . . , or were a generic term of wide application. . . ." He was also concerned with how the term was misapplied to American art, remarking that "the word . . . for several years very much annoyed the art-loving public of New York. . . . Firstly, every odd-looking picture is called, in popular language, 'Pre-Raphaelite,' especially if the color is at all vivid, or the shadows of unusual sharpness or definiteness."[23] Sturgis, a charter member of the Society for the Advancement of Truth in Art, objected to the indiscriminate and pejorative uses of the term, writing the next year in the *Nation* that "The cry of 'Pre-Raphaelite' had been, in the little world of art here, what the good old Democratic cries of 'nigger' . . . had been in the country at large."[24] However, other critics resented the term but not the method of painting nature which it described, an opinion voiced, for example, by the art correspondent for the *Galaxy* in 1867.

While many American writers dwelled upon the hyper-realism of style or the awkwardness of effect of Pre-Raphaelitism, others focused on different but related qualities to define this radical development in art. The *Evening Post*, for example,. emphasized the truth-seeking qualities of the new art, asserting that

> Truth first, and pleasure afterward, should be the motto of every artist and lover of art. And here we may draw the great distinction which lies between the Pre-Raphaelites and the great mass of art since Raphael—the distinction by which it deserves its name—that it is a truth-seeking art, while the other is a pleasure-seeking art—the one is philosophic, poet, religious, the other the pandering to any fallacy of taste or freak of pride or fashion—the one is a pursuit worthy of a human soul, the other is but a dignified kind of decoration, better left to upholsterers, grainers of wood and the like. All works which belong to the former class are akin to Pre-Raphaelitism whether they recognize the Pre-Raphaelite Brotherhood or not—but no man who has not once in his life sat down before nature, with his heart full of some beauty she has shown him, gone resolutely to work to tell all of it that he could see, and worked until his eyes grew dim and his hand weak with his intensity, can ever fully comprehend the earnestness and devotion of these pre-Raphaelite pictures, qualities which should ever secure them against the flippancy of any but fools or the sarcasm of any but professed critics.[25]

While some of the efforts to define Pre-Raphaelitism proved more accurate and convincing than others, it is clear that the notion of the group's intensity and earnestness mattered a great deal to many writers. In the first volume of the *Crayon* Stillman not only described Pre-Raphaelitism as a preliminary state of art, but he also singled out conscientiousness and

intensity as the salient characteristics. He defined the first quality as "the rigid adherence to that which the artist sees in Nature and considers worthy of imitation;" the second was an intensity that was utterly jolting in effect. Stillman then described the impact in curiously sexual terms: "Pre-Raphaelitism . . . seems to us like an awakening of Art from a long sleep, when, for the first time recognizing the features of his loved Nature, his embrace is so ardent that no fold of her garment, no hair on her head, no grain of dust on her feet even, could escape his loving regard, but reverencing, adoring everything pertaining to her, he worships in supreme devotion and self-forgetfulness."[26]

While Stillman endorsed this effect, the *Evening Post* commented that viewers might loathe such pictures and yet admire the sincerity they embodied: "*Dislike* them if you will, it is your right; but do not jest with the souls of earnest men laid open in their work to the world."[27] "The souls of earnest men" turned out to be a point that fascinated many Americans, for the openness and the humility of the artist struggling with nature and with his medium were both appealing notions. The philosophy of hard work itself was revered by Victorians on both sides of the Atlantic, but earnestness also belied to American critics a certain profound and purposeful search for the truth. In fact, the use of nature as the source of inspiration took on quasi-religious dimensions, thus conferring upon Pre-Raphaelite artists the status almost of priests or acolytes bent on devotion to the natural world and its reflection of the divine Creator. The *Knickerbocker, or New-York Monthly Magazine,* for example, attempted to clarify this appeal by commenting, "Much maudlin talk there has been of Earnestness and Earnest men, but there is behind, or shall we not rather say above, all this, elevated upon a height from which the unreal has fallen, a genuine love, inborn with every noble heart, that craves for the truth and energy of purpose which constitute real earnestness? Herein, therefore, we find the power, after which this school of painting is now half-blindly groping."[28] Others, like the critic for the *Atlantic Monthly* in 1858, commented that earnestness actually proved a deterrent to technical mastery: "Young men filled with earnestness and enthusiasm . . . will spend little time in acquiring academic excellence, or trouble themselves much with methods or styles of drawing. They dash at once to their purpose, and let technical excellence follow, as it ought, in the train of the idea of their work."[29] Thus, while truth and diligence were laudable aims, they were not enough, and the *Knickerbocker, or New-York Monthly Magazine,* for example, in the end qualified its approval of Pre-Raphaelite conscientiousness by recommending some areas for improvement: "Seeking no aid from melodramatic contrasts of light and coloring, it needs not to rob itself of all that Art has learned; it may be all truth, and yet have breadth, and depth, and effective force of composition; foreground and back-ground need not be rolled out flat, like the pie-man's crust . . . that the artist may prove himself too much in earnest with his main design for any care of such trivial considerations as distance, relative distinctness, or real appearance to the eye."

The search for truth led to flatness and pictorial effects which, to some critics, smacked of pseudo-photographic aims. The *Boston Courier and Enquirer* critic, writing about the 1858 exhibition of British art in that city, addressed the issue of such mechanical literalism in art: "Whether this idea has arisen from a repugnance to the intense school . . . or whether it has grown up from a fear that the photograph is to rival art, it has evidently had possession of many of the artists whose works are here exhibited, who have sacrificed to it an amount of skill and labor marvellous in itself, and perfectly astounding in its misapplication."[30] To that writer, the mimetic goals of Pre-Raphaelitism produced characterless and labored results that resemble in some way a photograph which, "even of the finest, is, after all, a cold affair." The flaws of sharp focus and hard detail which were particularly irksome included the "constantly obtrusive finish, the hard lines, the unsoftened garnish, dazzling contrasts of color, often apparently chosen to show how unpleasant discordance can be employed, if not reconciled. Everything is brought out and forward to the last degree; . . . and you may spend hours, nay days, in counting the bricks and the boughs. . . ." The critical reactions to photography in mid-century

England were quite mixed, and it is apparent that the parallel drawn with this new medium was not intended as a compliment; ironically, Ruskinian hyper-realism would be partly defeated by the rise of photography in both England and America.

A related point was further discussed by one of the founding members of the Society for the Advancement of Truth in Art, which held up Pre-Raphaelite art as its model of style and content. Thomas C. Farrer wrote in the June 1863 issue of this association's journal, the *New Path*, about how Pre-Raphaelitism had previously been denounced, and at times almost persecuted, by critics who failed to understand the concept of "painful fidelity" to nature, yet another consequence of earnest and sincere goals. To Farrer this was a rather paradoxical idea, for " . . . painful labor in good works of Art is an utter impossibility, and if the signs of careful, earnest drawing, and deep love for the Creator's work, in an artist, afflict you with any sense of agony, . . . look to yourself. . . , not the artist or his picture."[31]

The *New Path* and some earlier journalists (in the *Crayon*, for example) also seized upon the alleged medievalism of Pre-Raphaelitism, Sturgis in the *Nation* commenting on the Brotherhood's penchant and respect for "the beauty and sentiment of the Middle Ages, . . . for chivalric customs, for splendor of dress, ornament, and architecture."[32] The neo-gothic, medievalizing spirit was particularly apparent in the works of Dante Gabriel Rossetti. Awareness of such matters was largely confined to a general recognition of stylistic similarities with early Italian Renaissance paintings, however, and analogies were not made with art that is today considered to be "medieval." The Ruskinian belief in the decline of art after Raphael—the loss of religion and of "medieval principles" was also bemoaned by some writers, who obviously ascribed to various ideas current in Ruskin's "Edinburgh Lectures" and "Art and Poetry, being thoughts towards Nature" (both of which had been published and reviewed in America.) In "The Limits of Medieval Guidance" in 1863, for example, the unnamed author in the *New Path* refuted the notion that this new school tried merely to revive medieval art, stating instead that "Modern Pre-Raphaelite art is as far from being an imitation of early Italian art, as light is from darkness." Moreover, he quoted Ruskin's pamphlet on Pre-Raphaelitism for its assertion that " . . . The Pre-Raphaelite pictures are just as superior to the early Italian in skill of manipulation, power of drawing and knowledge of effect, as inferior to them in grace of design; and that, in a word, there is not a shadow of resemblance between the two styles. The Pre-Raphaelites imitate no pictures; they paint from nature only."[33] Thus, it was the spirit of truth embodied in the early art that the Brotherhood perceived as worth emulating, not its style or content.

There were passing comments as well on how "religious feeling was a controlling influence over all their actions," although accusations of being Anglo-Catholic or "Papist" were not leveled by American critics as they were by the English.[34] Americans seemed untroubled by the sometimes sacred subject matter, and critics here also respected the Brotherhood's desire to treat only serious subject matter. Even their utilization of contemporary poetry (Tennyson and Coventry Patmore) was appreciated (the *Crayon*, for example, reminded readers of the Moxon edition of Tennyson with its illustrations by Hunt, Millais, and Rossetti), and the *Nation* perhaps voiced a popular opinion in 1865 that the Pre-Raphaelites " . . . were deeply in sympathy with the modern respect for quiet domestic feelings and simple incident."[35]

Journalistic responses to the 1857–58 exhibition in America, logically enough, often focused on these same complaints as well as on the basic and obviously vexing issue of the kind of new realism forged by Pre-Raphaelitism. The Philadelphia critic for the *North American and United States Gazette*, for example, commented that "The artists of this faith undertake to paint objects exactly as they find them, without the slightest shade of difference, and they certainly succeed to a wonderful degree. Whatever else we may say of them, there are no daubs bearing their names. Their ducks are real birds, beyond all mistake. Their leaves, ferns, grass, stones, are all vividly drawn and colored. Those who would see what Preraphaelitism can accomplish should see this exhibition."[36]

Minute, almost microscopic, attention to detail and the astonishing visual effects that were the outgrowth of intense scrutiny were elements applauded by the *Knickerbocker, or New-York Monthly Magazine,* which remarked upon how even compositional elements of trivial importance were endowed with religious or cosmic significance and were monumentalized by the Pre-Raphaelite approach: "every leaf and every blade of grass seems to have been made the subject of a study." However, in large landscapes this could create a supposedly misleading or false impression, since "The eye in looking, rests but upon few objects, and these the ones to which it is attracted by some exciting cause; so in painting objects, what gives the name and character to what is painted, have a distinctness to which all their surrounding must be subordinate."[37]

While the *Knickerbocker* remarked about the selective detail and the two-dimensionality that often resulted in Pre-Raphaelite canvases, it also commented on a kindred quality: namely, the high degree of finish "given to all the details, even to those of the most trivial importance; every leaf and every blade of grass seems to have been made the subject of a study, and in an extended landscape the effect is displeasing and false." While this critic and others tended to accuse all the Pre-Raphaelite painters of this flaw, a few writers like Sturgis understood that not every member of the PRB was "equally strict in carrying out the principles which governed them" and that not all compositions with minutely rendered foregrounds were Pre-Raphaelite.[38]

While the imitative qualities of Pre-Raphaelite art were often praised, there was probably more opposition than approbation overall. A scathing assessment appeared in the *New York Times,* for example, after the momentous 1857–58 exhibition, including the following lengthy analysis of the new style and school:

> Possibly a better thing could not have been done, both for the interests of British Art and for the Pre-Raphaelites themselves, than to give them the unluckily conspicuous place which they occupy in the present exhibition. For if anything can make the clever but crochety adepts of this Eleusinian corporation understand the enormity of the absurdities on which they are wasting their talents, their utter failure to touch the sympathies of a people almost entirely new to the appeals of art, almost as ignorantly fresh, in fact, as were the Italians of the really Pre-Raphaelite period, ought to do so. The Pre-Raphaelites undertake to receive the traditions of the time 'when art was still religion.' They wish to make a penance of every picture, and of every penance at once a spiritual pleasure and a spiritual profit. Because the painters who tried to paint before Masaccio and Perugino, and Ghirlandaio, Leonardo and Raphael succeeded in painting, [they] naturally devoted their energies to the details. . . . Therefore, argue the modern Pre-Raphaelites, no man can possibly cherish a passionate love of his art unless he abdicates all the facilities of subsequent experience, and all the principles subsequently discovered, and goes back to the tedious processes and the minute results of the 'Ages of Faith.'[39]

The *New York Times* deplored the religious tone the reviewer intuited in Pre-Raphaelitism. This seemingly false spirituality was compounded by an exhaustive degree of mimetic reality that clearly annoyed the critic because it concentrated upon the commonplace details of "weeds, dandelions, bits of straw, old glass, fence-rails, and pokers. . . ." Protest was also raised that "Some of these interesting fanatics are farther afflicted with religious and poetic tendencies which they indulge in the representation of the most incredible medieval anatomy, and the most incomprehensible antique symbolism. . . ." Furthermore, the conclusion reached was that, in spite of its novelty, Pre-Raphaelitism was not unique in the history of art: "This is the sum of Pre-Raphaelitism as a speciality. For the mere fidelity in the study of nature, of which they speak as if it were their monopoly, belongs to a dozen other sections of the World of Art as truly as to themselves. Without going back to Mieris, and Metze and Terburg, who would be but names to most of our readers, we have only to refer to the French. . . . [for] examples of

truth of detail, not to be surpassed by the indefatigable Hunt or the incoherent Millais, and not to be equalled by most of their followers."[40]

The way that this creed of microscopic fidelity to nature constituted a distortion of the pictorial world, much less of the aesthetic of the beautiful and the sublime, was of particular concern to American critics. While *Dwight's Journal of Music,* for example, applauded Ruskin's other favorite, Turner, for his evanescent and poetic views of the Alps, for example, John Brett's *Glacier at Rosenlaui* (see fig. 21) was denounced because its elaborate degree of verisimilitude seemed to have been " . . . realized at the expense of the higher, general truths, the result . . . an abnegation of all artistic truth." There was no grace or geniality in this cold-blooded style and constrained faith in nature to this author, who also maintained that "We see, then, evincing a strong grasping at the actual, striving without the cheering light of internal truth. . . . The *intention* is all that is expressed, while in the representation of the subtile [*sic*] qualities of nature, their faith seems soulless, and all their labour vain. . . . Devotees in the new faith seem to be . . . bending themselves to the fruitless labor of making microscopic, geological, or botanical studies, simply because the voice that calls them speaks in the name of truth. . . . The specific beauty of the simplest objects is . . . quite beyond our power of adequate Art reproduction . . . so that *progress* which the nearly exclusive devotion to little things in the new Art is said to symbolize, seems somewhat abnormal."[41]

While the limitations of truthfulness in art were persuasively debated in *Dwight's Journal of Music,* there were additional, related arguments found in Adam Badeau's essay on Pre-Raphaelitism in an 1859 book called *The Vagabond.* While the religious content or guise of Pre-Raphaelitism was sometimes alluded to as an underlying or latent trait, Badeau tended to emphasize the religious fervor, the spirit that animated artists like Giotto and Cimabue, which to him was absent in the modern English brand of realism. The Pre-Raphaelites were seen as disciples who "rival their models in the careful delineation of trivialities; they will paint you the back of a chair that shall be carved as finely as the work of Albrecht Durer . . . but they have not the motive that the old painters had. Their art is not religious." In focusing on how the group were instead realists, Badeau criticized their prescription of truth over beauty in art, for "Nature is often unlovely, and its effects disagreeable; truth to nature, under such circumstances, is falsehood to art. . . . Would you have the sculptor carve out the grossnesses and imperfections of the human form? . . . Would you have a comic actor represent all the odious vulgarities, the revolting indecencies of low life? . . . If we want nothing more of painters than absolute representations of old buildings, or copies of oak trees and fern leaves, Pre-Raphaelitism is very well; but if artists are to awake emotions, to excite sentiments, to arouse feeling, then Pre-Raphaelitism is not well."[42]

In discussing the higher truths which this new breed of realism allegedly could not achieve, Badeau spoke of the materialism of the Pre-Raphaelites, an aspect of their work which was of interest to numerous American authors. To him (and to the critic of the *Boston Daily Courier,* for example) the almost smothering accumulation of detail and "painful fidelity" proved noxious, creating a false doctrine of materialism that was spiritually bankrupt and compromised the purity of truth and the natural world. The idea that verisimilitude sacrificed the poetic and the immaterial qualities of art and "truth in art" also was an integral part of such criticism: "Will you have nature in which a divinity is incarnate, or nature like that of the brutes that perish? . . . Would you be blind to the light of the stars, and see only sticks, and clods, and stones? This fault I find with the Pre-Raphaelite brethren—that their doctrine leads directly to a worship of the material; to an ignoring of the ideal; to putting outsides and externals on an equality with the essential and the superior." Like some of the other critics, he also cited the similarity of Pre-Raphaelite canvases to photography as a decided flaw, for "you may look at these elaborate photographs all day, and get no ennobling feeling from them. . . . What do you see in all these careful pictures but the most marvellous accuracy, the greatest degree of mechanical skill, the

most remarkable imitation, the most painstaking assiduity, the same traits that ennable a man to weave a Brussels carpet, or an old woman to put together a patchwork bed-quilt?" Thus, the same qualities of hard work and visual accuracy which appealed to some English—and American—critics were here repudiated to some degree and relegated to the status of a minor accomplishment and a major theoretical flaw.

In terms of the laws of perspective, Badeau reiterated some of the same problems that Ruskin had noticed in works like *A Huguenot* (see fig. 31). "No human being distinguishes distant objects with the same degree of accuracy as near ones; no human being could perceive leaves and flowers at the distance represented in many of these pictures. . . ." Once again Ruskin was named as the ultimate font of wisdom on the subject, for to Badeau Pre-Raphaelite pictures " . . . all fail in embodying that religious feeling which Ruskin says truly is the great distinguishing characteristic of Giotto and his contemporaries. . . . Whoever can admire such pictures (as Hughes's *Home from Sea* (see fig. 13, for example) . . . is too far gone for me to argue with; whoever believes them, as I do, to be legitimate results from the teaching of the school, will either receive that teaching implicitly, or else reject entirely that which puts flowers and humanity in the same scale; that which appreciates a stick as highly as a soul, and lavishes as much labor on the portraiture of a pan as DaVinci would have bestowed on the 'Last Supper' or Raphael on a picture of the Fornarina."

Perhaps the most important development in the appreciation of Pre-Raphaelitism in America (as well as in the growth of a more professional type of art criticism) occurred in 1863 with the establishment of the Association for the Advancement of Truth in Art, which revered Pre-Raphaelite art and included in one of the articles of its founding manifesto the following injunction: "We hold that the revival of Art in our own times of which the principal manifestations have been in England, is full of promise for the future and consolation for the present. That the Pre-Raphaelite School is founded on principles of eternal truth."[43] Members of this group publicly defended Pre-Raphaelitism, especially in the pages of the *New Path*, an organ designed to be a counterpart of the *Germ* in England. Charter member Thomas C. Farrer in an article for the *New Path*, for example, invoked Ruskin's own words in his counter-attack directed against "would-be critics" of Pre-Raphaelitism, pointing out that, in addition to other aesthetic achievements, this brand of realism would provide future generations with very precise notions of how the nineteenth century looked, both topographically and in other, more emotional, terms.

Farrer also addressed the objection that Pre-Raphaelite adherents " . . . draw every leaf on a tree that is three miles off, with all the careful precision with which we draw leaves right in the foreground." "Painful fidelity" or verisimilitude in this respect is justified on the grounds that "it is just as wrong for a man to paint leaves when he cannot see leaves, as for the old fogies to paint trees and weeds that are close to the spectator with a few careless daubs of the brush, that mean nothing but imbecility and look like nothing but the paint-pot."[44] In a second article a few months later in the *New Path*, art as a "record" or document was discussed (although no analogies were drawn with photography, as had been the case in the *Crayon*.) In this documentary category Pre-Raphaelite pictures were placed, this classification justifiable because: "Anything that seems odd to one who is accustomed to the everyday, conventional work, brilliant color, strong and bold contrasts of light and shade, form and outline, called ungraceful and stiff, results from the earnest effort to represent nature as she is."[45]

Farrer's last point about color and shadow touched upon one of the remaining areas for scrutiny by American critics, namely, their opinions on the stylistic merits and deficiencies of Pre-Raphaelitism. Often there were complaints about the allegedly defective draftsmanship in these works, and many remarks of this type are offered in a forthcoming chapter on the journalistic responses to the 1857–58 exhibition. There was also somewhat of a gap between the perceptions of the "professional" or sophisticated critic and the amateur-connoisseur who had

his opinions published in a newspaper. For example, the *Crayon* satirized the idea that "the public are taught to delight upon murky old masters, with dismally demoniac trees, and dull waters of lead, colorless, and like ice upon rocks. . . . Thousands are given for uncomfortable sunlights, but if you are shown a transcript of day itself, with the purple shadow across the mountains. . . , you know nothing of it because your fathers never bought such works. . . ."[46] While this writer praised the Pre-Raphaelite palette and visual effects, there was general journalistic outcry about the lack of dark shadows and the vivid but seemingly patchy dryness of hues, which were not overly "protected" by yellow varnish and which often shocked viewers with their raw visual effects. Furthermore, there was no indication that American writers knew much about the white wet ground technique that the Pre-Raphaelites were prone to use, a method that contributed to some of the flatness of color and space that annoyed various reviewers. The curious lack of three-dimensionality that sometimes resulted was thus not readily understood or explained to readers as a logical by-product of special methods and especially of the painstaking one-to-one correspondence that the artist aimed to recreate from the real object to the canvas.

In addition to these drawbacks, there were sporadic references to the alleged "childishness" of the drawing or the effect of some Pre-Raphaelite compositions (for example, those by Elizabeth Siddall and Arthur Hughes), yet other authors paradoxically hailed the childlike innocence, the almost divinely-endowed naïveté, of the Pre-Raphaelites in their return to nature and their concomitant delight (if not hedonistic joy) in their discoveries there. As the *Atlantic Monthly* noted in its assessment of this quality, Pre-Raphaelitism represented " . . . a childhood of Art, but a childhood of so huge a portent that its maturity may well call out an expectation of awe. In all its characteristics, it is childlike—in its intensity, its humility, its untutored expressiveness, its marvellous instincts of truth, and its very profuseness of giving. . . ."[47]

Because landscapes were a central feature of contemporary American art, it is not surprising that a great deal of interest was expressed in seeing Pre-Raphaelite canvases of this genre. There were only a few pure landscapes included in the 1857–58 exhibition (see the end of chapter 3 for Stillman's awareness of this lack), and it was typically the single details—floral or foliage—that impressed critics. The *Christian Register* in Boston, for example, remarked that "there is something very touching in the patience with which strong men have painted the details of grass blade and dandelion-down, and the furze on the inner petals of the violet, because they would not slight what God had made!"[48] The nature worship of the Pre-Raphaelites thus proved inspirational in a very specific way, American artists adapting to their own vernacular the close-up view of a natural nook crammed with flora and fauna. And as a critic for the *Round Table* remarked in 1864, by as early as 1856 "Pre-Raphaelitism, in so far as it is the affirmation of the direct study of the absolute facts of nature, was accepted in this country," and its artistic adherents included Aaron D. Shattuck, William Hart, and William Trost Richards.[49]

By 1865 virtually all of the debate and definition of Pre-Raphaelitism and its tenets had ceased, American critics reiterating familiar compliments and barbs. Russell Sturgis for the *Nation* even speculated that " . . . the spirit of art, . . . the carefulness and truthfulness that the new reform represented" had dramatically changed by that date in England, having a rather homogeneous effect upon the state of contemporary art in general: "For Pre-Raphaelitism has gone through the first phase of its life and has entered on its second. It is hard now to distinguish and draw a line between the new school and the old. . . . For between the crowd of well-meaning and hard working artists and the great chief Dante Rossetti himself, there is no gulf or visible separation. Realistic, painstaking, purposeful work is the rule with so many painters that they set the fashion. Pre-Raphaelitism as it once was exists no longer, having done its work."[50]

While Sturgis's article proved to be a somewhat premature death knell for Pre-Raphaelitism,

its tolling rang true in its consciousness of the major characteristics of the movement and in its ironic prediction that, after the 1860s, the Brotherhood would exert a dwindling impact on American art and journalism. By the next generation, American Pre-Raphaelite Clarence Cook would write in 1888 that the cause he had committed himself to earlier ultimately proved to have "the least substance, and the least coherence of any attempted revolution. . . . Whatever claim it may have to be remembered is due partly to the undoubted earnestness as well as to the talent of its creators, and partly to the fact that it was a symptom of the great disturbance of the times. . . . Its origin was purely local. . . . The exaggeration and misunderstanding were increased by the shrill-screaming advocacy of the self-constituted prophet of the school, Mr. Ruskin. . . . If the truth were told, we should confess that not in one single point did the Pre-Raphaelite Brethren obey their own laws or follow their own principles. They cultivated oddity, indulged in affectation, and exaggerated in their own way as much as ever Raphael or Michel Angelo. What saved them was, that the world believed they were dead [sic] in earnest, as they were; they thoroughly loved their work, they opened up a new world of subjects, and gave us all something serious or delightful to think about."[51] Thus, by the 1880s the pendulum had swung back in its initial direction—scorn had turned to praise and back to disdain for the aberrations of Pre-Raphaelitism.

3

The 1857–1858 Exhibition of English Art in America: The Pre-Raphaelites on Trial

Bʏ ᴛʜᴇ ᴍɪᴅ-1850ѕ ᴀᴍᴇʀɪᴄᴀɴ ᴀᴜᴅɪᴇɴᴄᴇѕ ᴡᴇʀᴇ ᴇᴀɢᴇʀ ᴛᴏ ѕᴇᴇ ꜰɪʀѕᴛʜᴀɴᴅ ᴄᴏɴᴛᴇᴍᴘᴏʀᴀʀʏ Bʀɪᴛɪѕʜ ᴘᴀɪɴᴛɪɴɢѕ, especially the controversial art of the Pre-Raphaelites about whom they had read in the pages of the *Crayon* and elsewhere. As the *Evening Post* writer commented in that year, prior to this exhibition, few examples were found in America:

> Our means of acquiring even a slight knowledge indeed have been so few that, to untravelled persons, the present exhibition must reveal a mine of art, of whose richness, however familiarized it may have become to them by tradition or repute, they knew almost nothing. A stray picture by Landseer or Herring or Maclise has occasionally found its ways to our shores, but what do we know of their contemporaries and compeers, whose works crowd every annual exhibition in England? What we do know of the famous watercolor school . . . or what of the last, and as many contend, the greatest manifestation of modern art—the works of the pre-Raphaelites? Engravings of these works have not been wanting, but the thing itself, as it left the artist's easel, stamped with the impress of his hand and glowing with the illusions of color, we have not yet seen. German, French, Italian paintings, old masters and copies innumerable have filled our galleries, auction-rooms, and dwellings: the artists of the mother country are alone unknown.[1]

Thus, the exhibition of English art that traveled to a few Eastern cities in late 1857 and early 1858 was a monumental event, both because it opened the cultural door to English painting and because it provided viewers with examples of modern, particularly Pre-Raphaelite, works of art to judge. As the organizers of the exhibition hoped—and as the *Evening Post* affirmed, " 'the time is fully arrived when the kindred intellects of the two countries should be interchanged in other forms besides those of literature.' "[2]

To begin with, the complex chronology of the exhibition and its inception deserve attention, along with a city-by-city analysis of content and then a concluding evaluation of journalistic response, especially to Pre-Raphaelitism, both in general and in terms of specific works of art and artists included in this venture.[3] The idea for this project seems to have originated with Augustus A. Ruxton, although others like the well-known London art dealer Ernest Gambart

had considered undertaking such an enterprise in America. William Michael Rossetti, who was to play a central role in the arrangements, recalled in his memoirs that in 1856 he first met Ruxton, a handsome and suave "officer who had retired from the army still youthful" as well as the brother of a popular author who wrote stories about American frontier life that enthralled English audiences.[4] It was to Ruxton that Rossetti attributed the origin of the project, and although Ruxton was almost universally described as affable and competent, he was really quite an inexperienced newcomer to the arts. Perhaps Rossetti's later remarks about him were deliberately undercut with irony: "Capt. Ruxton had no sort of connexion with fine art or its professors but he felt a liking for pictures, and, having all his time for himself, and a wish to come forward in any way which might ultimately promote his fortunes, he partially matured this American project in his own mind and then looked for someone to act as secretary and to serve as medium of communication with artists."[5]

As a result, Ruxton, who wanted to secure works of "Pre-Raphaelite quality," asked Rossetti, a founding member of the Brotherhood, to function as an intermediary and negotiator. Rossetti naturally knew all the principal figures and also had another asset: his "recent connexion with the American artjournal, *The Crayon*," to which he contributed monthly columns as a foreign correspondent from the April 1855 issue through December of 1856. Ruskin himself had recommended Rossetti for the post, having turned it down himself. Accordingly, Ruskin wrote to his friend in February of 1855, "I was much gratified by receiving your letter, as it assured me . . . of the American public being well and faithfully guided in matters of art, so far as they trust the London correspondent of *The Crayon*."[6] Rossetti must have gained faith in the newcomer to the arts, for he wrote that after numerous interviews with Ruxton, he agreed to take on the job, which also provided him with a modest salary.

It is not clear precisely when in late 1856 or early 1857 the actual plan was formulated, but prior to June of 1857 Rossetti wrote a circular which was sent to artists and art periodicals in order to explain the scheme and to solicit cooperation. His text revealed his understanding of the best way to appeal to painters—by appealing to their vanity somewhat in suggesting how sought-after their works of art were by affluent Americans and by anticipating their anxieties about the display and insurance of their contributions. He also rather lucidly assessed the likely reception of the American public and its growing taste for art and foreign culture: "There is good reason for believing that such an exhibition would be welcomed by the Americans. The wealthy classes in New York are well known to be lavishly sumptuous in the arrangement and decoration of their dwellings; and it is confidently anticipated that they would be glad not only to call in the aid of Fine Art for this purpose, but to have its productions brought home to them for that constant contemplation and study which exhibitions and museums of a similar order receive from the cultivated classes. . . . The taste for Art is growing in America. . . . Americans are already in Europe keen competitors at any sale of objects of *virtu*, or antiquarian interest. The success which appears to have attended the Exhibition of Paintings of the Dusseldorf School . . . may also be deemed an encouraging precedent. It is difficult to imagine that, if the works of this alien school excite the interest of Americans, those of a race to which they are so closely allied in blood, character, and tradition will be otherwise than successful with them."[7]

Rossetti also reassured potential contributors about the legal and technical arrangements for the undertaking, stating that "Active measures are already in progress for making the projected Exhibition a fact. Mr. Augustus Ruxton—the original projector—left London for New York at the beginning of May, with the view of communicating with some of the leading men in the States, and of obtaining a gallery. Mr. Ford Madox Brown—the historical painter—has consented to accompany to America the works that may be offered, and to superintend the hanging and all other such preliminaries. Contributors may, therefore, rely upon it that justice will be done to their works. An unexceptionable guarantee-fund will be obtained before the works are removed for exhibition, including ample insurance—to the extent probably of not

less than 50,000£. An eligible offer has already been made for this purpose; and one main object of Mr. Ruxton's visit to America is to prosecute further inquiries on the matter. Exhibitors would be relieved from all expenses of transport; but a moderate per-centage to be fixed before final arrangements are made would be charged upon the sale-price of any works disposed of out of the Exhibition. The first Exhibition will, it is hoped, be opened in New York in October next, and remain open for some months; and it would be for the contributing artists to determine whether any of their works which might remain unsold at the close of the term should be returned to them (transport free) or should be left to re-appear in the Exhibition of the succeeding year."[8]

The brochure provoked immediate response in various art periodicals, the majority of which endorsed the premise in principle but expressed concern about its feasability. The *Athenaeum* speculated that artists would "hesitate to send their works to America, except on the very highest guarantees,"[9] while the *Builder* chimed in with a warning about previous failures of similar shows of foreign art at the Universal exhibition. "If well managed, we should have no doubt whatever of the success of the scheme," the *Builder* intoned, but "we would suggest the desirability of not confining it, even in appearance, to any one school or party."[10] The *Art-Journal*'s assessment was also wary, lauding the project as "admirable in theory" but indicating real misgivings about the timing of the venture and other factors: "Our doubts arise from our belief that it is next to impossible to collect a sufficient number of high-class pictures to form an exhibition, which . . . is to open in New York on the first of November; and we strongly advise its postponement for a year. It will be a serious and fatal mistake to imagine that the Americans will be satisfied with mediocrity—they can distinguish excellence quite as well as we can. . . . The experiment will, therefore, be a failure unless a large number of paintings of the highest merit be submitted to them. The project, originally started, we believe, by a few English artists, is now mainly under the direction of Mr. Gambart: he is a gentleman of intelligence and experience, and is, perhaps, the only person in England in whose hands it will be comparatively safe; but even he will find it difficult, if it be possible, to achieve this object worthily. We confess that our fears on this subject are stronger than our hopes."[11]

By the following month the *Art-Journal* sustained its negative reaction and added that, as it had hinted in the June issue, "the committee have evidently found it . . . no easy matter to get together any number of works of the best order, and by our best painters."[12] A long list of eminent artists, some of whom would never be included in the exhibition, was offered, and the *Art-Journal* also remarked that watercolor pictures would be better represented partly because "they are more easily collected than large and important works in oil."

Following such published acknowledgments of the project, including the *Athenaeum*'s misattribution of the venture to Gambart, a major difficulty developed. Rossetti delicately alluded to the problem as follows: "When Capt. Ruxton's American project had obtained some degree of publicity, it turned out that Mr. Ernest Gambart, then the most prominent and resourceful picture dealer in London, had also been entertaining a plan of like kind. Some uncertainties ensued. . . ."[13] The latter understatement politely minimized the crossfire of correspondence that took place betwen Rossetti and Gambart, who was very annoyed that Ruxton's efforts were pre-empting his own plans. Gambart's 5 July 1857 reply to a (lost) letter from Rossetti nonetheless retained some degree of cordiality beneath its rather insistent and huffy tone:

In reply to your esteemed of Saturday I acknowledge having for a long time entertained the notion of an exhibition of British works of art in New York, but it is only since the reduction of the tarif [sic] that I have taken any decided steps in the matter—I have some time ago sent orders to my correspondent in New York to engage rooms & have since then read in the Athenaeum an article aluding [sic] to a similar object & glad to find by your letter that my project had found already

advocates—& Now I will at once state that I have in this as in all other Exhibitions of Pictures in which I am already or may hereafter be engaged no expectations nor wish to secure personal direct remuneration—Interested as I am & deriving revenue from my publishing firm, anything that spreads & promotes the interest in the fine arts, promotes at the same indirectly the interests of my firm—Therefore if this exhibition can be well managed by you and your friends I shall at once give up my own projects as having no speculative end & competition could not be entertained. . . .[14]

Within a few weeks of this exchange, however, the tone of negotiations changed radically to one of icy confrontation. In the interim, Rossetti and Gambart had apparently met and concurred that two British exhibitions of art opening at the same time and place would be "foolish" and "detrimental" to both parties. Gambart also suggested that he had no "direct advantages" to receive from this venture (although this seems rather unlikely), yet he implied that Rossetti would have made a personal profit (although the latter's monetary gain from his honorarium would have been quite minimal). In a letter of 21 July, Gambart also reported that numerous artists had pressured him to rethink his decision, and he implied that the Pre-Raphaelite content of the show could be overpowering and thus unfairly represent the state of modern art in Britain:

> I am so much upbraided for giving up my scheme of a New York English Exhibition by artists who seem to place their confidence in me & denounce your ability of gathering a genuine English Collection as representing the British School that I must in justice to my friends whom I seem to have deserted too easily ask you what prospects you have of success & the names of the artists who have either given you or promised you Pictures, for if, as I am told on every side, you represent only *a very small body* of men & have no support of the academical body & the generality of artists I would be guilty of gross neglect towards my friends if by my withdrawal I lent myself to the furtherance of the interests of a cottery (sic) to the exclusion of the generality—Now, as I told you above my friends complain & deny you any authority to call yourself their representative; they denounce your utter inability in gathering an exhibition of the British School in works of art contributed by artists, they pretend your efforts will remain unsuccesful, & between your pretentions [*sic*] and my desertion they will either be in a very unsatisfactory exhibition or no exhibition at all—I send you a rapid exposé of what I understand to be the state of affairs & ask you for a meeting of your supporters or a list of the names that I may have an answer to give to those who assail us.[15]

Clearly, Gambart was highly agitated, his run-on prose style even more garbled than usual, and his remarks seemed to hurl numerous unspoken accusations at Rossetti.

As a result of these developments, there were various delays and probably some negotiations about merging the two efforts. As Rossetti later wrote in his *Reminiscences,* "finally it was arranged that Gambart should combine his scheme with ours—he being the far stronger in water-colours, while the great majority of the oil pictures came through our agency. Gambart sent at the same time a collection of French pictures to America for separate exhibition."[16] Rossetti also noted that Ruxton obtained through him " . . . an introduction to Madox Brown; and at one time it was proposed that Brown should accompany the works across the Atlantic, but this came to nothing." Indeed, the circular had mentioned Brown's involvement in overseeing the installation of objects, but Gambart seems to have been the one to interfere and put an end to this idea. Brown was greatly annoyed (at one time he had thought of emigrating to America), and he fumed in his diary on 17 January 1858: "I was to have gone over to hang the pictures, however, the scoundrel Gambart put a stop to that and all I had was the trouble of going to select the daubs."[17] Nevertheless, Brown's remarks reveal that he was at least instrumental in choosing the paintings that were included in the exhibition.

During the summer of 1857 and the brouhaha with Gambart, Rossetti kept busy contacting various artists. He wrote to Millais several times about the exhibition, realizing that this artist's pictures would be much admired and recognized in America. Millais demurred, however,

writing on 29 July, "I cannot give you an answer in the American Exhibition matter just yet, but I see very little chance of getting anything of mine."[18] Millais complained about having had only one entry to represent him in the important Manchester exhibition of 1857 and said he was "tired of being refused. You will understand this." The next missive however, from 13 August seemed more optimistic: "I have made an effort to get the Blind Girl for the American Exhibition as I should like it alone to represent me."[19] But by early September Millais wrote apologetically to his friend, "I am sorry that I cannot help you," adding that he would have been pleased "if Mr. Windus had sent one or two to America, or Mr. Arden had lent his but they seem to be sick of exhibitions."[20] Apparently Millais had sincerely wanted to participate in this enterprise, for he later wrote to an American patron named Charles Warren, "I have often wished to exhibit a picture in America publicly, but I have never had the opportunity, as my works have always been sold in this country to men who have the greatest objection to parting with them even for engraving. Do you think it is likely there will be another exhibition of English art in New York, in which case I might retain an important work on purpose."[21] And as Rossetti may have intuited, the absence of works by this artist (and, to a lesser extent, by Dante Gabriel Rossetti) was later mourned by critics.

While the English journals generated pessimism about the forthcoming exhibition, the *Crayon* welcomed it warmly and likened the idea for this to recent analogous shows of French and German art in London. The August and September 1857 issues offered the editorial opinion (probably that of co-editor William J. Stillman) that "we do not think any other school appeals so strongly to American sympathies" and also stated that what rendered "the English school specially interesting at the present time is the degree of development of Pre-Raphaelite form." Canvases which belonged to the latter category were eagerly awaited as part of the proposed exhibition, and examples by Millais, Hunt, Rossetti, Hughes, and others were mentioned along with names followed by the initials P. R. B. to indicate their artistic alliance. Rossetti's brochure was quoted to reinforce the notion that "The names of Longfellow, Bryant, and Prescott are as familiar in the old country as those of Tennyson, the Brownings, and Macaulay in the new, and the co-projectors earnestly hope that, if they succeed in rendering well-known to Americans the best names in living British Art, they shall be no less paving the way to the knowledge of American art in England."[22]

While such paeans were appearing in print before the October opening in New York, Rossetti also approached John Ruskin, whose *Modern Painters* was avidly read in America, about possibly becoming associated with the exhibition. Ruskin had previously decided not to write a column on art for the *Crayon* because he felt that he was not familiar with America or its artists, and he rejected Rossetti's request on similar grounds. In a letter of 23 September he somewhat apologetically penned to his friend, "You must have thought me very hard not to help you with the American Exhibition, but I have no knowledge of America, and do not choose to write one word about things which I know nothing of."[23]

As it happened, Ruskin's refusal to be of assistance and the general sense of English foreboding about the enterprise were part of an unfortunate chain of events that beleaguered the exhibition. Above all, the timing sadly coincided with a desperate financial crisis in the American stockmarket, a subject that dominated the daily newspapers with headlines like "The Panic of 1857 and Great Monetary Convulsions," along with related topics concerning serious unemployment trends, bank frauds, and the like. Four sites had originally been envisioned for the venture—New York, Philadelphia, Boston, and Washington, D.C.; but although Rossetti in his recollections named the nation's capital as the place where "a sudden and violent storm of rain damaged several of the watercolors, including a work by Madox Brown," no proof of a showing in Washington seems to have survived.[24] The other three sites remained on the itinerary, and, following the tepid reaction of the press in Boston, in the end the objects were mostly likely simply returned to England and their owners or creators. Of the initial stopover,

Rossetti later recalled the bleak monetary situation, remarking that: "The exhibition arrived in New York just in the thick of one of the most calamitous money-crashes which marked the nineteenth-century . . . people had very few dollars to spend, and not much heart for thronging to places of amusement. . . . Besides, the British artists had not after all come forward with adequate zeal. It was the year of the great Art-Treasures Exhibition in Manchester, and several men had really nothing to contribute; there was no important oil picture by Turner, no Millais, no Rossetti,—and the American devotees of Ruskin and sympathizers with Preraphaelism had been specially looking out for all these."[25]

Ruxton's correspondence with Rossetti in late September confirmed the dire circumstances that altered initial plans: "Instead of the four sources of returns which the interchange of the exhibitions between Philadelphia and New York would have yielded, we fell back upon the one chance alone; that chance is weakened, unfortunately, by the position of the rooms, and the sudden panic in the money market. . . . We could not have undertaken our enterprise at a more unfortunate, I may say disastrous, time. . . ."[26] The situation was ameliorated somewhat in that there were ultimately three locations for the exhibition, and another felicitous development noted by Ruxton was that "the Commissioner of the Customs has not only given authority to pass the frames as well as the pictures free of duty, but allows them to be handed over to my agent from the ship without examination. . . ."[27] However, Ruxton lamented the lack of pictures by Rossetti and Millais, and just before the New York opening he wrote that "Durand [of the *Crayon*] requests me to apply to your brother for a portfolio of his drawings. I promised to make the request, but I did not answer for its fulfillment. Your brother will not be displeased to hear that great interest is felt here in his works."[28] Ruxton also reported that in Brown's absence he had help from both John Durand and W. J. Stillman to hang the exhibition, using this opportunity as well to express the hope that "Mr. Miller will allow Turner's *Whalers* to come—Mr. Mulready may obtain two of his—and something must come from Millais. . . ."[29]

The New York installment of the exhibition opened in the new gallery of the National Academy of Design (at the corner of Tenth Street and Fourth Avenue, near Broadway) on 20 October 1847, and ran until early December. A total of 356 objects was included, 168 of these in oil and 188 in watercolor. In the negotiations for the show and in subsequent arrangements Ruxton ruled with his characteristic "plausible manner and excellent address," despite the fact that the vice-president and shrewd money manager of the Academy, Thomas S. Cummings, had, by his own admission, "opposed the whole scheme," even though his colleagues on the committee had been "perfectly charmed" by it.[30] New York's exhibition was favored by the largest number and highest caliber of objects, for there were several works—by Arthur Hughes and William Hunt, as well as five Turner watercolors—that did not appear in any other city. The majority of works were not Pre-Raphaelite—just as Gambart had wanted—and this may have reflected the dealer's influence in the final choice of objects. (Indeed, Gambart's name appeared, along with those of the playwright Tom Taylor, Madox Brown, and John Miller, as a member of the Selection Committee.)

Among the oil paintings most often singled out for accolades were Mark Anthony's *The Monarch Oak*, F. B. Barwell's *The London Gazette, 1854—Bad News from Sebastopol*, John Cross's *the Burial of the Princes in the Tower of London, 1483*, John Linnell's *Abraham Entertaining the Angels*, and Daniel Maclise's *The Installation of Captain Rock*. Reviews from the metropolitan press were generally favorable, the *Evening Post* hailing the effort as "an epitome of all that is distinguished in contemporary British art"[31] and the *New York Herald* commending the watercolors and remarking of the quality of the entries in general that "not one of all this number is bad, few are indifferent, nearly all are very good, and many superb."[32] The *New York Times* did not like either the installation of pictures or the dearth of contributions by Millais and Rossetti, noting of the former problem that "The paintings are disposed after a strange, incoherent fashion, which dazzles the eyes as you enter and leaves the brain bewildered when you go out.—They are

hung without respect to Chevreuil [*sic*], or the laws of color—Pre-Raphaelite intensities killing 'naturalistic' composure, and flagrant oils literally burning the life out of quiet aquarelles."[33] The *Crayon* was particularly complimentary, reserving its particular approval for the Pre-Raphaelites while at the same time repeating the universal complaint about the unfortunate lack of paintings by Millais. All of the New York newspapers and journals made at least some pointed references to Pre-Raphaelitism, some pejorative and others laudatory, and these will be discussed more fully later in this chapter in terms of individual paintings.

In the middle of the exhibition, on 3 November, Gambart fired off another chiding letter to Rossetti complaining that he feared "Ruxton loses sight of our premises, which are *to do the thing in the interest of the artists.*"[34] Stating that their artists-clients wanted primarily "the sale of their pictures or their return as early as agreed," he urged a pre-Christmas deadline. His tone became quite agitated in such sentences as "Ruxton seems to think only of receipts at the door. . . . In fact what pictures are not sold in New York stand very little chance of being sold in other places." Gambart was so upset by this alleged breach of a pledge to the artists that he seems to have used this development as an excuse to withdraw completely from the venture: " . . . I think it perfectly useless to consult exhibitors unless a schism is contemplated and for myself I feel the weight of my responsibility and the sooner I am clear of it the better and I wish to be released of all anxiety by the end of the year."[35] However, Gambart seemingly did not harbor a permanent grudge against Ruxton, writing to Rossetti in August of 1858 that he did not want this exhibition to jeopardize Ruxton's future prospects. Given the complications that ultimately transpired, perhaps Rossetti's latter succinct evaluation of the situation was the most accurate: "Ruxton was a loser by his spirited speculation—Gambart, I dare say, not a gainer."[36]

Besides Gambart's criticisms there were various objections registered by W. J. Stillman. Rossetti had been correspondent for the *Crayon* while Stillman was its editor, but the two had not at that time personally met (later Stillman became a friend of the entire Rossetti family). Nevertheless, Rossetti remembered that the American "exerted himself vigorously in favour of Ruxton's enterprise," which had "tended all the more to promote the best relations between him and me when eventually he came to London" in early 1859.[37] Although the two later became "fast friends," Stillman felt compelled in November of 1857 to write a frank but rather prickly letter about the official reaction of the National Academy of Design to the show it had sponsored in its building: "The Committee seem to have thought that things which were second-rate at home were fit to represent English art here, while our amateurs are in the main as well acquainted with English art as the English public itself. . . . There are many pictures which the public feel were sent here in presumption of ignorance or bad taste on our part, and we are a sensitive people on such points. . . . The preraphaelite pictures have saved the Exhibition so far as oil pictures are concerned, but even they should have been culled more carefully. You should have thought that the eccentricities of the school were new to us, and left out such things as Hughes's *Fair Rosamund* and *April Love* . . . with Miss Siddal's *Clerk Saunders* . . . all of which may have their value to the initiated, but to us generally are childish and trifling. Then you have too much neglected landscape, which to us is far more interesting than your history painting. . . . There must be something vital and earnest in a picture to make it interesting to our public,—and any picture which has not that had better stay in England. The P. R. B. pictures have, I venture to say, attracted more admirers than all the others for this reason, and at the same time have been more fully appreciated than they are *at this day* in England."[38]

Perhaps Rossetti overstated the degree of American enthusiasm for Pre-Raphaelite canvases (and also underestimated how much they were appreciated in England), but he did express a sense of national pride in the ability to ascertain quality and not to be fooled by mediocre art. He also commented that the dearth of landscape paintings frustrated American viewers—a point of greater importance for subsequent advocates of American Ruskinianism.

Rossetti probably knew the considerable truth of Stillman's complaints even before they were expressed, and his own feelings about many of the objects in the New York version of the exhibition were chronicled in a handwritten list. While he lauded various pictures, noting often whether Ruskin also approved of specific objects or their makers, he admitted that not all the paintings were of particularly high caliber. For example, some of the Turner watercolors he deplored as "child's work"; W. C. Ross's miniatures of Queen Victoria and Prince Albert were "not firstrate specimens," and other works were also slight. In the oil medium, he deemed P. F. Poole's *The Wreath* as "very faulty in execution," Sophie Anderson's *Lending a Deaf Ear* as "secondrate Pre-Raphaelitism—somewhat overdone," and reserved for William Huggins the dubious distinction of being called an artist who "ranks perhaps supreme for poultry." Barbara Leigh Smith Bodichon, whom the *Crayon* later described as contributing several landscapes " . . . of great power that will repay study," was perceived by Rossetti as " . . an amateur (I think) of great power. Has just gone to America. Well known as a woman who writes & exerts herself for public objects in England—& I fancy, known to many persons in America."[39] While original objects for all these artists have not yet been traced, a characteristic (and rather lackluster) work by Huggins, for example, was his *On Guard* (fig. 5) of 1853.

Figure 5. William Huggins, *On Guard*, 1853. Oil on canvas, 12 × 14¹/₁₂ inches. (*Courtesy of the Walker Art Gallery, Liverpool.*)

When the exhibition was still in New York, Ruxton proposed a new plan to manage future exhibitions of European and British artists in the United States, this seemingly without assistance from Rossetti or Gambart; moreover, he planned to add works by American painters to these shows. Council Minutes of the National Academy of Design from January 1858, for example, record this proposal, along with an accounting (and probably a heated discussion) of the unpaid and late rents Ruxton owed on the galleries.[40] These problems no doubt later contributed to Cumming's skepticism about Ruxton's abilities. The proposed enterprise would also have involved the Pennsylvania Academy of the Fine Arts and the Boston Athenaeum, with all three museums sharing the costs (not to exceed $1,666.66) of procuring, insuring, and transporting objects. Ruxton was to be paid to serve as administrator of the projects, and any profits from the exhibitions were to be used and controlled solely by the participating institutions to purchase works of art from the shows for their own collections.[41]

Meanwhile, the exhibition, with various replacements and omissions, moved on to Philadelphia for the period beginning 3 February and ending on 20 March 1858. The tally of objects was now substantially reduced to 232 items, 105 oils and 127 watercolors. In early January, Ruxton had contacted the Pennsylvania Academy to request a maximum sum of $1,200 to transport the pictures from New York and to cover some of the freight and insurance fees to England, stipulating as well that any forthcoming profits were to be applied (as had been agreed) to the purchase of paintings from the exhibition.[42] Initially, the Academy agreed with the terms and the pending proposal to join the National Academy of Design and the Boston Antheaeum (and also, possibly, the Art Association in Washington, D.C., or another gallery) in sponsoring subsequent displays of European art. However, the Academy later withdrew from the agreement, probably due to low attendance and receipts from the exhibition of English art in their museum. In fact, by 22 February a vote was taken in the Committee on Exhibitions, and chairman J. R. Lambdin "ordered the North and Northeast Galleries to be closed at night for a week in consequence of the small attendance of visitors, to reduce the consumption of gas."[43] Although expectations had been high, the Academy ended up paying only $500 as its share for the exhibition, and there were no profits to be used to acquire paintings for the permanent collection.[44]

In contrast to these disappointments, several Philadelphia newspapers liked the exhibition, including the *Public Ledger,* the *Morning Pennsylvanian,* and the *Pennsylvania Inquirer,* the latter stating that "the surpassing excellence of many of the specimens . . . so far exceeded our anticipation that they excited surprise as well as intense admiration. . . ."[45] The *North American and United States Gazette* maintained that there were no poor or even mediocre works included, while the *Press* lauded the Academy for bravely risking a winter exhibition "brought here to test the probable success of a design entertained on both sides of the Atlantic regarding the need for European art in America."[46] The *Inquirer,* the *Press,* and the *Sunday Dispatch* all asserted that the watercolors were the principal gems to see, and most of the critics also singled out Pre-Raphaelite canvases as dazzling experiments not to be missed by spectators. The *Sunday Dispatch,* however, hated the Pre-Raphaelite efforts, which were deemed rigid, false, and even too medieval and "Catholic." Moreover, Ruskin himself was criticized for his part in having "done much to introduce this method of barbaric painting into the English school, and in such proportion he has marred its taste."[47] The author of the review also could not reconcile Ruskin's equal and ardent endorsement of both Holman Hunt and Turner, since the latter was capable of producing "wonderful effects by a single stroke of the brush, which neither Hunt, Millais, nor any other Pre-Raphaelite could produce if they lived until dooms-day."

In Boston the total number of objects rose again to 321, including 104 oils and 214 watercolors, plus three bronze medallions by Pre-Raphaelite member Thomas Woolner that had not been exhibited elsewhere. The show opened to the public on 5 April 1858 and closed on 19 June. Ruxton was assisted at the Boston Athenaeum by Dr. Robert W. Hooper, E. C. Cabot, and

C. R. Codman, all members of the Committee on Fine Arts, and by Superintendent A. Ordway; however, no correspondence by these individuals about the exhibition survives in the archives.[48] As at the other institutions, the plan to have participating museums acquire works from the show went unrealized. A writer in the *Crayon* pointed out in its May 1858 issue, "Although the exhibition is a decided success, I do not think that Bostonians take very kindly as yet to the works of the Pre-Raphaelite school," an allusion to what might be called the Brahmin-versus-British aesthetic conflict that evolved on this subject.[49] In general, Boston newspapers preferred the watercolors to the oils, and the *Boston Post* even jingoistically suggested that American paintings should have been placed alongside their British counterparts in order to prove American superiority, "for in fact there is not a landscape in this whole collection that will come up to our artist, Mr. [Frederick Edwin] Church's magnificent picture, exhibited here a year or two since."[50] The *Boston Daily Advertiser* reiterated Stillman's belief that there was not enough quality art included and that "many of the most distinguished British artists of the present day are not represented here at all."[51] *Dwight's Journal of Music* (whose critic provided the most lengthy of all the analyses of the show) regretted "the losses which the collection has suffered since its arrival in this country, losses for which the recent importations offer us inadequate compensation," probably a fair assessment of what had happened in terms of content.[52]

Once again, it was the Pre-Raphaelite works that drew the most spirited response—in this city, a decidedly testy one, at least in the minds of critics for the *Boston Daily Courier,* the *Christian Register,* and *Dwight's Journal of Music,* for example. A public lecture that Stillman delivered in early May was derided by one reviewer precisely because it bestowed "the laurel to the pretentious egotists of the so-called Pre-Raphaelites for turning from the puerile pursuit of beauty to the search for truth, be it ever so hideous or disgusting."[53] While some accused Stillman of espousing this radical new creed in America, others laid the blame directly on Ruskin, one author claiming that it was Ruskin who had insisted that "art was only rightly to be seen from a nutshell."[54]

The analysis of unfolding events that culminated in the 1857–58 exhibition itself can now be shifted to focus on individual works of art that were displayed in the three cities. In addition to those artists already named as contributors to the New York portion of the show, there were various others whose works were included in all three locations. Among the oil canvases most frequently mentioned were John Calcott Horsley's *Prince Henry Assuming His Father's Crown,* Edward M. Ward's *Izaak Walton Fishing in the Colne,* and Richard Redgrave's *In the Midwood Shade,* the latter quite similar to a landscape nook of 1846 by Redgrave (fig. 6). Works by James Collinson, Charles Lucy, and Edward Lear also received some attention. Among the modern-life subjects singled out were F. B. Barwell's *The London Gazette, 1854: Bad News From Sebastopol* and Anna Blunden's *The Song of the Shirt* (fig. 7). Blunden's canvas featured a popular sentimental theme inspired by Thomas Hood's poem of the same title, and her work and Barwell's were labeled by the *Boston Daily Advertiser* as part of the "groups and studies of the present time."[55] While the Pre-Raphaelite pictures generally captured the headlines (as will be apparent later in this chapter), they were definitely outnumbered by more traditional paintings executed in a more conventional style. In this less radical category was Frederic Leighton's *The Reconciliation of the Montagues and the Capulets* (fig. 8, watercolor version), which had been included in the great Parisian Universal Exposition of 1855. The *Crayon* alone proffered a positive reading of this work, for in spite of alleged defects of drawing, the work was called brilliant: "It is Art which sweeps one away, overcoming every thought of criticism."[56] In contrast, the *New York Times* scorned the picture and maintained that the composition consisted of "frantic and cadaverous 'disfigurement' of 'Romeo and Juliet,' " as well as "false sentiment and odious coloring."[57] The *Pennsylvania Inquirer* similarly branded it an "appalling scene . . . regarded as that man's masterpiece. To obtain a proper concept he induced Fanny Kemble to read the passage to him

Figure 6. Richard Redgrave, *The Moorhen's Haunt*, 1846. Oil on panel, 8 × 12 inches. *(Courtesy of the Yale Center for British Art.)*

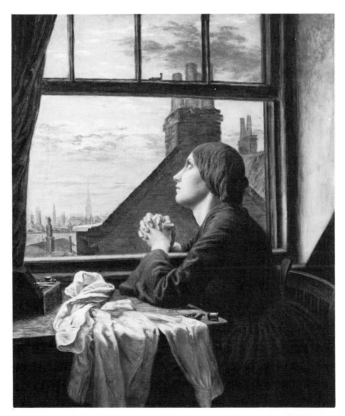

Figure 7. Anna Blunden, *The Song of the Shirt*, 1854. Oil on canvas, 18½ × 15 inches. *(Courtesy of Christopher Wood.)*

Figure 8. Frederic Leighton, *The Reconciliation of the Montagues and the Capulets*, ca. 1853–55. Watercolor version, 15½ × 20¼ inches. *(Courtesy of the Yale Center for British Art.)*

from the immortal bard. . . ."[58] Notwithstanding such attacks, the work was bought by a Philadelphia collector directly from the exhibition. A more serious problem that Leighton faced was censorship, for his (lost) works entitled *Pan* and *Venus and Cupid* were removed from display early in their itinerary and without the consent or knowledge of William Rossetti.[59] As Leighton later wrote to his mother about this predicament, "From America I have good news and bad news. The bad is that my 'Pan' and 'Venus' are *not being exhibited at all* on account of their nudity, and are stowed away in a cupboard where F. Kemble with the most friendly and untiring perseverance contrived to discover them. This is a great nuisance. I have sent for them back at once; they know best whether or not it is advisable to exhibit such pictures in America, but they certainly should have let me know. I have written to Rossetti about it today, expressing my regret and desires. . . . Meanwhile I am neglecting the opportunity of showing and disposing of them in England, a possibility I might willingly forego for the sake of supporting an enterprise in which I am interested, but not to adorn a hidden closet in the United States."[60]

Sometimes a painting was singled out for approbation partially because it did *not* possess Pre-Raphaelite traits. Such was the case with William Windus, whose style is today often associated with the Pre-Raphaelite circle but whose contribution to the American exhibition was exempted from most of the excoriating criticism heaped on his colleagues. The *Crayon* for example,

generally liked his literary illustration entitled *The Surgeon's Daughter: Middlemas' Interview with his Unknown Parents* (fig. 9), while the *New York Times* also pronounced this a "capital" work largely because it abjured Pre-Raphaelite qualities: "Mr. Windus' picture is positively painted with so little Pre-Raphaelite earnestness that he has neglected to deprive Middlemas of his midriff, and has pandered to the popular eye by obeying the laws of perspective."[61] The canvas was also admired in Boston, although the subject, taken from a novel by Sir Walter Scott, struck one reviewer as an "unpromising theme" in a "vividly drawn picture."[62]

Perhaps the single most frequently mentioned oil painting was Madox Brown's *King Lear and Cordelia* (fig. 10), which was simultaneously applauded and censured, often in the same review. The *Crayon* called it a work with "superb drawing, powerful color, and originality of composition" that was "one of those vigorous artistic creations that carries away all prejudice."[63] But although it thought the other figures in the painting were impressive looking, it excoriated the head of Cordelia as betraying a feebleness of mind—a point echoed by the critic for the *Knickerbocker, or New-York Monthly Magazine.* Cordelia was, the latter journal asserted, almost comically "a Billingsgate fish-wife gone into high tragedy on the boards of a provincial theatre."[64] The *New York Times* deemed the perspective to be atrocious (contradicting the *Atlantic Monthly*'s praise of the excellent drawing), and concurred with the feeling that Cordelia was depicted as a coarse specimen of femininity.[65] In Philadelphia, the *Sunday Dispatch* preferred more conservative paintings by Cross, Horsley, and Redgrave to Brown's "melodrama" with its

Figure 9. William L. Windus, *The Surgeon's Daughter: Middlemas's Interview with His Unknown Parents*, 1855. Oil on canvas, 17½ × 13½ inches. *(Courtesy of the Walker Art Gallery, Liverpool.)*

Figure 10. Ford Madox Brown, *King Lear and Cordelia*, 1848–49. Oil on canvas, 28 × 29 inches. *(Courtesy of the Tate Gallery.)*

supposedly ugly Cordelia.[66] Bostonians, however, waxed rhapsodic about the canvas, the *Boston Daily Courier* hailing the "true grandeur of conception" and the "penetrating and profound" tragic gloom conveyed by the prostrate monarch. This critic liked the "all-pervading air of romantic regality," stating that "The character of magnificence . . . is strongly though subtly expressed in the royal design of all the costumes and properties of the scene."[67] However, another entry by Brown, a watercolor version of *Jesus Washing Peter's Feet* (fig. 11) seen only in Boston, was the object of much scorn. *Dwight's Journal of Music* regretted the muddied background and the "palpable and puerile affectation"[68] of the work, and a correspondent reporting on Stillman's lecture in conjunction with the Athenaeum show soundly upbraided the American for endorsing Brown's "idiotic scribblings . . . in *Christ Washing The Feet of Peter.*"[69] Some works by Brown escaped invective, however, including a pen and ink design for *The Prisoner of Chillon* (fig. 12), which was on view in both Boston and New York.

In every city, nearly all of the periodicals—including the well-informed and articulate *Crayon*—focused on Pre-Raphaelitism as the most significant revelation of the exhibition, and the development of this phenomenon was almost universally attributed to Ruskin's influence. Most of the critics had difficulty comprehending the tenets of Pre-Raphaelitism beyond its transcription of and fidelity to nature, and their comments thus reflected their rather muddled

and, at times, contradictory, responses. Even the *Crayon*, a fervent advocate of the Pre-Raphaelites, had some trouble explicating the subject to its readers, although F. G. Stephens's earlier articles on "The Two Pre-Raphaelitisms" were in many respects quite insightful interpretations of this revolution in art.

One of the works labeled as Pre-Raphaelite that was frequently cited—and in fact roundly condemned—was Arthur Hughes's *Home from the Sea: A Mother's Grave* (fig. 13), a work repainted after the exhibition with the figure of the girl added. The *Crayon*'s reaction was the mildest, calling it "a painter's puzzle. Ruskin has said that the checkered sunlight was the finest thing of the kind he ever saw. For ourselves, we are indifferent to the technical problems involved in an analysis of its merits. . . ."[70] According to the *Evening Post*, the work was "absurdly drawn and bad in color, with the foreground grass more like cut paper than the sod of nature."[71] The *Knickerbocker* chided the *Crayon* for even tentatively endorsing the picture, which it found to have an awkward composition and a very ungainly pose for the boy, who

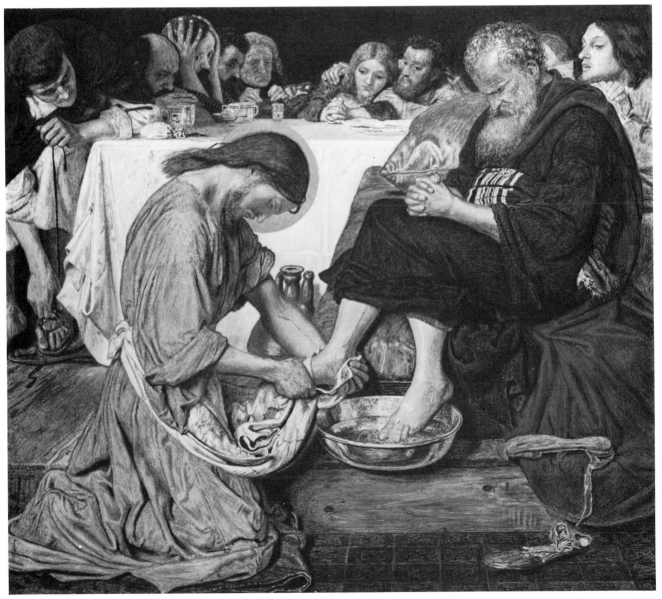

Figure 11. Ford Madox Brown, *Jesus Washing Peter's Feet*. 1851–56. Oil on canvas, 46 × 52⅓ inches. *(Courtesy of the Tate Gallery.)*

Figure 12. Ford Madox Brown, *The Prisoner of Chillon*, 1858. Watercolor, 5 × 3½ inches. *(Courtesy of the Yale Center for British Art.)*

seems "to have lain so long upon his mother's grave that his . . . trousers have become mildewed."[72] The *New York Times* fulminated that the painting was mere "puerile cant . . . a miracle of misery and of white mushrooms, while a little lamb skips along, a neat pathetic symbol of orphanage, through the air or rather through the space that should be air, and at some considerable distance above the pea-green turf."[73] When the canvas arrived in Boston, the reviews were just a negative, the *Christian Register* characterizing the supposed stony coldness of the boy as "a piece of malachite."[74] Perhaps Hughes added the figure of the sister in part bcause of such criticism; at any rate, the work when seen in America probably more closely resembled the preparatory drawing (fig. 14) than the final version.

Other entries by Hughes were also lampooned. His *Fair Rosamund* (fig. 15) was described as "childish" by the *Evening Post* and as a "fearsome maiden" with wild tresses by other New York periodicals.[75] A lost work called *Two and a Half Years Old* was denounced as badly drawn and as a pictorial joke or "abortion," as the *Philadelphia Sunday Dispatch* penned with ironic disgust.[76] *Ophelia* (fig. 16) was similarly assailed because it was "a powerful representation of a maniac, but not of *our* Ophelia."[77] One of the few works to escape complete scorn was a version of *April Love* (fig. 17), which was only seen in New York. The *Crayon* pronounced this painting "perfectly fascinating: this picture did not please us at first sight, but the more we look upon it, the more we become absorbed in its simple embodiment of deep, pure intense feeling."[78] A critic writing

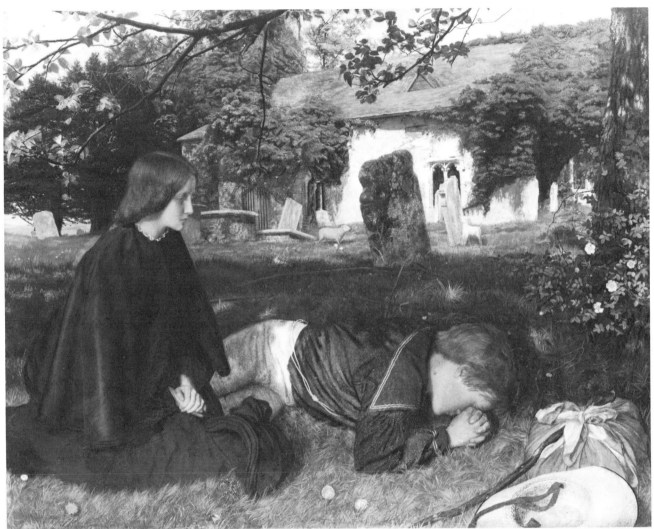

Figure 13. Arthur Hughes, *Home from Sea*, 1863. Oil on panel, 20 × 25¾ inches. *(Courtesy of the Ashmolean Museum, Oxford.)*

under the pseudonym "Mesos" in Boston, however, did not like the canvas, calling it "a queer compound of good feeling and bad judgment. The ugliness of the picture is, I doubt not, a part of the artist's conception."[79]

Like several of Hughes's canvases, Elizabeth Siddall's watercolor drawing of *Clerk Saunders* (fig. 18) appeared only in New York, and was the recipient of kindred pejorative criticism about its supposed "childish vagaries" and defective draftsmanship.[80] William Rossetti had noted in his handwritten memorandum that Ruskin admired Siddall's "power greatly, thinking her . . . possessed of more natural genius for art than any other woman."[81] However, the *New York Times* concurred with another periodical's evaluation of the work as "Pre-Raphaelitism gone mad," deploring *Clerk Saunders* and two works by Hughes as representing the absolute nadir of quality in the imported exhibition.[82]

The single Pre-Raphaelite picture that received the most attention was Holman Hunt's *The Light of the World* (fig. 19), which Rossetti had delineated in his notes as "the picture of which this is a duplicate is considered by many Hunt's masterpiece and the loftiest effort of Pre-raffaelitism [*sic*]. . . . I have sent Ruxton an enthusiastic letter which Ruskin published in The

Figure 14. Arthur Hughes, study for *Home from Sea*, 1863. Pen and ink, 8¼ × 10¼ inches. (*Courtesy of the Ashmolean Museum, Oxford.*)

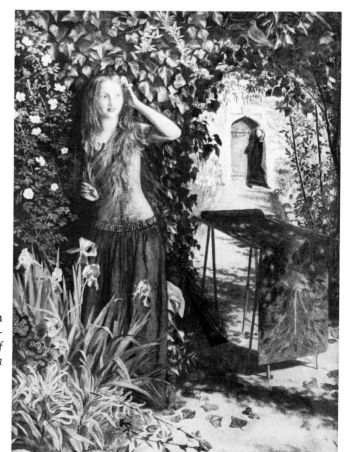

Figure 15. Arthur Hughes, *Fair Rosamund*, 1854. Oil on academy board, 15¾ × 11¾ inches. (*Courtesy of the National Gallery of Victoria, Melbourne. Presented in memory of P. A. Daniel, a close friend of Hughes, by his niece, Mrs. Eva Gilchrist, 1956).*

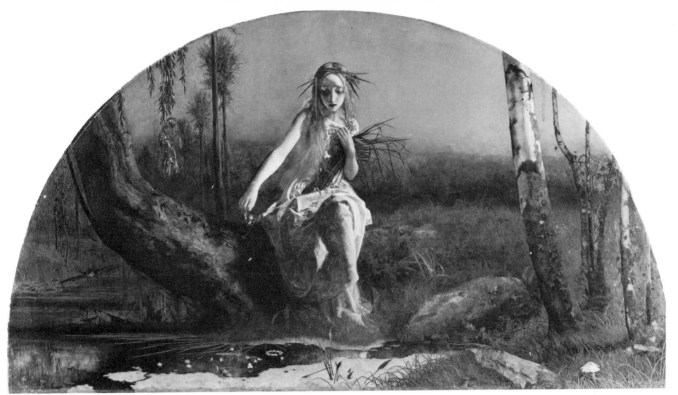

Figure 16. Arthur Hughes, *Ophelia*, 1852. Oil on canvas, 27 × 48¾ inches. *(Courtesy of the Manchester City Art Gallery.)*

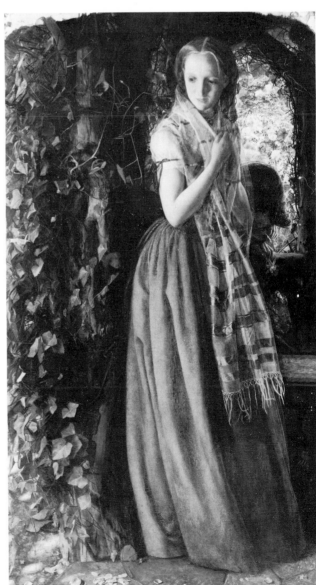

Figure 17. Arthur Hughes, *April Love*, 1855. Oil on canvas, 35 × 19½ inches. *(Courtesy of the Tate Gallery.)*

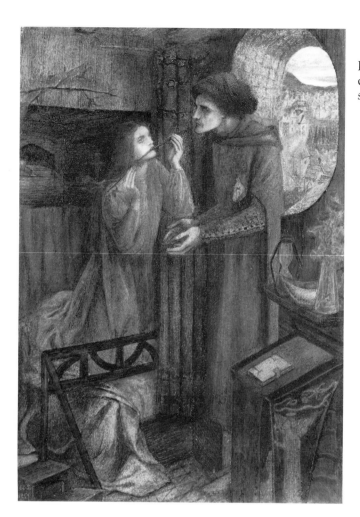

Figure 18. Elizabeth Siddall, *Clerk Saunders*, 1857. Water-color, 11 × 7¾ inches. *(Courtesy of the Fitzwilliam Museum, Cambridge.)*

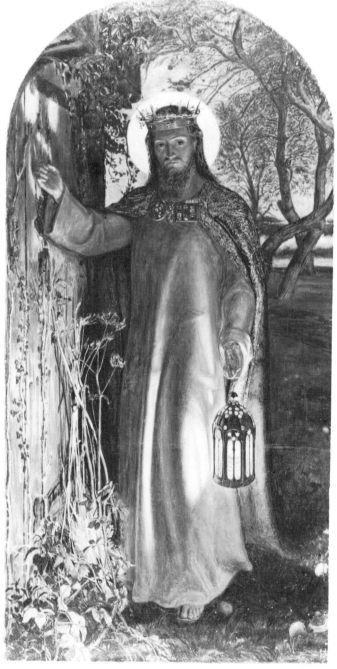

Figure 19. William Holman Hunt. *The Light of the World*, 1853–56. Oil on canvas, 19⅝ × 10⁵⁄₁₆ inches. *(Courtesy of the Manchester City Art Gallery.)*

Times." Even before the painting was exhibited Ruxton was able to report to Rossetti in October of 1857 that he should tell Hunt "That a man said, 'Never mind the gas, the picture will light us up'. . . . P.R.B.ism takes with the working men—they look, and they look, and they look, and they say something that the author of the picture would be pleased to hear. *The Sailor Boy, Try and Remember, King Lear,* above all, *The Light of the World* . . . are immensely popular among my hangers."[83]

In spite of the enthusiasm of such working-class viewers (which would have also pleased Ruskin), both Stillman and the *Knickerbocker, or New-York Monthly Magazine* reprinted Ruskin's encomium of the painting, the latter reprinting most of the letter to the *Times* in its review of the exhibition as a means of explicating the work fully to an American audience. Among metropolitan critics, the *New York Times* reviewer, for example, abhorred all the other Pre-Raphaelite canvases but was enthralled by *The Light of the World* for its tender sentiment and splendid tones, " . . . which would have moved the heart of Albrecht Durer. . . . This is one of the few Pre-Raphaelite pictures in which the artist and his 'elevated motives' do not immediately obtrude themselves between the spectator and the canvas; it is, of course, a piece of mere mystical symbolism, but it has the interest of true power."[84] In Philadelphia, the reaction was more divided. While the *North American and United States Gazette* appreciated the ethereal beauty of the picture, which they felt was "sufficient to immortalize its author,"[85] the *Philadelphia Sunday Dispatch* detested it and wrote bitterly of its faulty drawing, "hard and unnatural color," of Christ's "stiff and inactive" pose, and of the general tone of "moral blasphemy" that the work seemingly conveyed.[86] Of Ruskin's long exegesis, the reviewer commented, "We could not conceive of any intellect so diabolically humorized as to write five volumes octavo, besides a whole farrago of nonsense in numberless pamphlets, if we did not know the existence of John Ruskin." Bostonians seemed to agree with this negative assessment of Ruskin's writings about Hunt's canvas, stating moreover that "this enthusiast does not prepare his rhetoric in accord with Pre-Raphaelite rules."[87] And of *The Light of the World* as a visual phenomenon, the *Christian Register* continued, "In vain we turn our eyes from point to point. Everywhere some haunting vision is looking up, or looking down, or across at us, making us shrink and shudder with its strange, spiritless, galvanic life."[88]

Madox Brown and Hunt were thus the most touted artists; Hunt was also represented by a reduced replica of *The Eve of St. Agnes* (see fig. 51), which, Rossetti thought, with its new background figures, was "of course, better than the original." However, New York reviewers largely ignored it. The *Philadelphia Sunday Dispatch* found it badly drawn, "notorious and wretched," and even unattractive, while the neighboring *North American and United States Gazette* claimed it was superb. In Boston the crazy quilt of mixed reactions was complemented by the *Boston Daily Courier,* which maintained that *The Eve of St. Agnes* had much less grandeur than Brown's *King Lear,* "though hardly less unity or intensity; and though it possesses more of the animation of exciting or interesting action, it wants the potential charm of pathos."[89]

A latent aspect of the criticism concerned the American spectator's desire to see the Pre-Raphaelite style translated in terms of landscape, a point Stillman had made to Rossetti when he wrote from New York that the selection of works "too much neglected landscape, which to us is far more interesting than your history pictures."[90] Several reviewers discussed the technique or approach of the Pre-Raphaelites as these were applicable to the representation of still-life details in the landscape. The *Atlantic Monthly,* for example, singled out the floral details and accordingly wrote that "the pre-Raphaelites look at Nature as full of beautiful facts, and like children amid the flowers, they gather their hands full, . . . crowd their laps and bosoms, and even drop some already picked, to make room for others which beckon from their stems— insatiable with beauty."[91]

As an extension of this idea, in evaluating specific objects, some of the most revealing criticism was dedicated to landscape elements, or more exactly, to close up views of rocks or

weedy nooks burgeoning with foliage. This was true somewhat of Redgrave's *In the Midwood Shade* (see fig. 6), of course, but works such as Mark Anthony's *The Monarch Oak* (now lost) were also fulsomely praised, Anthony's composition even called a facsimile of a tree. Rossetti confirmed this effect, stating that *The Monarch Oak* was an effort in which the artist combined "his own color and handling" with "Preraffaelite [*sic*] fulness and precision of detail." The *Crayon* also saluted the Pre-Raphaelite propensities of lesser known artists such as William Davis of Liverpool and Thomas Sutcliffe. Of Davis's *Evening* and *An Old Hedge*, Stillman commented that "they are unpretending transcripts of Nature, evincing true feeling and adequate power" and wrote that Sutcliffe's watercolors like *The Banks of Wharfe—Bolton Abbey* mingled the painter's "fine taste" with the "prescribed study of detail."[92] The *Evening Post* also cited William Webbe's *Twilight* and *An English Pastoral* as embodying the new style, a point echoed in Rossetti's notations that Webbe produced "good typical specimens of that class of Pre-raphaelism which confines itself to representation without invention of subject." In a similar vein, brief mention was made elsewhere of W. T. Bolton's watercolor with its quotation from Tennyson—"The rusted nails fell from the knots / That held the peach to the wall," a composition suggestive of both Millais's wall in *A Huguenot* and of Hunt's weedy one in *The Light of the World*. There were also references to W. S. Rose's *A Weedy Nook on the Thames* and P. J. Naftel's *One of Nature's Ferneries,* the latter complimented as a delectable "place to extract from a July noon-tide sensations sweet and meditations divine."[93] The very titles of many of these works reinforced the artists' preference for microscopic botanical detail and for a close up or "accidental" format. These same qualities probably delighted American artists but irked the *New York Times* critic, who rather satirically opined: "Conceived by men of genius the Pre-Raphaelite theory has been adopted by weaker brethren, who are pertinaciously painting up all the weeds, dandelions, bits of straw, old glass, fence-rails, and pokers that can be found in Great Britain, in an orgasm of mingled tenderness for the 'neglected truths of Nature' and contempt for sentimental fellows like Claude Lorrain and Edwin Landseer."[94]

Of the more renowned practitioners of landscape in the Pre-Raphaelite mode was Madox

Figure 20. Ford Madox Brown, *An English Autumn Afternoon*, 1852–53. Oil on canvas, oval 27½ × 53 inches. (*Courtesy of the Birmingham Museums and Art Gallery.*)

Brown, who was primarily represented in the exhibition by figural compositions in both oil and watercolor (and also in a non-Pre-Raphaelite style). In Boston only his *An English Autumn Afternoon—London Outskirts* (fig. 20) was on display, garnering as many accolades as contributions by John Brett and John Inchbold. The obvious tendency of these three artists to intensify details and to aim at a kind of topographical objectivity "raises one of the most vexed and difficult problems of the age, namely, whether the utmost practicable exactness to truth may consist with the unity and harmony of nature. . . ," as one reviewer observed.[95] The "seeming veracity" of the magnificent suburb seen in Brown's painting, "relieved from the fire and smoke of the day's battle of life," impressed the *Boston Daily Courier,* as did the vivid power of "the ruling sentiment of emerald freshness, of breadth and richness of shade and cool quietness of light" and the "air of tangibility [that] gives us the body as well as the soul of 'an English Autumn Afternoon.' "[96] Similarly, although *Dwight's Journal of Music* faulted the aerial perspective, it too remarked on the "feeling of drowsy autumnal quiet" that the work exuded.[97]

John W. Inchbold, who was named by William Rossetti as "perhaps the highest of the strictly Pre-Raphaelite landscape painters—much praised by Ruskin," contributed a work with the accompanying lines, "When the Primrose flower / Peeping forth to give an earnest view of the Spring," and this otherwise unidentified picture was the focus of intermittent discussion. The *Boston Daily Courier* saw it as a primary example of the Pre-Raphaelite characteristic of intense sincerity and of "nature worship, involving a ritual or aesthetic method of almost sublime faithfulness and simplicity. . . ."[98] His colleague John Brett, whose *Glacier at Rosenlaui* (fig. 21) is today considered a superb exemplar of Pre-Raphaelite landscape, was mentioned only occasionally by the critics; Rossetti had noted in his memorandum that Brett's work was "much admired by Ruskin (tho' he has not written about it)." Brett's *The Bank Whereon the Wild Thyme Grows* was embraced by the *Philadelphia Press* because it was "so perfect in coloring, and so elaborate in execution, that one wonders alike at the skill, taste, and patience of the artist—you might blow the dandelion blossom from its stem."[99] However, more attention was given to the glacier picture, which to *Dwight's Journal of Music* also posed quintessential questions about whether art could simultaneously serve science as well as its own goals and whether "particular" truths of verisimilitude are "realized at the expense of the higher, general truths."[100] To that reviewer, the result in Brett's work was merely a portrait of a rock, "an abnegation of *all artistic* truth." In spite of the degree of indefatigable accuracy in this image, Brett had allegedly "made no visible record of those bodiless immaterial qualities common to all Nature, without which a picture can have no verity either of representative or imitative art." The same issue was raised by the *Boston Daily Courier,* which also believed that the full expression of detail risked soullessness of effect and failed to convey the awful grandeur of the actual scene. Brett's picture thus served as the vehicle for a provocative digression by the critic, who hypothesized that "it certainly appears that there are effects of details and conditions, especially in the distances of landscape views, really appreciable to our perceptions by the mere faithful imitation of what is only definite and tangible, the sight, effect, or impression of such subjects can be rendered."[101] Both Inchbold's primrose picture and Brett's *Glacier at Rosenlaui* provided almost the ideal fulfillment of "definite drawing to a definite end. In the first, the intense expression of natural color, of rich though saddened tones, confers upon a commonplace subject an impressive character of blended beauty and pathos; and in the second, the pale ice-fields, the high and purple precipice, and the rock-strewn foreground are realized seemingly to the last line and speck—till, if we only knew the language in which time and the elements write, we could surely find here not only 'sermons in stones' but whole antediluvian histories, maybe, in the cerulean cells of the glacier and upon the cold and expressive faces of its adamantine walls."[102]

Given all these factors as well as Ruskin's general notoriety for having encouraged artists to indulge in quasi-photographic and microscopic inspections of nature, it is not surprising that Ruskin's own *Study of a Block of Gneiss* (see fig. 1) did not escape attention. It triggered myriad

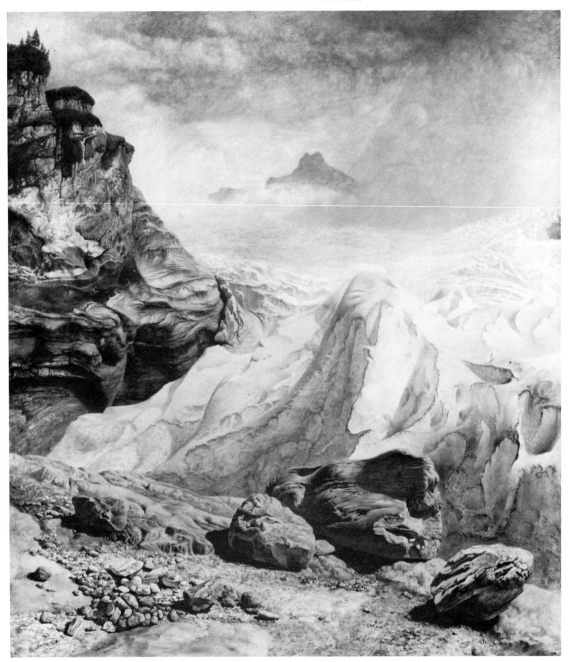

Figure 21. John Brett, *The Glacier at Rosenlaui*, 1856. Oil on canvas, 17½ × 16½ inches. *(Courtesy of the Tate Gallery.)*

responses, Rossetti commenting in his notes that this was "one of the completest studies he has yet done" and adding that Ruskin was also to have sent "something more important from Scotland but it has not been done in time." Although *Study of a Block of Gneiss* was exhibited in all three cities, New York critics referred to it very little, while the writer for the *Philadelphia Sunday Dispatch* claimed it was false to nature and stylistically trivial as well as worthy of being the butt of a local joke: "And how the ladies go into extacies [*sic*] about this. . . ! Oh! look what Ruskin has done! Is not this fine in effects! . . . We have seen gneiss, but never such a piece as this of Ruskin's; it looks like an unfortunate elephant's back that has been subject to the whip,

full of niches elaborately worked out. A friend at our right says it looks like a bundle of oyster-shells tumbled out of a hot kiln. But such a sky! really, Mr. Ruskin, you must have had the *blues* when you painted it. You must have been on a month's spree. It is really incorrigible—nay, contemptible."[103] Perhaps in keeping with one Bostonian's humorous mistitling of Ruskin's watercolor as a "block of genius," [104] *Dwight's Journal of Music* gave the work a rather harsh reading: "The opalescent hues of this wonderful block test an artist's power of color much less than the simple grey tones of our mountain boulders; and that, in his rendering of the more quiet tints of sky, mountain distance, and foreground trees, there is a lifeless condition that ill accords with the impressions of natural beauty which we derive from his grandly wrought descriptions."[105] Thus, Ruskin himself was as much the target of censure as fellow artists who followed this exacting creed.

Critical response was one index of success or failure, but so, too, was commercial appeal. Incomplete and scant records survived overall about the sales of works of art from the 1857–58 exhibition, but those details extant provide another perspective on the undertaking. As early as February of 1858 Ruxton wrote to Rossetti that he had "accepted an offer, conditional upon Mr. Hunt's approval, of 300£ for *The Light of the World*. It is from a gentleman, Mr. Wolf who has the finest collection of pictures in New York and who apologizes for making an offer below the sum named, but pleads the pressure of the times, and inability to pay more just now."[106] (The monetary crisis thus appears to have been a real factor in the faltering sales of works of art.) Apparently Hunt would have preferred to sell the replica to an English buyer, but, as he wrote to a friend and patron Thomas Combe, "I had no opportunity of selling my sketch of the 'Light' ere its departure. I designed a frame for it which turned out most lovely when completed and made the picture look quite precious."[107] The *Crayon* clearly identified the buyer of Hunt's canvas as John Wolfe of New York, one of the most important mid-century collectors in America.[108]

For reasons that remain largely inexplicable, as Cummings of the National Academy of Design later commented, commercial prospects in Philadelphia proved "much more favored than in New-York."[109] Ruxton reported that he sold Leighton's *Reconciliation of the Montagues and the Capulets* for four hundred pounds sterling to a Philadelphia client named Harrison, and also Charles Lucy's *Lord and Lady William Russell* for the same sum.[110] The *Crayon* added that in addition to these works, several watercolor drawings had "passed into the hands of Mr. J. Harrison," undoubtedly Joseph Harrison, who like Wolfe was one of the most prestigious collectors, with the money and taste for fine art. The correspondent for the *Crayon* noted that many pictures were disposed of to other "amateurs of that city . . . Mr. S. B. Falles' collection is enriched by several pictures, embracing specimens of Sutcliffe, Hulme, Collingwood, Hough, and Ferguson. 'The Prussian Fair,' by E. Corbould, has become the property of Mr. W. T. Stewart. Wehnert's 'Ragged School' is disposed of, and other pictures (twenty-eight in all) to parties whose names are unknown to us."[111] In urging Rossetti to arrange for good replacements for the Boston Athenaeum leg of the exhibition, Ruxton alluded to "talk of a subscription to buy Horsley's *Prince Harry* for the large saloon of the Philadelphian Opera House." Two landscapes by J. W. Oakes were also "reserved for the Academy if there are funds to buy them. . . ."[112] Neither hope for a Philadelphia purchaser was realized, however, and attempts to find a patron for Brown's *King Lear* also proved unsuccessful. In Boston, few sales records survived, but "the first picture sold was a landscape, by Miss Fanny Steers, which was purchased by Professor Longfellow, of Cambridge."[113] Although Henry Wadsworth Long-fellow bought Steer's *The Reeks*, there were apparently few other buyers, perhaps due to the high prices of the objects.[114] Many of the asking prices seem rather high, with Horsley's history picture set at $2,500, Maclise's canvas at $2,250, Redgrave's *Mid-Wood Shade* at $1,300, and most of Brown's works (notably *King Lear* and *An English Autumn Afternoon*) listed at $1,000.[115] However, there was no huge commercial success in the venture—partly due to the catastrophic

tenor of the American business world at the time—and Ruxton consoled Rossetti that basically "you must consider what has been already done a great success, considering all things."[116]

Ultimately, of course, the exhibition of English art cannot be measured simply either in terms of journalistic reviews or actual sales, but, rather, at least partly by the influence it exerted on contemporary American artists. Although the exhibition was besieged with woes and was constantly under attack, American painters forged their own opinions and pictorial interpretations of Pre-Raphaelitism. They clearly chose to pursue landscape rather than the figural aspect of the Pre-Raphaelite style and approach, thus heeding the advice given by the *New York Herald* that "there are some studies of flowers and foliage from which our artists may take a lesson to their profit."[117] Whether in great naïveté or in wisdom, the Pre-Raphaelites were perceived in the 1857–58 exhibition as having paved the way towards a divergent but important means of seeking truth in art. In spite of the drawbacks of the creed allegedly personified in the works of Hughes and others, Pre-Raphaelitism had much potential to offer viewers and artists alike. Accordingly, the *Atlantic Monthly* somewhat prophetically intoned, "Pre-Raphaelitism must take its position in the world as the beginning of a new Art—new in motive, new in methods, and new in the forms it puts on. To like or dislike it is a matter of mental constitution. . . . In all its characteristics it is childish, . . . filling its caskets with an unchoosing lavishness of pearl and pebble, rose and may-weed, all treasures alike to the newly-opened eyes, all so beautiful that there can scarcely be choice among them."[118]

4

John Everett Millais: Triumphs with the American Public

JOHN EVERETT MILLAIS'S NAME, AS MIGHT BE EXPECTED, WAS FREQUENTLY MENTIONED IN THE PAGES OF THE *Crayon* and the *New Path* during the years those periodicals existed (1855–64), and the American public's general familiarity with his work was also betokened by the fact that he was cited in more obscure sources such as the *Photographic and Fine Arts Journal*. In a July 1854 issue of the latter, for example, an unnamed Yankee correspondent reported on the annual Royal Academy exhibition and said that, in spite of two stellar contributions by Holman Hunt, "the absence of Millais is not compensated for by the whole Academy."[1]

Perhaps the first mention of this artist in the pages of the *Crayon* was in William Michael Rossetti's March 1855 column as a foreign art correspondent. In that report Rossetti mentioned that Millais was slated to illustrate some of Tennyson's poems—"The Miller's Daughter," "Mariana," "Dora," "The Eve of St. Agnes," and others—and Rossetti whet the curiosity of his readers by noting that for the next Royal Academy exhibition Millais was likely to contribute "a remarkable subject of our actual London life—possibly, but not probably, a second picture."[2] The first oil painting by Millais chronicled in the *Crayon* was his *Christ in the Carpenter's Shop* (see fig. 2) in a piece written by W. J. Stillman entitled "Pre-Raphaelitism and Its Lessons" for the April 1855 issue. In his *Autobiography*, Stillman had maintained that this painting had exerted a great influence on him, for it "determined me in the manner in which I should follow art on my return home. . . ."[3] Five years after his first sight of this work during an 1850 trip to England, Stillman still had reservations about what he deemed the cumbersome composition "ugly in expression and heavy in color," but he nonetheless felt that the moral content and power of *Christ in the Carpenter's Shop* overcame such deficiencies.[4] Charles Dickens in *Household Words* had castigated the picture, ridiculing the ". . . wry-necked, blubbering . . . boy in a bed gown" and the "kneeling woman, so hideous in her ugliness, that . . . she would stand out from the rest of the company as a Monster, in the vilest cabaret in France, or the lowest gin-shop in England. . . ."[5] Dickens's remarks were an overreaction to Stillman, who pronounced this painting "conscientious and intense to such a degree, that it commanded the respect of the hanging committee who placed it on the first tier above the line. . . ."[6] More accolades were reserved for this painting by F. G. Stephens in his third *Crayon* article of 1856 entitled "The Two-Pre-Raphaelitisms." To him, *Christ in the House of His Parents* was a "vast advance" over *Isabella* of

1849 in terms of color and design, and Stephens also alluded to the vehement notice which the work had initially triggered when it was shown at the Royal Academy.[7]

Such enthusiasm for Millais was, in the mid-to-late 1850s and 1860s especially, a typical response, aided mainly by the insightful columns written by William Michael Rossetti and Stephens, both of whom were contributors from England to the *Crayon* beginning in 1855. Their constant and supportive references to Millais thus provided a major means of disseminating information and criticism about his subjects and his progress in art. In his first remarks to American readers, Rossetti described Millais's masterly purity of color, an admiration of the artist's handling of flesh tones that continued in later commentaries about Millais. Of the famous 1855 exposition in Paris, Rossetti mentioned the positive Gallic reception and conjectured that "the Pre-Raphaelites seem especially likely . . . to create a corresponding movement among the French." He also reported that *Ophelia* and *The Order of Release* both excited "curiosity and wonder" among French viewers.[8]

To Rossetti, *Ophelia* (fig. 22) drifting to her death amid a luminous net of hair was a tour de force that "nothing in Pre-Raphaelitism has surpassed for exquisite profusion and realization of Nature, and for heart-rending pathos."[9] When it had been exhibited at the Royal Academy in 1852, English critical response was mixed but generally favorable. The *Athenaeum*, for example, cited the controversy that the work had generated, nevertheless applauding the luminosity and marvelous degree of finish in the work: "The water-lily is the botanical study of a Linnaeus:— every incident and accident is depicted." The flesh tints were also admired, although Ophelia's open mouth was criticized as "somewhat gaping and gabyish,—the expression is in no way suggestive of her past tale. There is no pathos, no melancholy, no one brightening up, no last lucid interval."[10] In a somewhat less enthusiastic vein, the *Illustrated London News* protested the alleged absurdity of the situation, Ophelia's head being unsupported and "the absence of the slightest ripple of the water . . . and the calm chirruping of the robin red-breast on the tree . . . amongst the conceits of this school which common sense cannot approve of."[11] Contrastingly, in the pages of the *Crayon* F. G. Stephens concurred with Rossetti's high esteem for the picture, and in his 1856 article subtitled "The Modern Pre-Raphaelites" said that the picture qualified

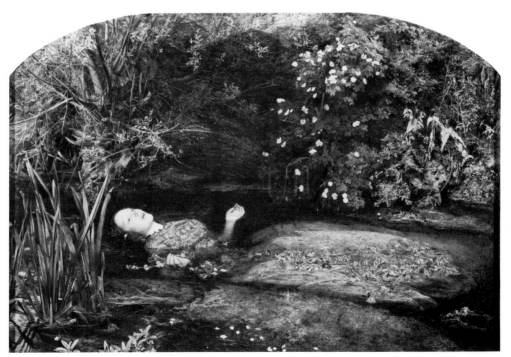

Figure 22. John Everett Millais, *Ophelia*, 1851–52. Oil on canvas, 30 × 40 inches. *(Courtesy of the Tate Gallery.)*

above all as a portrait of a "tangled thicket . . . wonderful in its intricacy . . . one of the most faithful transcripts of nature,"[12] with precisely the kind of descriptive approach that would have appealed to American landscape artists. The stream itself with its fanatically depicted minutiae of weeds and flowers was also judged to be the most salient aspect of the composition, and the reader was advised that if he had "ever studied such a thing, he will not fail to have observed the hazy pearlishness which water vegetation receives when seen through its own element— this was admirably rendered, as was the variety of those weeds which floated above." On the other hand, another writer, presumably an American, named C. P. Cranch, wrote a counter-balancing viewpoint in a letter to the *Crayon* written from Paris in late 1855. Cranch despised the supposedly waxy flesh, flat colors, and cheerless lights of the Pre-Raphaelite mode, alleging that in "*The Ophelia,* for example, the bark of the willow is not barky, but the thinnest washiest suggestion of it—which is not in keeping with the elaborate minuteness of the water flags and the numberless leaves and flowers over the stream."[13] While he admitted that the face of the woman was "remarkably executed," he too clearly preferred "the drawing of the weeds and foliage, . . . so intensely chrome-green, that the picture seems like a good instrument out of tune."

The Order of Release, 1746 (fig. 23) was also given considerable attention in America, having initially elicited various reactions at the Royal Academy exhibition of 1853. The *Illustrated London News*, for example, called this a "remarkable production" full of pathos and high finish, "triumphs of manipulation which must be seen to be appreciated, and which no words of ours

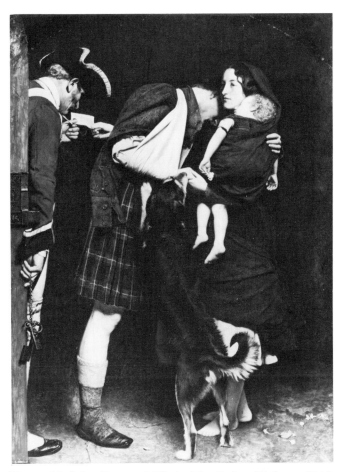

Figure 23. John Everett Millais, *The Order of Release, 1746,* 1853. Oil on canvas, 40½ × 29 inches. *(Courtesy of the Tate Gallery.)*

can over-praise."[14] The *National Magazine* countered some objections to the alleged coarseness of the Highlander's wife by asserting that this was "was one those subjects in the treatment of which Millais has wholly escaped from the poverty and incompleteness of the pre-Raphaelite style, while rejecting the untruth which in art is misnamed the ideal."[15] Rossetti himself had, for his English readers, dwelt on the complicated emotions which the artist had captured: "triumph, endurance, the fulness of a heart torn with the ecstasy of joy and tenderness."[16] He also admired the color harmonies and flesh tones, objecting to the dark background and, perhaps somewhat peculiarly, to the "preternaturally delicate and unsoiled" feet of the wife, who had been walking barefoot to bring the order of release for her prisoner-of-war husband. In the pages of the *Crayon* he reported that after the Paris exhibition of this canvas, the work "carried fame by storm at the Academy Exhibition of 1853 and substantially crushed the venomous abuse of Pre-Raphaelitism."[17] He too admired the glowing flesh colors, a point on which the prickly Mr. Cranch also agreed, the latter adding that this was "a very impressive picture, perhaps the best of the sect. The horn buttons and stuffs are quite a marvel of finish, and the modelling of the child's legs beautiful."[18] By July of 1856 the *Crayon* also told readers that a finished proof by Samuel Cousins was available and again praised "all the elements of high art" that the picture contained.[19] Furthermore, readers were admonished: "Let this engraving be carefully studied, not for the sake of the medium by which the thoughts in it are expressed, but for the thoughts themselves." There was additional mention of *The Order of Release* by Stephens in his November 1856 "The Two Pre-Raphaelitisms," where he paid homage to Millais as "the modern Titian" for his skill in producing "rosy and tender" flesh-tones.[20] Later this same painting greatly impressed a young Henry James, who recalled ". . . stopping long before 'The Order of Release' of a young English painter. . . , who had just leaped into fame, and my impression of the rare treatment of whose baby's bare legs, pendent from its mother's arms, is still as vivid to me as if from yesterday."[21]

The final work by Millais in the Exposition Universelle of 1855 on which Rossetti remarked was *The Return of the Dove to the Ark* (fig. 24), which to him was "a lovely piece of painting and naive tenderness" and an improvement over the verisimilitude of *Ferdinand and Ariel*.[22] Even the rather contentious Mr. Cranch liked *The Return of the Dove to the Ark*, revealing a very American attitude in his approval of the details of "the weather-beaten bird, and the straw, which is imitated with such singularly photographic exactness, that it seems like real straw put into the glass case which covers the picture."[23] Stephens also pronounced the work superior to *Ferdinand and Ariel* and—like Mr. Cranch—singled out the hay, "which for richness, delicacy, and manipulative power, was a marvel. . . ."

Another painting given some attention in the *Crayon* in 1856 was *The Proscribed Royalist* (see fig. 3), which had been in the 1853 Royal Academy show and was praised by the *Illustrated London News*, for example, as "a very attractive and richly-coloured picture" of a man hiding in a tree and being stealthily brought bread by a Cavalier lady.[24] What must have especially stimulated American artists and readers was Stephens's description of the verdant undergrowth in the scene: "The trunk of the tree of refuge, an ancient oak, silvered and whitened by age and lichens, lies full in the blaze of sunlight, and shows like a gigantic specimen of silver ore. . . . Through the broken and leafy underwood, in the freshest green of nature, the eye penetrates from tree to tree, till lost in the labyrinth of various boughs, while the tall flowers stand between and among the saplings;—for here are trees of every age, from the fresh seedling to the old oak in the chief of the picture,—nor are they of one kind only, not all oaks or all firs, but birches, beeches, ashes, and dwarf oaks;—in fact it is a perfect painting from a wild plantation."[25]

The editor of the *Crayon* also shared Stephens's enthusiasm for *The Proscribed Royalist*, for Stillman noted later in his *Autobiography* that during his crucial 1850 trip to England he saw this canvas by Millais and was thus inspired to produce a landscape with the sort of compulsive

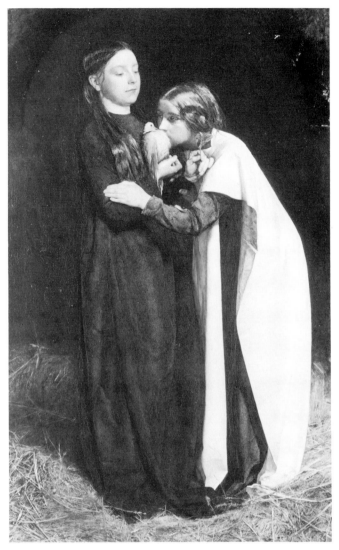

Figure 24. John Everett Millais, *The Return of the Dove to the Ark*, 1851. Oil on panel, 34½ × 21½ inches. *(Courtesy of the Ashmolean Museum, Oxford.)*

details found in *The Proscribed Royalist*. The emphasis in Stillman's *Forest Spring* of 1853 was on foreground detail in particular, and for this effort the artist "transplanted a violet which I wanted in the near foreground . . . to be sure that it was in correct light and proportion. . . ."[26] In true Pre-Raphaelite fashion, he immersed himself in the hard labor of painting: "On that study I spent such long hours of the day as the light served, for three months. . . ." When it was shown at the National Academy of Design in New York in 1854, *The Forest Spring* was praised by the critics, none of whom specifically mentioned, however, the direct influence of Millais's detail-packed painting.

Although it is not a work generally held in such high esteem today, Millais's *The Rescue* (fig. 25) was much celebrated in its own time. The *National Magazine* defended the work against censure of the "too crimson" hues of the fire, extolling in this "wonderful picture" the grandeur of the phenomenon and the realism of the emotions captured in the faces of the fireman, the children, and the anxious mother.[27] In the *Crayon* of 1855 this canvas was also hailed as a worthy contemporary subject, and Ruskin's remarks on the picture were also cited in the

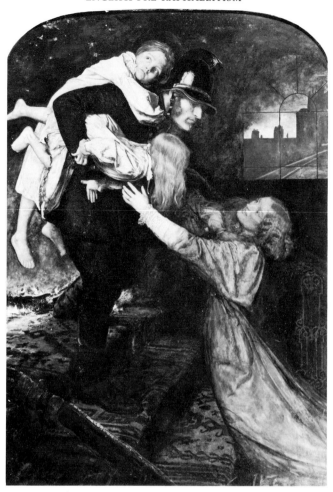

Figure 25. John Everett Millais, *The Rescue*, 1855. Oil on canvas, arched top, 46 × 32½ inches. *(Courtesy of the The National Gallery of Victoria, Melbourne. Felton Bequest 1924.)*

August issue, so that American readers were told how he deemed this "the only *great* picture exhibited this year . . . and the public very generally understand it."[28] He, too, thought Millais was a great colorist and disagreed with those who thought the reds too lurid and the blacks too dark in *The Rescue.* Given such endorsements, it is not surprising that Stephens wrote in 1856 that this work fulfilled "our ideal of the proper functions of art," the heroic fireman a dual merciful knight and modern hero who brings joy and spiritual peace to the grateful mother. To him, the luminous glare of the fire was "the most startling in its brilliancy" of the entire composition.[29] Elsewhere in the *Crayon* in his "Idea of a Picture," Stephens penned that this contemporary interpretation of the deposition from the cross was the perfect embodiment of noble action or history picture: "It is a subject combining all the requisites of a work of the highest class; perfectly novel, perfectly real, and perfectly true. . . . Upon consideration, the reader will hardly find a better subject for Art . . . than this."

Stephens, unlike Rossetti, also mentioned several other key works by Millais. To Stephens, *The Blind Girl* (fig. 26) was a novel and pathetic subject with "a peculiar truth of daylight effect, which made it a striking study."[30] He did not recognize the rainbow in the picture as the studio concoction that it was, but rather interpreted it as an emblem of hope that the girl could not see, but instinctively reacted to, in her facial expression, which was "full of innocence and uncon-

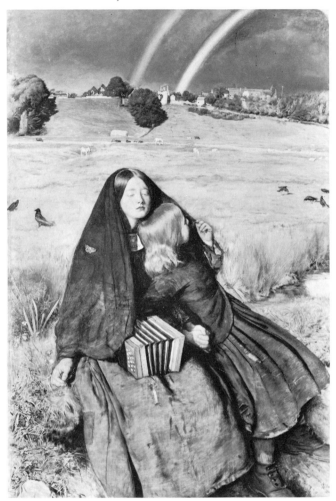

Figure 26. John Everett Millais, *The Blind Girl*, 1856. Oil on canvas, 32½ × 24½ inches. *(Courtesy of the Birmingham Museums and Art Gallery.)*

scious contentment." Rossetti maintained that the theme was "treated in a spirit which may be called religious,"[31] but he also praised "the exquisite truth of the English landscape, and the faithful purpose which makes every detail of homeliness in the figures touching and valuable," offering negative comments only about the minor faults of the blind girl's clumsy hand, "the cutting-off of her feet just at the edge of the frame, and the excessive size of the sister's boots." A youthful Henry James used this picture as a point of digression on Pre-Raphaelitism, remembering from the 1856 show the " 'Vale of Rest', his 'Autumn Leaves', and if, I am not mistaken, his prodigious 'Blind Girl.' The very word Pre-Raphaelite wore for us that intensity of meaning, not less than of mystery, that thrills us in its perfection but for one season, the prime hour of first initiations. . . ."[32]

More extensive analysis was reserved by Stephens for *Peace Concluded*, which the *Art-Journal*, for example, had expained in great detail; however, this English magazine also queried whether the originality of the theme and symbolism could be successfully offset by the alleged eccentricities of the Pre-Raphaelite style. Stephens similarly focused on the narrative details in this tender scene of "matrimonial reconciliation," rightly perceiving it as a modern allegory of the aftermath of the Crimean War, complete with animals—lion, cock, turkey, and bear—symbolic of the warring nations. Yet, in contrast to the *Art-Journal*, he complimented the "novel and rich"

coloring and lamented the lack of "finish which had previously distinguished the paintings of Millais. . . ."[33] Elsewhere, in the *Crayon*, the complaint was also registered by Rossetti about "how far an invention of this calibre is to be approved, coming from a man who would invent *The* [sic] *Huguenot*, *The Ophelia*, and *The Rescue*."[34] Moreover, Rossetti himself had published an account of the canvas for English readers that underscored his own enthusiasm for certain aspects of the work (for example, the well-painted portrait of the dog) but also his wariness about the "somewhat puerile" invention of the subject and "some partial slapdash of handling."[35]

Another entry was *L'Enfant du Regiment* (fig. 27), and Rossetti rather caustically and disappointedly remarked to his English readers that "the work is of minor importance, but very agreeable, and painted with great exquisiteness. The background figures, however, are not studied with a solidity worthy of Millais."[36] Stephens, however, called it a "charming little picture," complimenting, in particular, the unusually restrained color scheme: "The tomb of alabaster mainly of white, with various tones of pale greys, purples, and other low tints, filled nearly the whole of the picture, and was the means of illustrating a curious and novel experiment in color, by somewhat reversing the ordinary arrangement."[37]

The last of the five Royal Academy entries by Millais in the 1856 exhibition was *Autumn Leaves*

Figure 27. John Everett Millais, *L'Enfant du Regiment (The Random Shot)*, 1855. Oil on canvas laid on board, 17¾ × 24 inches. (*Courtesy of the Yale Center for British Art.*)

Figure 28. John Everett Millais, *Autumn Leaves*, 1856. Oil on canvas, 41 × 29⅛ inches. *(Courtesy of the Manchester City Art Gallery.)*

(fig. 28), which in England the *Art-Journal* had described as "interpreted by the admirers of 'pre-Raffaelite' Art as an essential sign of the divine afflatus. . . . The three figures represent, perhaps, priestesses of the seasons . . . In what vein of mystic poetry will the picture be read? . . . The work is got up for the new transcendentalism, its essences are intensity and simplicity, and those who yield not to the penetration are insensible to fine Art."[38] In an even more emphatic way, Stephens hailed the canvas as "unquestionably the most impressive" work that the artist had yet produced. Rossetti as well felt this work was, in the spirit of Venetian art and especially of Giorgione, "a work entirely of sentiment and effect . . . to convey an emotion at once intense and undefined."[39] Both Rossetti and Stephens had the foresight to realize that *Autumn Leaves* was basically subjectless, the latter commenting that "the whole treatment is of that intense order—intense and splendid color in glowing sunset, and a certain passionate feeling and tone throughout—where one does not demand subject, but recognizes the things as a complete and noble artistic achievement of an order apart." Noting as well that the work could be perceived either as an awesome study of nature or as an allegory of mood in the landscape vernacular, Stephens was—among contemporary critics—the first to offer various scriptural texts to help explicate the fateful mood of changing seasons in the stages of life and of the world: "For wickedness burneth as the fire; it shall devour the briers and thorns . . . and they shall mount up like the lifting up of smoke."[40]

What is moreover interesting about Stephens's remarks in the *Crayon* was that Millais himself read the review and wrote to thank him for his sensitive reading of *Autumn Leaves*. Stephens had described the four "fate-like" children with their expressions of "strange passivity" and their almost sacramental activity of heaping leaves upon a pile or little pyres rather like young acolytes performing some secret rite. In addition, he speculated on the pertinence of various biblical excerpts from the Gospels of St. John and Isaiah which he felt communicated the "awful" mood of the picture. Millais acknowledged that his friend seemed to have virtually read his mind, especially in his scriptural exegesis, yet the artist also complained that he was "disappointed that the public did not interpret my meaning." Millais's letter also revealed his awareness of and admiration for the fledgling American art journal. Accordingly, he wrote that "I have read of your review of my works in the *Crayon* with great pleasure, not because you praise them so much but because you entirely understand what I have intended."[41] While it is usually assumed that American artists frequently read and knew about British art periodicals, the converse has not hitherto often been asserted. As a result, Millais's comments underscore the importance of the *Crayon* as an advocate of Pre-Raphaelitism which was understood and appreciated by one of its key English practitioners.

A final example in this chain of images from 1856 that appeared at the Academy and in the pages of the *Crayon* was *Mariana of the Moated Grange* (fig. 29), also of importance because it seemed to serve as the likely pictorial model for such American figural exercises in Pre-Raphaelite style and subject as Thomas Farrer's *Woman Sewing* of 1859, William J. Hennessy's *Mon Brave* (fig. 30) of 1870, and other works. While Holman Hunt's 1867 *Isabella and the Pot of Basil* is one obvious parallel to *Mon Brave*, so too is *Mariana*, whose altar of love and curtained

Figure 29. John Everett Millais. *Mariana*, 1851. Oil on panel, 23½ × 19½ inches. *(Courtesy of the Makins Collection.)*

Figure 30. William Hennessy, *Mon Brave*, 1870. Oil on board, 12 × 8⅞ inches. *(Courtesy of the Brooklyn Museum. Gift of The Rembrandt Club.)*

bed are recurring elements in Hennessy's picture, along with the shared reliance upon a "secret" floral language. In addition, *Mon Brave* continues in the tradition of countless Victorian images of solitary and rather anesthetized-looking women with long, flowing locks engaged in some private moment of reverie, expectation, or epiphany, a transfixed state also portrayed in Millais's *The Bridesmaid* of 1851. British critics had not been very enamored of *Mariana* when it was exhibited in 1856, but Ruskin was somewhat complimentary and said that he was pleased to see that this "lady in blue is heartily tired of painted windows and idolatrous toilet table."[42] For readers of the *Crayon*, Stephens expressed his liking of this small panel depicting the Tennysonian theme of female "impatient languor" and "undying hope," praising in particular "the half-opened, eager mouth, which mourned forth that sad complaint. . . , all perfectly expressed."[43]

 As might be imagined, the longest and most fulsome praise throughout the period—not only the 1850s and 1860s—was saved for Millais's *A Huguenot, on St. Bartholomew's Day, refusing to shield himself from danger by wearing the Roman Catholic Badge* (fig. 31, an engraving of this work by W. H. Simmons). When it was exhibited at the Royal Academy in 1852, the English press generally reacted favorably; the *Times,* for example, extolling the minutely delineated wall with "its mosses, its stains, its cracks, and its tendrils of ivy," continuing, "the expression of the female figure is admirably wrought with tenderness and terror. . . ."[44] Similarly, the *Spectator* claimed this was a work in which "human love, the solemn firmness and conviction, are expressed with equal intensity."[45] On the other hand, the *National Magazine* pronounced this

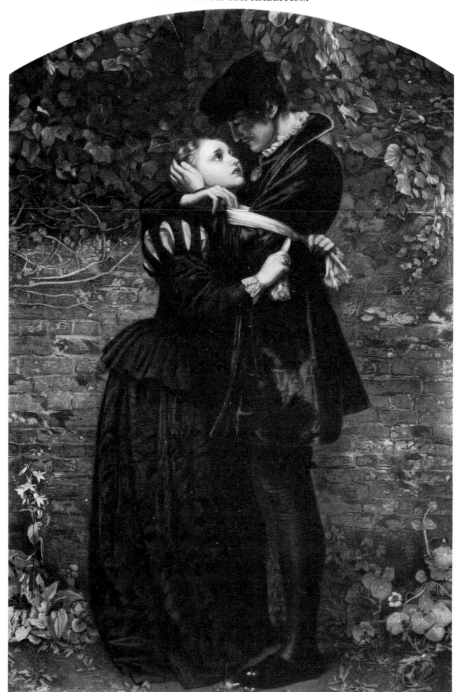

Figure 31. John Everett Millais, *A Huguenot, Eve of St. Bartholomew's Day, 1572*, 1857 Mezzotint by T. O. Barlow after the 1851–52 original, 25 × 16⅛ inches (plate size). *(Courtesy of the Yale Center for British Art, Paul Mellon Fund.)*

perfect in design and meaning, but felt the work was proof that Millais had already departed in some ways from the pictorial dogma of Pre-Raphaelitism. Rossetti labeled this the apex of "the Preraphaelite principle of faithful unswerving truth" and, like nearly all other critics, praised the expressive human love legible on the faces of the Catholic woman and her Protestant lover."[46] It was this work and *Ophelia*, the *Illustrated London News* reported in 1852, that gathered

daily crowds around them. This was, moreover, a tour de force that Ruskin also adored, lavishing considerable prose to explicate the symbolic foliage: the ivy evoking the pair's fidelity, the yellow nasturtiums emblematic of the sorrow of departure and of unfulfilled love, and the tolling bells on the frame signifying a warning of impending massacre and the lovers' doom.[47]

Thus hailed on both sides of the Atlantic in the 1850s and for decades afterwards, the painting served as the archetypal Pre-Raphaelite composition throughout the artist's career and virtually invented the seminal image in courtship imagery of the "courting wall".[48] In Millais's airless vacuum occupied by two figures and a minutely rendered wall, the lovers enact the operatic *liebestod* theme of a tragic choice between life and death, love and duty. In their enclosed world of timeless and yet paradoxically momentary embrace, the couple melt into one another's arms, while behind them the wall stands as a barrier and emblem of unyielding fate and death.

The *Crayon* initially reprinted the discourse on this picture which appeared in the *National Magazine*, presumably echoing the opinion that the work united "technical excellence" with a "command over profounder emotions." Moreover, the sublime sentiment of the work was praised, and the English critic—rather like his American counterpart—remarked that "We cannot but regret that no similar example of a moral ideal has been given to us by Mr. Millais or others."[49] There was also a reference to the work in Stephens's November 1856 article on Pre-Raphaelitism, in which *A Huguenot* is described as full of "the ineffable love and struggling alarm which fill the features of the woman. . . . Let not the reader think that this is one of the ordinary class of pictures of lovers' meetings. . . . You see at once that he is a thinking man" and the woman inexpressibly tender and beautiful. Yet the old brick wall itself, along with the ivy, also merited special attention, for on this "weatherworn surface the spider has left ancient webs, and the lichens are making pale yellow, grey, and purple stains," just the sort of heightened detail that would have delighted American landscape artists.[50] Stephens also mentioned that the work was "now in the course of engraving, and will, when seen in America . . . fully carry out what has been said. . . ." And, in a subsequent issue of the *Crayon*, mention was made that "the engraving from this picture . . . was . . . doubtless well known in America."[51] Even a periodical like *Dwight's Journal of Music*, which generally disliked Pre-Raphaelite art when it was shown in America in 1857–58, remarked that "If the true result of modern Pre-Raphaelitism appears in the 'Huguenot' let us honor the faith as one born of inspiration."[52]

Within a few years of the *Crayon's* initial remarks about the picture, *A Huguenot* exerted a tangible impact on American art, especially by its appearing within paintings as a kind of visual footnote to Millais and Pre-Raphaelitism. This is the case in *Gone! Gone!* (fig. 32) of 1860 by Thomas Farrer, an Englishman who arrived in America in 1856–57 and eventually exhibited and taught. Farrer had apparently seen Millais's *The Black Brunswicker* when he had been in London in 1860, but an engraving of *A Huguenot* hangs on the wall behind the weeping woman. In 1864 an American critic hailed *Gone! Gone!* as a milestone in the progress of native painting, and the work seems to synthesize various aspects of several paintings by Millais. The ominous sunset, for example, invokes comparison with the background in *Autumn Leaves*, while the arched top owes a debt to *A Huguenot*, which inspired scores of similarly shaped canvases with melancholy romantic vignettes in the 1850s and 1860s. In terms of subject, the cause of feminine anguish here may be from the separation of war, a permutation of Millais's love versus duty notion in spite of the fact this was painted just before the Civil War began, or possibly due to the death of a loved one, rejection, or even the emigration of a beloved. In Farrer's canvas the window, rather like Millais's imposing wall in *A Huguenot*, functions as a barrier from the outside world of ships passing the Palisades, the silhouette of rock eerily reminiscent of Ford Madox Brown's 1855 *The Last of England* with its emigration theme. The season is autumn, as in *Autumn Leaves*, a time of transition and passing, and a woman in the solitude of her domestic world faces grief— although ultimately not alone, as the scriptural passage inscribed on the work suggests. Yet she

is totally downcast with despair, inhabiting a world as insular as the star-crossed lovers in Millais's masterpiece.

Just a few years following the exhibition of Farrer's *Gone! Gone!* in 1861 at the National Academy of Design in New York, Millais's *A Huguenot* was referred to many times in the pages of the *New Path* and elsewhere. In a letter concerning Ruskin published in the May 1863 issue, for example, some earlier correspondence by a Mr. Ward referred to how the Pre-Raphaelites ". . . are distinct from the mass, because they are earnest, conscientious to a fault, and seem impelled with the deepest sentiment and most genuine feeling. 'The [*sic*] Huguenot' by Millais, which is familiar to your readers, is one of the best illustrations of my meaning."[53] In October of that year two references to this painting were made in the same issue, artist Charles Moore citing in "Fallacies of the Present School" the "consummate excellence" of *A Huguenot* and of Hunt's *Light of the World* above all. "Who feels that the leaves and flowers on the wall in the background of Millais's *Huguenot Lover* detract anything from the expression or superior importance of the figures? Are 'pebbles and petals' here 'made of equal importance with the human countenance?' or the texture of garments with the play of the features?"[54] Moreover, in an article in the same issue, written by a cryptic "J. S." entitled "Naturalism and Genius," the

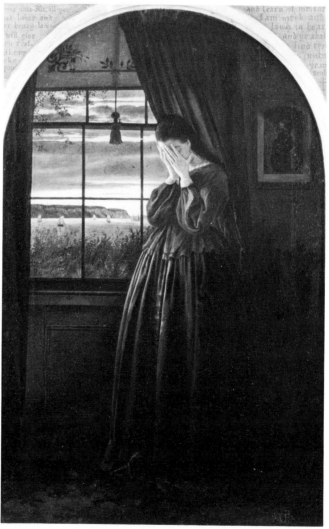

Figure 32. Thomas C. Farrer, *Gone! Gone!*, 1860. Oil on canvas, 20 × 14 inches. *(Private Collection.)*

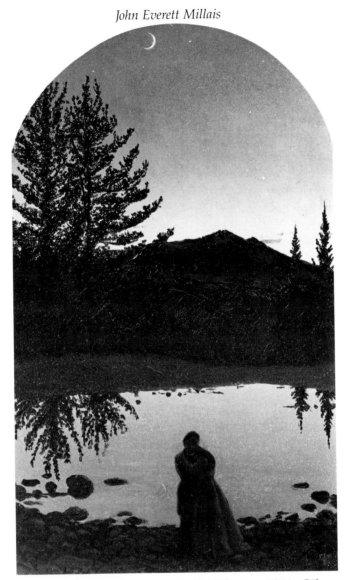

Figure 33. Thomas C. Farrer, *Twilight*, ca. 1864. Oil on academy board, 8 × 4⅞ inches. *(Courtesy of Mr. and Mrs. Wilbur L. Ross, Jr.)*

writer discusses the painting, "one known to some of us in the original, to all of us by the engraving, *The* [*sic*] Huguenot Lover by Millais."[55] Labeled a work of true genius, the canvas was thought to exemplify Millais's unique command of the pictorial language, especially in delineating the figures, wall, foliage, and drapery, as well as his perfect understanding of color, shadow, and light. His astuteness in recording the nuances of human emotion was also appreciated, for "Facts and gesture combine to tell the tale of impending death, of strong and tender love, of stronger integrity." Through the powers of imagination Millais thus conceived of the subject, the grouping, the individual personages and their accessories, using a stylistic "minute insight into natural fact" in order to create "something not seen by the eye" but superbly invented.

Furthermore, in a July 1864 issue of a New York art periodical called the *Round Table* a critic waxed at length about the superlative qualities that made this painting "unsurpassed in the art-work of any age or people." The "pure pleading, loving girlhood, and a man's heroic strength of purpose . . . make us feel the beauty and dignity of men and women. . . . To look at Millais' picture is to believe in the goodness of love, and honor . . . the best and most healthful fact that

art in England of the nineteenth century has given us. It is purer than the purest, more delicate than delicacy, and withal sweetly impassioned."[56] Such remarks reveal how thoroughly Americans understood and appreciated *A Huguenot*, which may have again partly inspired another work by Thomas Farrer, *Twilight* (fig. 33) of ca. 1864. The poses in this work reverse those of Millais's lovers and are intensified in a more passionate embrace; moreover, the inner sanctum of the garden of love has been exchanged for the dark, dramatic mystery and romance of an evening landscape. An even stronger figural comparison can be made with Millais's *The Black Brunswicker* (fig. 34) of 1860, which was warmly received at the Royal Academy that year and praised by the *Athenaeum* in terms of the artist's previous tour de force: ". . . if 'The Huguenot' had not been painted, we should have thought this picture the best of his works."[57] Millais himself considered this to be an informal pendant to *A Huguenot* both in pose and in its theme of doomed love and heroic honor. A foreign correspondent only identified as "P" referred to *The Black Brunswicker* in the *Crayon*, saying that the artist had "finally abandoned his early absurd manner" but with disappointing results. The lady's face lacked the depth of emotion found in her counterpart in *A Huguenot*, although "P" hypothesized "her great grief has passed some time before . . . for he has made a touching allusion to the many tears shed an hour or two before" on her face.[58] The *Round Table* of September 1865 also commented on the publica-

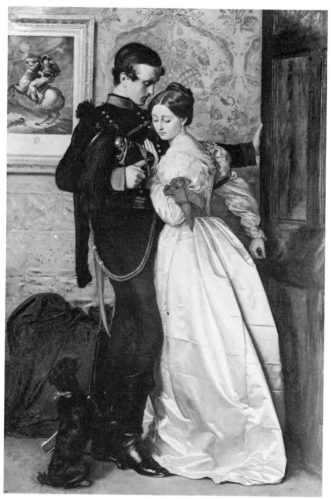

Figure 34. John Everett Millais, *The Black Brunswicker,* 1860. Oil on canvas, 39 × 26 inches. (*Courtesy of the National Museums and Galleries on Merseyside, Lady Lever Art Gallery*).

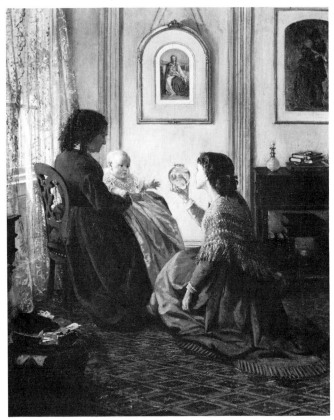

Figure 35. Aaron D. Shattuck, *Shattuck Family with Grandmother, mother, and Baby William,* 1865. Oil on canvas, 20 × 16 inches. *(Courtesy of the Brooklyn Museum. Given in memory of Mary and John Nodine by Judith and Wilbur Ross.)*

tion of a print of the 1860 canvas, suggesting that the soldier possessed character and emotion but that his companion was "nothing more than a lay figure for the display of an excellently painted satin gown."[59] Speculating erroneously that *A Huguenot* was executed later than *The Black Brunswicker,* the author commented that "the 'motive' of the picture is the same as in the more celebrated *Huguenots* [sic]—a picture which has proved widely popular. . . , but in the *Huguenots,* it is the woman's face that is the finer, and the struggle between the two is over a question of far higher bearing than the mere desire to avenge the death of a military commander." Perhaps the real subject of Farrer's *Twilight* with its couple posed à la *The Black Brunswicker* is courtship and the sympathetic response of the natural world at dusk, but there may be other implications, especially given Millais's precedents, of the man's imminent departure for war and of the need for both male and female courage in a time of both personal and national loss and crisis. (Millais's *The Black Brunswicker* was itself occasionally mentioned in American periodicals, the *Crayon* remarking in July 1860 that "The opinions expressed by American letter-writers in relation to the prominent paintings in the present Exhibition of the Royal Academy are strangely at variance with the criticisms which have appeared in the London journals. Our countrymen do not appear to be favorably impressed by the 'Black Brunswicker' of Millais. . . ."[60])

A final example of how *A Huguenot* was incorporated into the American consciousness and into American painting appears in another picture-within-a-picture context in Aaron D. Shattuck's *Shattuck Family with Grandmother, Mother, and Baby William* (fig. 35) of 1865. The function of

the print of *A Huguenot* on the wall at the right is an allusive one referring to the end of the Civil War. Beneath the sanctity of an image of the holy mother and child (a print after Paul Delaroche), the artist's own family kneels to contemplate the miracle of life within the orb of a fishbowl—and perhaps also to "adore" the real child on its mother's lap.[61] Yet beyond this cosy womb of tranquility, bloody warfare has raged during four years of national strife. The females here represent domestic harmony and stability, an interest in the continuance of life in all forms, and as the print after Millais's canvas on the wall suggests, a seemingly holy feminine and pacifist impulse to restrain men from self-destruction. Even a subtle religious note is injected by the inclusion of a rosary with a tiny cross on the table at the right. In addition, the absence of a male in this scene may allude to the masculine struggle between love and honor that is represented by the unyielding integrity of the Protestant man in *A Huguenot*.

While canvases like *A Huguenot, The Black Brunswicker, Mariana,* and *Autumn Leaves* undoubtedly left their imprint, it may well have been Millais's black-and-white illustrations that exerted as great—or greater—an influence on American artists. This is particularly likely given the fact that Millais did not contribute anything to the British exhibition of art in America in 1857–58 (although he had hoped to send *The Blind Girl* or another work of similar stature) and that original works by him were such a rarity in America. Even prior to the 1857–58 exhibition, the *Crayon* remonstrated that "this reformatory sect [needed] a work by Millais to make its corps of pictorial exponents complete."[62] Similarly, of the New York portion of the exhibition, the *Evening Post* complained that "we miss . . . Millais, the bulwark of Pre-Raphaelitism and its highest technical attainment. . . ."[63] Nonetheless, Millais's participation in this project never became concrete. The artist himself regretted this and tried to rectify it somewhat by sending two works to the United States for exhibition in 1859, when Ernest Gambart organized another show for the National Academy of Design entitled *The Second Exhibition in New York of Paintings, the Contributions of the Artists of the French and English Schools.* There was surprisingly little mention made of this exhibition in the press, which had devoted so much prose to the 1857–58 efforts, but there was a passing reference to Millais in the *Cosmopolitan Art Journal,* and a critic for the *New York Times* in September 1859 took this opportunity to remind readers that "The exhibition of French and English pictures by contemporary artists which took place here two years since, must have been sufficiently successful to induce the artists interested in it to repeat the experiment. . . . Maclise is represented by his celebrated 'Strongbow', . . . Landseer by a Highland scene. Millais, none of whose pictures have been seen on this side of the Atlantic, has two pieces in the collections."[64] (These two may have been two small heads of girls that were commissioned by Gambart in 1859.[65])

As a result of these circumstances, graphics were the source of the public's knowledge of Millais's work, for the most part, and on the odd occasion when his works were exhibited, the quality proved to be rather mediocre. The *Round Table* thus lamented about a December 1865 show of foreign paintings that Millais was only indifferently represented by a group of heads entitled *The Departure of the Crusaders* (fig. 36): "The types of faces selected by him for his gazing group are far from good, nor is there much to be said in favor of the patchwork counterpane in which the leading old man is wrapped."[66] In fact, Gambart himself owned the oil of *The Departure,* a composition that the artist begun and then abandoned in 1858 and that was subsequently sold to Gambart in 1862.[67] The *Crayon* had previously commented on this piece in June 1859, telling readers that this "half-finished [work] . . . has, it is said, been consigned to an indefinite rest. . . ."[68] In the same issue it previewed his 1859 Royal Academy entries *Spring* and *The Vale of Rest.* Quoting the London *Illustrated Times* for its praise of *Spring* that breathed "light, air, sunshine, happiness, and youth," it also expressed some preference for the convent scene, which was generally criticized by English critics (and even branded too "Papist" in subject). Of *The Vale of Rest* it remarked that the expression on the face of the seated novice was "perfectly marvellous—a hopeless, hapless resignation, a fixed, stern determination, a submis-

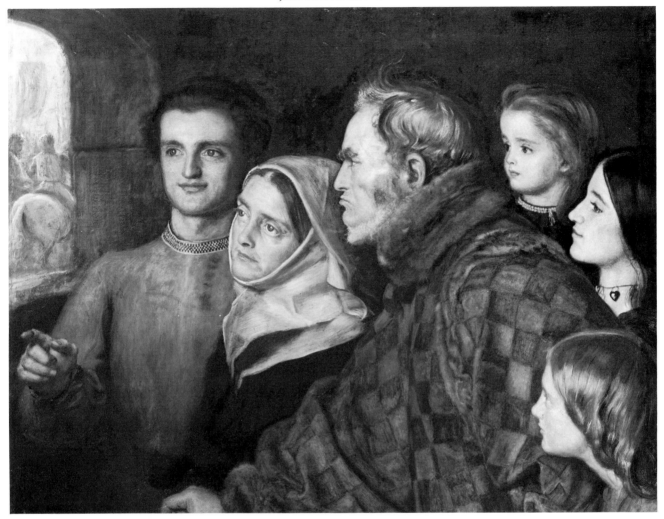

Figure 36. John Everett Millais, study for *The Departure*, ca. 1860. Oil on canvas, 22 × 26¾ inches. *(Courtesy of the Oldham City Art Gallery.)*

sion to ills past, a defiance to ills to come—throughout all a worn, wan, strangely touching melancholy. . . ."

Although finished canvases were rare, copies of Millais's illustrated works were, in addition to prints, available in America in both English and American editions, and *The Round Table* reminded readers in 1866, "France has her Doré, England her Phiz, her Tenniel, her Millais."[69] Among the examples of his work that were in current circulation were his drawings for Sarah Tytler's *Papers for Thoughtful Girls* (published in Boston in 1865) as well as for the 1867 edition of *Twenty-nine Illustrations of John Everett Millais,* the latter mostly featuring images from the *Cornhill Magazine.* In fact, the *New Path* reviewer of the Fourth Annual Exhibition of the Artists' Fund Society went so far as to claim about American artist Eugene Benson's entry, entitled *Autumn Walk,* that "If J. E. Millais had not illustrated *Orley Farm* (see, e.g., fig. 37) and other English novels, Mr. Benson would never have painted this picture. It looks real to many people . . . because instead of the ideal mountains, hills, foregrounds. . . , they can make out a field, and a fence, and trees, . . . and a patch of corn. Then, the young lady has a round hat, and a vail [sic], and a dress made in modern fashion. . . . Mr. Millais' work looks easy to do, but even the coarsest and most careless of his illustrations of *Orley Farm* has a great fund of experience

Figure 37. John Everett Millais, frontispiece for *Orley Farm*. Engraving from Anthony Trollope, *Orley Farm* (London: Chapman and Hall, 1862). *(Private Collection. Photo courtesy of the Yale Center for British Art.)*

Figure 38. John Everett Millais, illustration from *Orley Farm*. Engraving from Anthony Trollope, *Orley Farm* (London: Chapman and Hall, 1862). *(Private Collection. Photo courtesy of the Yale Center for British Art.)*

and knowledge at the back of it and could only have been drawn by a man who had served a long apprenticeship of labor and study."[70]

An even more emphatic endorsement of *Orley Farm* (which had been serialized with Millais's illustrations in the *Cornhill Magazine*) appeared in a long *New Path* review otherwise devoted to Millais's *Parables*. A specific image (probably this one, fig. 38) was chosen by the author to exemplify the Englishman's skill at capturing modern life: "As for the matter of modern costume, there is no living artist who finds it less a trammel to his art than Millais. Take . . . his drawing of Lady Mason in Trollope's novel, *Orley Farms* (1862). We do not happen to have it by us just now, but the drawing we mean is the one that represents her sitting alone, in the twilight, in a large armchair. Who that looks deeply into this little work, and looks long, until he finds himself in sympathy with the sad woman who sits there holding her heart with a strong hand, and with a silent courage of endurance trying to trample her conscience under her feet, and hold her lie out of the sight of the world for her son's sake—who that, having gone thus far in the story, unsuspecting her crime or unbelieving, suddenly reads in this drawing,— full confession, as if the guilty woman had spoken to him with her own lips—will care for the modern costume, or the clumsy chair, or the ugly room. Nay, does not the very fact of their being modern make the picture more impressive?"[71]

Another noteworthy project undertaken by Millais was his illustrations for the Dalziel Brothers's 1864 edition of *The Parables of Our Lord and Saviour Jesus Christ*, a book which the *New Path* reviewer in March 1864 said had been "long looked for" but which disappointed him overall. In that article, the previous Moxon edition of Tennyson was implicitly criticized for the poor quality of its engraving, while the Dalziels's efforts for Millais's *Parable* woodcuts were deemed intelligent and sensitive. However, the basic criticism was that "by far the great number of [illustrations] are not made clearer by the pictures. . . . Out of these twenty, we cannot recall one which tells any story so clearly as to be intelligible without a previous acquaintance." The author admitted how hard it was to transform the written word into symbolic visual expression and asked concerning *The Leaven* (fig. 39), "what better can be done with it than Millais has done; and what has he made of it but a first-rate drawing of a woman kneading bread? A very pleasing thing to contemplate . . . but no more an illustration of the Parables than of a half-dozen other subjects that might be mentioned. . . . We should like it thoroughly, if the artist had only shown us the woman's face." Once again with this project the issue of modernity arose, for the *New Path* critic maintained that the only man who could offer the public strictly "truthful" Oriental landscape, costumes, and other accessories was Holman Hunt, who had travelled to the Holy Land and who would supposedly have "brought the Parables before our eyes, as the disciples heard them." Millais's alternative, it was argued, was to make the tone wholly British and contemporary, yet even this was difficult to sustain, and an admixture of approaches confusingly resulted in the depiction of "an Englishwoman kneading bread, and English virgins with Eastern lamps going on an errand never heard of in England." The Parables should have been "*interpreted* to the eyes of the English people," it was urged by the writer, and although Millais was credited with having attempted this experiment, he was condemned for having "faltered, or turned away from it with dislike. This gives his work a mongrel air and makes it therefore unsatisfactory."

The focus on contemporaneity and on the "ugly costume" of everyday life resurfaced in remarks about *The Sower* (fig. 40), which this critic liked precisely because of the strongly Pre-Raphaelite element of gradient texture in the landscape and the resulting "truthfulness of the stony foreground on which the unprofitable seeds are falling, to be choked by thorns, withered by heat, and devoured by the fowls of the air." But the birds in this composition were deemed a little "too symbolical and clumsy," and Millais was again urged to place the farmer in English garb and not in inaccurate Eastern attire. There was also a recommendation to emphasize the hill in the distance for the supposed "encouragement of good but despondent children," for the

Figure 39. John Everett Millais, *Leaven*. Engraving from *The Parables of Our Lord*, the Dalziel Brothers's edition (London: Routledge, Warne, and Routledge, 1864) *(Private Collection. Photo courtesy of the Yale Center for British Art.)*

Figure 40. John Everett Millais, *The Sower*. Engraving from *The Parables of Our Lord*. *(Private Collection. Photo courtesy of the Yale Center for British Art.)*

end of the tale injected an optimistic idea concerning man's goodness, while Millais's illustration seemingly juxtaposed a threatening and unproductive "obtrusion of stony ground . . . to the ungracious exclusion of the good ground." Of this same image well-known American author and connoisseur James Jackson Jarves also commented in *Art Thoughts*, published in New York in 1869. To him *The Sower* was an "impressive composition of profound aesthetic as well as moral meaning, a serious thought put into serious coloring and suggestive design of prodigious force."[72]

The *New Path* also maintained that other works such as *The Hidden Treasure* should also have been "done into English." While Millais's verisimilitude in delineating the oxen and the furrows of the plough was applauded, the question was asked "why not have drawn an English ploughman in that honest, plaited frock of his, and his broad hat and heavy shoes, eagerly intent over a find of Roman . . . coins, such as is lighted on every year . . . and is the exact equivalent of the treasure in the Parable?" *The Lost Piece of Money* (fig. 41) also did not succeed as a suitable representation, since Millais was seen as having adhered to a very conventional academic model and approach that appealed to the public but was, in the end, merely graceful and not truthful or enlightening.

With one fell swoop, *The Lost Sheep, The Hireling Shepherd, The Unmerciful Servant,* and *The Laborers in the Vineyard* were all chastized for being "unsatisfactory and uninteresting. They do not tell their separate stories very clearly and lose very much of their force to use from the attempts to give them an Eastern look." This false veneer of Orientalism obviously galled the

Figure 41. John Everett Millais, *The Lost Piece of Silver.*
Engraving from *The Parables of Our Lord. (Private Collec-*
tion. Photo courtesy of the Yale Center for British Art.)

author, who asserted in rather original yet jingoistic terms that "if Jesus were to come among us today, he would translate the Parables in to the most unmistakable English, would indulge in no orientalisms . . . but would draw his illustrations from the things here in America, from elm trees and pine trees, cotton and Indian corn, the Libby prison and Bunker Hill" and his disciples would include "brokers, firemen, and carpenters."

Among the few outstanding images that were sanctioned were *The Unjust Judge, The Good Samaritan,* and *The Prodigal Son. The Unjust Judge* was reckoned to be an exception in the requirement of a modern contemporary setting, for it was thought that this "could not have been translated into a modern rendering. . . . The weak, sensual face of the judge, whom the widow's distress moves only to incredulous mirth, is well contrasted with the calm, reflective countenance of the scribe, who, roused by sympathy, waits before he records the degree already rendered, in hope that the desperate woman's prayer may avail to change it." And in spite of the awkward disposition of the two heads in *The Prodigal Son,* this image was perceived as replete with energy, pathos, and quiet suggestiveness, especially in the "meek, unconscious way . . . the fatted calf chews the cud, couched at his ease on the grass, happily blind to the way in which his fate is mixed up with this meeting of father and son."

The best of the woodcuts was *The Good Samaritan* (fig. 42), which was regarded as a simple, direct, and a complete telling of the story. The *New Path* admired the implied humanitarianism of the samaritan and how his strong back implied to viewers that this was a man "able to lift a world of robbed and beaten men out of the mire." Even the donkey was allegedly infused with the spirit of his master's benevolence, so that it seemed to await the moment when its own back

Figure 42. John Everett Millais, *The Good Samaritan*. Engraving from *The Parables of Our Lord*. (*Private Collection. Photo courtesy of the Yale Center for British Art.*)

would be permitted to "do his share of the charitable duty." Millais had also clearly communicated this altruistic message even to an audience of children, for the Levite in the distance was read as a symbol of selfishness, his ample cloak having never been "wrapped about any body but himself."

The artist Eugene Benson also appreciated Millais's *Good Samaritan* along with his other graphic works for this project and wrote about these in an April 1864 article entitled "Three Parables Illustrated by Millais" for a magazine called the *Spirit of the Fair.* He too commented about the selfish priest in the *The Good Samaritan* and how he continued on his journey while another man stopped to "lift the poor injured man who fell among thieves and murderers. . . . This picture is drawn truthfully and with feeling."[73] He also mentioned the significance of the "gentle and complacent donkey" and commented that "we do not remember any picture more appropriate to typify the purpose and action of our people for the benefit of the sick and wounded." In addition to the purposeful sentiment and action in this saga of generosity, the details of the Samaritan's hair and beard and the landscape elements of the cedars were deemed "poetic and beautiful."

Benson felt all the woodcuts were touching, "positive, singular, full of interest," and sometimes profound in meaning, mentioning as well *The Parable of the Tares* and *The Parable of the Wicked Husbandsmen* (fig. 43). The former he described as a "forcible and imaginative picture which represents the Evil One sowing tares." Under a dark and threatening sky, the figure "looks back . . . with a malignant expression," and vipers and a howling hyena add to the ominous mood. Thus, to Benson "the half-crouched and shuffling figure of the hateful Old

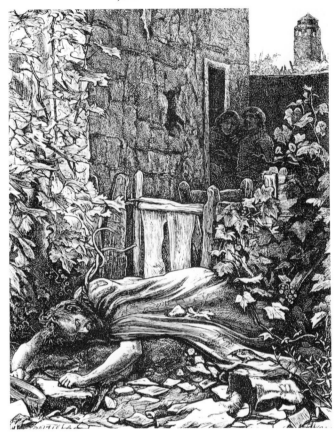

Figure 43. John Everett Millais. *The Wicked Husbandsmen.* Engraving from *The Parables of Our Lord. (Private Collection. Photo courtesy of the Yale Center for British Art.)*

Man of Sin, the noiseless and fascinated movement of the vipers, and the singular break in the thick drifting clouds, combine to make an expression which is at once strong . . . as imaginative, as intense as Doré's, [and] is as original and bold in conception." *The Parable of the Wicked Husbandsmen* was also full of malevolent symbols: the dead son with a slimy toad upon him and a dove nearby "symbolic of his innocence, lies dead also, probably killed with the stones which were thrown upon him. . . . What we must admire in this most tragic work is the disordered look, as if violence had been done . . . and also the seemingly unconsidered disposition of the corpse half hidden by the rank vines and weeds growing beside the fence."

Benson was thus more enthusiastic about the engravings than his counterpart in the *New Path,* yet he admitted that the illustrations were imperfect in some senses, for Millais was seen to have "taken certain parts and made them the occasion of pictures full of truth, charged with meaning, but faulty in relation of light and dark, childish or willfully wrong in composition." He thought that many of the images looked as if they were segments lifted from large and complete works. But all the works were "entitled to our respect and admiration," because each image was so remarkable "in *expression,* so unusual in fineness and delicacy. . . ."

There were numerous later references to Millais's art in American sources, but, as will be apparent, most of these tended to concentrate on the same pictures which have thus far been mentioned. In addition, there was some sense that Millais's art had already reached its prime by the late 1850s, an opinion expressed in the *Atlantic Monthly,* for example, in 1858. The author judged that "Millais will probably be the first important recusant. He is a man of quick growth, and his day of power is already past . . ."; this, however, was an unusual assessment, for most

critics at this point had nothing but accolades for this artist.[74] After the notorious 1857–58 exhibition organized by Rossetti and Ruxton, there were also hopes to borrow more original pictures by Millais for loan exhibitions, the *Round Table* commenting in September of 1865, "Will not someone, whose pride in his countrymen outweighs his desire for pecuniary benefit, take pains to let . . . [the] . . . 'barbarians' see one or two first-rate works by such men as Dante Gabriel Rossetti, Millais, Holman Hunt, William Hunt, J. F. Lewis, Leighton, J. C. Hook, Wallis, Arthur Hughes, Brett, and a few others, whose names are much better known among us than their works."[75]

In 1866 Millais lent one picture to the fifth exhibition that Gambart put together of French, English, and Flemish pictures, but this was not enough to please the critics. The reviewer for the *Nation*, for example, dismissed Millais's sole contribution as "not . . . of any importance" as well as "small and not very characteristic."[76] He also expressed considerable frustration that during the private view he "missed from the walls only one important canvas, Millais's small study of the famous 'Order of Release.'" *The Order of Release* was among the best known of Millais's paintings here, but a small study was clearly insufficient in satisfying the public's hungriness for more of the "real thing."

Since only a few works by Millais "infiltrated" the United States at this time, Pre-Raphaelite supporters and critics had little recourse but to rehash and editorialize about relevant paintings at the annual Royal Academy exhibitions. A critic for the *Galaxy: An Illustrated Magazine*, for example, had obviously seen Millais's *Sleeping* and *Waking* (fig. 44) pendants at the Academy in 1867 and accordingly reported to New York and metropolitan connoisseurs, "If an artist were to introduce the white satin quilt which you see before you into the same picture, his sun would appear no brighter than the reflected lights upon the satin, to obtain which Mr. Millais has employed the most luminous tones his palette affords."[77]

Among the articles on Pre-Raphaelitism that continued to appear in the 1860s was one in an 1868 issue of *Littell's Living Age*. This was one of the first American commentaries that took note of the dramatic changes that had occurred among the Pre-Raphaelites, above all, the "defection" of Millais to a looser style and less serious subject matter. This was a judgment that had previously been expressed rather often in England, and was then absorbed by American critics. The author in *Littell's Living Age* thus mourned (in somewhat melodramatic tones) the loss of Millais in particular to the conventions of the Royal Academy and to the throes of popularity: "The Pre-Raphaelite movement having made Mr. Millais the most popular painter of the day, he, according to the old practice, speedily became a Royal Academician. . . . On this desertion from the ranks, Mr. Rossetti, apparently with tears in his eyes, says: 'It was expected that Pre-Raphaelite pictures would continue to be painted. . . .'" The writer also asked rather pointedly what the Academy had gained by this apparent conversion by Millais and answered this query as follows: ". . . they have gained an excellent designer for monthly magazines—a man who can paint a little girl in a pew at church well; who can paint a little girl in bed well; and who can paint the bedstead not quite so well; but who, judging from his historical pictures exhibited at the Royal Academy in the last two years, cannot paint important compositions of that class well. Indeed, it must be confessed that, for a painter of his newly acquired dignity, they were failures." Some remarks were also reserved for Millais's little picture entitled *Charlie is My Darling*, a composition which the author rather unfavorably compared with the artist's drawings for such publications as the *Cornhill Magazine*, Trollope's novels, and the *Parables*; ". . . if Mr. Millais' picture be compared with his illustrations . . ., it will be found in the latter that the heads of the females are idealized, the heads of the men perfectly modern in character, and all are very nicely drawn. The doubts thus suggested as to his entire conversion to pre-Raphaelitism were more confirmed than shaken by an early work from his pencil recently in the picture gallery at the Crystal Palace."[78]

In the remaining decades of the century, numerous pieces devoted exclusively to Millais

Figure 44. John Everett Millais, *Waking*, 1868. Mezzotint with engraving by T. B. Barlow of the 1865 original, 14 × 22 inches. *(Private collection.)*

appeared in American periodicals, a salient example from the 1870s being J. D. Champlin's "John Everett Millais" for *Appleton's Journal* in 1874. In this Champlin provided a quick sketch of the painter's career, singling out the same works which the *Crayon* had featured nearly twenty years earlier: namely, *Isabella, Ferdinand and Ariel, Christ in the House of His Parents, Mariana, The Return of the Dove to the Ark, Ophelia, A Huguenot, The Proscribed Royalist, Autumn Leaves, The Order of Release, Peace Concluded, The Blind Girl, L'Enfant du Regiment,* and *The Rescue.* Much less space was devoted to subsequent paintings such as *A Dream of the Past: Sir Isumbras at the Ford* of 1857, *The Escape of the Heretic* of 1858, and *The Vale of Rest, Spring,* and *The Love of James I of Scotland,* all of 1859, *The Black Brunswicker* of 1860. Moreover, only a sentence mentioned in passing later paintings like *My First Sermon* of 1863, *My Second Sermon* and *Charley is My Darling* of 1864, and *Sleeping* and *Waking* of 1867. Essentially no new information or insight was offered on the early paintings (or the later ones), although the author did express considerable awe of Millais's "ingenious religious symbolism" in *Christ in the House of His Parents* and in *The Return of the Dove to the Ark.* He also suggested that as early as 1852 the painter, "as if in distrust of the success of his revival of medieval symbolism, apparently abandoned his lofty aims in favor of lowlier themes, and devoted himself to the depiction of a tender sentimentality, without, however, abandoning any of his characteristic peculiarities." In this category he interestingly placed both *Ophelia* and *A Huguenot,* which, in spite of the tremendous success they generated for the artist, were chastised for revealing some "ignorance of anatomy in the drawing of the figures, too many suggestions of the brush in the painfully-labored details, and a general want

of breadth in the treatment. . . ."[79] Occasionally a painting by Millais was seen in America in the 1870s, the most notable being his contribution to the British division of the Philadelphia Centennial Exposition. This was presumably a work entitled *Early Days,* which originally showed a little girl with a kitten (although Millais in the 1890s painted over the kitten with a rabbit.[80]) There were works by Frith, Holl, Leighton, Faed, Hunt, and others, but seemingly little criticism was devoted to analyzing these entries. The majority of guidebooks and accounts of the "world's fair" merely described the contents of Memorial Hall to readers, and one author rather amusingly misconstrued Millais's name but nonetheless appreciatively commented that "Millois [*sic*] sends a charming study of a child" to the 1876 endeavor.[81]

During the decade of the 1870s, Henry James, whose first reactions to Pre-Raphaelitism as a boy had been so vivid, as a London correspondent wrote a considerable amount about Millais, much of it adhering to the prevailing complaints about Millais's society portraiture and its flaws: "That Mr. Millais's brush has at its worst a certain indefeasible manliness there is no need of affirming; this the artist has been proving to us any time these ten years."[82] He also poked fun at the 1877 Royal Academy Picture *Yes!* (the romantic climax to a proposal), asking "of what order is the painting . . . of an immense ulster overcoat, flanked by a realistic leather valise and roll of umbrellas, and confronted by a provisional young lady with clasped hands and a long chin?" To James this conclusion of a three-part amorous series qualified as a trivial "lithograph on a music sheet, mercilessly magnified," but he did briefly praise *Effie Deans* and especially a large landscape entitled *The Sound of Many Waters,* the latter because, as he drolly put it, "after all this emulation of the *tableau vivant,* it has the merit of no expressiveness at all."[83]

Millais's Royal Academy entries of 1878 triggered an outpouring of prose by James, who mentioned with varying degrees of enthusiasm or censure the portrait of the legendary beauty Lily Langtry in *A Jersey Lily* (in which she was allegedly passed off as a modern "heroine of a serial in a magazine"), of Lord Shaftsbury ("Mr. Millais' best thing, so far"), the "curiously motionless and photographic quality" of the landscape *St. Martin's Summer,* and the mostly admirable canvas of *The Princes in the Tower.* In addition to his remarks on how some of these paintings revealed how very "right" Millais's choice of models could be, James spoke at length and with conviction about how this painter had succumbed to commercialism and had pandered to public tastes. Such statements as the following reaffirm how seemingly universal this lament was: "In any exhibition in which Mr. Millais appears, Mr. Millais is always the strongest genius present; though his pictures on particular occasions may be by no means the best. But it is interesting to see how he, rich and strong in the painter's temperament as he is, shirks, as it were, and coquets with, the plastic obligation, and plays into the hands of the public desire for something more amusing or more edifying. Mr. Millais always knows thoroughly well what he is about, and when he paints very badly he is certainly aware of it, and of just how it serves his turn; indeed, I must say that to paint so badly as Mr. Millais occasionally does a great deal of knowledge must be brought to bear."[84]

On the other hand, at the 1878 Grosvenor Gallery exhibition the acerbic American found things both to praise and to scorn. He liked a portrait called *Twins* in which the two young women were "looking out of the canvas as Mr. Millais can so often teach his figures to look." However, the other contribution was not named out of supposed deference to Millais's previous talents, for to James this painting resembled more "the work of a vulgar and infelicitous imitator" than that of the master himself.[85] Yet James tried to remain open-minded about Millais's art, and the next year claimed his 1879 portrait of William Gladstone was "a brilliant success . . . a very manly, masterly, simple piece of portraiture."[86]

This pattern of mixed approbation and disapproval by James continued throughout the 1880s and 1890s, with, for example, the critic hating all of Millais's portraits in the 1882 Royal Academy and heaping particular invective on the "furious red" cape of Cardinal Newman and its "violent, monotonous, superficial, uninteresting" effect. He also reiterated the complaint

that Millais was simultaneously one of the most accomplished and yet most disappointing contemporary masters—facile and unsurpassed—a vexing combination of "celebrity" portraitist and painterly genius, and yet a man who in the end chose to embrace the role of "popular purveyor of pictorial anecdote."[87] These objections were more poignantly expressed in James's remarks about Millais after his death, for at the 1897 exhibition the American admitted "it is surely with him as with Leighton, that he cast across the desert a bigger shadow than we knew." On this occasion James described Millais's absence as a reason to review his past, from the heights of "the three pearls" of *A Huguenot, The Blind Girl,* and *Ferdinand and Ariel* to the nadir of his later career. To James, the decline of this artist from youthful intensity almost seemed worthy of a short story, for "the difference of quality in the two periods is not to be explained, the explanation not to be imagined, the hiatus, in fine, not to be bridged. The case would have been a subject for Browning, a story for him to have dealt with or got behind. . . ."[88]

Aside from James's lucid commentaries, in the 1880s interest in the artist was sustained in part by the remarks of other reviewers on both sides of the Atlantic. As James had done, considerable attention was given to Millais's portraits, and often comments mixed respect for the artist with more than a touch of disparagement. The *Art Interchange,* for example, complained that Millais's 1879 submissions to the Academy (portraits of Thomas Carlyle and William Gladstone) were not in ". . . a very forward state," complimenting the likeness of Mr. Gladstone yet finding it "quite different from the conventional treatment of his face. . . ."[89] The next year presumably the same author for this American magazine was disappointed by Millais's two portraits exhibited at the Grosvenor Gallery, suggesting that although "that of Mrs. Caird is sympathetic and charming, . . . both pictures have the curious opaqueness of flesh, not to say absolute chalkiness, that Millais affects so much."[90] The *Art Interchange* sometimes faulted Millais's technique, and a correspondent called Montague Marks, for a regular column entitled "My Notebook" in the *Art Amateur,* similarly waxed hot and cold about the artist. Accordingly, he wrote of the 1882 Academy that this "really great English painter . . . evidently is working more for money than fame. Some of his portraits are dashed off without attempt at completion. It will be remembered that he used to be a Pre-Raphaelite of the Pre-Raphaelites. . . . Remembering his early performances, I know that he could, if he chose, be more than a portraitist, but he seems contented to follow this branch of his art, and probably he knows his own business best."[91] Of the 1883 Royal Academy exhibition Marks reported that "In portraiture Millais shows some of his best work [portraits of the Marquis of Salisbury, Thomas H. Ismay, and Charles Waring]."[92] The painting of the marquis was singled out for praise, because in this ". . . no attempt whatever is made at pictorial effect." In the realm of genre or costume pieces was ". . . 'Une Grande Dame,' a pretty child in gorgeous robes with a humorous consciousness of her importance. The picture is rich in color and decidedly attractive; but the overloaded painting of the face leaves a very disagreeable impression on the spectator." (The latter picture was also seen in America in an April 1887 exhibition at the Brooklyn Art Association, where a collection of works owned by Mr. George I. Seney was shown to aid the building fund of the Brooklyn Home for Aged Men.[93])

Another pertinent article of the early 1880s appeared in the *Andover Review* and again referred to the classic and "well-known Huguenot Lovers." Millais's mastery of technique was said to surpass that of his colleagues, and although he was very popular with the public, the author pointed out the "uneven quality" of his paintings. Nonetheless, she cast him in the role of a demi-god to American viewers, who ". . . despite their animadversions against the Brotherhood, had regarded its shibboleths with a secret awe, were as much delighted as if a god had stepped down from the home of the Immortals to entertain them with a picture-book."[94]

Shortly thereafter, in 1885, an entire article was devoted to Millais (and then to other modern painters) by Maria G. van Rensselaer in *The American Architect and Building News.* She alerted

readers to other late works by the artist, mentioning particularly the portrait of William Gladstone "which hangs at Grosvenor House" and also a painting of Lord Rosebury's little daughter from the 1885 Academy, the latter with a beautifully rendered landscape background and a figure full of "fearless innocence" and "delicious baby grace . . . , the ideal English baby. . . ." The most interesting remarks, however, are reserved for Millais as "one of the two or three greatest portrait painters of his time" and one of the best in English history. To Van Rensselaer, basically two categories of portraiture existed: the first, occupied by the likes of Titian, Veronese, Raphael, and Reynolds—involved capturing a sitter's true inner nature, rendered on canvas "directly, straightforwardly, dispassionately. . . ." The other, allied with the art of Rubens and Gainsborough, was very subjective in approach. The author maintained Millais belonged to the more "objective" classification of Reynolds, for in his work ". . . it is the soul of the model, divined, translated, perhaps clarified or intensified, yet not altered out of its own semblance in the slightest, not colored by any reflection from the painter's soul."[95]

Van Rensselaer also alluded to the stylistic alteration in Millais's work, which had taken place from his early and intense Pre-Raphaelite canvases. This change she attributed to "the tendency of the English public at large, and even of its more critical circles, to care more for *sentiment* in a work of art than for anything else. . . . He [Millais] has somewhat yielded to this national satisfaction. . . . I think there may be many American readers who, while they fancy they know what is meant when Mr. Millais' art is named, . . . are really very much astray. I know such had been my case; and I had seen many canvases of his, as well as countless reproductions. . . . Indeed, it is remarkable that since great inequalities exist between his pictures, and since they have been very prolifically produced, their average should be so high, and the very best among them so numerous." Moreover, van Rensselaer indicated her hopes that more works by Millais would be acquired by American museums, since most of his paintings were ". . . in private possession and invisible to the majority of tourists—a state of things which, one hopes . . . , will be remedied long ere our children's children seek the National Gallery of England."

Van Rensselaer's approbation of Millais's skill as a portraitist was also shared by the writer for the *Art Interchange,* who commented that his portrait of "Lady Peggy" in the 1885 Royal Academy was ". . . one of the most enchanting pictures in the exhibition, and will rank with any of the Sir Joshua Reynolds children, which are still the admiration of successive generations of art lovers."[96] Increasingly, Millais turned to eighteenth-century prototypes in portraiture— especially to Reynolds—for inspiration, and this debt was not lost either on American or British critics. Yet at the same time this writer also rather scorned Millais's other two entries that year, disliking even the title of the ornithological subject for *The Ruling Passion* and expressing clear distaste for how "the world is going into ecstacies [*sic*] over the painting of the blanket, which is the most that can be said of the picture as a work of art." Moreover, although the portrait of Lady Peggy was deemed of high caliber, Millais's propensity to churn out somewhat vapid images of children to please the public did not go unnoticed, and the correspondent rather acidly pronounced that: " 'The Orphans' is one of those pretty children which Mr. Millais paints for Christmas numbers for the illustrated papers, a child carrying a rabbit in her lap."

Another signal publication of the 1880s was *Art and Artists of Our Time,* written by Clarence Cook, the articulate former fine arts contributor to the *New York Herald Tribune,* editor of the *Studio,* and author of *The House Beautiful.* Cook wrote at length about Millais, offering a tempered overview of the artist's strengths and weaknesses. His first focus was on early works and how *Christ in the Carpenter's Shop* exemplified "the new-old way of looking at things. In its avoidance of Raphaelesque grace and elegance, everything was made as awkward and ugly as possible." The homely Mary and the general "obstinant adherence to nature in the action and expressions of the actors" brought a storm down upon Millais's head and so, too, to a lesser extent did *The Return of the Dove to the Ark,* in which the two girls "clad in mantles of the crudest color, are fondling and cooing over the dove. In this picture the attempted realism in the

painting of the straw and of the plumage of the dove excited a lively curiosity, but it was impossible not to see that the only important thing, the painting of the faces of the women, had been sacrificed to the mechanical perfection of these details."[97] From these Millais moved on to a more successful and romantic blend of realism and subject, including *A Huguenot* (illustrated in a nearly full-page engraving), *The Black Brunswicker, The Order of Release, The Rescue*, and *Ophelia*, although to Cook in all of these a certain "preference for the grotesque in gesture" still lingered. Rather surprisingly, *Ophelia* was criticized both for her wholly modern dress and for a supposed want of taste in "the over-elaborate painting of the foliage and especially of the wild roses." Yet the comely, fair heroines of these pictures had been eclipsed by more superficial subjects in later works, and for this change Cook too joined the ranks of Millais's detractors.

While Millais's portraits and subject pictures were the main fare of his exhibited work and were thus also much discussed by James, Cook, and various other critics, occasionally American writers commented on the Englishman's landscape style. One such example occurred in the pages of the *Art Interchange* in 1889, when a reviewer drew a rather interesting comparison between the Briton and a prominent American painter. Of a Royal Academy picture Millais submitted that year, the correspondent wrote: ". . . Millais is also a name to conjure by, and this distinguished name is signed to a long landscape which it is no exaggeration to define as worthy of Mr. Cropsey."[98] The reviewer was obviously used to the fact that Millais's works were primarily known second-hand in America, for he also mentioned the fact that "the catalogue assures us . . . that an etching is to be published of it by Mr. McLean, and the misguided public will doubtless accept the etching as it does the painting."

The dearth of good pictures by Millais in America was a recurrent complaint in the 1880s as it had been over twenty years earlier, and the writer known as "Montezuma" for the *Art Amateur* lamented in 1886, "It is not surprising that Americans entertain the poor opinion they do of English art; for British painters are seldom represented at their best in pictures seen in this country. Who, by looking at that mushy production by Sir John Millais, at Knoedler's, 'Little Nell,' can understand why the artist was knighted, or how, indeed he can rank at all among the great artists of the day?"[99] In the July 1895 issue of the *Art Amateur* the hope was expressed that important works could be obtained for a New York exhibition of portraits of women and children, especially ". . . the delightful painting by Sir John Everett Millais . . ., *Ducklings*, . . . the only characteristic child picture in this country from the brush of this most noted living English painter of children."[100] Presumably the same critic a few years later dispatched a rather vitriolic attack on Millais, referring to the artist's comments in the *Magazine of Art* in August of 1888 and citing his belief that ". . . the best artist of modern times is as good as any of its kind that has gone before." To this *Art Amateur* reviewer, Millais symbolized in some ways the modern artist's greed for high prices, suggesting that he was complacent about his art and, because of his reputation, was able to sell pictures for enormous sums. As a result, "England would seem a Paradise for bad painters. . . ."[101]

Prior to Millais's death in 1896, several other articles on the artist appeared and were available for American readers. For example, Esther Wood's *Dante Gabriel Rossetti and the Pre-Raphaelite Movement* was published in New York in 1894, and while the author's emphasis was on Rossetti, considerable attention was also given to Millais. All the key early pictures—*Christ in the House of his Parents, Ferdinand Lured by Ariel, A Huguenot, Ophelia*, were cited and briefly explicated. But particular emphasis was given to the change or progress of Millais's style, which Wood asserted in *The Black Brunswicker* marked ". . . the final merging of the Pre-Raphaelite heretic into the popular Royal Academician." Acknowledging the controversy and censure that this change caused, she recited the impatient claims registered by some detractors that "Millais lacked original imagination, and could not sustain his early level without the constant inspiration of stimulus of Rossetti and Hunt. . . . More ardent apologists have claimed that his Pre-Raphaelite period was but a curious episode in Millais's career; a mere incident in the growth of

a genius too brilliant to submit for long from without; and that his impressionable nature was only temporarily swayed by the proselytizing enthusiasm of his comrades." Yet Wood ultimately offered a milder judgment, conjecturing that if Millais, ". . . was spoilt, it was by success, not failure; if corrupted, it was by popularity, not neglect. . . . It can only be assumed that Millais, in forsaking the high and steep paths which he had once chosen, sincerely followed what he felt to be a more excellent way, and honestly believed his decadence to be an advance upon his maturity."[102]

Following Millais's death, a spate of articles appeared in England to commemorate him, and among American contributions to this phenomenon were S. Beale's obituary for the *American Architect and Building News* in March 1896. Beale reminded younger readers that this new audience ". . . who only know Millais by his later work, or who look upon the 'Huguenot' as a fine work of an archaic order, have no conception of the furious onslaughts made upon some of the painter's works in the fifties." A string of the predictable early canvases was then recited (and some mention was also made of the important retrospective of the artist's works at the Grosvenor Gallery in 1886), and particular attention was curiously focused on a defense of *The Vale of Rest* (a much maligned painting in England) as probably "Millais' greatest work after the 'Huguenot.'" While van Rensselaer had chided Millais for his pandering to the public love of sentiment in art, Beale in contrast said, "[W]e all owe an enormous debt of gratitude to Millais for purging English art from maudlin sentimentality" and also extolled him as a superb colorist. The standard denunciations of his compromising stylistic conversion and his implied acquiescence to the demands of the viewing public were also mollified and stated in a different light: "He moved on and developed his *technique,* but his art was always equally true; even when he pandered to popular taste, the pity of it was not on the score of want of truthfulness."

It is in hindsight perfectly clear, however, that the heyday of American criticism and appreciation of Millais was in the mid-1850s and -1860s, both in terms of the frequency of comments on his art and the qualities observed in it. Just as the years 1855–68 were the most fertile for American interpretations of Pre-Raphaelitism in the realm of landscape painting, so too were these same years the most positive and influential for Millais and his impact on American artists and readers. *The Rescue, Ophelia, The Order of Release, The Proscribed Royalist,* and above all, *A Huguenot,* remained monuments to his greatest talents both in the realm of criticism and its effects on American artists, and not even an admirer of Millais like van Rensselaer would have dared to suggest that his considerably later *Portrait of Gladstone* (hailed by the author as a great portrait "of an ideal English statesman in the class of Gainsborough, Reynolds, and Titian") could really emulate the noble sentiment, palette, and meaning of the most famous canvases of the 1850s.

At the turn of the century Millais's image was still being upheld by Pre-Raphaelite enthusiast Russell Sturgis, who admired Millais but bemoaned his apparent acquiescence to the demands of popularity. Accordingly, he wrote in 1900 in an article on "The Pre-Raphaelites and Their Influence" that "Millais followed sincerely the avowed principles of the school for ten years, and then dropped them absolutely and followed as sincerely a path of more popularity, more easy, more fruitful, more speedy execution which led to his immense social and pecuniary success."[103] Sturgis correctly perceived the 1850s and 1860s as the key period for Millais's productivity and appeal in America, but other critics such as the artist Kenyon Cox, cited slightly different (but familiar) aspects of his career. In his 1905 book, *Old Masters and New,* Cox not only mentioned all of Millais's principal pictures; he also hailed the Englishman as an outstanding illustrator of works such as *The Parables* and *Orley Farms.* And although Cox reiterated the usual appreciation of the engraving of the *Huguenot* (remarking that it had been "selling like hotcakes" many years earlier), he too was well aware of the painterly "fall from grace" evident in Millais's stylistic changes over the decades.[104]

Thus, while Millais apparently sometimes expressed a certain disdain for American pa-

trons—haughtily refusing at one point a commission from a Yankee gentleman and also occasionally "threatening" to go off to the United States when there were financial pressures, his artistic status in this country remained fairly intact and positive, waning from an apogee of praise at mid-century to a more tempered but still relatively untarnished appreciation of his talents and particularly of his earlier works of genius.[105] And although it was *Ophelia* which made his early reputation in England (followed by successes like *A Huguenot* and other works), in America it was almost singlehandedly the courtship image of a Catholic and a Protestant which forged—and then sustained—Millais's reputation.

5

Holman Hunt: The Light of the World Illuminates America

Considerably less was written about Holman Hunt in American journals than was penned about Millais or Rossetti, but the comments that were offered basically revealed much more consistency in the generally positive appraisals of his art. In 1858, for example, the *Boston Daily Advertiser* described the important exhibition that went there as "especially of the pre-Raphaelite or Holman Hunt School . . ., the newest rage of English art."[1] Similarly, James Jackson Jarves in an article for the *Fine Arts Quarterly Review* expressed the customary hope that "If we could possess fine specimens of the English school, such as . . . Millais, Hunt, and their compeers, our improvement [as artists] would be more marked. We say this without fear of falling into soulless imitation, for, whatever may be said of the quality of American paintings, at home it possesses largely the virtue of original conception."[2] Yet, as with his colleagues, Hunt also suffered the fate of "under-representation" in America, but unlike Millais he was unable to establish a reputation largely through engravings of his work.

While Americans could certainly have read the *Art-Journal,* the *Athenaeum,* the *Spectator,* or other British periodicals for an assessment of the reigning shows at the Royal Academy, such native magazines as the *Photographic and Fine Arts Journal* also provided some insight on this matter. In the July 1854 issue of this publication, for example, Hunt was applauded for having almost exclusively sustained the reputation of the Pre-Raphaelites with his two commanding entries—*The Light of the World* and *The Awakening Conscience*—that were "well worth any passionate art-pilgrim's while to come across the Atlantic to see."[3]

Not surprisingly, it was seemingly the *Crayon* that almost singlehandedly fanned the fires of interest in this artist, and in Frederick Stephens's 1856 essay "The Two Pre-Raphaelites" several pages were devoted to a protracted discussion of Hunt's major pictures. Brief mention was made of his *Rienzi* of 1849, "a picture of singular promise [that] showed great labors of finish, and excellent judgment of expression, and found many admirers, who foresaw the future eminence of the painter."[4] Another work executed that year, *A Christian Missionary Receiving Succour from a Converted British Family from the Persecution of the Druids,* was also mentioned, but mostly in terms of the imaginary incident and of the "massive description," the energy, and the almost overwrought labor that were to become so characteristic of Hunt's art throughout his

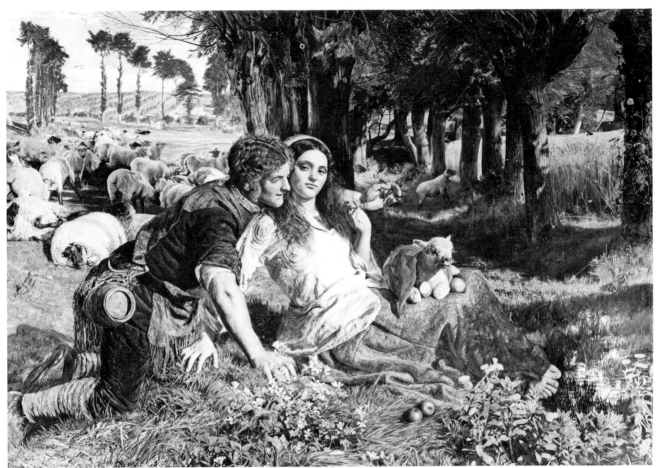

Figure 45. William Holman Hunt, *The Hireling Shepherd*, 1851. Oil on canvas, 30 × 42½ inches. *(Courtesy of the Manchester City Art Gallery).*

career. In contrast, more than one long column was devoted to *The Hireling Shepherd* (fig. 45), which had been exhibited at the Royal Academy in 1852 and was characterized by William Rossetti (in one of his English reviews) as full of "moral suggestiveness" and not merely ". . . a casual episode of shepherd life."[5] A decidedly caustic reading, however, was proffered by the *Athenaeum*, which branded the rustics as repulsive, ". . . ill-favoured, ill fed, ill wanted. . . . Their faces, burning with a plethora of health, and a trifle too flushed and rubicund, suggest their over-attention to the beer or cider keg."[6] Stephens offered a full and perceptive analysis to his readers, citing the neglectful shepherd who makes "love to a girl of his class" and catches a death's-head moth to show her. He was characterized as "rough, rustic, and coarse" and she as a temptress, "a full-blown, robust, rustic, beauty."[7] The symbolism of the errant sheep and of the foliage in the foreground was also explicated, with particular attention given (even more so than comments on Rossetti's bright mosaic compositions) to the extraordinary hues of purple shadow, for example, created by the artist's quasi-scientific observation of sunlight. (Parenthetically, Hunt's originality in his treatment of these optical facts and of the landscape must have been especially interesting to American artists, for whom landscape was more revered and pursued than history paintings or even genre scenes.)

Claudio and Isabella (fig. 46), painted in 1850 but not exhibited until three years later, was also highlighted, and Stephens's comments were remarkably free of the kind of vituperative criticism often leveled against this picture in England. The naturalism of pose and expression that

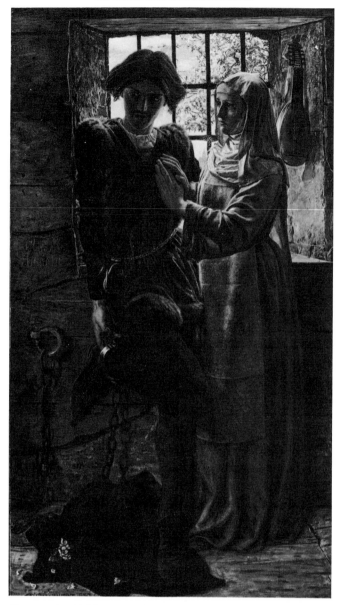

Figure 46. William Holman Hunt, *Claudio and Isabella*,
1850. Oil on canvas, 30½ × 18 inches. *(Courtesy of the Tate
Gallery.)*

was the outgrowth of the Pre-Raphaelite fidelity to real persons and things resulted in numer-
ous attacks by critics on the alleged physical ugliness and ungainliness of the figures. Thus, the
Athenaeum, for example, loathed the way the protagonists were depicted: ". . . Claudio is, after
all, but a vulgar lout, and Isabella never could have inspired the passion of Angelo. If Mr. Hunt
will not give us beauty, at least let him refrain from idealising vulgarity. . . ."[8] By contrast,
Stephens's remarks were much more measured and concerned with the different, intense
emotions of the pair and the meaning of the accessories around them: "Nothing more perfect
than the expressions of face or action can be conceived; he lolls against the wall with unnerved
wretchedness, anticipating fate; she, erect, startled from that faith which nature taught her to
hold in her brother; the gloomy, narrow prison, the bright sky, and rosy apple-blossoms
without, are all suggestive of deep feeling for the subject; he has carved the name 'Juliette'

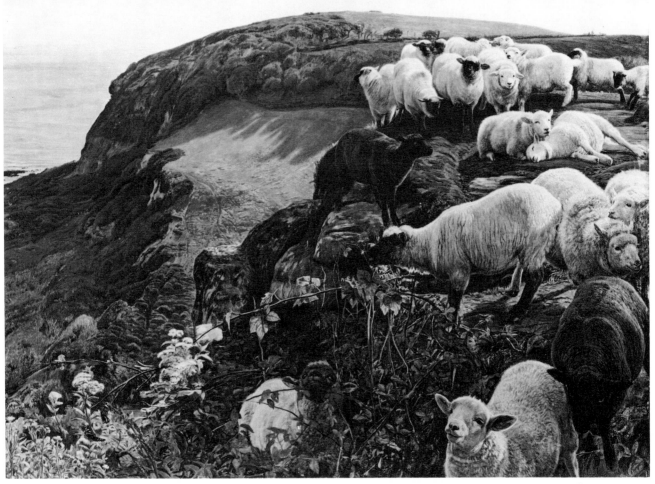

Figure 47. William Holman Hunt, *Our English Coasts (Strayed Sheep)*, 1852. Oil on canvas, 16¾ × 22¾ inches. *(Courtesy of the Tate Gallery.)*

upon the wall; perhaps he sees the sweet young face of her he has betrayed. . . ."[9]

Similarly, a somewhat atypical evaluation was offered readers of the *Crayon* for *Our English Coasts* (fig. 47), which was shown in London in 1853 and also caused quite a stir when included in the 1855 Exposition Universelle in Paris. Stephens referred to the "meaning" of the picture as "a satire upon the reported defenceless state of the country against foreign invasions"—but focused instead mostly on the innovation of the work as a piece of pure landscape.[10] The portrait of the grassy, jagged cliff was enthusiastically delineated, yet the author's real zeal was for the way ". . . the sunlight lying upon the place, was reflected into a whitish, hazy glare, which showed above and around it, though the cause was invisible,—a very subtle piece of observation, which we never remember to have seen painted before."

As had generally been the case in England, Stephens and other critics were fascinated by Hunt's decision to go on an extended sojourn to the Holy Land and the arid, dangerous desert and "unwholesome borders of the Dead Sea" to study first hand the landscape and realities of the East in order to transcribe them for his new own, quite personal, vision of religious painting. The *Scapegoat* ironically lived up to its name for Hunt, since even Ruskin seized upon it as "a total failure, . . . blinded by his intense sentimentality to the real weaknesses of the pictorial expression; and in the earnest desire to paint the Scapegoat, [he] has forgotten to ask

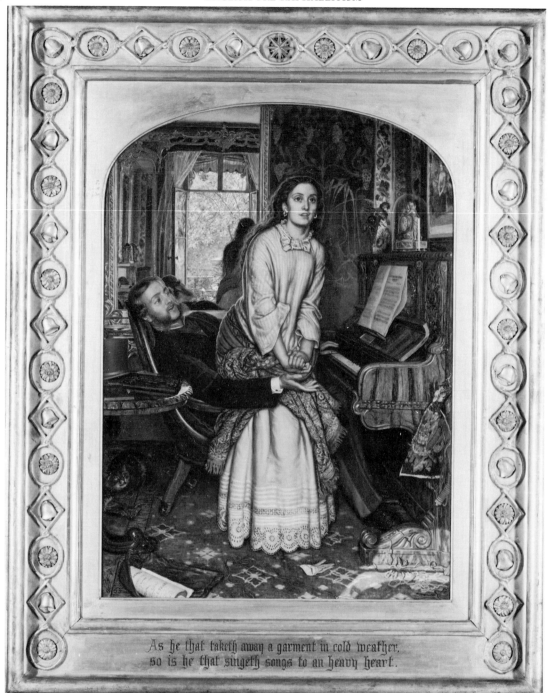

As he that taketh away a garment in cold weather,
so is he that singeth songs to an heavy heart.

Figure 48. William Holman Hunt, *The Awakening Conscience*, 1853–54, retouched 1856. Oil on canvas, arched top, 29¼ × 21¾ inches. *(Courtesy of the Tate Gallery.)*

himself first, whether he could paint a goat at all."[11] The *Times* and the *Athenaeum* also pronounced the canvas disappointing, the latter particularly affronted by the almost sacrelicious way that Hunt conceived of the animal as symbolic of "a type of the Saviour. . . . Here we join issue, for it is impossible to paint a goat, though its eyes were upturned with human passion, that could explain any allegory or hidden type."[12] In contrast to these tepid remarks, Stephens expressed his admiration for the picture in the *Crayon,* hailing the "masterpiece of

painting" of the animal's woolly fur and the background landscape as "a marvelous piece of powerful execution" and "a very subtle piece of observation." Thus, American readers were exposed to Stephens's opinion, at least, that this work should ". . . always be considered one of the noblest works of art produced by an Englishman."[13] Later Henry James would remember the almost terrifying effect of this painting on him as a youth visiting the exhibition: "Momentous to us again was to be the Academy show of 1858, where there were . . . still other challenges to wonder, Holman Hunt's 'Scapegoat' most of all, which I remember finding so charged with the awful that I was glad I saw it in company—*it* in company and I the same: I believed, or tried to believe, I should have feared to face it alone in a room."[14]

The greatest degree of enthusiasm was reserved, however, for *The Awakening Conscience* (fig. 48) and its pendant *The Light of the World.* Both had been exhibited at the Royal Academy in 1854, when Ruskin had offered an almost painfully loaded exegesis, item by item, of the symbolism of *The Awakening Conscience* and its theme of a moment of epiphany experienced by a courtesan in her bourgeois "gilded cage" with her lover. While the *Athenaeum* and the *Morning Chronicle,* for example, found the work to be esoteric and inappropriate, even repulsive, in tone, Ruskin defended the work in the pages of the *Times* as a superb pièce de théâtre: "There is not a single object in all that room, common, modern vulgar . . . but it becomes tragical, if rightly read."[15] Stephens had obviously been aware of Ruskin's spirited analysis when he wrote his column, for he, too, wrote about this interior as ". . . of one of those *maisons damnées,* which the wealth of the seducer has furnished for the luxury of a woman who has sold herself and her soul to him." The woman, whose dormant conscience has been aroused, seems almost felled by the power of her revelation, but her cad of a companion is oblivious to this and was characterized for readers as "a handsome tiger of the human species; heartless and hard as death," a ferocious beast who has succeeded in trapping his victim.[16] The critic of the *Photographic and Fine Arts Journal* also commented on the "fast young man and his mistress, . . . a painful subject—painful in its associations and its truthfulness." He remarked as well upon the agonized (original) expression of the woman, perspicaciously noticing her left hand, which ". . . has rings on each finger, save the marriage one, and that is vacant!"[17]

The text devoted to *The Light of the World* (fig. 49), however, was perhaps the most significant, since it was this painting that was seen in a replica in America in the 1857–58 exhibition. At the Royal Academy show of 1854 the work had elicited mostly adverse reactions, the *Athenaeum* proclaiming it an eccentric and mysterious failure, "The face of this wild fantasy, though earnest and religious is not that of the Saviour. It expresses such a strange mingling of disgust, fear, and imbecility, that we turn from it to relieve the sight."[18] Once again Ruskin leaped to defend Hunt's canvas, offering a heartfelt and minute exegesis of the pictorial symbolism—the barred door, the bat, the fruitless corn, the lantern of conscience, and so forth. Americans were given a preview of the work in the pages of the *Crayon* initially in a brief review of Jarves's *Art-Hints* in the August 1855 issue. Another reference appeared several months later in an article discussing the Brotherhood in March of 1856. The author was probably not Stephens, for there was criticism of Millais's *Return of the Dove* as well as Hunt's *Hireling Shepherd* and *The Light of the World,* the latter notable for the "decidedly ignoble" representation of Christ's face. However, in Stephens's article of the same year, the author concurred with Ruskin that this was decidedly Hunt's masterpiece to date, "for profound feeling, for executive power, or for intense judgment and knowledge of expression." Reiterating many Ruskinian points of analysis, Stephens also commented on the extraordinary effects of lighting and on the gothic design of the lantern, which to him was emblematic of ". . . that faith which is given the northern nations to keep. . . ." While some reliance on Ruskin's ideas was evident, Stephens (as was often true) did not shrink from positing fresh insights about the meaning of the work and of such aspects of the composition as the depiction of a "waste orchard," the thorns of passion and vestiture of Christ, and even the face of the Saviour, which to him was ". . . inexpressibly awful and

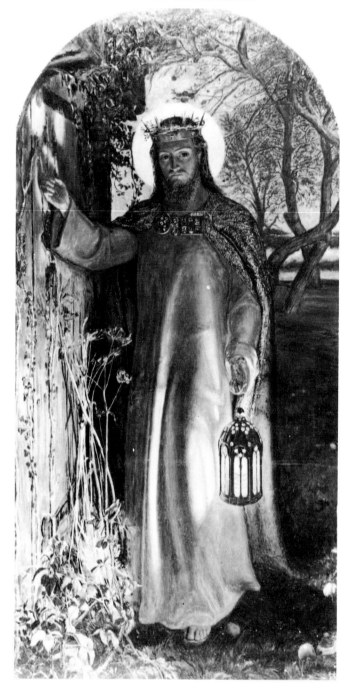

Figure 49. William Holman Hunt, *The Light of the World*, 1853–56. Oil on canvas, 19⅝ × 10⁵⁄₁₆ inches. *(Courtesy of the Manchester City Art Gallery.)*

beautiful; a royal dignity and a godlike mercy are blended upon it; it is not the face of an intellectual *man*, neither is it all softness and tender mercy, but a wonderful combination of expression and feature, suggestive of wisdom and goodness, and godlike judgment. . . ."[19]

As has been commented in the chapter of the 1857–58 exhibition, a small replica of *The Light of the World*, described by William Michael Rossetti as "the loftiest effort of Pre-Raffaelitism," traveled to America, where it received more attention from the press than almost any other

work.[20] Ruskin's exegesis was reprinted nearly in full in the *Knickerbocker, or New-York Monthly Magazine,* which approvingly wrote, "Happily for the reputation of the Pre-Raphaelite brethren, there is in the collection a small copy of Holman Hunt's noble and now-world-renowned painting, 'The Light of the World.' We cannot convey any idea of its beauty by mere description."[21] The *New York Times*—which seemed to despise nearly all the other Pre-Raphaelite canvases—also praised this painting. In *The Light of the World,* the *Times* wrote, "one knows not which most to admire, the splendor of the tones, . . . or the delicacy and tenderness of the sentiment, which would have moved the heart of Albrecht Durer. . . . This is one of the few Pre-Raphaelite pictures in which the artist and his 'elevated motives' do not immediately obtrude themselves between the spectator and the canvas; it is, of course, a piece of mere mystical symbolism, but it has the interest of true power."[22] Even the working-class men who installed the show at the National Academy of Design were enthralled by the canvas, apparently remarking that "the picture will light us up" even if the gas lamps failed to do so. Some affluent visitors registered a similarly strong reaction, one self-made and rich American remarking that "I'd rather have that picture than any other you've got, for there's something in it that's different to any other picture I ever saw."[23]

When the show moved on to Philadelphia, the response was somewhat mixed, the *North American and United States Gazette* expressing approval for "the ethereal beauty of this magnificent specimen. . . . It is a picture sufficient to immortalize ifs author."[24] Most critical reactions in that city were more damning, however, often settling into rather nasty declamations about the work's allegedly harsh color, defective drawing, and "moral blasphemy" in the depiction of Christ. The *Philadelphia Sunday Dispatch,* for example, told its readers to "Look at it without any prejudice. . . . Is not the color raw, hard, and unnatural? Is not the drawing out of proportion? The left arm is badly posed, and the figure stiff and inactive. The chief charm of the Pre-Raphaelites is the sweetness and sentiment they try to obtain; but it is the figure of Christ, of which this seems to be an attempt to portray him, full of sweetness, meekness, and spiritual benevolence? It is an abortive attempt to personify such a character, to say that such a picture presents us to anything like an idea of Him who was scoffed at, derided, persecuted. . . ."[25] In spite of such remarks it was in "the city of brotherly love" that the painting was actually sold, apparently through Ruxton's ministrations, for £ 300 sterling. The purchaser was John Wolfe, who was years later described in the *Art Amateur* as "a buyer whom dealers could depend on" to acquire "conspicuous gems" by artists as diverse as Bonnat, Meissonier, Cabanel, Hasenclever, and C. R. Leslie.[26]

Although *The Light of the World* did not appear in the Boston portion of the show, the work was nonetheless mentioned in the local press. While *Dwight's Journal of Music* described the work as "embodying more than any other picture in the collection, the personal and intense thought, the severe power of the New School," the general reaction was decidedly pejorative, an equal mixture of loathing of Ruskin's ecstatic endorsement of the picture with a general abhorrence of the visual effects caused by all the strange details and symbolism.[27] The critic for the *Christian Register,* for example, seemed ultimately more upset with Ruskin than with Hunt for his interpretation of Christ, stating that "It is a fine picture, tender and beautiful in sentiment and execution; but the word painting by which Ruskin describes it, and the substance, not the splendor, . . . presents a finer picture, and awakens us fully to the oft-repeated fact, that this enthusiast does not prepare his rhetoric in accordance with Pre-Raphaelite rules. The work fits into his mould, and the critic is satisfied." While other authors found fault with the expression on Christ's face, this writer commented in much milder terms, "Yet when the Savior of the world really stands and knocks at the door of the sinful heart, does not his face beam with more inspiration, more command, more tenderness than this gentle but human visage?"[28]

There was also a reference to this work in an essay by Adam Badeau that appeared in the

Vagabond in 1859. In addition to extensive comments on Pre-Raphaelitism in general, Badeau described how Hunt represented what he imagined to exist, not what he saw, in *The Light of the World*. This was a canvas in which "Pre-Raphaelitism dictated the flowers so elaborately drawn and colored, the curious workmanship of the Saviour's robes, and the general quaintness of treatment; but not the expression of the Christ, not the sentiment of the picture, not the really beautiful traits of the work."[29]

F. G. Stephens also discussed this work in his article on "The Idea of a Picture" for the *Crayon*. Comparing *The Light of the World* favorably to a masterpiece in the category of Bellini's sublime "Salvator Mundi," Stephens expressed a preference for the "direct and particular" explication of text in Hunt's interpretation. To him, "Hunt's subject seems of vital and individual interest . . ., while the other, grand and noble as it is, approaches rather to the universality of an allegory. . . ."[30]

The Light of the World also found favor in the pages of the *New Path;* and in a November 1863 article on "The Work of the True and False Schools" the painting was called "one of the noblest of modern pictures" and considered "another illustration of the variety of truths given in one picture by the new school. . . ." The author defended Hunt against the charge that he could only paint minutiae, singling out the distant apple tree as proof of his more suggestive, looser way of painting. Not surprisingly, "the apples of the neglectful orchard . . ., their rosy roundness clearly defined" appealed to the American writer, who also extolled the three kinds of lighting—starlight, dawn, and artificial—which "fill the picture with the most wonderful combination of color ever given in the same space to the world." The effects of illumination especially enhanced the naturalistic details: "the golden glow of the lantern light makes the leaves of the foreground weeds bright yellow on one side and deep purple on the other. It gilds the ivy leaves climbing over the door. . . ."[31] The fact that Hunt also painted these effects in the open air was important, but not as much as the principle of botanical accuracy itself.

Still another perspective was offered in a piece on "Three Representative Pictures" from the *Round Table* in the summer of 1864. A print of *The Light of the World* hung on the wall of the author, who hailed it as a true example of religious painting, a "product of faith" and a pictorial "conscience," which could purportedly move even a skeptic or agnostic to believe in it. Hunt was praised for having given spectators "the divine and supernatural in the real. . . . [His] picture of Christ knocking at the door is like a conscience. We find ourselves looking at it, questioning, and wondering if our imagination gives it the marvelous meek, wise, pleading, and all-comprehensive expression, or the painter has in truth realized the same. . . . Hunt's picture, full of symbolism, a thought in every inch of the canvas almost, exists in art as a great and permanent example of a modern man's faith and belief in Christ."[32] In a similar way, James Jackson Jarves thought *The Light of the World* showed the artist's "love of the picturesque symbolical."[33]

Hunt's masterpiece also apparently affected the way that modern European art was being taught at some American colleges. Professor John F. Weir at Yale favorably mentioned the work to his scholarly colleague Professor Salisbury, and in a letter of 1871, for example, said "It is strange that your letters should mention having made purchases for yourself which I have had in mind of late for the Art Department, i.e., the engraving of Hunt's 'Light of the World'. . . ."[34] Weir was also very impressed by Hunt's *The Finding of the Saviour in the Temple* (fig. 50), begun in 1854, and accordingly told his friend, "I thought of procuring a print of his 'Christ in the Temple' which I think is even a greater work, and in fact one of the most remarkable productions of modern times." However, Weir's hopes were thwarted by the unavailability of decent engravings of this work, and he lamented "of this there are no good prints remaining in this country, and the publication of the Arundel Society." This artist and teacher of art even included *The Light of the World* and *The Finding of the Saviour in the Temple* in his lectures, calling

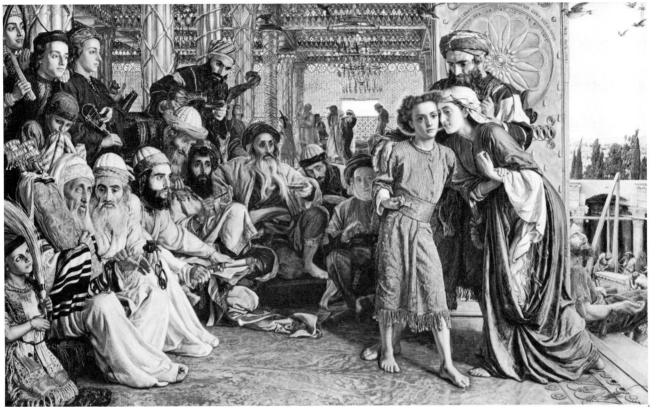

Figure 50. William Holman Hunt, *The Finding of the Saviour in the Temple,* 1854–55, 1856–60. Oil on canvas, 33¾ × 55½ inches. *(Courtesy of the Birmingham Museums and Art Gallery.)*

these "the leading illustrations in a lecture I have recently prepared, and it is gratifying to hear that such works address you with similar interest."

In terms of his most popular creation, despite the obvious dominance of the figure of the Saviour in *The Light of the World* and the way the gentle and searching expression of Christ preoccupied numerous critics, it seems to have been the microscopic botanical detail, the tangles of ivy and foliage, which most interested and influenced American artists. William Trost Richards (who may have seen the American show of English art in 1857–58 and was surely aware of Ruskin and Ruskinian painting), for example, attempted several Pre-Raphaelite exercises in a Huntian mode. Among these was a (lost) painting exhibited at the Pennsylvania Academy of the Fine Arts in 1863 and entitled *And Some Fell Among Thorns.* The title was derived from Matthew 13:7, the parable of the sower—"And some fell among thorns: and the thorns grew up and choked them. . . ." The subject itself obviously invoked that of Hunt's barred door to the soul, choked with weeds and thorns and neglected until Christ arrives to offer redemption.[35] Richards and other artists like Fidelia Bridges used the Ruskinian and Pre-Raphaelite "magnifying lens" to telescope close up botanical details into their compositions, combining emblematic with realistic visual effects. In Richards's case, the Biblical approach to the "naturalistic nook" both looked and even sounded from its title as if it has been transplanted from a corner of *The Light of the World.* John La Farge was actually to "transplant" the image of *The Light of the World* to his own work, placing an embossed engraving of Hunt's famous painting on the gilt cover of his 1913 book entitled *The Gospel Story in Art.*

While Hunt's "finished study for the larger picture" of *The Light of the World* found a new home in Philadelphia and many admirers among artists, a replica of his *Eve of St. Agnes* (fig. 51)

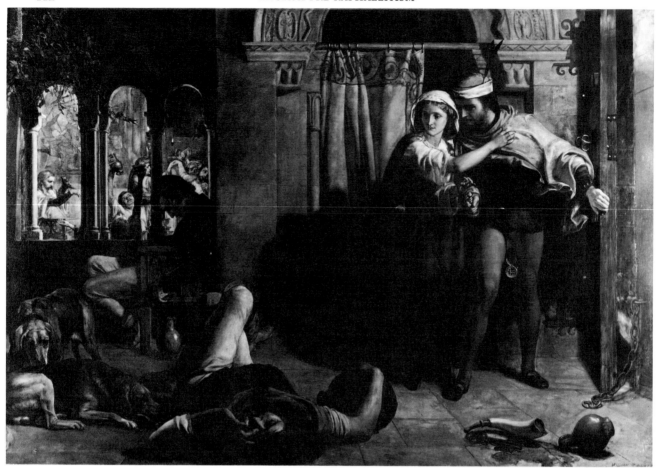

Figure 51. William Holman Hunt, *The Flight of Madeline and Porphyro from the Drunkenness after the Revelry (The Eve of St. Agnes)*, ca. 1848. Oil on canvas, 30½ × 44½ inches. *(Courtesy of the Guildhall Art Gallery, London.)*

appeared in all three cities on the American circuit in 1857–58. William Michael Rossetti had deemed this version of *The Flight of Madeline and Porphyro During the Drunkenness Attending the Revelry* (its full title) superior to the original, but there was relatively little notice taken of the picture, especially in New York. In Philadelphia the reaction was mixed, the more positive reading of the work as "a reduced copy . . ., a fine painting [that] cannot fail to attract general attention" appearing in the *North American and United States Gazette*.[36] Yet the *Philadelphia Sunday Dispatch* was definitely negative in its assessment of *The Eve of St. Agnes* as "really contemptible in comparison with the works of other painters of less reputation," being particularly annoyed by the "badly drawn leg of the principal figure" and also with "the barbarous color, [that] renders the picture anything but attractive."[37] The same pattern of reaction occurred in Boston, where the *Boston Daily Courier* paid the work some "left-handed" compliments by comparing it with Madox Brown's *King Lear and Cordelia*. In a more positive vein, *Dwight's Journal of Music* remarked that this replica was "one of the most interesting features of the exhibition. . . . But the scope of Mr. Hunt's conception is confined to the mere physical fact and circumstance of the elopement. He disregards all emotion save that of fear of detection. . . . The color of the picture challenges some attention and its originality, and also admiration for its partial beauty, especially in the background and draperies. . . ."[38] It was also this painting that partially inspired Badeau's essay on Pre-Raphaelitism, for the author admitted to his readers that "After studying 'The Anti-Puseyite Lady' and 'The Eve of St. Agnes' till I thought myself fully aware of their

aim, and able to appreciate their execution, I went the other day to Mr. Bryan's gallery, to compare the real Pre-Raphaelites with their imitators."

Interestingly, *The Eve of St. Agnes* reemerged in New York in 1859 at the *Second Exhibition in New York of Paintings* that Gambart had organized at the National Academy of Design. The work curiously only appeared in the second edition of the catalogue for that show, perhaps a later addition to the contents. It was offered for sale in New York, and the Boston Athenaeum's annotated copy of its 1858 catalogue reveals that at one point it was marked "sold," and this notation was then crossed out and subsequently changed to a cryptic "gone home." The latter suggests that possibly Hunt withdrew the painting before the exhibition closed, with Gambart perhaps convincing him the next year to try again with an American audience. In 1859 the replica was lent by John Miller to the Royal Scottish Academy; in the same year Gambart purchased the large version of the painting at Christies and may have thus had considerable financial incentive to include this picture rather than the "reduced copy" in America.[39]

There did not seem to be much critical reaction in particular to *The Eve of St. Agnes* in the 1859 show, but there were numerous articles in the New York press and various art journals that offered a general overview of the exhibition. The French portion of this exhibition usually received more praise, and even the *Crayon* in its December 1859 review of this exhibition focused only on the works of Troyon, Gerome, Bonheur, and the like. The *Cosmopolitan Art Journal*, on the other hand, did point out the eminent British representatives in this dual venture: ". . . the great Sir Edwin Landseer, Millais, Holman Hunt, J. F. Herring, Linnell, Poole, Solomon, Stanfield, Wallis, etc." Moreover, the impact that these foreign pictures had on American artists was reinforced for readers: "We rejoice at the exhibition of these works in our midst, for the double reason that they expand the popular knowledge of art greatly, and give our own artists something for study and emulation. A wonderful progress has the public made, in the last five years, in its capacity of judging properly of art; the exhibition of superb foreign pictures here has had very much to do in the matter."[40]

While it was evident that no subsequent work by Hunt could attain the degree of popularity and publicity in America that *The Light of the World* had, a few other paintings were mentioned or exhibited in the 1860s and 1870s, in particular. The *Crayon*, for example, in July of 1860 commented on how much appeared in the British press on Hunt's *The Finding of Christ in the Temple*. Mostly negative evaluations were included, leading the editors to state that "From what we have read in the puffs of the same order, we fancy 'The Finding of Christ' to be full of displeasing surprises in the way of labored details; of some significance, it may be, in relation to patience and perseverance, but none in relation to genuine Art."[41] Lest it sound like the *Crayon* was merely endorsing the English viewpoint without any access to the picture, the editors also justified their response by reprinting an extract from the *Tribune* noting how an American, "Mr. Young, of *The Albion*, is rather severe upon Holman Hunt's 'Finding of Christ in the Temple,' which is extolled in the English papers as a miracle of art. It has been stated that this last picture was purchased by the great London picture dealer for $25,000, and it has since been stated that three Manchester men had subscribed $40,000 toward purchasing it for the new Free Art Gallery in Manchester.' "

While the *Crayon* focused in 1860 on a religious painting, a few years later the *Round Table* commented in its June 1864 issue on the exhibition in London of *The After-Glow in Egypt* (fig. 52), offering little more than a description of the life-sized Fellaheen girl who posed in a field with a ripened sheaf of corn on her head.[42] More mention of the work appeared in the *New Path* in 1865, where the author spoke glowingly of the colors ". . . brilliant enough for sunshine, yet there are no shadows towards you" and the admirable merging of the hues of the grass and sky with "the soft, mysterious forms of the vegetation."[43] When this painting was shown in 1877 in London, Henry James once again expressed the same dislike of Hunt's work which he had voiced about *The Light of the World* and used this work as a pretext for a diatribe about the artist:

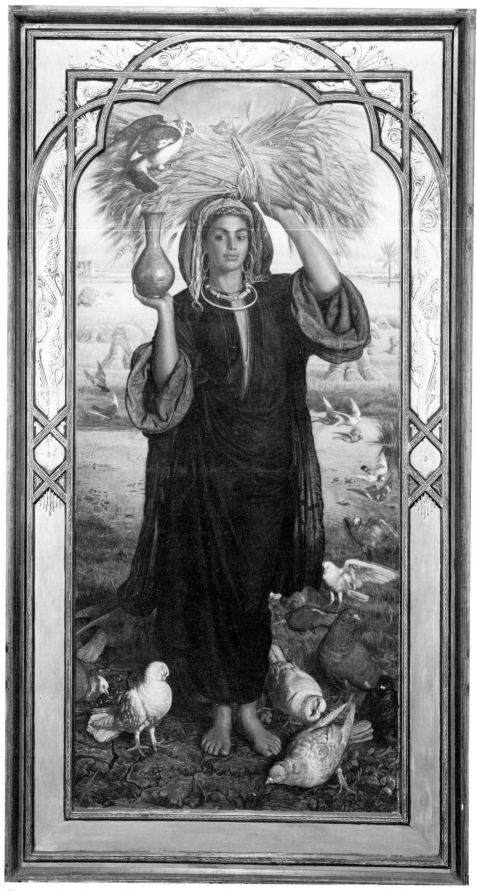

Figure 52. William Holman Hunt, *The Afterglow in Egypt*, 1854–56. Oil on canvas, 73 × 34 inches. *(Courtesy of the Southampton City Art Gallery.)*

"Neither will I stop longer before Mr. Holman Hunt's *After-Glow in Egypt* than to pay my respects to its beauty of workmanship, and to wonder whence it is, amid all this exquisitely patient labour, that comes the spectator's sense of a singular want of inspiration. Do what he will, Mr. Holman Hunt seems prosaic."[44]

In 1864 some reviewers also alluded to Hunt's *London Bridge* composition, the *New Path* expressing some misgivings about the subject but liking "the effect of moonlight on London smoke."[45] A rare suggestion that the ever-serious Mr. Hunt had a lighter side was sustained, in contrast, in the 1864 *Round Table* commentary; the author speculated that "in this picture Mr. Hunt makes his first appearance as a humorous painter, and is said to have delineated modern London character with admirable effect."[46] The *Round Table* maintained a constant interest in this artist, advising readers in 1866 of Hunt's next departure for the East to produce more art "in new and fertile fields of beauty and romance" and also noting that his *Festival of St. Swithin* (fig. 53) was a remarkable composition of a dovecot "of disconsolate pigeons sheltering among its ledges" with the rendition of the "plumage of the birds and accessories . . . said to be superb."[47] The still life elements of the birds' brilliant feathers and their treetop nest would have had special appeal to American artists like John William Hill and his son John Henry Hill, both of whom produced myriad images of birds' nests in a natural setting.

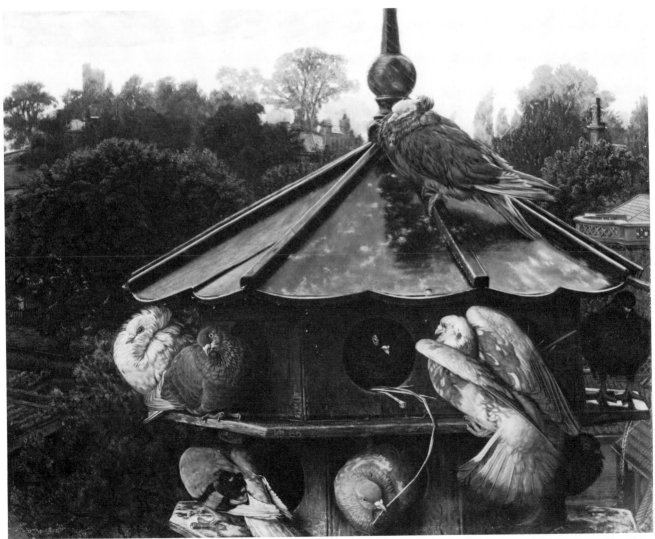

Figure 53. William Holman Hunt, *The Festival of St. Swithin*, 1866–75. Oil on canvas, 28¾ × 35⅞ inches. (*Courtesy of the Ashmolean Museum, Oxford.*)

In 1866 a critic for the *Nation* used his review of the Fifth Exhibition of French, English, and Flemish paintings as a way to register his dissatisfaction with the sort of British art that was being exhibited in America: "While we set a high value on these exhibitions, we regret that so few English pictures are included in the collections that Mr. Gambart sends us."[48] Perhaps Gambart had learned his lesson with the 1857–58 "fiasco" and its lack of commercial appeal. At any rate, there was "not a Whistler nor a Rossetti, but for the Artists; Fund loan collection; . . . not a Byrne Jones [*sic*], a Holman Hunt, a Hook, nor a Wallis at all; that seems to be the way the account stands on the side of the importer of pictures, while on the other side is shown a large number of buyers ready to buy whatever they are told they ought to like."[48]

Perhaps it was for those reasons—the lack of good original paintings by Englishmen and also the possibility for American patronage—that Hunt, like his colleague Millais, also lent a painting to the selection of English pictures destined for the Centennial Exposition in Philadelphia in 1876. Among the other contributions were Luke Fildes's *Applicants Seeking Admission to the Casual Ward,* William Powell Frith's *Railway Station,* Holl's *The Lord Gave, the Lord Hath Taken Away* and *The Village Funeral,* a few works by William Quiller Orchardson, a landscape by John Brett, and *The Convalescent* and five other contributions by Lawrence Alma-Tadema. In the scores of guidebooks to the fair there were few specific references to Hunt's entry, *A Self-Portrait*

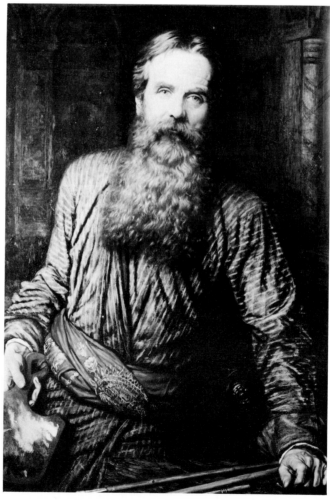

Figure 54. William Holman Hunt, *Self-Portrait,* 1875. Oil on canvas, 40¾ × 28¾ inches. (*Courtesy of the Uffizi Galleries, Collection of Self-Portraits—Firenze.*)

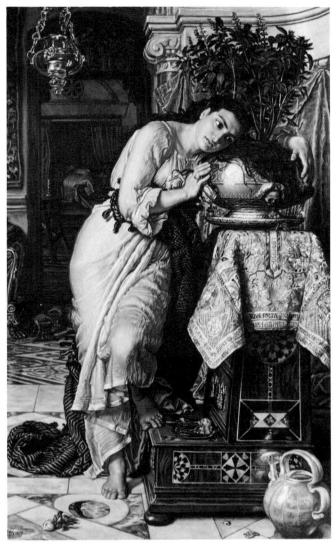

Figure 55. William Holman Hunt, *Isabella and the Pot of Basil*, 1867 replica. Oil on canvas, 23⅞ × 15¼ inches. (*Courtesy of the Delaware Art Museum, Wilmington.*)

(fig. 54) of 1875. And while portraits of Leighton and Millais by G. F. Watts and others by G. H. Boughton and G. A. Storey were mentioned, Hunt's picture was typically and curtly referred to as ". . . a curious portrait of himself. . . ."[49] Another American writer offered a different explanation for the dearth of British art, pointing out the apparent difficulty that English artists had penetrating the art market in this country: "We do not remember seeing one label 'sold' on an English work of art, in striking contrast to other nations' exhibits where the ambition seemed to be that the owner or representatives might have the *éclat* of truthfully attaching a 'vendue' label upon a painting."[50]

At the same time that his self-portrait was displayed in Memorial Hall, Hunt also apparently lent from his own collection *Isabella and the Pot of Basil* (fig. 55) to a special Centennial Loan Exhibition organized by the Metropolitan Museum in New York. This work was probably the replica that was apparently later purchased by John Taylor Johnston, an American railroad magnate who had become a millionaire by age twenty-eight. New York newspapers pronounced the exhibition a popular success, but there were few specific judgments offered of

Hunt's work, so it can only be surmised how this painting, exhibited in its larger version at Gambart's in 1868, affected American viewers or artists. In the fall of 1876 a writer for the *New York Tribune* reported on the forthcoming sale of the Johnston collection, listing *Isabella and the Pot of Basil* among the dozen or so foreign paintings (including Turner's *Slave Ship*) that were "perhaps the most important" of the owner's holdings. Certainly Americans knew and admired John Keats's poem of the same title, and works such as William J. Hennessy's *Mon Brave* (see fig. 30) of 1870 seem to allude to the poem and perhaps also to Hunt's composition.[51]

In the same decade some American artists also had direct contact with Hunt and his work; among these was John Ferguson Weir, who visited Hunt in Florence apparently after the death of Fanny Waugh Hunt in late 1867. Weir remarked in his memoirs that "Holman Hunt was then in Florence, on his way to the East to make studies for his 'Shadow of the Cross.' " This was undoubtedly *The Shadow of Death* (fig. 56), a rather startling religious picture which the artist had begun in the Holy Land in 1869 and ultimately completed in London in 1873. Weir then described the circumstances of their meeting as well as Hunt's hospitable reactions:

> Launt Thompson and I were asked to call on him at his studio where we found a young American girl sitting to him. As he laid aside his palette he asked us to dine with him at a trattoria on the edge of the town toward Fiesoli; it was quite a little walk and as we sat at table our host seemed fatigued and depressed. But presently he roused himself and spoke of a portrait by Raphael he had seen that morning in the Uffizi: "A beautiful portrait by one of the greatest of portrait painters!" he added. But Mr. Hunt! I replied, I thought a "Pre-Raphaelite" felt that the light had gone out with the painters of that time? "Spiritual light!" he replied; adding what seemed to imply that the estimates of youth are

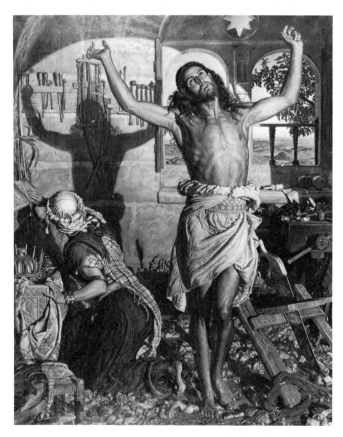

Figure 56. William Holman Hunt, *The Shadow of Death*, 1870–73 replica. Oil on panel, 40 × 31½ inches. *(Courtesy of the Leeds City Art Gallery.)*

not to be taken too seriously. Then he went on to speak of the realism of some of Dante's backgrounds in his great poem, especially in the *Inferno,* and seemed satisfied in his own mind that he had discovered one or two of these for himself in the neighborhood of Florence.[52]

Weir and his friend not only discussed Pre-Raphaelitism with Hunt; they also commented about how Hunt's canvases generated a sense of "medieval art and feeling" and even worried about his apparent state of emotional depression at the time.

In the late 1870s this same painting seen by Weir subsequently traveled to America, to the Williams & Everett Gallery in Boston and possibly elsewhere as well.[53] In England, *The Shadow of Death* had elicited mixed reviews, the *Times* voicing its approbation of Hunt's earnest toil yet also conveying some degree of latent censure in its comments that "Every detail . . . is painted with a determined and equal completeness. . . . In executing it he has only one rule to follow: paint everything in the same way, with the same insistence, and the same care. Leave the relative importance of the things painted to assert and settle itself."[54] When Hunt's picture was shown in Oxford, it was excoriated by some Church of England members as blasphemous. However, in the North of England, *The Shadow of Death* found approval and acclaim among the working classes in particular, much as had been the case with the reception of *The Light of the World* by everyday laborers in New York.

It is unclear who wrote the pamphlet accompanying the work when it was shown in Boston, but it seems to have been derived from one that first appeared in England. Most of the prose was highly descriptive, chronicling various aspects of the moment when Christ ends his day's labor in a carpenter's shop (in the tradition of Millais's early *Christ in the House of His Parents*) and rises both to stretch and to unintentionally (but prophetically) foreshadow the crucifixion in quite a literal way. Mary's examination of the gifts of the Magi was viewed as an act that both alluded to the annunciation and suggested her foreknowledge of her son's death. Even more attention was given to how much trouble the artist went to in Nazareth to locate a real carpenter's shop, find a suitable model, and ascertain the appropriate tools and garments for the picture, Hunt thus admirably availing himself ". . . of all the modern research into Oriental life and customs."[55]

In addition, the painting elicited a lengthy editorial in the pages of a leading American art magazine, the *Aldine,* in late 1879. The author, noting the great controversy the work generated, admired the exhaustive technique and research that were such hallmarks of Hunt's mode of realism. After offering an extensive description of the subject, however, he pronounced the painting "materially a waste of noble powers; it neither reaches the true nobility of the great subject, nor promises to be remembered among those works which have brought the Divine Being so much nearer the fancies of man than it could have been brought without the pictorial art."[56] A list of complaints was then registered, ranging from the poor choice of moment for "a grand expression," the "two fatal improbabilities" of the alleged hard yellow tone and dry realism, and the perilous characterization of the Saviour as an ordinary Arab who is "pinched and lip-drawn" and not a suitably ennobled embodiment of the biblical "God-Man." Furthermore, by subtitling this article "A Picture to Fight Over," the author added the *Aldine* as an American "contribution to the inevitable literature of the controversy."

In the 1880s there was still some interest in Hunt in America, but this was waning and at times much more negative than had been the case in the past. Henry James continued to harp on Hunt's supposed flaws, attacking his contribution to the 1882 Grosvenor Gallery in venomous tones: ". . . I suppose it took Mr. Holman Hunt as many months to bring his garish 'Miss Flamborough' . . . to its extraordinary perfection of hideousness."[57] The *Andover Review,* for example, judged Hunt rather harshly in an 1884 article, stating that—in spite of his "uncomprising realism [he] . . . cannot rank high: but his moral earnestness, candor, and conviction command our reverence and impress us through his works." Hunt's tendency to

paint a rather intense, even convoluted, type of figure was also a valid point for criticism: "The faces he paints are never vapid, but rather over-intense in expression, and there is great beauty of detail in his pictures, though these details often refuse to fall into the ranks of orderly subordination."[58] Moreover, the *Art Amateur,* for example, informed its readers that in an 1886 exhibition of 300 English watercolors organized by Henry Blackburn and held in Boston "there is a landscape by Holman Hunt, perhaps twelve inches by eight, catalogued at $12,000, which carries conviction that his fame and prices are arrant humbug; any student in the public art schools would be discredited by its crude colors, clumsy drawing, and utter lack of truth or charm."[59]

Another commentator on Hunt in the 1880s was the illustrious author and critic Clarence Cook, who refrained from attack by focusing on how Hunt had chosen not to swerve in his career "from the line he marked out for himself on his first appearance. He paints the same subjects and he paints them in the same way." Characterizing him as "pre-eminently a religious painter," Cook predictably singled out *The Light of the World* as a "singular work" in which Hunt "had endeavored to secure an absolute realism. . . . There was an earnestness and conviction of deep sincerity in this picture that won for it a warm welcome with the English public, and . . . it remains . . . Mr. Hunt's best work." There was both admiration and mild censure in Cook's assessment, and he placed in a similarly scrupulous category of detail and esoterica *The Finding of Christ in the Temple, The Scapegoat,* and *The Flight into Egypt,* in all of which there is "the same striving after the union of the mystic and the real, the same want of power to satisfy the mind."[60]

These evaluations of the 1870s and 1880s were harsh words for a man who had earlier earned such acclaim and was still—in spite of weakening eyesight by the 1890s—earnestly painting, exhibiting in London at the Fine Art Society in particular, and writing about the Pre-Raphaelite Brotherhood. American interest in him had thus seemed both to falter and to sour somewhat by the 1880s, peaking in essentially the same period—the mid-1850s through the late 1860s—that was also critical to the reception of Millais. By the end of the century the assessment of Hunt did not radically alter, and *New Path* writer Russell Sturgis in 1900 singled out Hunt as a solitary man who ". . . was in his maturity the same devoted follower of the fixed principles of his Brotherhood as he was at twenty years of age."[61] Only a few pictures by Hunt had ever been shown in this country, and even with the huge audiences that presumably saw his *Self-Portrait* in the Centennial or *Isabella and the Pot of Basil* in 1876, it was always *The Light of the World* that—as was the case to some extent also in England—remained the salient image in the collective American consciousness.

6

Dante Gabriel Rossetti: Understood and Misunderstood in America

Iт was once again the *crayon* that provided americans with some of the first responses to dante Gabriel Rossetti's art, notably in F. G. Stephens's 1856 article in a series entitled "The Two Pre-Raphaelitsms." In his third article only two paragraphs were initially devoted to Rossetti, this brevity justified by the author's explanation that "The works of . . . Rossetti which are known to the public are but few; but, as we said, at the first, even those would place him in a most honorable position. . . ."[1] His "innumerable water-color pictures" were mentioned and commended for their exquisite design and pure coloring, "but it is useless to treat of them, as they are almost inaccessible to the world; in the portfolios of private collectors, and far more even than this, the subjects are such as require almost a special education, and a most rare and elevated description of mind to appreciate properly, or at least fairly describe. The subjects he chooses are of the subtlest and most delicate order, almost psychological paintings in fact." Such remarks obviously helped to create a mystique about Rossetti, a sense that his works were esoteric and enigmatic, this in spite of the arcane subjects often treated (and sensitively interpreted by the *Crayon*) by Hunt and Millais. In this first reference to Rossetti's works, only two canvases were cited, *The Girlhood of the Virgin* (fig. 57) and *The Annunciation (Ecce Ancilla Domini)* (fig. 58). The subject of the former was rightly perceived as a scene of Mary's youth in which she was surrounded by symbolic objects including a vine outside her window (emblematic of the true church), a tall lily (symbolic of her virginity), a pile of books with the titles of "chastity" and other virtues, and other accessories which communicated "happiness, repose, and purity." While the head of the Virgin was hailed for its beauty, *The Annunciation* as a composition was criticized overall for its "very peculiar qualities of color," especially the brilliant white effect of the robes of the Angel and Mary and the walls and floor of the room. The only touch of color—crimson—emanated in the flames from the Angel's feet. The awed and startled Virgin was, like her counterpart in *The Girlhood,* seen as sensitively delineated; "her face is most delicately beautiful and its expression perfect."

This was not the sole opportunity to read about Rossetti in the *Crayon,* however, and in the concluding two-part article of this series other pictures—especially watercolors with Dantean

Figure 57. Dante Gabriel Rossetti, *The Girlhood of Mary Virgin*, 1849. Oil on canvas. 32¾ × 25¾ inches. *(Courtesy of the Tate Gallery.)*

themes—were discussed in considerable detail. Rossetti's seemingly personal identification with Dante and his preference for Dantean tales "of the most exquisite description, as respects psychological value" met with approval from the critic, who wrote effusively about the water-colors *Giotto Painting Dante's Portrait* and also *Dante Rebuffed by Beatrice*.[2] The latter was a typical "Vita Nuova" subject, one in which a heart-stricken Dante was contrasted with a cold Beatrice and an angelic choir of attendants, the overall effect so "charming" and "expressive" that the critic felt unable to articulate his admiration for the work.

In addition to these works, the author singled out stories involving the chivalric adventures of Sir Lancelot and imaginary historical or literary themes like *Hist! said Kate the Queen* (fig. 59) for their archaistic, neo-medievalizing appearance. In the latter, the protagonist was described as having "long hair of pale gold [that] lies like a veil over her white surcoat and pale violet robe; she checks with her hand the prattling of her waiting damsel, and listens with eyes expressive to the singing of the youth. . . ."[3] There was also approbation reserved for the saga of Paolo and Francesca da Rimini, their tale of illicit love communicated by a trembling "first fiery kiss" in an atmosphere of "fiery rain . . . and hopeless gloom" that was "terribly sad." Romantic dangers and erring lovers were also inherent elements in the tale of *Hesterna Rosa* (fig. 60), which appealed to subsequent American critics and journals and was, despite its inspiration from a dramatic source, hailed as "an admirable 'modern instance,' a subject of subjects, one applica-

Figure 58. Dante Gabriel Rossetti, *Ecce Ancilla Domini (The Annunciation)*, 1850. Oil on canvas, 28⅝ × 16½ inches. *(Courtesy of the Tate Gallery.)*

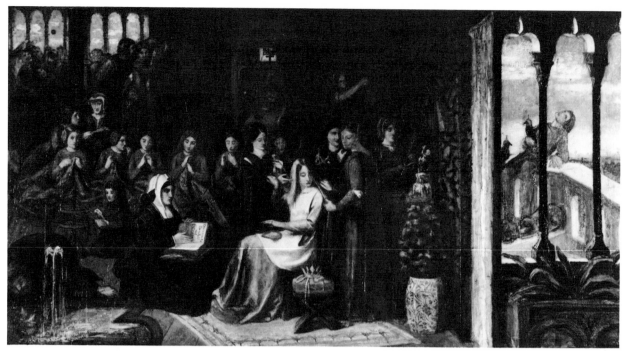

Figure 59. Dante Gabriel Rossetti, *Hist! said Kate the Queen*, 1851. Oil on canvas, 12¾ × 23½ inches. *(Reproduced by permission of the Provost and Fellows of Eton College.)*

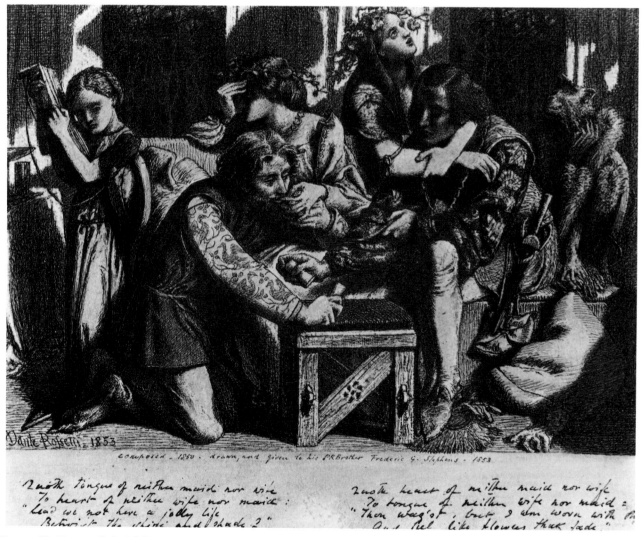

Figure 60. Dante Gabriel Rossetti, *Hesterna Rosa*, 1853. Pen and ink, 7½ × 9¼ inches. *(Courtesy of the Tate Gallery.)*

ble to all time, and full of interest and most sorrowful value." The symbolism of the contest between virtue and vice was well understood and explained, the main male gambler called "sickeningly grotesque" with a "feverish gloat . . . and a look of satiric vileness." The two mistresses were also deemed meritorious, their lugubrious expressions contrasted with the lasciviousness of their male companions, a contrast also heightened by the juxtaposition of "the grace of the musician . . . with the obscenity of the ape. . . ." Rossetti was also favorably judged for his manipulation of light, shade, and texture, in this watercolor, in such a way as to create "the truth of a flare of hot light to perfection. . . ."

There were also biblical or religious subjects described in fulsome and fervent detail, including *The Celebration of the Passover in the Holy Family*, which was praised for its complex and pervasive symbolism of the fresh vine, the dead sticks, the well, the threshold, all of which became "a perfect illustration of the mystic meaning of the sacrifice of the Passover, and the realization of the promise it referred to." Rossetti's execution, which some English reviewers had criticized at times, was pronounced by the *Crayon's* correspondent to be exquisite: "the drawing is beautiful, delicate, and the colors of skillful and new combinations. . . . The expressions are of the pure and holy noble order which befits the subject . . . [all set] . . . in a certain mysterious dreariness . . . which has a dim rich brightness about it. . . ." In addition, drawings such as the design for *Mary Magdalene at the Door of Simon the Pharisee* and *The Virgin in the House of St. John* (fig. 61) were graphically delineated for readers, the latter showing Mary in another mysteriously dim chamber as she rose from her woolcombing tasks to undertake trimming a lamp.

Figure 61. Dante Gabriel Rossetti, *Mary in the House of St. John*, 1858. Watercolor, 18 × 14 inches. (*Courtesy of the Delaware Art Museum, Wilmington.*)

As was the case with other Pre-Raphaelite brethren, Americans had more opportunity to read about the group than to see original pictures by them, and real works by Rossetti "in the flesh" (or, it is tempting to say, in their fleshliness), remained a literary experience only for several years. The August 1857 issue of the *Crayon* reported that Rossetti would be represented in the 1857–58 exhibition, but this was only one of several promises that were not kept. As has been pointed out in the chapter on the 1857–58 circuit of English art that traveled to three American cities, the dearth of works by Rossetti was, as in the case of Millais, generally noted and lamented by the critics. The *Atlantic Monthly,* for example, in early 1858 analyzed most of the "Pre-raffaelite school," remarking that "William Holman Hunt and Dante Rossetti are great imaginative artists, and will leave their impress on the age."[4] Aware of this potential audience in the United States through his brother and probably other sources, Dante Rossetti apparently decided in the summer of 1858 to use Ruskin's friendship with Charles Eliot Norton of Harvard University as a professional springboard of sorts. Norton had evidently first seen works by Rossetti in the home of John Ruskin and wrote to a friend about the "beautiful drawings by Burne-Jones and Rossetti" that were on the walls.[5] He also went with Ruskin to the Pre-Raphaelite exhibition at 4 Russell Place in 1857 in London; some of the works in this show (including Madox Brown's watercolors of *Jesus Washing Peter's Feet* and *The Prisoner of Chillon*) later traveled to the American 1857–58 exhibition. Rossetti was represented by four watercolors, two of which were *Mary in the House of St. John* and *Portia.* Norton was especially impressed by Rossetti's interpretations of Dantean themes and accordingly reported to a friend on the exhibition in a July 1857 letter: "Many of the pictures are interesting, some of them are beautiful, many of them full of thought, and as careful, exact studies from nature, some of them are hardly to be surpassed." He singled out Rossetti as his favorite, stating that "Rossetti's are by far the best, for in force and beauty of colour he stands above the others, and also in depth and delicacy of imaginative power. Among his pictures were those of 'Mary, the Mother of Jesus' (probably *Mary in the House of St. John*) and the 'Mary Magdalene' that we saw at Ruskin's last year, the picture of Dante's vision at the time of the death of Beatrice, and, as a companion piece to this, the anniversary of the death of Beatrice representing Dante becoming aware of the presence of the persons who had been watching him as he drew an angel upon certain tablets."[6]

As a result of this encounter with Rossetti's art, Norton met the artist through Ruskin and shortly thereafter commissioned both a portrait of his artistic mentor and also a watercolor. When a year passed with no sign or either painting and no word from Rossetti, Norton wrote to inquire about these things. Rossetti used this as a chance to send a plea to Norton both to forgive his tardiness and to try to interest him in buying *Before the Battle* (fig. 62). In this letter of July 1858 Rossetti claimed that this watercolor was a superior one and with some audacity pressed for an immediate reply from his patron. Rossetti asked fifty guineas for the work and admitted that his labors on the murals for the Oxford Union had "resulted in leaving me a little aground."[7] He also alluded to his brother's efforts on behalf of the American exhibition, but did not explain why he failed to send any pictures to this project: "My brother has largely been occupied with duties in your neighbourhood [Boston], and I suppose the English Exhibition may be considered *un fait accompli.*" Norton apparently assented to the purchase of *Before the Battle* and sent payment, but four years later Rossetti had still not finished the work, perhaps because Ruskin had rebuked him for "forcing" an inferior picture on Norton. Ruskin, although applauding much of Rossetti's work (and arguably even supporting him to some degree through his stipend for Elizabeth Siddall's watercolors), nevertheless recognized how unethical Rossetti could be by exploiting Norton and others like Miss Heaton and Thomas Plint to the limits of their patience by procrastinating wildly about the completion of works they had commissioned. Norton's daughter recalled later that, as a result of these circumstances, Ruskin, ". . . seeing the picture Rossetti had intended for Norton, and thinking it did not represent

Figure 62. Dante Gabriel Rossetti, *Before the Battle*, 1858. Watercolor on paper mounted on canvas, 16⅝ × 11 inches. *(Courtesy of the Museum of Fine Arts, Boston. Purchased, Picture Fund, 1912.)*

Rossetti so nearly at his best as he would have him known, chose another painting of Rossetti's—a scene from the 'Vita Nuova'—and sent it to Norton as a gift."[8]

In spite of Rossetti's constant delays, Norton remained a faithful friend and patron and endured still more abuse from the artist. Norton had at one point bought Siddall's *Clerk Saunders*

(see fig. 18), but when Rossetti later asked him to return it, Norton did so, hoping that this gesture would ensure the artist's completion of a portrait of Jane Burden Morris that he wanted. Years later—in the spring of 1869, Norton took the novelist Henry James to the artist's residence at Cheyne Walk, and James later remembered this visit with "the great (if great!) and strange and more or less sinister D. G. Rossetti, whom Charles was in good relation with, difficult as that appeared already then to have become for most people."[9]

Another American who befriended Rossetti and ultimately became quite a confidante and advisor was William J. Stillman, who knew most of the Rossetti family members quite well along with many others in the Pre-Raphaelite circle. Late in his life, Stillman wrote his autobiography, and there he reminisced not only about Rossetti's art, but also expressed his latent guilt for having introduced the insomniac artist, ". . . excitable, and possessed by the monomania of persecution . . . to try chloral," the drug that ultimately wrought so much damage on the painter's health.[10] In judging his friend's painting in 1898, Stillman expressed considerable admiration for Rossetti and his early watercolors in particular: "Rossetti, like Turner, stood alone. He even less resembled all his predecessors, and has been followed by no disciples. For felicity of imaginative design, nothing in art surpasses some of the work of his youth—such drawings, for instance, as his *Cassandra, Hamlet,* and the *Magdalen's First Sight of Christ;* or, in chromatic brilliancy and weird harmony, some of the water-colour drawings, all drawn to the minutest details from imaginative vision."[11] Stillman did indicate some reservations about Rossetti's lack of technical knowledge, but he nonetheless greatly praised his compositions, originality, and color, comparing him to Tintoretto. In his *Autobiography* Stillman also hailed *Hamlet and Ophelia* (fig. 63) and other works as "designs of unsurpassed power, eminent in all the great qualities of design, harmony of line, invention, and dramatic intensity."

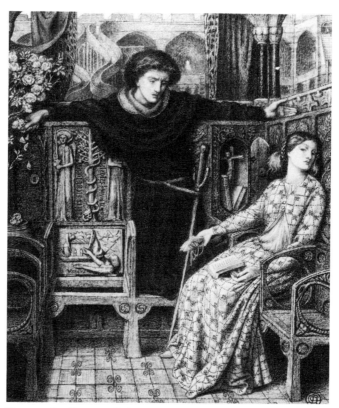

Figure 63. Dante Gabriel Rossetti, *Hamlet and Ophelia,* 1858. Pen and ink, 12 × 10½ inches. *(Courtesy of The British Museum.)*

These early works especially ". . . had all the purity and intensity of feeling of the primitive Italians."[12]

Despite the enthusiasm of men like Norton and Stillman, it was not until the 1860s that actual paintings by Rossetti finally came to American shores, although his name was known in the *Crayon* and mentioned often in the pages of the *New Path,* notably in a letter from Ruskin in 1863 that glowingly identified Rossetti as "the greatest of English painters now living."[13] References to Rossetti abounded in the *New Path,* and his poem, "The Blessed Damozel," for example, was both reprinted in the December 1863 issue and also read aloud by Russell Sturgis at a meeting of the Association for the Advancement of Truth in Art.[14] Rossetti's medieval revivalism seemed to have an especial appeal to this band of American artists, and Thomas Charles Farrer even immortalized Rossetti along with Turner in a ca. 1861 *Portrait of Clarence Cook* (fig. 64), in which Rossetti's name was inscribed and thereby enshrined above a print of *The Light of the World* by his Pre-Raphaelite colleague Holman Hunt. Clarence Cook referred to a drawing by Farrer that was deliberately Rossettian in style, urging his friend to go see Norton's drawings—"The two by Rossetti and the one by his wife."[15] Furthermore, Russell Sturgis, another member of the Association, wrote to Farrer in 1863 about a trip to see Norton's collection, promising later to divulge to his friend ". . . all about the Rossettis" and to report on the content of "recent and intimate letters from Ruskin & D. G. Rossetti."[16]

In addition to the coverage and adulation he received in the *New Path,* Rossetti was also discussed in an 1865 article on "Pre-Raphaelitism" in the *Nation.* In the latter his poems that had appeared in the *Germ* were briefly alluded to as "full of the loftiest sentiment and pathos," and he was called "imaginative" and the "great chief" of the new movement.[17] The next year, 1866, witnessed the display of a few of his works in an exhibition at The Artists' Fund Society, which was held at the National Academy of Design in early November. Among the four hundred entries were many watercolor drawings. In the category of works by artists who have "hitherto

Figure 64. Thomas C. Farrer, *Portrait of Clarence Cook,* ca. 1861. Pencil? size unknown, untraced. *(Private Collection. Photo by Scott Hyde.)*

been little known in this country" were Mrs. Elizabeth Murray, Joseph Nash, and Rossetti, "who have already made their reputations on the other side of the Atlantic," as an article in the *Round Table* noted.[18] Among the reviews was a lengthy one entitled "Two Drawings by Rossetti" in the *Nation* that focused exclusively on this artist and his two watercolors in the exhibition. He was singled out as having been "the chief of the Pre-Raphaelite brotherhood in respect of actual original power. Now that the P.R.B. exists no longer, . . . he is still the greatest painter of the English school, not so much by amount of work done as by his natural and acquired strength. He is probably the most truly imaginative man who, in these latest times, has given his life to art; and he is a colorist unsurpassed, perhaps unequalled, among his contemporaries of all lands."[19] Just as the *Crayon* had commented on the rarity of exhibited works by Rossetti, so too did the *Nation:* ". . . the case is peculiar in this, that Mr. Rossetti has never exhibited. It is very seldom that any opportunity has been given to Englishmen to see an original Rossetti, except at the painter's studio or on condition of buying it; and very seldom that a would-be purchaser has been able to buy except on condition of waiting patiently for awhile." (The last part of the sentence clearly alluded to the dilemma faced by Norton and other patrons.) As a result, connoisseurs could only know his art under those circumstances or from "a few wood-cuts from his designs which are procurable in a very few little books. The actual number of his works is not large, and the number which any one student finds within his reach is sadly small."

The two watercolors analyzed were (once again) *Before the Battle* and also *Dante Meeting Beatrice.* In the first, the medievalizing interior and scene of squires, pennants, and the lady of the castle were described as "real and natural, full of feeling as well. The picture is of interest, as a history, to those who care for the beauty and stir of the Christian Middle Ages. But its principal charm is as a work of color . . . of extraordinary merit, and of a beauty almost unsurpassed." The bright hues of Rossetti's vignette were compared with the "more refined and subtle harmony" of a nearby Turner watercolor, and the unnamed author then comments on the arcane subject and almost contradictorily suggests that the work is "too strong in color" because ". . . in its very magnificence . . . [it is] the sort of color composition which does not easily grow out of our time."

The other work by Rossetti was deemed a more interesting but less satisfactorily executed subject. The artist's own translation of the "Vita Nuova" from Dante was quoted in full, but there was some doubt in the reviewer's mind about the meaning of the dramatic moment chosen: "It does not positively appear whether Beatrice was the bride at this marriage or not. The painter has left it in the doubt he must have felt, and we are left to guess which of the damsels in the drawing is she whom he worshipped." This rather negative reaction was considerably amplified in Stillman S. Conant's review of the watercolors for the *Galaxy* in early 1867. The Dantean subject was pronounced to be imperfectly rendered, the figures generally rather "awkwardly painted and placed" and the women on the stairway "a train of wretched virgins, scrawny, sharp featured, with high cheek bones, prominent noses, protruding eyes, and lips that never could provoke a kiss."[20] Conant pronounced the overall impact ". . . full of dreary awkwardness. The drawing is rude and clumsy, the handling scratchy and disagreeable to the eye. Nor can I discover in the picture any sentiment or current of thought that might atone for its defects as a work of art. . . . Why should an artist of the nineteenth century adopt the style of the fifteenth? . . . If nature is beautiful, why should artistic devotees to truth always paint ugly-looking women, and give us compositions that can be tolerated only in medieval work. . . . I would rather believe that Rossetti has permitted himself to dwell upon the works of the earlier masters until his admiration of their spirit his unduly influenced his judgment of their artistic merits as pictures."

Thus, while most critics applauded Rossetti, some dared to dissent. Conant wrote that these two watercolors ". . . are, I believe, the only specimens of his genius in America; I hope so,

unless they do him injustice. I have heard them extravagantly praised by some, and by others emphatically condemned." To him *Before the Battle* was somewhat childish, with "an indescribable appearance of incertitude, as if the artist were not sure of the effect he wanted to produce." For these reasons Conant enunciated his opinion that "Fully alive to the danger of not admiring Rossetti's work, I confess that the longer I study these pictures the less I like them. I find little in them which, to my taste, is lovely or admirable."

James Jackson Jarves, perhaps under pressure from earlier criticism because he had failed to mention—or to like—the Pre-Raphaelites, did mention Rossetti and his colleagues in his 1869 book *Art Thoughts*. In fact, he urged American artists to "temper their enthusiasm for French subjects with the wholesomer motives and more sincere treatment of English painters. Millais, Holman . . . Dante Rossetti . . . deserve to be better known abroad. They paint brilliantly and with signal ability and versatility."[21] After the late 1860s, however, there then ensued a hiatus of several years during which time Rossetti's art seemed to be neither seen nor mentioned much in the United States. Even Henry James had only a sentence or two to bestow upon Rossetti, who along with Burne-Jones and Leighton he placed above all literary artists, "the cleverest English painters of the day. . . . These gentlemen's pictures always seem as if, to be complete, they need to have a learned sonnet, of an explanatory sort, affixed to the frame; and if, in the absence of a sonnet, the critical observer ventures to improvise one, . . . there is a certain justification for his temerity."[22] Ironically, the artist's death in 1882 seems to have provided the occasion for some reassessment and reemergence of his work, notably in an 1882 piece for the *Century Illustrated Magazine* by Edmund W. Gosse, who knew and corresponded with the artist. As in the past, Rossetti's somewhat fiery and enigmatic personality was recreated for readers, who were told that he was ". . . a nucleus of pure imagination. . . . The function of Gabriel Rossetti . . . was to sit in isolation, and to have vaguely glimmering spirits presented to him for complete illumination."[23] Rossetti's insomnia and problems with the drug chloral were also alluded to, as well as his reputation for somewhat morbid reserve and his general "dislike of cordial society." Poems such as "The Blessed Damozel" and "The Sister's Sleep" were mentioned, and both "Pax Vobis," which appeared in an issue of the *Germ*, and "The Church Porch" of 1852 were reprinted in full. In the conclusion to his lengthy article on Rossetti, the author also singled out the poem "Rose Mary," about which Rossetti apparently wrote to Gosse in 1873.

Among the paintings that Gosse cited were *The Girlhood of Mary Virgin*, to which the opinions and reminiscences of artist-poet William Bell Scott were linked. Scott's perception of a latent Catholic meaning—what Gosse called "Rossetti's religious mysticism"—was also suggested, for "the very pulse and throb of mediaeval adoration pervaded the whole conception of the picture, and Mr. William Scott's first impression was that, in this marvelous poet and possible painter, the new Tractarian movement had found its exposure in art." The large picture *Kate the Queen*, based on a poem by Robert Browning, was also briefly mentioned, but more significant were Rossetti's "small drawings of poetical subjects in water-colours." These were relatively few in number, but reminded Gosse of the "radiant jewel-work which fret the gloom of Chartres"; indeed, Rossetti's stained-glass windowlike compositions were so jammed with figures and objects that sometimes "the limbs of the dramatis personae were sheered away by the frame." These watercolors were full of imaginative sentiment and brilliant color, the latter so strong that other works of art could not hang next to a Rossetti without suffering: "No other man's color will bear these points of ruby-crimson, these expanses of deep turquoise-blue, these flagrant scarlets and thunderous purples."

In addition, the 1857 exhibition of the Pre-Raphaelites at 4 Russell Place, Fitzroy Square, was noted, with Rossetti called "the principal exhibitor." Five or six of his best watercolors were remarked upon, including *Dante's Dream*, its counterpart entitled *The Anniversary of the Dream*, *The Blue Closet* (fig. 65), described as "the most brilliant piece of color at the Russell Place Gallery

Figure 65. Dante Gabriel Rossetti, *The Blue Closet*, 1857. Watercolor, 13½ × 9¾ inches. *(Courtesy of the Tate Gallery.)*

Figure 66. Dante Gabriel Rossetti, *Mary Magdalene at the Door of Simon the Pharisee*, 1858. Pen and ink, 21¼ × 18⅜ inches. *(Courtesy of the Fitzwilliam Museum, Cambridge.)*

. . . a picture which either illustrated . . . or suggested . . . Mr. Morris's wonderful poem", and *Mary Magdalene* (fig. 66). The latter was hailed as an "extremely original design" in which the architecture of Simon the Pharisee's house was, however, ". . . almost childish; the wall . . . is not three inches thick, and there is not room for a grown-up person on the stairs that lead to it; but the tender imagination of the whole, the sweet persuasiveness of Christ, who looks out of a window, the passion of the awakened sinner, who tears the roses out of her hair, the curious novelty of treatment in the heads and draperies, all these combine to make it one of those works the moral force and directness of which appeal to the heart at once."

Besides the success of such drawings as *Mary Magdalene Entering the House of Simon the Pharisee*, the failure of the Oxford Union murals was referred to, although the circumstances of this were deemed by Gosse still "fresh in the memories of too many living persons of distinction, to be discussed with propriety by one who was not present." Moreover, Rossetti's poems for the 1856 *Oxford and Cambridge Magazine* were praised and the assertion was made that he was the leader of a new generation of artists including Edward Burne-Jones, William Morris, Arthur Hughes, and others. Even without exhibiting often, Rossetti had, in the course of slightly more than a decade, ". . . become the center and sun of a galaxy of talent in poetry and painting, more brilliant perhaps than any which has ever acknowledged the beneficent sway of any one Englishman of genius."

In 1882 Rossetti was also the exclusive subject of a long article by Mary Robinson in *Harper's*

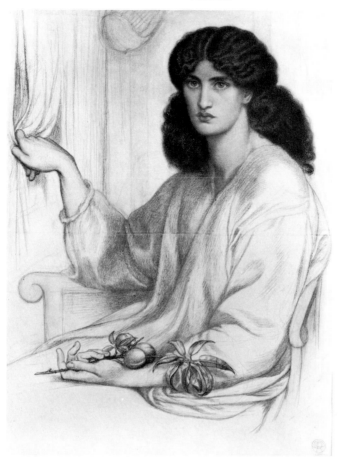

Figure 67. Dante Gabriel Rossetti, *Silence,* 1870. Black and red chalk, 37½ × 32 inches. *(Courtesy of the The Brooklyn Museum. Gift of Mrs. Luke Vincent Lockwood.)*

Monthly Magazine, a piece in which the artist was further lionized after his death and placed within the ranks of geniuses like the Americans Longfellow and Emerson. The author seems to have known Rossetti personally and placed him as the key force in the formation of the Brotherhood, a "Davidsbund of young art students indignant at the triviality of English art. . . ."[24] In fact, although Millais is also noted as gifted, it was Rossetti who is credited with moving Pre-Raphaelitism from a "stiff early manner . . . into a finer, larger, more aesthetic phase," an allegedly superior stage refined by the efforts of Swinburne, Morris, and Burne-Jones. Individual works by Rossetti such as *La Pia* and *The Salutation of Beatrice* are cited, and his series of single female figures are noted as the reason that "his fame as a painter has been most widely spread." Furthermore, *Silence* (fig. 67) is singled out as "probably familiar to an American public" because it was photographed as an autotype. This image is rightly perceived as representative of the Rossettian woman: "it is a type that we associate with no other painter: tall, of queenly figure and superb pose; the face shadowed by the abundant waves of crisped black hair; the bone of the face clearly marked . . . the eyes large, spiritual, and dreamy; the mouth full, Sphinx-lipped. . . ." Nonetheless, the author took apparent care not to characterize Rossetti's art just in sensuous terms, denying that claim and suggesting instead that these feminine icons generate ". . . a look of mystery, awe, passion [that] broods over the solemn countenance."

The year after Rossetti's death two biographies appeared in England and America that also

shaped his legend and the American interpretation of it. This is clearly evident in an 1883 anonymous review in the *Atlantic Monthly* that discusses these memorials to the artist. T. Hall Caine's *Recollections of Rossetti,* faulted for its cumbersome style by the reviewer, is nonetheless accorded a general nod of approval partly because Caine, as the artist's constant companion in the last year of his life, knew so many details of his subject's life. Rossetti's addiction to chloral and morbid temperament are also alluded to, the American writer commenting on the almost "oppressive atmosphere of suffering" in Rossetti's poems. A link with Longfellow is also mentioned, although the latter is described as having called upon the artist and also ". . . made the mistake of supposing that it was Rossetti's brother who was the poet."[25]

The same article in the *Atlantic Monthly* also reviewed William Sharp's 1883 book on Rossetti, and it is this book which triggered the author's judgment that Rossetti would, "unless our estimate be falsified by time, stand higher as a painter than as a poet." Rossetti's comparatively later maturation as a painter than as a poet is discussed, but his literary contributions are deemed less significant than his accomplishments in art. In addition to the "female facial type which Rossetti created," the drawing *How They Met Themselves* (fig. 68) is singled out as a consummate design, perhaps because its *doppelgänger* subject was partly inspired by Edgar Allan Poe's sonnets "Silence" and "Ulalume" (works Rossetti apparently knew well.)[26] The *Atlantic Monthly* columnist hailed this drawing for its "marvelous variation between the actual lovers and their doubles" and offered a particularly insightful reading of its meaning: "The spectral pair represent the man and the woman as they once were, and show an idealistic, a youthful grace and fervor, which the real man and woman have lost. These latter find them-

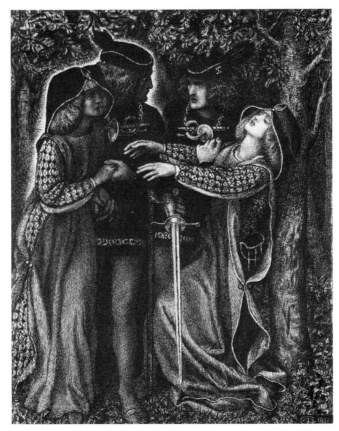

Figure 68. Dante Gabriel Rossetti, *How they Met Themselves,* 1851/1860. Pen and ink and brush, 10½ × 8¼ inches. *(Courtesy of the Fitzwilliam Museum, Cambridge.)*

selves confronted by this apparition, with the tragedy of their own slow, unsuspected deterioration."

Another landmark essay after Rossetti's death was Helen Bigelow Merriman's 1884 "The English Pre-Raphaelite and Poetical School of Painters" for the *Andover Review*. The conflict between the idealistic and realistic strains of Pre-Raphaelitism were the primary topics under scrutiny, with Rossetti categorized as the major proponent of the former approach. He was singled out for his strikingly original subjects as well as his symbolism, "both of form and color, into which so much more meaning was packed than could be understood without profound study, that his pictures have as little to say to the ordinary beholder as the most vapid of the works which moved his scorn."[27] In fact, his symbolism bordered on the solipsistic, for it was seemingly so abstruse and arbitrary to Merriman that "the danger . . . lies in its being . . . at least so remote . . . that the intellectual effort required to understand his pictures threatens to defeat their charm." Even more than her colleagues in 1882–83, Merriman introduced American viewers to the idea of the passionate side of Rossetti's pictorial imagery, alluding to how "he and his school have suggested to contemporary criticism such unpleasant adjectives as 'fleshly' and 'sensuous.' " His isolated and troubled nature wrought their effects on his art, and thus it was "not surprising that his pictures lack the freshness of the out-door atmosphere and become introspective, and in a few cases morbid and even unwholesome, despite his brilliant imagination and great originality." She excused his fleshliness partly because of his extraordinary abilities as a colorist, admitting that his poems were "often frank and startling, but that infers that any impure meaning may be intuited by those with a vulgar mind, thus asking the question: ". . . is it not, perhaps, because both thought and passion in them [his poems and paintings] work on the high plane of the spirit, and things seem to them pure and safe which to lower minds are fraught with dangerous suggestion?"

While Merriman's reactions atypically referred both to specific poems (such as "Jenny) and even to the famous vituperative attack on Rossetti's "fleshly" or "amatory" verse by Robert Buchanan in the 1871 *Contemporary Review*, her choice of paintings was quite predictable of American reviewers. She discussed, with varying degrees of enthusiasm and description, the Renaissance qualities of *The Girlhood of The Virgin*, the originality of the sunflower in *Mary Magdalene at the House of Simon the Pharisee*, the weirdness of *How They Met Themselves*, and the grandeur of *Dante's Dream*. In the realm of "moral" pictures were *Hesterna Rosa* and *Found*, the latter described as "intensely dramatic . . . [with a] poor, lost girl . . . shrinking . . . with unutterable poignancy." She also felt that there was a kind of sinister beauty conveyed by Rossetti's late and obsessive images of temptresses like *Lilith* and *Sibylla Palmifera*. In *Lilith* (fig. 69) there was "that beauty of sense which ends in self and bondage," while in the latter there was "ideal beauty whose service is perfect freedom" and a sibyl "with eyes absolute in knowledge and power." In the final analysis, however, Merriman maintained that "a curious proof of the fact that he was, on the whole, more in his element as a poet than a painter, is found in two pictures from his enchanting poem called the 'Blessed Damosel.' " In the oil painting version the damozel was surrounded by couples of reunited lovers in the thick groves of Paradise; "every inch of space is filled, and great bunches of roses are massed along the parapet, lest there should be a gap. The whole effect is stuffy and like an opera-box, and we feel as if we must rush out somewhere to breathe." Thus, while some of the standard recitations of Rossetti's artistic and personal traits were repeated in this article, Merriman added to the American writings on the artist by describing both the idealistic and realistic tendencies in Pre-Raphaelite art (as well as comparing these with contemporary French art) and by trying to come to terms with the hermetic qualities of Rossetti's depictions of women, temptresses, and goddesses.

Another astute assessment of Rossetti's work was to be found in a long, two-part article entitled "Rossetti and the Pre-Raphaelites" that appeared in 1885 in the *New Englander and Yale*

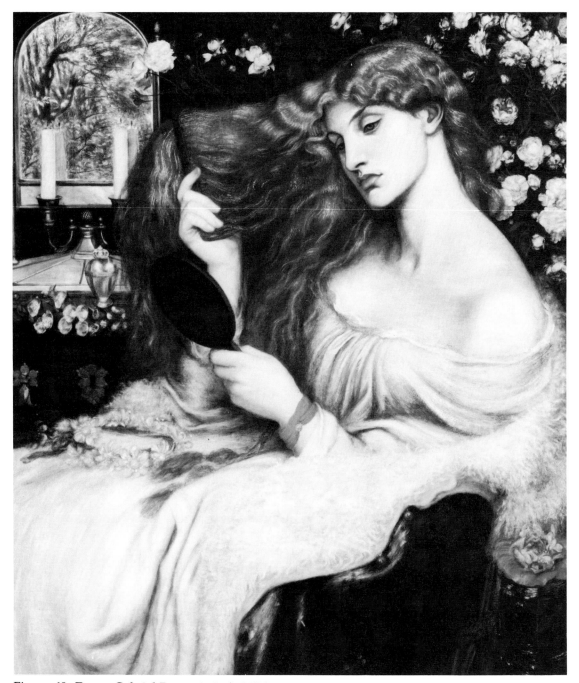

Figure 69. Dante Gabriel Rossetti, *Lady Lilith*, 1868. Oil on canvas, 37½ × 32 inches. *(Courtesy of the Delaware Art Museum, Wilmington.)*

Review. The author was probably Louis J. Swinburne, an amateur critic or even a professor or student at Yale University; if this is the case, his interpretations may have thus reflected an "academic" awareness of Rossetti's poems and paintings. The stimulus for the piece seems partly to have come from Ernest Chesneau's book on *The English School of Painting* (translated in 1885), and this Frenchman's opinions were surveyed as an example of how the Gallic audience had to make "a deliberate effort to adapt themselves to a method and a point of view so altogether new and individual . . . bizarre [because of the] excessive crudity of Pre-Raphaelite

color . . . so like the scale of tones and transitions in medieval glass painting, the utter disregard of the principles of softness and gradation which distinguish Renaissance painting."[28] Another impetus was an 1885 display of George F. Watts's art at the Metropolitan Museum of Art, since apparently "before the exhibition of Mr. Watts's works in New York comparatively few Americans had any acquaintance with the achievements of modern English art; the special phase known as Pre-Raphaelitism is still known as its best development, and what is worse, apparently no sense of loss is felt and no inclination to amend an ignorance so much to be lamented." It is also interesting that this writer also subscribed to the moody image of Rossetti in real life, to his chosen isolation and limited production, reiterating the view that "Producing in solitude, and for private patrons almost always, Rossetti's works in color were, with rare exceptions, never submitted to public examination until his death as late as three years ago."

Whether student or professor, the author provided a competent biographical and stylistic overview of Rossetti's work and had a good grasp of the impact of the Pre-Raphaelite rebellion in comparison with the art of British predecessors such as Wilkie, Eastlake, and Mulready; he moreover attributed their gothicism of spirit both to quattrocento Florentine art and to mid-century religious developments. Rossetti's style and subject matter in particular were rightly deemed unthinkable without the precedent of the Oxford Movement and increasing interest in Gothic architecture, because "without Newman and the tracts, without Keble and Pusey and the Lyra Apostolica, without that other artistic revival that took its rise with Pugin and Rickman, and the whole movement toward the recovery of Gothic design and sentiment, the Pre-Raphaelite group might never have risen into any considerable degree of favor and influence." To this writer, the religious theme of Rossetti's *Girlhood of the Virgin* was, according to William Bell Scott and others, "directly inspired by the Tractarian movement," an idea that may have appealed to Americans but was initially repugnant to the English, who criticized early Pre-Raphaelite works, especially those by Rossetti, for being too "Papist" or "Romanizing."

One of the more perceptive observations in this 1885 article was that the Pre-Raphaelites in general and Rossetti in particular needed to "resort to the illustrative symbol" because of the very nature of the literary and recondite subject matter typically employed in their pictures. In *Dante's Dream* (fig. 70), for example, Rossetti's ability to transcend natural forms to create "wonderful incarnate forms" was recognized, thus making him a link—the so-called chief representative of English romantic art—between the art of "domestic materialism" in Reynolds and Gainsborough in the eighteenth century and the modern spiritualism of G. F. Watts. *Dante's Dream* was hailed as perhaps Rossetti's greatest work because of the "temper of wonder, the element of mystery, which pervades it." In this composition, "so charged with the very pathos of sorrow, we have an extreme example of Rossetti's love of symbol. The figures of Dante and Beatrice alone would not convey to him the whole of Dante's conception; the flowers and birds and inscriptions grew up about his interpretation as integral and necessary portions of it." The symbolism itself was well understood, the roses and violets in the frieze typifying "the purity of her who lies at peace, and the sleep of death that comes in the springtime and is watched over by Love is suggested in the poppies that lie strewn about, the may-blossoms, and the crimson doves hovering near."

Another work that was again deemed exceptional was *How They Met Themselves*, which to this author (as had been the case with the writer for the *Atlantic Monthly*) showed better than any other work "how profound was his sense of mystery, how subtle his penetration of the supernatural." The eeriness of this encounter of *doppelgängern* was noted, as was the way the "Lady of Life faints against a tree" and the light streaming in suggested the light of immortality. Other works such as *Sibylla Palmifera, Rosa Triplex, La Ghirlandata,* and *La Bella Mano* were briefly catalogued, the author acknowledging (in a rather unusual sign of Victorian candor) how sensuous many of these images of love and womanhood were. The spectrum of Rossetti's

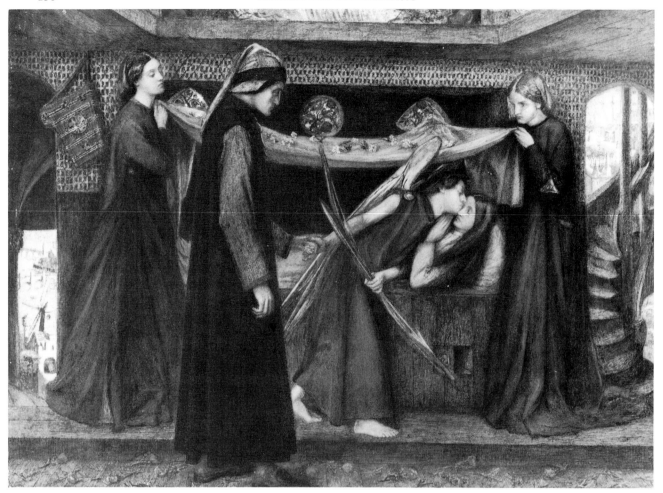

Figure 70. Dante Gabriel Rossetti, *Dante's Dream at the Time of the Death of Beatrice*, 1856. Watercolor, 18½ × 25¾ inches. *(Courtesy of the Tate Gallery.)*

feminine types was called "a great variety of . . . scriptural, legendary, classical, medieval; heads, figures, faces uplifted in devout and holy aspiration, eyes looking frankly at you out of the depths of a superb sensuousness. But in this complexity of type what especially impresses us, is the magnetic attraction of the feminine face for this dreamy and sensitive nature. It is the emblem to him of all beauty." In fact, Rossetti's awe of female beauty seems to have charged all his work, resulting in an "intermixture of sensuousness and mystic passion, impregnating it with a nameless charm, an indefinable and occult suggestiveness which eludes the most searching analysis. . . ." Yet the author asserted that Rossetti's females were very distinctive from what was often supposed to be the "conspicuously Pre-Raphaelite type, the pale, gaunt, and angular type that has come to be popularly associated with the works of Mr. Burne-Jones. With this they have absolutely nothing in common and the later ideal woman of his is the exact opposite."

In this category of femmes fatales were such works as *Venus Verticordia* (fig. 71) of 1864–68, a "Gothic Venus" very different from the archaicizing and angular females in early watercolors and even the young Mary (her face "full of tranquil dreams and visions") in *Ecce Ancilla Domini*. The Titianesque *Venus Verticordia*, by contrast, possessed an "imperious loveliness and bodily bloom, a remorseless and insatiable craving for the love and desire of lost men's hearts." She and her counterpart *Lilith*, described as "equally ample and voluptuous in her beauty," were

both representative of Rossetti's new type of women with "long throats, columnar and white as alabaster, and full curving lips, the eyes, placed far apart, and with lids drooping to hide the light of passion that burns in them, low brows, and black thick clustering hair." Such frankness about the sheer sexiness and passionate desire of Rossetti's women was rather rare in late nineteenth-century criticism, and why this American writer described these effects so vividly can only be guessed at.

There was, moreover, additional commentary reserved for two of Rossetti's best known images of "fallen women," namely, *Found* (fig. 72) and *Hesterna Rosa*. The tragedy of the young prostitute was briefly alluded to, as were the poem "Jenny" and the sonnet later written by Rossetti to accompany *Found*. The scenario in the latter was described as a supreme moment of recognition, an instant when it suddenly occurred to the young male "in an agony of despair that she is forever and irretrievably lost to him." The symbolic accessories of such details as the drover's homely smock and his ex-sweetheart's gaudy finery were also understood, and the figure's face was described as contracted ". . . with bitter misery . . ., the drawn lines of the mouth and the lips pursed tightly, with their pathetic memory of beautiful curves, now soiled and worn, the golden hair, a relic of her spring-time, straggling down her face in piteous dishevelment as if to hide it along with her woe. There is in it all a concentrated image of desolation, of recoil before the present, together with a mysteriously suggested recollection of the past days of sweet innocence and love, which, once seen, stamps itself upon the mind with extraordinary power."

Similarly, *Hesterna Rosa* of 1853 was aptly characterized as a vignette of two mistresses engaged in a revel in a pleasure tent at dawn. As with the woman in *Found*, one of the females experienced "some sudden memory of past purity and girlhood, having perhaps been struck by the low lute-music made by a young serving-maid or innocent sister beside her." Con-

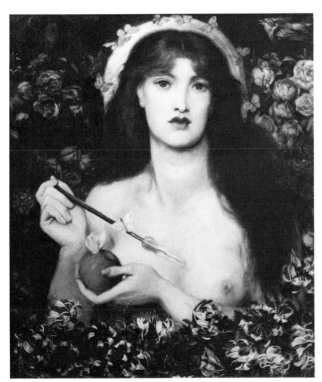

Figure 71. Dante Gabriel Rossetti, *Venus Verticordia.* 1864–68. Oil on canvas, 38⅝ × 27½ inches. *(Courtesy of the Russell-Cotes Art Gallery and Museum, Bournemouth. Photo by Shawn Garner.)*

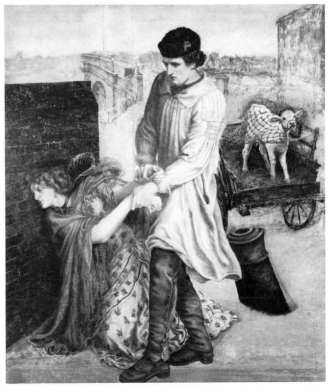

Figure 72. Dante Gabriel Rossetti, *Found*, Begun 1854. Oil on canvas, 36 × 31½ inches. *(Courtesy of the Delaware Art Museum, Wilmington.)*

trastingly, her companion registered no reaction, and "is either beyond or reckless of the past, and with an ungirlish song on her lips leans over the sofa clasping both arms around the neck of her lover." Moreover, both women were crowned with flowers, "but they are wreaths such as Bacchantes may have worn; and beyond, on the right, a hideous ape is scratching himself, adding by its presence a significant type of degradation."

The mid-1880s were also the years when Samuel Bancroft, Jr., a prominent industrialist and connoisseur in Wilmington, Delaware, began to become seriously interested in Rossetti's art. During a visit to England in the early 1880s Bancroft saw his first painting by Rossetti in the home of a friend, William Turner, and a subsequent friendship with the British architect Alfred Darbyshire fostered the development of his interest in the artist. In his 1882 and 1883 visits to England, Darbyshire gave his friend four pictures by Rossetti as well as a book about him and also introduced Bancroft to various eminent figures from the English theatrical and literary worlds.[29] In 1885 Bancroft purchased an autotype or photograph of the central figure in *La Bella Mano,* which he later bought in its finished, oil version. It was not until 1890 that this wealthy cotton mill owner bought *Water Willow,* his first oil by Rossetti, and the next year he bought a watercolor study of Ruth Herbert by this artist. During an 1892 trip to England (a decade after Rossetti's death), Bancroft bought about $22,000 worth of works through the London dealer Thomas Agnew and Sons, and these included Rossetti's *Found, Lady Lilith,* and also a portrait of *The Dead Rossetti* by Frederick James Shields. At the same time he apparently made contact with the woman who appeared in *Found,* Fanny Cornforth Schott, and arranged to buy a copy of Rossetti's poems, *Hand and Soul,* from her. As a result of his buying spree and increasing commitment to Pre-Raphaelite art, Bancroft had his house, "Rockford," enlarged. He was also pleased by the exhibition in 1892 of several of his paintings at the Pennsylvania Academy of the Fine Arts and then at the Century Club of New York, writing to a friend that the response in Philadelphia had "'queered' all the newspaper critics" but been a big success with the public there and an even greater one in New York.[30]

In the mid-1890s Bancroft's "hobby" continued. In about 1895 he eagerly sought out the collection of Mary Garrett in Baltimore, for she had bought at auction in the mid-1880s Rossetti's *Mary in the House of St. John* of 1858, a work which was added to the collection at Wilmington years after Bancroft's death. In 1898 he purchased Rossetti's *Portrait of Frederick Leyland* from Fanny Cornforth Schott and continued to add to his collection of "Rossettiana," which by the turn of the century amounted to nearly two hundred and fifty books, papers, and photographs of the artist's work. The last work by the artist which Bancroft acquired during his own lifetime occurred in 1909, when he paid £ 2,000 for *La Bella Mano,* the original of the work he first knew by photograph only. He also knew Charles Eliot Norton and his heirs, thus forging another link with the few fellow Americans who took an avid interest in Rossetti's career.

Concurrent with Bancroft's interest and purchases in the late 1880s and 1890s were, not surprisingly, various articles about Rossetti. Some of the same biases and "legends" about Rossetti resurfaced, for example, in an article written by Theodore Child for *Harper's Monthly Magazine* in late 1890. In "A Pre-Raphaelite Mansion" (which later appeared in Child's 1892 book entitled *Art and Criticism*), the architecture and artistic contents of the home owned by Frederick R. Leyland were discussed, and numerous works by Watts, Whistler, Burne-Jones, and Rossetti were mentioned. Again the writings of the Frenchman Chesneau were cited, as was the prevailing "myth" of Rossetti's choleric temperament and his private subject matter and output for only a chosen circle of elite patrons. Rossetti was described as "not a preacher, a symbolist, a moralist, an ascetic and fervent expounder of abstractions, like Holman Hunt, but . . ., nevertheless, equally spiritualist, mystic, and full of personal and recondite meaning."[31] Interestingly, however, Child dismissed the importance of too much theorizing or information about the Pre-Raphaelites, remarking that "Anecdotic psychology of individual artists, com-

plete estimates of the scope and character of their works, minute analysis of their lives and thoughts, are luxuries in which the few may indulge if such be their good pleasure, but which have very little real interest. An artist lives by his works and not by what his friends and admirers write about him." By far the most space given by Child to any artist was reserved for Rossetti, and full-page engravings of *The Blessed Damozel, Veronica Veronese,* and *The Loving Cup* appeared. (Brief reference to other works in the collection—*La Pia, Dîs Manibus, The Sea Spell, Lady Lilith,* and *Proserpina*—was also made, while later in the text additional works by Rossetti— *The Girlhood of the Virgin, La Donna della Finestra, La Bella Mano, La Ghirlandata, Ligeia Siren, Sibylla Palmifera, Venus Astarte, Hesterna Rosa, La Bionda del Balcone,* and *Aspecta Medusa*—were also cited in passing.) Overall, Rossetti's pictures were characterized as communicating "dreams full of silence and solemnity. Like his sonnets and ballads, his paintings are visions—visions that are often so personal to himself, so esoteric, that the painting is not completely intelligible without the intervention of the poet's exegesis." In this category was *The Blessed Damozel* (fig. 73), in which the splendid impact of Giorgione and of Venetian color was invoked. Here the poem alone was seen as providing true insight into the meaning of the painting, the "idea of a young woman who has died in the pride of youth, and who awaits in paradise the coming of her lover, who still dwells upon earth, and whom we see in the predella reclining under a tree and yearning for the lost one as she yearns for him." Rossetti's poem, which had been published in the *New Path* years earlier without an illustration, was subsequently illustrated by an American in 1886. Kenyon Cox, who was in many ways the diametric opposite of Rossetti as an academic painter, nonetheless had been aware of the Englishman's drawing for the Moxon edition of Tennyson and described his characteristic content in his book *Concerning Painting* in 1917 as "sentimental medievalism . . . easier of imitation than the strenuosity of Hunt or Brown."[32] To Cox, Rossetti possessed a "brilliant, flighty, poetic nature . . . to the end an amateur of genius," an opinion he expressed earlier in his book on past and contemporary artists.[33] Commissioned to illustrate *The Blessed Damozel* by the American publishers Dodd and Mead, he ultimately produced twenty grisaille on canvas illustrations, some of which were exhibited in New York in 1886. While the figure style is Cox's own rather than Rossettian, there were a few works that evoked the spirit of the Pre-Raphaelite poet-painter, particularly "The Blessed Damozel" herself (fig. 74) who with her long crinkly hair, half-closed eyes, and pose vaguely echoes Rossetti's own painted titan. Perhaps the amorous themes of separation and reunion in love appealed to Cox, who was otherwise best known for his large-scale murals and oil paintings. Ironically, some of Cox's other illustrations of nude women were deemed too robust for Rossetti's spiritual but sensuous poetry. Mariana Griswold van Rensselaer, who wrote the preface to this edition, praised Cox but damned Rossetti's poems as overly morbid, "unwholesome," and "over emphasizing . . . a melancholy . . . self-conscious type of beauty."[34]

The same sort of dream world that prevailed in *The Blessed Damozel* and other works was recreated as well in *Proserpina,* in which the destiny of the beautiful protagonist was enhanced by the inclusion and interpretation of symbolic objects around her: a "fateful pomegranate" which doomed her to Hades, and (according to a letter cited by Rossetti), an incense burner indicating "the attribute of a goddess," and the ivy branch in the background as "a symbol of clinging memory." On the other hand, in *Veronica Veronese,* there was less reliance on literary associations and more on pure aesthetic beauty, this in spite of the fact that an inscription on the frame described the work as a scene of creative genius, "the dawn of mystic creation," in the inspiration of the bird on the woman's music. The composition was praised as highly original, as was the pose of the hands. "There is something strange, intimate, and at the same time dreamily beautiful, comparable with nothing that ancient or modern art has produced— something so refined, so harmonious in effect, and so complete and direct in expression that the charm is as instantaneous as it is lasting."

Quite a different kind of feminine protagonist was found in *Lady Lilith,* which was perceived

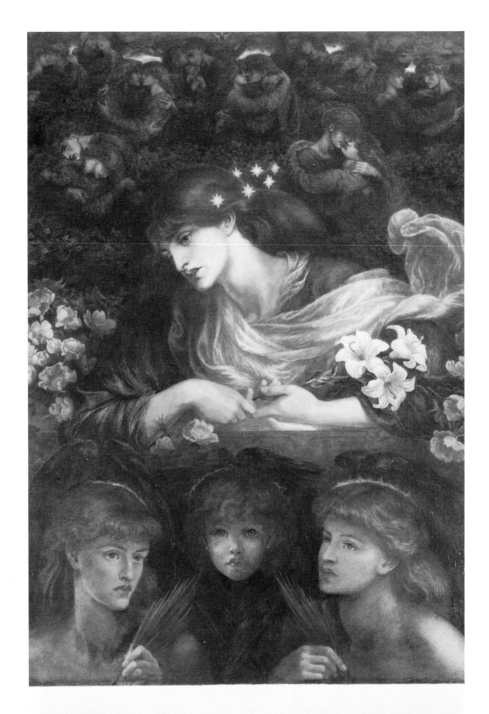

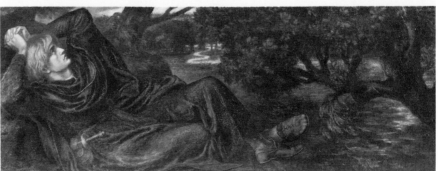

Figure 73. Dante Gabriel Rossetti, *The Blessed Damozel*, 1871–77. Oil on canvas, 68½ × 37 inches with predella. *(Courtesy of the Harvard University Art Museums, Fogg Art Museum. Bequest of Grenville L. Winthrop.)*

Figure 74. Kenyon Cox, *The Blessed Damozel*, 1886. Grisaille on canvas, 17⅝ × 13¼ inches. *(Courtesy of the Brooklyn Museum. Gift of Mrs. Daniel Chauncey.)*

as depicting a modern woman at her toilette. The details of a white fur dressing gown, a bare bosom, and the golden hair were all recorded, as was the poppy in a jar, the branch of pink foxglove, and the vanity of the creature hypnotically combing her long and ensnaring tresses. The contrast of reds and whites and their varieties were seen as appropriate for this imaginary portrait of Adam's first wife, "the purely animal woman who preceded Eve, and who still remains soulless yet animated by an immortal spirit." This provided a significant foil to the relative innocence of the female in *The Loving Cup*, in which the female was placed in a highly decorated and claustrophobic niche (with symbolic trailing ivy, as in *Proserpina*) and advanced towards the spectator with her offering. This was an image Child found to be so powerful that to him it defied prosaic description and was therefore engraved as an illustration for his article.

As the 1866 exhibition in New York had been an important event in the American consciousness of Rossetti's art, so too—perhaps even more so—was an exhibition in 1892 entitled *Examples of the English Pre-Raphaelite School of Painters, Including Rossetti, Burne-Jones, Madox-Brown, and Others, Together with a Collection of the Works of William Blake*. The show was held both at the Pennsylvania Academy of the Fine Arts and also at the Century Club in New York. The lenders included Rossetti's most important patrons in the United States: namely, Charles Eliot Norton and Samuel Bancroft, as well as Charles L. Hutchinson (the president of the Art

Institute of Chicago). Rossetti was represented by nearly a hundred objects, the vast majority being photographs taken by the Englishman Hollyer of the artist's paintings, drawings, and watercolors. The only original works of art were *Lady Lilith, Found, Mary Magdalene* and a study for it, assorted studies for *Dante's Dream, Water Willow,* and a watercolor portrait of Ruth Herbert, all of these from the Bancroft collection. Norton lent two watercolors by Burne-Jones along with Rossetti's *Beatrice Meeting Dante at a Marriage Feast, Denies Him her Salutation* and also *The Chapel Before the Lists.* Hutchinson's sole picture by Rossetti was an 1872 replica of *Beata Beatrix* (fig. 75) which was apparently bought at the Christie's sale in spring of 1886.[35]

There did not appear to be a great deal of critical comment on the exhibition in Philadelphia, but one reviewer in the *Art Amateur* accurately remarked that this effort put on display "almost all the Rossettis in this country." The list of paintings included the 'Beata Beatrix,' "the original painting of which is in the National Gallery, London, an idealized portrait of the painter's wife, done after her death, which belongs to Mr. Hutchinson, and 'Found,' a London street subject, painted in 1882 [sic], which belongs to Mr. Bancroft."[36] In *Beata Beatrix* the powerful visual effect was attributed less to the emotion than to the work's color, a "blending of many hues of red and green." *Found,* the subject of which—a fallen woman—was exceedingly rare in American art— was applauded as "generally held . . . to be Rossetti's best work. It is remarkable above all for the expressions of the faces of the man and woman, who meet unexpectedly in the gray, cold dawn, in a deserted street near the river. . . ." Other works in the exhibition (represented by photographs or autotypes) were *Proserpina* and *Astarte,* "simply portraits more or less successful of the beautiful or distinguished-looking women who sat to him—Mrs. Rossetti, Mrs. William Morris, Miss Ruth Herbert, Miss Mary Morris, and others." Jane Burden Morris's face was recognized in *Water Willow* "and again as Mary Magdalene and as Beatrice in a small watercolor belonging to Professor Norton." *Lady Lilith* was condemned for being "rather badly drawn", but in this same picture there were accessories which are beautifully painted—red camellias, foxgloves, rosebuds, roses, "and the flesh of the woman herself." In addition, more works from Bancroft's collection were briefly singled out, including studies of heads and figures for *Dante's Dream,* a crayon portrait of Christina Rossetti, a pencil one of Elizabeth Siddall Rossetti, and studies for the predella of *The Blessed Damozel* and for *Fiammetta.* Norton's watercolor of *The Chapel before the Lists* was also accorded some praise.

The publication in 1894 by Scribner's in New York (and concurrently in London) of Esther Wood's *Dante Rossetti and the Pre-Raphaelite Movement* was another pivotal event, affording American readers with an extensive discourse on Rossetti. Wood's sometimes chatty, some- times erroneous text treated the usual details of Rossetti's early years, focusing much more than others had on the literary influence of Ruskin, Keats, Browning, and Tennyson. Some of the details of his relationship with Elizabeth Siddall were glossed over, but this was understandable given the author's Victorian stance toward morality and convention. In fact, a decidedly "moral" tone pervaded the entire book, and Wood leveled judgment not only at Millais's "apostasy" and defection from Pre-Raphaelite principles, but also emphasized the ethical versus the aesthetic qualities of the art of the Brotherhood. She was much preoccupied, for example, with Rossetti's treatment of religious subjects and dedicated an entire chapter to analyzing *The Girlhood of Mary Virgin, Ecce Ancilla Domini,* and other paintings in this category by members of the Pre- Raphaelite group. She even detected a Christian element in Rossetti's early medievalizing watercolors, remarking as well that "in the most naive phase of romantic mysticism, with its devout faith in the presence of spiritual forces in play at all points upon the human soul, . . . Rossetti conceived the finest of his early dramatic sketches,—'How They Met Themselves' and 'Michael Scott's Wooing. . . .'"[37] Like earlier critics, she illustrated and interpreted such works as *Mary Magdalene at the Door of Simon the Pharisee* and *Beata Beatrix,* mentioning most of the standard favorites in Rossetti's oeuvre yet failing to probe very deeply into the meaning and mystery of his late representations of phlegmatic females like *Our Lady of Pity.* A concluding

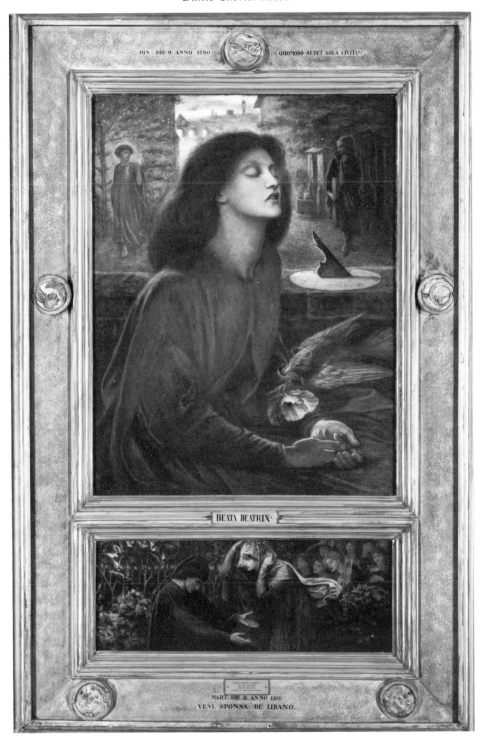

Figure 75. Dante Gabriel Rossetti, *Beata Beatrix*, 1872 replica. Oil on panel, 33¾ × 26½ inches. *(Courtesy of The Art Institute of Chicago. Charles L. Hutchinson Collection.)*

chapter solely discussing Rossetti's poetry rightly reinforced "the intimate relation of his poetry to his painting" and was quite frank in its acknowledgment of the sensual undertones of Rossetti's art, with the result that Wood's exegesis of "Jenny," "The Blessed Damozel," and other poems perhaps proved quite rivetting (and even disturbing or shocking) to some American

readers. Her explication of the richness and fecundity of both his pictorial and poetic imagery undoubtedly helped to give readers an overall, if personalized, viewpoint of his creativity. All in all, Wood certainly belonged to that class of admirers of Rossetti who deemed him a genius, perpetuating the legend in his own time and beyond of his rather gloomy temperament and monumental ego but also his colossal powers of imagination and invention.

In addition, a noteworthy article from the *Art Amateur* by Sidney T. Whiteford in 1895 helped to synthesize certain salient late-century perceptions in America of Rossetti and his art which had hitherto crystallized in the writings of others. Following the typical recitation of biographical facts, Whiteford indulged in the usual digression about the shadowy personality of the artist, whom he called the "Veiled Prophet": "In spite of all that is told of his magnetic sociability, the impression remains that he was distinctly self-absorbed, somewhat fantastic, hypersensitive, and intolerant of whatever was not accordant with his own prejudices. . . . Transcendental and mystical in imaginative bias, but an imperfect draughtsman . . ., Rossetti could not give pictorial form to his thoughts without direct aid from the realism of a suggestive model."[38] Thus, this painter-poet concentrated his energies on the depiction of fateful women, often portrait studies which, while they represent actual females, are—in Whiteford's opinion, overpowered by his imagination and by his obsession with themes of love. His female protagonists were thus creatures who needed ". . . loving and being loved, and . . . working weal or woe by the agency of passion. The list of paintings comprises so many Monnas and Donnas, Venuses and Magdalenes, that it is not surprising that he should . . . have grown weary of inventing titles. . . ." Accordingly, three works were illustrated in the article—the replica of *Beata Beatrix* which was owned by Charles Hutchinson (as well as the predella for it), *The Girlhood of Mary,* and *Rosa Triplex.* Whiteford did not go into the analytical detail of these works that Child had, but he was much more forthright about discussing the "dark Venuses" than his predecessors were, and his remarks also conveyed a hint of latent censure of the sensuousness of Rossetti's portrayals of women. Nonetheless, "whatever critical objections Rossetti's paintings and designs may be open to, yet as expressions of enigmatic thought, fervid imagination, and intense feeling, instinct with mysticism and elaborate in symbolism, they have permanent and exceptional value. By the phenomenal character of motive and treatment they are placed altogether apart." Rossetti's solitary and peculiar genius, as well as his idiosyncratic way of "embowering" and embellishing his post-1860 images of women, were thus entitled to admiration, even if his content did seem to strike some critics as potentially objectionable.

The following year, 1896, a discussion of Pre-Raphaelitism and Rossetti by artist Will H. Low appeared in *McClure's,* a magazine published in London and New York. Here, too, Rossetti was named the leader of the Brotherhood, and while a few works like the *Annunciation, Dante's Dream,* and *Rosa Triplex* are briefly mentioned, it is the stuff of his life—his wife's death, the tale of the exhumation of his manuscripts, and his reclusiveness—not art that particularly interest the author and the public. Again and again the sensational aspects of the artist's life were recited for readers, and there was not much respite until Herbert Gilchrist's "Recollections of Rossetti" for *Lippincott's* in 1901. Gilchrist, who knew Rossetti in his later years, described his friend's eccentricities without dwelling on his morbidity and even injected a digression about Rossetti's interest in Walt Whitman.[39]

Nonetheless, in spite of Gilchrist's less insistent treatment of Rossetti's personality, by the end of the century the painter was consistently viewed as a morbid man, a lone dissenter in the Brotherhood who had, according to an American Pre-Raphaelite, ". . . never obeyed, even for a day, the Pre-Raphaelite principles, but painted in oil or in watercolor, . . . his brilliant dreams as unconcernedly as if he had never vowed allegiance to serve fixed principles of graphic art."[40] The opinion of William Stillman in the 1890s also reinforced many of the preceding perceptions of Rossetti's art and contributions. In 1898 Stillman wrote about the unfulfilled potential of his friend's talent: "What he might have done for art, had his life and health been spared, we can

only conjecture; but what he has left is a page of art history, brilliant, indeed, but even more suggestive of what might have been."[41] To Stillman—as to many earlier critics—Rossetti was an egotistic, isolated figure, "the spoiled child of his genius. . . . He was undoubtedly the most gifted of his generation of artists, not only in England . . ., and I consider that if he had been of Titian's time he would have been one of the greatest of the Venetians. His imaginative force and intensity were extraordinary, and some of the elaborate compositions he drew in pen and ink, for future painting, are as remarkable in invention and dramatic feeling as anything I know in art. . . ."[42]

Like others, Stillman addressed the issue of the sensuality of Rossetti's art, remarking that "The sensuous quality of his painting, . . . like the same qualities in his poetry, remained as long as I knew anything of his life. . . . In his later years his work was nearly always more or less jaded. . . ."[43] Yet this aspect of Rossetti's art did not deter Stillman's respect, and this was true of the reaction of many American critics. As numerous remarks of the 1880s and 1890s have revealed, the prudery of critics was not really excessive, and their responses were seemingly more discerning, open-minded, and tempered than that of potential buyers. While not many Americans bought works by Rossetti, he had at least three significant patrons— Norton, Bancroft, and, to a lesser extent, Hutchinson—to support his efforts and to lend their paintings to American exhibitions for the critical exposure to and enjoyment of the public. He was also the best known—or at had the most verbiage written about him—of the Brotherhood. Moreover, there was to some extent a rather different appreciation in America of Rossetti's works than in his homeland. In this country a curious dichotomy reigned, for both his early watercolors like *Before the Battle, Dante Meeting Beatrice, Mary in the House of St. John,* and *Mary Magdalene Entering the House of Simon the Pharisee*—all with chaste, angular, "medievalizing" heroines—and also his later sensuous images and mystical images (such as *Lady Lilith* and *Beata Beatrix*) garnered continual attention, although this was not the basic pattern of critical response in England. Ultimately, Rossetti's tangible influence on American artists (much less on their literary counterparts) is hard to gauge (as well as beyond the scope of this book), but there were certainly echoes of his phlegmatic and omnipotent females in numerous paintings by Elihu Vedder, John LaFarge, Thomas Dewing, and others (see examples in the concluding chapter). In fact, Norton himself predicted that his friend and the Pre-Raphaelites in general would set a fine example and thus leave an imprint on American art, writing to Rossetti in 1863, "There is hope for Art in this Country. The true ideas—the ideas the P.R.B. has done so much to make clear—are extending among our younger men, both painters and architects, and we shall before long have good work to show you."[44]

7

The American Pre-Raphaelites: Following a New Path in Landscape and Figure Painting

As THE OPENING CHAPTER POINTED OUT, RUSKINIAN IDEAS WERE READILY TRANSPLANTED IN FERTILE SOIL IN America, where his beliefs in the 1850s met with "appreciation and frank acceptance. . . , and the number of earnest and intelligent adherents it has already found are more than its warmest friends hoped for so soon."[1] By the next decade, this welcome reception generally continued, although changes became evident by the mid-1860s. In a review for the *New York Daily Tribune* in 1864 Clarence Cook, a founder of the *New Path*, commented on the effects that both Ruskin and the Pre-Raphaelites had wrought in America: ". . . it was Ruskin who moved us, and had excited us all with a new interest in art, with higher and more inspiring views of it, and had prepared us to greet eagerly whoever should first move in the new path he had pointed out. Then, again, it was the Nineteenth Century that moved Ruskin—he was the spokesman for many silent thinkers, and found an audience waiting for him with eagerness to devour his words and ready to put them into act. . . ." Cook had personally been very influenced by reading *Modern Painters,* and thus wrote persuasively of how Ruskin's theories appeared at a ripe moment; as a result, ". . . convincing words crept cross the Atlantic, and waked us here, and we believed him; and then came these young men who so determined to follow his teaching; and they have done so; and they are teaching, helping, moving others, and so, the work goes on."[2]

Nonetheless, in an article on "Pre-Raphaelitism" in the *Nation* the next year, a less sympathetic critic (probably *New Path* associate Russell Sturgis) remarked that "it should be stated that, as far as we know, there has never been a Pre-Raphaelite picture in any exhibition of the Academy of Design, except on one occasion. . . . There is only one painter whose work is at all known in the Eastern cities of America who has ever been under the influence of the Pre-Raphaelite school, and he has long ago ceased to show sign of this training. Whether or not the Pre-Raphaelite influence is a good one or not, whether we regret the fact or not, the fact remains. American art has not yet been influenced by the famous school, except so far as the immediate personal weight of this one or that one of its more powerful members has made itself felt."[3]

Given the coexistence of these two polar responses, which of them told the "truth"? Was there no influence of Pre-Raphaelitism or, conversely, was there a tangible one imprinted on American art? In spite of the disclaimers in the *Nation*, it was indeed the case that English art had some perceptible effects, albeit for a fairly short but intense span of time—roughly 1855–67, basically the same period when the individual members of the Brotherhood benefitted from considerable attention from the American public and press. However, by the end of the 1860s critics looked upon Pre-Raphaelite qualities with less and less favor, partly because Ruskin's ideas had lessened in importance but also because of the demise of the *Crayon* in 1861 and of the *New Path* six years later.

Like their British counterparts, the eight original members of the Association for the Advancement of Truth in Art were extremists, radical reformers who wanted to create a new form of naturalistic painting and landscape. For example, an editorial reply to a subscriber in the *New Path* rather truculently and defiantly asserted that the publication existed "for the purpose of stirring up strife; of breeding discontent; of pulling down unsound reputations; of making the public dissatisfied with the work of most of the artists, and better still, of making the artists dissatisfied with themselves."[4] Concomitant with the *New Path*'s militancy was its quasi-evangelical preaching of the new gospel of naturalism. Charles Moore wrote in October of 1863 thta Ruskin had delivered "the truth and we thank him and give God the glory; and the truth once clearly shown becomes ours if we will receive it. It also becomes our imperative duty to proclaim it."[5] Thomas C. Farrer similarly joined in this spirit of moral fervor and spoke of his "glorious consciousness . . . after a summer of earnest effort, to know that . . . you sought God's truth and did it."[6] It is clear that the group saw themselves as apostles of a new creed, believing that "Pre-Raphaelitism will save our art, yet, if we can have the modesty and patience to obey its teachings."[7] There was a sense of impassioned religiosity as well in "seeing God and hearing His voice in every golden-hearted star that bends before the wind, in every blade of grass, in every rosy clover head, and every golden dandelion, think you we would dare to draw or paint any one of these things, bent into grace and loveliness by God's finger, carelessly or coarsely, and give a . . . daub of paint . . . as the truth of mullen, thistle, or dock leaf?"[8] However, some critics found this proselytizing offensive, the *Round Table* (which was otherwise generally often sympathetic to Pre-Raphaelitism) objecting in 1864 to the *New Path*'s condescending tone and to its failure to admit that Ruskinian principles had been consciously followed in art prior to the founding of the Society.[9]

It must be kept in mind, however, that the notoriety and visibility of the American Pre-Raphaelites in the press was far greater than the actual number of works that they created in accordance with this innovative pedagogy. As a modern authority has aptly pointed out, " . . . during their heyday from about 1857 to 1867, the American Pre-Raphaelites 'enjoyed' critical exposure far beyond the size and scope of their efforts"—this mostly due to the emerging professionalism of art critics like Moore and Cook, both of whom were part of the Association and naturally expressed their bias for it in print. Moreover, the works of these artists "tended to be relatively few in number, small in size, and often confined to what critics considered the 'lesser' media of watercolor and the graphic arts."[10]

As the *Round Table* realized, even before the Association for the Advancement of Truth in Art was founded in 1863, numerous artists began in the mid-1850s to assimilate and reflect Ruskinian tenets in their art. The most important adherents were William Stillman, John W. Hill and his son John Henry, William Trost Richards, Thomas C. Farrer, Charles H. Moore, and Clarence Cook, although there were other, more obscure artists, including several women painters such as Fidelia Bridges. Most of these artists exhibited at the National Academy of Design in the 1850s and 1860s especially, sometimes even selling pictures directly from the exhibition walls. While the better known of the American Pre-Raphaelites also exhibited in Boston and Philadelphia, it is perhaps most useful to focus on the critical responses of New

York newspapers and art periodicals to the shows at the Academy. Farrer, the Hills, Stillman, and Richards were all discussed as mainstream artists by the press, and they as well as their more elusive colleagues were analyzed in even greater detail in the pages of the *New Path.*

The first native painter to earn the nickname of "American Pre-Raphaelite" was William Stillman, for whom very few works in this style have survived, in part because Stillman destroyed some of his canvases in a fit of frustration with Ruskin's interference in his art. Among his pictorial attempts in this mode was a portrait of the famous poet Henry Wadsworth Longfellow posed amid rocks, the setting itself perhaps an allusion to Millais's commanding 1853–54 portrait of John Ruskin standing next to a stream in Scotland.[11] One of the few extant pictures is *Saranac Lake, Adirondack Mountains* (fig. 76) of ca. 1855, which may have been similar in appearance to the similarly titled work of 1860 which Stillman exhibited at the Royal Society of British Artists. Apparently the work at first repulsed a critic who claimed it was "an unpleasingly grouped assemblage of unpleasing natural objects," but the poet James Russell Lowell and others admired the verisimilitude and honesty of the picture.[12]

Similarly, the older (John W.) Hill read *Modern Painters* in the mid-1850s and, according to his friend Russell Sturgis, was "past forty when he came under the influence of Ruskin," nonetheless throwing himself into "the service of Ruskinian principles with the utmost zest and a determination that never flagged as long as he lived."[13] Clarence Cook also attributed the inception and promotion of American Pre-Raphaelitism to two key personalities: the older Hill and T. C. Farrer. Hill's situation was unusual because he chose to turn his back on 'the precepts and the models of the conventional school in which he had, up to that time, been steadily working. It was a singular case of conversion, but the convert gave . . . indisputable evidence of

Figure 76. William J. Stillman, *Saranac Lake, Adirondack Mountains,* 1854. Oil on canvas, 30½ × 25½ inches. (*Gift of Dr. J. Sydney Stillman. Courtesy of the Museum of Fine Arts, Boston.*)

Figure 77. John William Hill, *Bird's Nest and Dogflowers*, 1867. Watercolor, 10¾ × 13⅞ inches. *(Courtesy of the New-York Historical Society.)*

his sincerity."[14] Accordingly, Hill painted in the open air, devoting as much as ten hours a day to painting landscapes, flower studies, and vignettes of birds and fruits. His efforts resulted in his becoming what a modern historian called "the first American Pre-Raphaelite not only to treat individual natural forms with detailed emphasis in nature studies but also to work with intensity and great success in still life, as well as landscape."[15]

The first "studies" in nature by this English-born painter appeared in the 1856 National Academy of Design exhibition, and one lost work from 1857 sounded reminiscent of the "weedy ditch" from Millais's *Ophelia*. This work, entitled *A Sluggish Stream*, was hailed by the *Crayon*, for example, as "a remarkably fruitful study from nature."[16] Increasingly, Hill produced a type of still life that has been described as "weedy banks, masses of garden flowers, wildflowers, grasses, and natural growth," and a typical example of these preferences for the close up of humble flowers and mosses in a natural state is *Bird's Nest and Dogflowers* (fig. 77).[17] Both Hills knew the work of English artist William Henry ("Bird's Nest") Hunt, and the younger Hill sent a report to the *New Path* in the mid-1860s that referred to "several drawings of W. Hunt's at South Kensington; one, of 'Plums,' is exquisite."[18] Ruskin also praised this artist, whose still lifes (like this *Bird's Nest with Sprays of Apple Blossom* [fig. 78] of ca. 1845–50) set a standard for highly finished representations of apparently abandoned nests and eggs replete

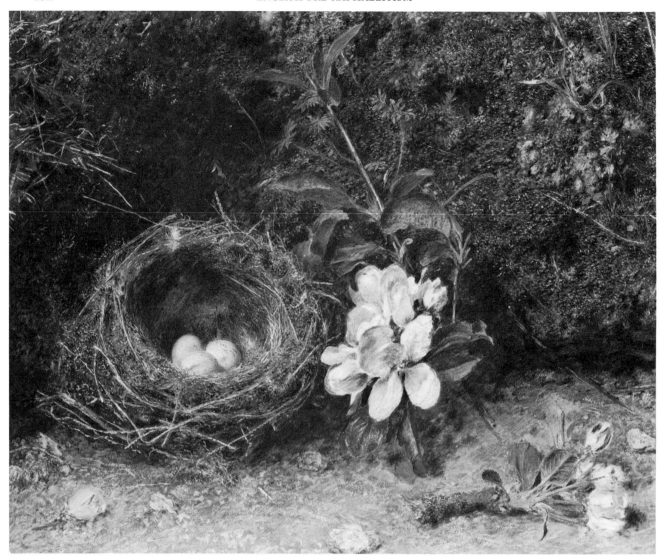

Figure 78. William Henry Hunt, *Bird's Nest with Spray of Apple Blossoms*, ca. 1845–50. Watercolor and bodycolor over some pencil, 10 × 12⅛ inches. *(Courtesy of the Yale Center for British Art, Paul Mellon Collection.)*

with vulnerability and delicacy. The older Hill's *Dead Blue Jay* of 1865 and similar works may have also been indebted to some English pictures in the 1857–58 show in America, including Hunt's *Dead Woodcock* or even Elijah Walton's *The Nest*.

Like his father, John Henry Hill also painted in watercolor and concentrated on still life elements in landscape, and sometimes their works were confused with one another. In addition to admiring the Pre-Raphaelites, the son also wrote of Turner's influence upon him to "watch nature with greater care."[19] In 1857 he submitted nine entries to the National Academy, and these were praised by the *Crayon* as "honest, faithful transcripts of the objects . . ." observed.[20] Among the younger Hill's Pre-Raphaelite essays was an (unlocated) oil painting entitled, *A Meadow Scene*, which was applauded as one of several "actual studies from nature. The tree is admirably executed; there are also some studies of weeds, etc. equally fine."[21] Ruskins also knew the younger Hill's works, and an 1860 letter from Charles Moore to Farrer indicated that Moore was "glad to hear that Ruskin speaks well of John's drawings."[22] J. H. Hill also knew Charles Eliot Norton well, for the two were neighbors in Ashfield, Massachusetts,

Figure 79. John H. Hill, Study of *Trap Rock*, 1863. Oil on canvas, 20 × 24 inches. *(Courtesy of the Metropolitan Museum of Art. Gift of the artist, 1882.)*

where the younger Hill moved in 1865 and where Norton spent his summers away from Harvard.

Like his mentor, the younger Hill was also interested in the formation of rocks, and the artist later wrote that *A Study of Trap Rock (Buttermilk Falls)* (fig. 79) of 1864 was "... the most elaborately literal study from nature I ever made." Appropriately hailed by the twentieth century as a "fully realized Ruskinian study," *Trap Rock* in partial reverse view was etched for Hill's book *Sketches from Nature* in 1867.[23] Another work which manifested Hill's continuing fascination with glacial and geological strata was the ca. 1866 watercolor entitled *View from High Tor, Haverstraw, New York* (fig. 80), in which both geographical and geological accuracy are combined to an extraordinary degree and evoke comparisons with the painters in England like J. W. Inchbold and John Brett.

Sketches from Nature was a compendium of twenty-five etchings of landscapes and numerous "classic" American reinventions of Pre-Raphaelitism: namely, bird's nests, flowers, and leaves. Among these plates was a specific nest identified as a thrush's nest and a close up of leaves called wildflowers of the genus *Bidens,* a quasi-scientific representation that revealed Hill's fervid application of Ruskinian principles of "selecting nothing and rejecting nothing" in nature. Moreover, in the introduction, Hill suggested readers carefully peruse *Modern Painters* and Ruskin's *The Elements of Drawing,* remarking that "drawing a single flower, leaf, or bit of rock thoroughly well is something better worth doing than conjuring up pictures in the studio."[24]

In the case of Thomas C. Farrer, an Englishman who came to New York in about 1857, the exposure to Ruskin also amounted to nothing less than a conversion experience. Arguably the most dynamic and controversial member of the group, he had—unlike his American cohorts,

Figure 80. John W. Hill, *View from High Tor, Haverstraw, New York*, ca. 1866. Watercolor, 11¾ × 18 inches. *(Courtesy of the New-York Historical Society.)*

Figure 81. Thomas C. Farrer, *Mount Tom*, 1865. Oil on canvas, 16 × 24½ inches. *(Courtesy of Mr. and Mrs. Wilbur L. Ross, Jr.)*

who knew their mentor primarily through books—studied with Ruskin himself at the Working Men's College in Red Lion Square and was, therefore, presumably full of his ideas and enthusiasm. Perhaps more importantly, Farrer not only espoused Ruskinian and Pre-Raphaelite tenets, he put them into action—not merely in his own art, but by encouraging others to do so, corresponding with myriad American artists, and helping to organize the Society in 1863. It may have been Farrer who prompted the Hills to pursue a more Ruskinian path, and correspondence between these men indicated that they even cryptically referred to themselves at times as the "P. R. G's," (the Pre-Raphaelite Group?). For example, in one letter of 1856 Hill mentioned to Farrer (in rather biblical tones) how ". . . we P. R. Gs are not at all notorious but—Trust in the Lord and do *good* and thou shalt dwell in the Land and verily thou shall be *fed*."[25] When his friend Farrer returned briefly to Britain in 1860, John H. Hill's letters also suggested how crucial a role the expatriate Englishman played as prime mover in the dissemination of the new tenets: "I am confident the Preraphaelite School will make sturdy progress. . . . I wish we could have such a school here, but the present prospects for it are very discouraging. We are very glad for our part that you are coming back. I am ready to give three cheers for the Pre-Raphaelite cause in America."[26]

In addition, Farrer later taught women's art classes between 1861–65 at the Cooper Union in New York, thus influencing many students. As Cook wrote in 1867 of this aspect of his friend's achievements, "Besides the pupils he has directly formed, his proselytising spirit, and the persistent earnestness of his teaching, have obliged the preachers and practicers of an opposing faith to burnish their weapons and look to their defense; and it is not a little remarkable that not a single writer of any ability or conviction has been found to uphold the opposite side, nor has any artist of mark appeared to establish an opposing school."[27]

Farrer produced some superb landscapes, especially his best-known painting entitled *Mount Tom* (fig. 81) of 1865, a masterfully rendered painting which heightened the artist's painstaking precision of detail and touch. These effects displeased the *New York Times* reviewer, who did not like the supposed hard outlines, cramped composition, and "pretentiousness" of the work. To him the infinite touches of a fine brush were only "a common trick with the Pre-Raphaelites, and a very shallow and transparent one." However, there was some grudging approval of "other pictures in the exhibition which we cheerfully commend to the attention of all who entertain the notion that the Pre-Raphaelite theory of art, as practiced by American or English artists, will ever lead to admirable results."[28] Another signal work of the same year was the *View of Northampton from the Dome of the Hospital,* a panoramic view exuding the abundance and beauty of a languid summer's day in Massachusetts. As with *Mount Tom,* nearly every inch of the relatively large canvas was crammed with detail, and the prismatic colors and dizzying details in each canvas triggered both admiration and objection from some contemporary critics.[29] Occasionally Farrer was compared (by his comrade J. H. Hill) with the Englishman Thomas Seddon, whose *Jerusalem and the Valley of Jehosaphat from the Hill of Evil Counsel* of 1854–55 (fig. 82) was deemed "very like Farrer."[30] Hill's observation is astute, particularly since in all such views there is a high viewpoint and horizon, along with crisp draftsmanship and a prismatic palette. Similarly, a parallel might be drawn with John Brett, whose 1857–58 *Val d'Aosta* and 1862–63 view of *Florence from Bellosguardo* have some affinities with Farrer's aerial perspective and commanding panoramas.

Throughout his career Farrer typically received mixed reviews of his landscapes from the press, but his fellow Association member Clarence Cook glowingly wrote in the *New York Daily Tribune* in 1864, for example, that Farrer's Academy entries *Buckwheat Field on Thomas Cole's Farm* (fig. 83) and *Catskills from the Village* "will prove of more importance in the future development of art than all the pictures that have been painted by Academicians since the Academy was founded."[31] Although they were not masterpieces, these works embodied a truth to nature which was paramount, and Cook's review constituted one of the period's most compelling

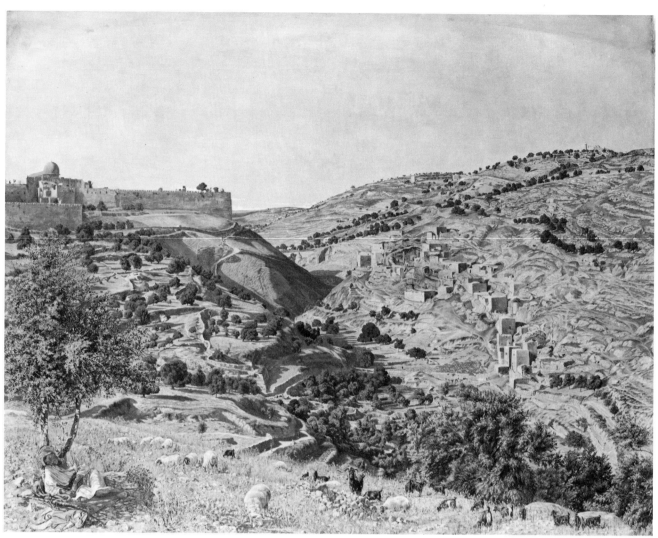

Figure 82. Thomas Seddon, *Jerusalem and the Valley of Jehoshaphat from the Hill of Evil Counsel*, 1854–55. Oil on canvas, 26½ × 32¾ inches. *(Courtesy of the Tate Gallery.)*

Figure 83. Thomas C. Farrer, *Buckwheat Fields on Thomas Cole's Farm*, 1863. Oil on canvas, 11¾ × 25 inches. *(Courtesy of the Museum of Fine Arts, Boston. Gift of Maxim Karolik for the M. and M. Karolik Collection of American Paintings, 1815–65.)*

defenses of Pre-Raphaelitism: "We pronounce that it is much nearer to truth than to falsehood, and have no hesitation in saying that the green of the trees and grass cannot be expected to please people who, for thirty years or so, have been learning from . . . conventional painters the interesting fact that grass may be gray, or brown, or pink, or black, but that, under certain circumstances, is it even green" He also liked the Pre-Raphaelite truth to nature evident in the local colors and shadows: "We believe it would be very hard to find anything sweeter or tenderer in any landscape in this country than the young cedar trees and their shadows in this picture. They are loyally true to nature in material form, in color, and expression They are the first pictures that have been painted here in open defiance of all established rules of art, with the avowed purpose of striking out on a new path, of going to Nature and proving the rules by comparison with her. . . . The public—you and I, and all of us—ought to buy, at once, every scrap of this honest, faithfull [sic] work we can get."

The sole member of the *New Path* group to actively participate in the Civil War as a soldier in the Union Army, Farrer was also the only member of the Association's circle to paint figural and genre scenes. The best example of his paintings of this type was *Gone! Gone!* (see fig. 32), which was exhibited at the National Academy of Design in 1861 and was clearly indebted to Millais's compositions. The *New Path* even detected a religious undertone which perhaps allies the work somewhat to modern viewers with Holman Hunt's *Awakening Conscience* (see fig. 48), for both show women in a moment in a crisis and have biblical inscriptions on their frames: "It is called by a suggestive name, and on the frame are written the words: 'Come unto me all ye that labor and are heavy laden, and I will give you rest.' As it is made to call for sympathy with the desolate, and to bid the desolate look for the best sympathy to their Savior, it becomes, therefore, a picture of worthy aim and noble subject." Moreover, the *New Path* specifically attributed both the serious modern theme and the verisimilitude of the objects in the room to the influence of their British role model, claiming that "for this tendency, Pre-Raphaelitism is partly responsible. It was a rule that nothing should be drawn except from the object itself. The rule was right and necessary; no remedy less severe could have brought the arts into health and energy. . . . Pre-Raphaelitism has saved the art of England, and made it the first art of the modern world, and Pre-Raphaelitism will save our art, yet if we can but have the modesty and patience to obey its teachings."[32]

Farrer's drawings were also highly finished and Pre-Raphaelite, and *Practicing her Lesson* (fig. 84) of 1859, like *Woman Sewing* of the same year, also seemingly alluded to at least one Pre-Raphaelite canvas, once again to Hunt's *The Awakening Conscience*, exhibited at the Royal Academy in 1854. The setting may have been the artist's own rooms, but the mood evokes that of Hunt, from the small accessories of the clock under glass to the elaborate mirror, the cupid figure, the symbolic prints on the wall, and even the sheet music on the piano. The narrative centered on a solitary lady in virginal white (for whom, like the mistress in *The Awakening Conscience*, the flowers in the room may have special meaning) playing music from *Norma* at a rosewood piano (the same kind that Ruskin described in Hunt's picture). The opera *Norma* unfolded a tale of romantic tribulation and conflict, and the presence of a man's top hat and gloves on the piano top may suggest a similar saga here.[33] Although the ultimate stories being told by Hunt and Farrer may have been different, both artists used real objects as part of an elaborate symbolism that heightened the emotion and meaning of the subject.

Just as Ruskin's *Fragment of the Alps* (see fig. 1) was a signal work cited in the *New Path* in January of 1863 and inspirational for countless artists who indulged in "scriptural geology", so too were Millais's *A Huguenot* and Hunt's *The Light of the World* of major importance in terms of figural painting. Both compositions became talismans and touchstones for American artists, and William Trost Richards's borrowing from Hunt and Aaron D. Shattuck's debt to Millais (see fig. 31) were mentioned in the respective chapters on these English artists. However, in general the status of this genre was still evolving, and thus James Jackson Jarves wrote in 1863, "Figure

Figure 84. Thomas C. Farrer, *Practicing Her Lesson*, 1859. Pencil with Chinese white, 11⅞ × 9¼ inches. (*Courtesy of the Pierpont Morgan Library.*)

painting . . . has not yet won a position. The rare and isolated instances of bold effort in this direction only prove the general truth, although leaving us hopeful for the future. Indeed, the public have no sympathy for it, owing in part to lack of artistic culture, and in part of the inability of our artists to express themselves sufficiently well as to command attention."[34] Furthermore, Farrer, who was undoubtedly the best-known and most capable figural artist in American Pre-Raphaelitism, was even advised by his friend Cook ". . . to let genre go, and keep to his out-of-door nature."[35] As the remainder of this chapter will indicate, for reasons of both training and national preference (as well as the existing precedent of the Hudson River School paintings), in America landscapes *à la* Pre-Raphaelitism greatly outnumbered figural essays in this style.

It was in Farrer's quarters that the founding meeting of the Association and the *New Path* was held, and among the supporters were the architects Russell Sturgis and Peter Wight, the geologist Clarence King, the critic Clarence Cook, and fellow artist Charles H. Moore. Farrer may also have been the catalyst in Moore's "conversion" to the creed, for an 1860 lettler from John H. Hill to the Englishman noted, "When I was down to the city last I saw Charlie Moore. . . . he said you had been down to see him and staid (sic) till one o'clock and had a good talk, I hope you talked him over to preraphaelitism."[36] Moore later remembered that the Association "never supposed that the mere literal study of nature . . . would of itself make good art. In this most important point we were, perhaps naturally, very much misunderstood by the general public." He also referred to how members of the new society were in communication with Ruskin and, in America, with Norton, who was very helpful and generous to these painters. Moore wrote, for example, that he made a copy of a picture by Rossetti that belonged to Norton. "He had kindly allowed me to have it in Catskill, and I spent a great part of one winter in copying it, as a means of thoroughly studying it."[37] Norton also bought several works by these artists, including "A Nest of the Brown Thrush" of 1860 by John Henry Hill. In addition, Moore moved to Cambridge, Massachusetts, in 1871 at Norton's invitation in order to teach drawing to engineering students. Perhaps his motives were inspired by Ruskin's own plans for the Working Men's Colleges in England, for Moore wrote to a friend in 1873 that he professed to adhere to "Mr. Ruskin's teaching so far as I could."[38]

Moore's landscapes had a broad range, and both his full-fledged panoramas and his studies of trees and tree trunks were often praised. Some of his forest "studies" of botanical specimens or branches are imbued with an earnest delicacy of touch and feeling, as in *Lilies of the Valley* (fig. 85) of ca. 1861, which even in its arched shape looks like a horticultural paean to *A Huguenot* or *Ophelia*. A panel from an American "altar to nature", this work and others had relatively few exact counterparts in English art, since there were typically figures in Charles A. Collins's *Convent Thoughts* (fig. 86) of 1851 or Millais's *Ferdinand Lured by Ariel* (fig. 87) of 1849–50 and not just plant specimens. However, there were a few English artists producing the same sort of image at about this time, including J. Atkinson Grimshaw's 1862 *Fair Maids of February* (fig. 88) with its closeup vignette of snowdrops and ferns "spotlit" on a natural stage within a darkened and dramatic "proscenium arch," and other artists followed Ruskin's admonition to select at random and paint a corner of nature.

Another side of Moore's work involved investigation of rock formations, just the kind of inanimate "portraits" advocated—and also painted—by Ruskin himself. The latter's *Fragment of the Alps: A Block of Gneiss* (see fig. 1) was among the first works by Ruskin ever to be seen in this country, and it was purchased directly from the exhibition by Norton himself. Reviews were mixed, but the *Crayon* wrote that Ruskin's "sketch is masterly, and said to be one of the most complete studies he has ever made."[39] Several years later the *New Path* still held up the work and the subject of a gneiss boulder as an excellent example for study, even describing the effect as seemingly "photographed in color."[40] Moore and Farrer were both trying to reinvent the American landscape that Thomas Cole had made so popular (and, to the *New Path*, which Cole

Figure 85. Charles Moore, *Lilies of the Valley,* ca. 1861. Watercolor, 8⅛ × 4⅜ inches. *(Courtesy of The Art Museum, Princeton University. Gift of Frank Jewett Mather, Jr.)*

had also debased), and their efforts to remake nature went through various phases and struggles. In Moore's 1860 *Rock Study,* for example, there was enough geology for even an ardent Ruskinian, as was true as well of J. H. Hill's 1863 *Study of Trap Rock.* These men had all probably been inspired by the stony, veined specificity of Ruskin's watercolor and of Brett's *Glacier at Rosenlaui* (see fig. 21), both in the American exhibition the previous decade. Ruskin's watercolor was also known to have directly influenced Moore's 1860s *Rocks by the Water* (fig. 89) as well as to have had a more general impact on David Johnson's *Natural Bridge* (Reynolda House) with its myopic, Ruskinian closeup of rust stains and erosion.

Moore's fully developed landscapes often met with some criticism, however. His 1865 National Academy entry *Winter Study in the Catskills,* for example, was hailed for its faultless

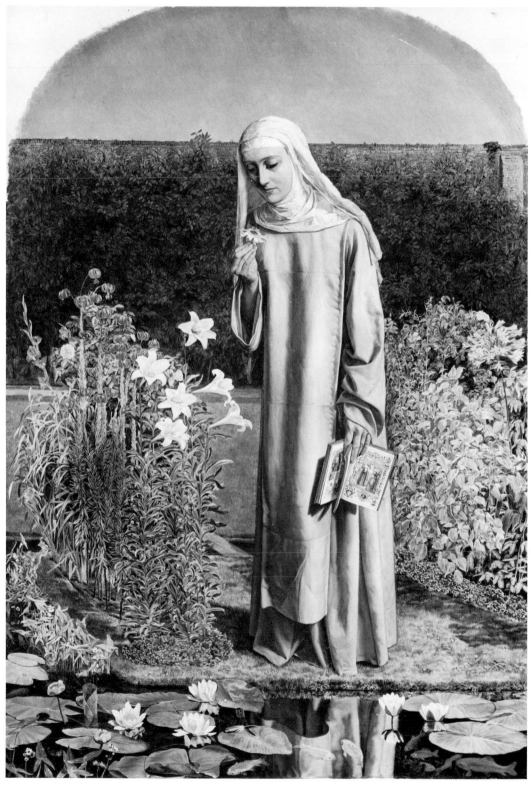

Figure 86. Charles A. Collins, *Convent Thoughts*, 1850. Oil on canvas, 33⅛ × 23¼ inches. *(Courtesy of the Ashmolean Museum, Oxford.)*

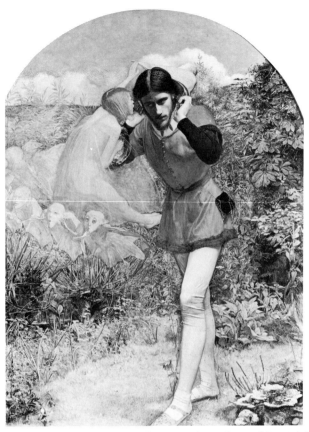

Figure 87. John Everett Millais, *Ferdinand Lured by Ariel*, 1849. Oil on panel, 25½ × 20 inches. *(Courtesy of the Makins Collection.)*

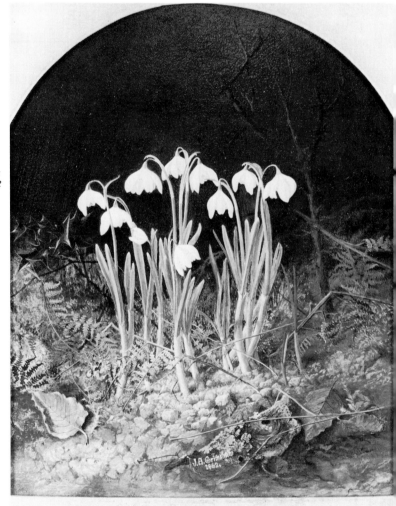

Figure 88. J. Atkinson Grimshaw, *Fair Maids of February*, 1862. Oil on board, 14 12 inches. *(Private Collection.)*

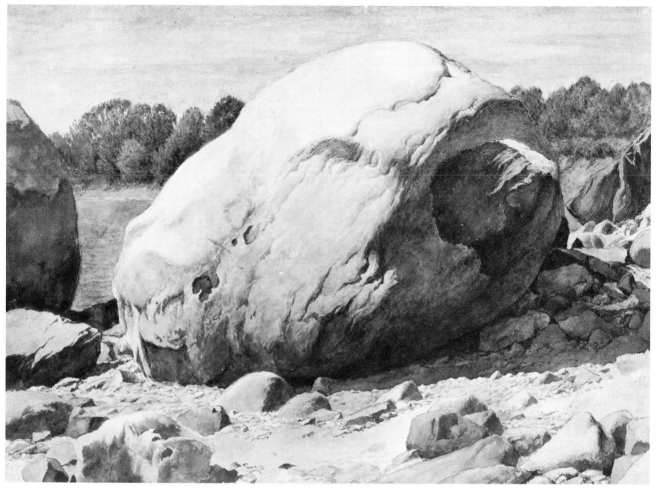

Figure 89. Charles Herbert Moore, *Rocks by the Water,* ca. 1860s. Watercolor and gouache over graphite on cream wove paper, 5⁹⁄₁₆ × 7¾ inches. *(Courtesy of the Harvard University Art Museums, Fogg Art Museum.)*

verisimilitude on several levels: its "truth of strength as well as a truth of delicacy . . . , truth of broad masses as well as truth of delicate detail; . . . , truth of general effect; and 'tone' as well as truth of local color, or truth of simple form." With these high standards Moore was seen as approaching the zenith of the landscape style: "the ideal of landscape is not the submitting of special truths to general truths, but the full realization of all the truths in perfect harmony with each other. The ideal of landscape is not a correcting of nature, but a stopping short of the whole truth of nature, just so far as is made necessary by the physical limitations of art. . . . This ideal is, so far as we know, yet to be reached."[41]

Yet other critics were less enamored of Moore's skill and attempts at "prophecy" in art. A letter to the *New Path* in 1865 remonstrated him for belonging to a near-sighted school of painting sarcastically dubbed "The Myopian Club." His transcripts of nature were accordingly ridiculed in terms that make the composition sound like an Americanization of the foreground of *The Light of the World,* for "the artist seized upon a bit of rail fence. . . . His reason for choosing this thrilling incident is . . . that Nature in an 'ideal' mood of remarkable virulence, has given to three of the posts that shadow-a-piece which belongs to them, while the fourth . . . has two, distinct and clearly marked!"[42] More significantly, Moore also crossed paths (and swords) with a key figure of the era, James Jackson Jarves, the nemesis of American Pre-Raphaelitism. Even though Jarves became a member of the Association in 1865, by that point he

had already had a lot of invective heaped upon him (by Charles Moore, for example, in the *New Path* in 1863) due to his dislike of both English and American strands of Pre-Raphaelitism. Although Norton was a friend they all shared, this relationship did not ameliorate the situation, and Jarves decided to single out Moore and Farrer for some blame in his 1869 book *Art Thoughts*. Accordingly, he described the two in rather mild terms as "exact literalists, having a conscientious regard for their specific motive, and doing their work with a thoroughness of touch and study which affords example to others." However, the charge was then made that their art relied "far too much on its local truth of design and hue, and topographical exactitude of representation, and too little on the sentiment of nature or on the language of color, the strong points of the idealists. It is based on a misconception of high art, which has a deeper purpose in view than mere truthful representation of external nature, though it demands that."[43] Like his previous comments in *The Art-Idea* that the "extreme Pre-Raphaelites" succumbed to "barren externalism and dry-bones literalism" instead of to truth, these slings must have personally offended and agitated both Farrer and Moore.[44]

As had been true with Farrer and Hill, there was another volte-face in the career of William

Figure 90. William Trost Richards, *Tulip Trees*, 1859. Oil on canvas, 13¼ × 17¹/₁₆ inches. *(Courtesy of the Brooklyn Museum.)*

Figure 91. Ford Madox Brown, *Hampstead—a sketch from Nature*. 1857. Watercolor, 5½ × 9 inches. *(Courtesy of the Delaware Art Museum, Wilmington.)*

Trost Richards, who had also read *Modern Painters*, and through his friendship with Farrer, was elected as a member of the Association in 1863. Probably his first Pre-Raphaelite composition was the result of his having seen the 1857–58 exhibition of English art in Philadelphia, an event which directly inspired a canvas called *Blackberry Bushes* of 1857–58. Not only was this a pictorial reply to the English mandate of Pre-Raphaelitism; it also recorded Richards's direct confrontation with nature and his documentation, in pure Ruskinian fashion, of every weed and bramble. *(Blackberry Bush* was a work later sent in 1860 to the Royal Academy, where it was probably seen by Farrer during his visit to England and was generally well received by English reviewers in the *Art-Journal* and the *Athenaeum.)*[45] Another pertinent example was *Tulip Trees* (fig. 90) of 1859, which was apparently a commissioned work that in its overall appearance and screen of foreground foliage recalled ". . . the handling of trees and bushes in Ford Madox Brown's watercolor in the 1857–58 American Exhibition of English Art, *Hampstead Heath—A Sketch from Nature* (fig. 91), which was purchased in 1858 by the Philadelphia collector Ellis Yarnall."[46]

Even before he joined the Association, his works were compared with that of the Pre-Raphaelites, the *New York Daily Tribune* critic in 1862 pronouncing five forest vignettes ". . . of such exquisite delicacy of finish, and such fidelity to nature, that a Pre-Raphaelite might blush to examine them."[47] Furthermore, Richards's 1859 *Ferns in a Glen* (reminiscent of Stillman's destroyed *Bed of Ferns* in its subject matter) underscored the "minute limning . . . marvellous in accurate imitation" for which he was extolled by Henry Tuckerman in 1867. Like Shattuck and Hill, his compositions often consisted only of foreground, a dense plane of foliage without spatial recession, an accidental or uncomposed nook of nature stumbled upon (yet carefully reproduced) by a Ruskinian enthusiast. He too seems to have taken literally the phrase in

Modern Painters that an artist's duty "is neither to choose nor compose, nor imagine, nor experimentalize; but to be humble and earnest in following the steps of nature and tracing the finger of God."[48] As Tuckerman wrote about the minutiae in Richards's pictures: "So carefully finished are his leaves, grasses, grain-stalks, weeds, stones, and flowers that we seem not to be looking at a distant prospect, but lying on the ground with herbage and blossom directly under our eyes."[49] To this critic Richards was both the chief pictorial spokesman of this new landscape vernacular and also the most obsessed of the group, carrying out ". . . in practice the extreme theory of the Pre-Raphaelites."[50] An outstanding example of this sort of densely-packed composition was *Red Clover, Butter-and-Eggs, and Ground Ivy* (fig. 92) of 1860, which in many ways embodied the description the *New Path* offered of the little "devotional panels" of nature executed through a strict regimen of dedication and labor: "No words can describe the myriad facts and marvelous delicacy and decision of hand and eye that has followed every little clover leaf with a loving care, and rendered the whole truth of every patch of lichen on the tree stems—in the foreground. . . ."[51] Another stellar example is *The Conservatory* (fig. 93) of 1860, in which the arched doorway seemed to borrow from *A Huguenot* and other English Pre-Raphaelite pictures where each flower, fern, and plant was delineated with decided skill and care. After this date, however, there was sometimes a certain tension projected between Richards's handling of the meticulously rendered foreground and more freely rendered distance, a slight "schizophrenia" apparent in this *Landscape* (fig. 94) of 1860.

Figure 92. William Trost Richards, *Red Clover, Butter-and-Eggs, and Ground Ivy*, 1860. Watercolor, 6⅞ × 5⅜ inches. *(Courtesy of the Walters Art Gallery, Baltimore.)*

Figure 93. William Trost Richards, *The Conservatory*, 1860. Oil on panel, 10⅞ × 8 1/16 inches. *(Private Collection.)*

Figure 94. William Trost Richards, *Landscape*, 1860. Oil on canvas, 17 × 23¼ inches. *(Courtesy of the Yale University Art Gallery. Gift of Mrs. Nigel Cholmeley-Jones.)*

Most of the American Pre-Raphaelites only painted in this style for a part of their careers and, after a few years, ceased to identify themselves as Pre-Raphaelites, a pattern of abandonment or change also true of Millais and others in Great Britain. One American who left the "new path" fairly early in his development was Aaron Draper Shattuck, a landscapist in the *New Path* circle whose meticulous meteorological diaries paralleled John Constable's interests in cloud formations in England. Shattuck exhibited regularly and his works sold well, and in 1861 several of his paintings were donated to Vassar College, including *Autumnal Snow on Mount Washington* (fig. 95) of 1856, with its earnestly rendered foliage and crystalline atmosphere. Shattuck's interest in vibrant colors and in linear foreground detail often added a strong gradient texture to his compositions, and among his works in this style was *Leaf Study with Yellow Swallow Tail* (fig. 96) of ca. 1859. Yet another arched, "head-on" confrontation with nature, this work exemplified the culmination of the "studies of rocks, grasses and field flowers" for which he was praised by the *Crayon*.[52]

Another Pre-Raphaelite enthusiast—at least for a while—was Henry Roderick Newman, "whose fruit pieces, rocks, trees, grasses, and scenery offer instructive exemplars, not without their inspiring as well as controversial influence," as one modern historian has pointed out.[53] Newman was "won over" in part by the editorials in the *New Path*, which he wrote to Farrer had

Figure 95. Aaron D. Shattuck, *Autumnal Snow on Mount Washington,* 1856. Oil on canvas, 10⅛ × 16 inches. *(Courtesy of the Vassar College Art Gallery.)*

Figure 96. Aaron D. Shattuck, *Leaf Study with Yellow Swallow Tail,* ca. 1859. Oil on canvas, 18 × 13 inches. *(Courtesy of the Collection of Jo Ann and Julian Ganz.)*

"so completely stirred me up that I will try and express my thanks to the Society for it."[54] He followed the article's instructions precisely, and his initial foray in this style was a watercolor in which he, like Ruskin, was "trying to get acquainted with a fragment of flint rock."[55] Like the elder Hill, he too painted out of doors, lamenting again to Farrer that "It is rather cold to work out of doors, but I bundle up and manage to get my 5 hours about every day. . . ."[56] And like Millais and Hunt, both of whom suffered during their painting excursions in the English countryside, Newman followed this creed in order to paint faithful transcriptions of flowers and fauna, a representative work being his best-known (and much later) watercolor entitled *Fringed Gentians* of 1887. However, he also produced some landscapes influenced by this style, including an 1867 watercolor entitled *Mt. Everett from Monument Mountain in April* (fig. 97), in which the foreground detail was remarkably microscopic and the bird's-eye aerial view rather English in inspiration. However, sometimes the pains he took were not very much appreciated by the public (or even by the *New Path*, which wavered in its support for his work), causing Newman to report rather ruefully that a few visitors, "After looking over my studies concluded that I was to [sic] Pre-Raphaelite. The lady said she could see why I worked in water color it was so much easier to work minutely than in oil. She said my work showed I drew my inspiration from Ruskin. . . . I find that Pre-Raph's are not fashionable here 'they are so ultra'."[57] In the

Figure 97. Henry Newman, *Mt. Everett from Monument Mountain in April*, 1867. Watercolor, 10⁷⁄₁₆ × 13⅞ inches. *(Courtesy of the Museum of Fine Arts, Boston. Gift of Mrs. Harriet Ropes Cabot.)*

same corrspondence he also mentioned that Sturgis intended to send some of his drawings to Charles Eliot Norton, who ultimately bought at least one work by Newman, his *Study of Pigeons*.[58]

Many of the works by Moore, Farrer, and Newman were in watercolor, a medium that was well represented in the 1857–58 exhibition of British Art in America and that fostered considerable interest and emulation among American artists. As has been pointed out, watercolor was perhaps the most Ruskinian mode, and the American Pre-Raphaelites can be "identified today as much by their choice of medium as by the style and content of the paintings." They also gained credence and exposure in the first exhibitions of the American Watercolor Society and "so laid the foundation of the medium's lasting popularity in the United States." Moreover, in many respects the American followers may have experienced such a meteoric rise to fame "if only because their experiments and style gave their watercolors a technical proficiency and intensity that attracted attention." Thus, by the mid-1860s, "despite the declining influence of Ruskin and the increasing criticism of their unimaginative 'photographic' manner, the American Pre-Raphaelites found themselves the principals of the native watercolor school. As Henry Tuckerman wrote in 1867, their works offered 'instructive examplars, not without their inspiring as well as controversial influence.' "[59]

There were others who flirted with Pre-Raphaelitism and painted landscapes in this genre, including Samuel Colman and James McDougal Hart, the latter praised by the *Crayon* in 1855 for foreground studies of nature that were ". . . perfectly pre-Raphaelite in their delicacy of rendering of detail."[60] Hart's *A Summer Memory of Berkshire* was also reviewed by the *New Path*,

Figure 98. James M. Hart, *Nature's Nook*, 1857. Oil on canvas, 12⅛ × 8¼ inches. (*Courtesy of the Vassar College Art Gallery.*)

which was pleased by the "beautiful combination of color, and of sparkling lights and shadows" but nonetheless found that its verisimilitude ". . . comes very near the truth, but always stops a little short. . . . In this picture there is a great deal of finish, but it is not 'added fact,' therefore is false."[61] A typical canvas embodying both the Scottish-born artist's strengths and weaknesses is *Nature's Nook* (fig. 98) of 1857, which was bought a few years later and donated in 1864 by Matthew Vassar to the college that bears his name. There were also artists like Margaret McDonald, Sarah Wenzler, Miss Rose, Miss Oakley, and Miss Granberry, whom the *New Path* predicted were ". . . all on the right road, and promise to do excellent work in time" but about whom very little is known today.[62] Among mainstream American artists Frederic Edwin Church received moderate praise (and some criticism) in the *New Path*, while Winslow Homer and Eastman Johnson were often approved of for their honest subject matter and for their technical expertise (although neither was singled out as a Pre-Raphaelite proponent *per se.*)[63]

At the end of chapter 3 in this book, Stillman's lament was registered that the 1857–58 exhibition of British modern art had failed to offer a sufficient number of landscapes for an American audience. Given native interpretations of that genre as indicated in this earlier chapter, it is worthwhile to consider some of the actual landscapes—in addition to that of Ruskin and Brett—which W. T. Richards and others were presumably affected by seeing.

Figure 99. William Davis, *Bidston Marsh*, 1855. Oil on board, 11⅞ × 17⅞ inches. *(Courtesy of the Walker Art Gallery, Liverpool.)*

Besides Brown's *Hampstead Health—A Sketch from Nature,* there were a few other painters whose rather small-scale Pre-Raphaelite "perfection" probably appealed to American artists. William Webbe submitted a few entries, for example, and William Davis of the Liverpool Academy sent *Evening* and *An Old Hedge* to at least two of the three cities on the northeastern tour; John Inchbold's *Noonday on the Lake of Thun, Switzerland* was on view in New York and Philadelphia. While these exact canvases remain unlocated, Davis's *Bidston Marsh* (fig. 99) of 1853 fairly represented his Pre-Raphaelite tendencies. Similarly, Inchbold's *At Bolton, (The White Doe of Rylstone)* (fig. 100) of 1855, *The Cuillin Ridge, Skye* of 1856, or *The Lake of Lucerne, Mont Pilatus in the Distance* of 1857 were all representative canvases, which, with their forceful gradient textures and plethora of foliage, would undoubtedly have been keenly appreciated had they traveled to America.

In terms of landscapes that were actually seen in America during that important event, F. B. Barwell's *A Day Dream* of 1855 (fig. 101) was accompanied by a florid passage from the poet Samuel Rogers when it went on view in New York and Boston. The recumbent child embedded amid a burgeoning nook both recalled Richard Redgrave's efforts of this sort (notably in his various depictions of *Babes in the Woods)* and also provided American artists with a relevant naturalistic ideal to emulate. Another canvas which came across the Atlantic was William Gale's *An Incursion of the Danes—Saxon Women Watching the Conflict* (fig. 102), which had been on display in the 1855 British Institution and was seen in all three American cities. While this canvas also incorporated figures into the composition, the sharp-edged detail of the foreground rocks was probably not lost on American spectators.

At this point it is perhaps useful to note that, while many Englishmen produced pure Pre-Raphaelite landscapes, a rather modest proportion of these corresponded with the miniaturized, microscopic portraits of botanical specimens in a leafy nook favored by American artists. In Britain numerous provincial artists in particular came under the sway of Pre-Raphaelitism and painted this same kind of basically Ruskinian vignette, and James Campbell's *The Dragon's Den* (fig. 103) certainly fit into this category. Another example is *A Mossy Glen* (fig. 104) of 1864 by J. Atkinson Grimshaw, who executed several works of this sort in the late 1850s and 1860s and by 1859 was described by a contemporary as selling "studies of dead birds and blossoms . . . , of moss-grown rocks, ferns, and foliage."[64] William Windus also explored this genre in *Stray Lamb* of 1864, and occasionally other artists experimented in this style, a curious example being Albert Moore's 1857 watercolor entitled *Study of an Ash Tree* (fig. 105), remarkably akin to works by Richards and Shattuck), yet another in a string of works indebted to the likes of Arthur Hughes's *The Long Engagement* or sundry canvases by Millais. Although this artist subsequently devoted himself to a more "aesthetic" palette and composition—especially to repeating neoclassical motifs and immobilized females in exquisitely colored settings—early in his career he (like many other English artists) briefly tested the waters of Pre-Raphaelitism, so to speak.

There were also British artists who blended the figural with the landscape in the paradigmatic Pre-Raphaelite composition, incorporating a surfeit of detail that made their canvases crowded with natural excess (and yet not necessarily transcribing these elements with the prescribed level of assiduity and seriousness of purpose). In this category were many works by artists who showed Pre-Raphaelite inclinations but came to that pictorial conclusion for different reasons. For example, Redgrave in the 1850s painted many canvases with figures overwhelmed by a detailed, burgeoning nature, among them *Little Red Riding Hood* of 1856. Another example was James Sant's *The Children in the Woods* (fig. 106), a Royal Academy picture of 1854 in which the massive forest and its glut of brambles and foliage seem to press in upon the lost children poised in a recess of nature. Americans also sometimes arrived at similar visual conclusions and consciously or not emulated these efforts, as in John George Brown's 1866 canvas entitled *Watching the Woodpecker.* W. J. Hennessy was also sometimes mentioned in terms

Figure 100. John William Inchbold, *At Bolton (The White Doe of Rylstone)*, 1855. Oil on canvas, 27 × 20 inches. *(Courtesy of the City Art Gallery, Leeds.)*

Figure 101. Frederick Barwell, *The Day-Dream*, 1855. Oil on canvas, 17½ × 29½ inches. *(Courtesy of Christie's London.)*

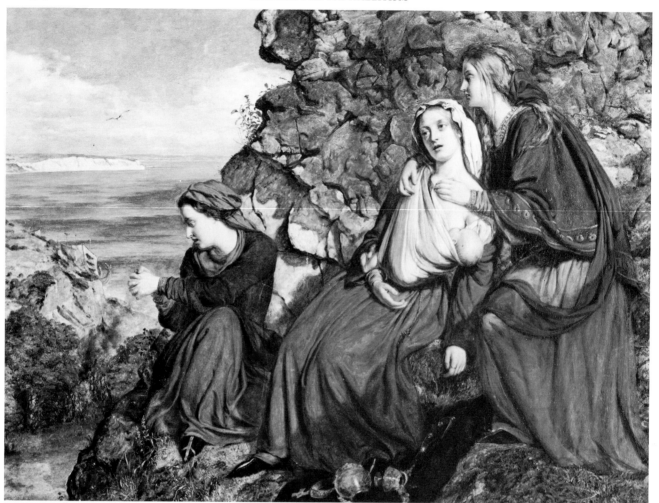

Figure 102. William Gale, *An Incursion of the Danes—Saxon Women Watching the Conflict*, 1855. Oil on canvas, 24 × 33 inches. *(Courtesy of Christie's London.)*

of Pre-Raphaelitism by the *New Path,* and his *The Honeymoon* (fig. 107) of 1869–70 seems to correspond to this description. Here a couple placed high upon a rock recalls both Ruskinian rock formations and paintings like *Our English Coasts,* as well as the highly successful figural landscape program evident in works such as Millais's 1853 *The Waterfall* (fig. 108), or even John Brett's *The Stonebreaker* of 1857–58 or William Dyce's *Welsh Landscape with Figures* of 1860.

As was mentioned earlier, Jarves wrote of the lesser popularity of genre and figurative art in America, and indeed there were fewer forays of the Pre-Raphaelite sort made by native artists. In addition to Farrer, Shattuck, and W. J. Hennessy, there were others artists who, at least for a time, found inspiration in the Pre-Raphaelite human subject pictures, although typically they too subsequently moved on to other styles and interests. John LaFarge was among those who, to a limited extent, briefly "tried out" Pre-Raphaelitism early in his career (in the 1860s especially), and both his landscapes and still lifes borrowed from this source. Before he left for a trip to England in 1857 he apparently, in his own words, "did not know of our Pre-Raphaelites here as a body, though I spent time with Stillman, who was one of their prophets."[65] Although ignorant of American efforts of this type, at the commanding 1857 Art Treasures Exhibition in Manchester, LaFarge's attention was rivetted by ". . . the [English] Pre-Raphaelites, whom I knew of by reading and by some prints but whom now I could see carefully. They made a very

great and important impressions upon me which later influenced me in my first work when I began to paint."[66] The works he saw at this exhibition (including Brown's *Christ Washing Peter's Feet* [fig. 11], which came to America shortly thereafter) "determined for many years certain admirations, and confirmed me in the direction of my ideas of color." To LaFarge the Pre-Raphaelites seemed "to be willing to meet many of the great problems of color, and my youthful energies sympathized with the stress and intensity of their dramatic programme."[67]

LaFarge knew of Ruskin's works too (probably through his professor of English at Columbia University) and was attracted to the medievalism of the Englishman's writings; he also owned an extensive collection of Ruskin's books. Sometimes LaFarge seemed to follow that critic's naturalistic creed with typical Pre-Raphaelite devotion and intensity, spending hours painting a single flower, which may not have ultimately been very Ruskinian in appearance but was so partly in spirit. However, this fascination with Ruskin ended by about 1860, after which

Figure 103. James Campbell, *The Dragon's Den*, 1860s? Oil on canvas, 15¹³⁄₁₆ × 15¹³⁄₁₆ inches. *(Courtesy of the Walker Art Gallery, Liverpool.)*

Figure 104. J. Atkinson Grimshaw, *A Mossy Glen*, 1864. Oil on board, 21 1/16 × 25 9/16 inches. *(Courtesy of the Calderdale Museums Service, Bankfield Museum.)*

Figure 105. Albert Moore, *Study of an Ash Tree*, 1857. Watercolor, 12 × 9 inches. *(Courtesy of the Ashmolean Museum, Oxford.)*

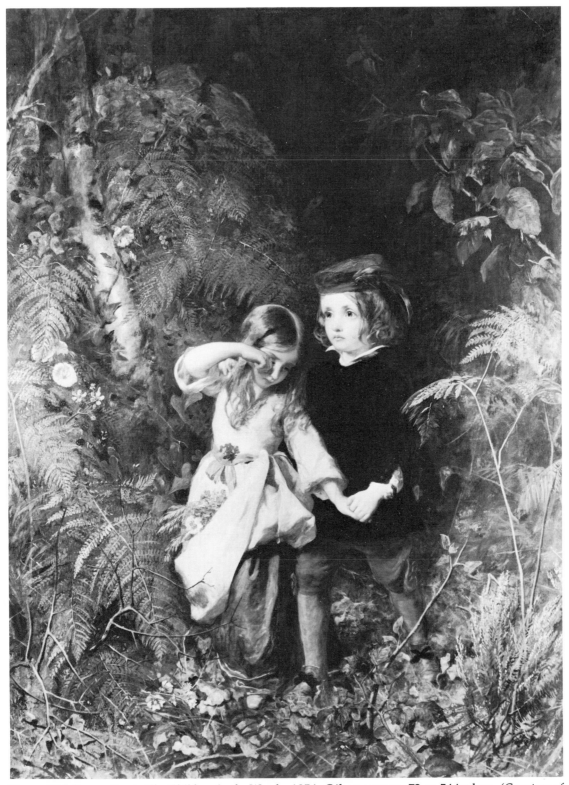

Figure 106. James Sant, *The Children in the Woods*, 1854. Oil on canvas, 72 × 54 inches. *(Courtesy of The Christopher Wood Gallery.)*

Figure 107. William J. Hennessy, *The Honeymoon*, 1869–70. Oil on canvas, 19 × 29 inches. *(Courtesy of the Hirschl & Adler Gallery.)*

Figure 108. John Everett Millais, *The Waterfall*, 1853. Oil on panel, 9$\frac{5}{16}$ × 13$\frac{3}{16}$ inches. *(Courtesy of the Delaware Art Museum. Samuel and Mary R. Bancroft Memorial Collection.)*

LaFarge rejected Ruskin's leaf-by-leaf delineation of nature. As the American later wrote about the Brotherhood and Ruskin: "These likings [for Pre-Raphaelite colors] I retained later when I began to think again of painting, even though Mr. Ruskin's teachings had become stumbling blocks rather than helps to my likings and my judgments. I find the trace of these influences pleasantly lingering in some of the drawings which I made even ten years later."[68]

As has been suggested, there is a likely homage to Pre-Raphaelite brightness of palette and handling of details in some of LaFarge's still lifes, and a work such as *Hollyhocks and Corn* of 1865 qualifies to some extent as a rather loosely painted but still basically Ruskinian close-up of nature, albeit with a certain *japoniste* assymetry. But LaFarge (who knew Stillman and may have read the *Crayon* and the *New Path*) did not succumb to the rigid 1860s format forged by American Ruskinians like Hill and Farrer, whose still lifes of botanical nooks left little to the imagination.[69] In fact, LaFarge's supposed rejection of the Ruskinian notion pleased James Jackson Jarves, who in *The Art-Idea* of 1865 praised his countryman for the greater spiritual (versus literal) qualities of his still lifes. To him, the power of imagination prevailed over gross realism: "His forms are missed and hinted at in an effective manner, instead of being sharply outlined and elaborated, as is the art of the realists. But LaFarge's, although devoid of much that the Pre-Raphaelites insist on as the exact, rigid truth of nature, as seen with the microscopic eye, is truer to the consciousness of his topics as a whole."[70] (At the same time in the *New York Times* Clarence Cook ironically criticized one of LaFarge's wreath paintings for its lack of hard-edged Pre-Raphaelitism.)

While a few of LaFarge's landscapes of the 1860s showed a slight indebtedness to Pre-Raphaelitism, its impact was far greater in the realm of his literary illustrations. As has been pointed out, LaFarge's latent Pre-Raphaelite tendencies were evident in such undertakings as his 1861 decorative frontispiece for an American edition of Robert Browning's "Men and Women." The image of a woman holding a statue of a winged child, for example, "suggests affiliation with the attenuated, delicate figures of Pre-Raphaelite illustration and with the decorative detail of illuminated manuscripts."[71] LaFarge owned a copy of the important Moxon edition of Tennyson with illustrations by the Pre-Raphaelites, and perhaps this tome had an influence on his draftsmanship; it certainly was occasionally evident in his choice of subjects, as in his ca. 1862 painting *The Lady of Shalott*, which is very similar to scores of English versions (i.e., Walter Crane's 1861 canvas) of this popular theme. Particularly striking were LaFarge's wood engravings for an 1866 Boston edition of Tennyson's "Enoch Arden," and one of the illustrations, *The Seal of Silence* (fig. 109) of 1864 with its close up, iconic, even protosymbolist representation of an angel-woman bears some resemblance of Rossettian enigmatic females like *Silence* (fig. 67), for example.

Following the success of "Enoch Arden," LaFarge undertook a series of illustrations in 1867 for the *Riverside Magazine for Young People,* and the artist later explained his partially Pre-Raphaelite inspiration for this project to his biographer Royal Cortissoz: "I carried out the notion which had been upon me at the beginning of my interest in art, and that is the manner of representing a subject in black and white for printing, as indeed the Pre-Raphaelites of England carried out; examples of these, dividing distinctly the illustrator and the painter or designer can be seen in the early Tennyson with illustrations by Rossetti and Hunt and Millais, etc."[72]

Riverside editor Horace Scudder actually showed William Michael Rossetti several examples of LaFarge's illustrations, and Rossetti noted in his diary in 1868 that he had "Showed Gabriel the photographs sent me by Scudder after designs ('Piper of Hamelin') by La Farge; he was pleased with them, and took them off to show Brown."[73] LaFarge was thus praised by both Dante Gabriel Rossetti and his brother, and although Brown's response is not known, the encouraging link was, according to LaFarge's biographer, ". . . a handsome message. . . . It was the first thing of the sort in his life . . . and it was really helpful to him."[74]

Ironically, after this period of experimentation, during his second trip to England in 1872–73,

Figure 109. John LaFarge, *The Seal of Silence*, 1864. Wood engraving illustration from Alfred Tennyson, *Enoch Arden* (Boston: Ticknor and Fields, 1865). *(Courtesy of the Beinecke Rare Book and Manuscript Library, Yale University.)*

Figure 110. Elihu Vedder, *The Lost Mind*, 1864–65. Oil on canvas, 39⅛ × 23¼ inches. *(Courtesy of the Metropolitan Museum of Art. Bequest of Helen Lister Bullard in memory of Laura Curtis Bullard, 1921.)*

LaFarge forged a personal relationship with members of the Pre-Raphaelite circle, especially with both Rossettis, Brown, and also Burne-Jones and Hunt, but at that point his interests had shifted from their illustrations and paintings to their stained-glass effects. Like many other early admirers of the Brotherhood, LaFarge later moved beyond their naturalistic creed, and by 1893 he had "recanted" the "lidless eyeball" or myopic theory and advised students in a lecture that "There is no absolute view of nature. . . . If you ever know how to paint somewhat well . . . , you will always give to nature . . . what is outside of you, the character of the lens through which you see it—which is yourself."[75]

Elihu Vedder, who also contributed illustrations to the 1864 edition of "Enoch Arden" along with LaFarge and W. J. Hennessey, was another American whose figural style in particular sometimes revealed a genuine debt to Pre-Raphaelite art. Like Rossetti, he, too, was interested in mystical subjects like the sphinx and was also obsessed with the idea of the immortality of

the soul. In truth, he knew or was influenced by numerous English artists—from William Blake to Walter Crane, G. F. Watts, and members of the Broadway group, and his friendship with the art critic William Davies brought him into close contact with the Pre-Raphaelite circle after 1870.

The Pre-Raphaelite influence, unlike with LaFarge, stayed with Vedder throughout his career, surfacing at various points and with different pictorial results. Vedder's *The Lost Mind* (fig. 110) of 1864–65, for example, suggests how the artist has combined the rocky setting of a Hunt religious landscape like *The Scapegoat* with the reddish-gold flowing hair and agonized emotional or "lost" state of the fallen woman in Hunt's *Awakening Conscience*. When it was exhibited at the National Academy of Design in 1865, the power of *The Lost Mind* was understood by the *New Path*, which commented on how the arid landscape added to the emotional abyss and "reckless grief" of the subject. The woman's mental state was even described in rather Huntian terms (for example, of *Our English Coasts* or *The Hireling Shepherd):* "The mind is gone astray from peace and truth, as a sinner is gone astray, when he or she also is said to be 'lost'—a lost sheep which only one shepherd can find. The woman's mind is lost to usefulness—lost to thought . . . it sees nothing but sterility and discomfort, is scarcely conscious, indeed, of anything but itself—walking so in the gloomy ways of life, stumbling over obstacles of its own placing, shadows of arid cloud going with it and shutting out the sun—a lost mind knows not its own needs and seeks not its own safety, hoping nothing from the world, where all seems as sad without as within."[76]

A much later example of Vedder's borrowing from another Pre-Raphaelite is his 1897 terracotta called *St. Cecilia* (fig. 111), which evokes comparisons with Burne-Jones, with Millais's mesmerized *Bridesmaid* of 1851, and especially with Rossetti's half-hypnotized, half-temptress females. This sort of creature reigned in innumerable works by the Englishman, for example, in *The Damsel of the Sanct Grael* (fig. 112) of 1857, an early depiction of a magical angel-woman with half-closed eyes and flying reddish-gold hair.

Figure 111. Elihu Vedder, *St. Cecilia*, 1897. Painted and gilded terra cotta, 11½ × 11¾ inches. *(Courtesy of the Hirschl & Adler Gallery.)*

Figure 112. Dante Gabriel Rossetti, *The Damsel of the Sanct Grael*, 1857. Watercolor, 14 × 4¾ inches. *(Courtesy of the Tate Gallery.)*

A more indirect, "spiritual" affinity with Rossetti may be discerned in some works by Thomas Dewing, whose manifestations of aestheticism were partly stimulated by seeing Whistler's *Symphony in White, No. 1: The White Girl* when it was exhibited in New York in 1881. During the late 1870s and 1880s Dewing experimented in a variety of styles and was occasionally "accused" of Pre-Raphaelite tendencies. For example, his work entitled *A Musician* at the Society of American Artists exhibition in 1878 was lampooned in the American magazine *Puck* as depicting "a woman who has been making desperate efforts to be pre-Raphaelite, and who has signally failed. She has sat down before a pre-Raphaelite background, in a state of pre-Raphaelite nudity, with a feebly pre-Raphaelite bullrush in a post by her side. She was the regular pre-Raphaelite trademark—she is in urgent want of a wash. She has procured a pre-Raphaelite musical instrument, and she has evidently made a dead set at the neopagan style."[77]

The American press also compared Dewing with Rossetti's friend and former pupil Edward Burne-Jones, and another parallel could have been drawn with the aesthetic and neoclassicizing paintings of women in togas by Albert Moore.[78] While his tonal friezes of languid women were kindred works, so too, less directly, were Rossetti's paintings of women embedded in a beautiful world of decorative objects, flowers, and musical instruments. There is also a quality of narcissism, passivity, and melancholy which infects both the Englishman's and the American's portrayals of women, and the resulting indolent women seem in a permanent dozing state of semi-consciousness or, as has been maintained, in a "languid and sensuous state on the edge of consciousness."[79] Both Rossetti's and Dewing's protosymbolist depictions of the enigma of womanhood were independent yet interconnected expressions of aestheticism on both sides of the Atlantic. The females in Dewing's *The Days* of 1887 or in myriad paintings of figures dancing amid lush green fields or reclining in exquisite interiors all seem to live in a basically Pre-Raphaelite atmosphere—isolated, legendary, and dreamlike—that took Rossetti's paintings to the next logical step of pictorial resolution. As one critic observed in 1880, "Each painting has been allegorical or illustrative of some unknown . . . rhapsody out of Swinburne or Rossetti, and unintelligible to the coarse unfeeling world which the artist must paint."[80]

In spite of the existence of such figural experiments in and permutations of Pre-Raphaelitism, the American form of this style was preeminently a landscape phenomenon. The most easily distinguishable variety already discussed was painted out of doors and directly in front of the flower or turf, with a brilliance of hue (including colored shadows), a static clarity, and an obsessive and linear attention to detail which were the by-product of agonizing technique and labor that were, in themselves, seen as fulfilling the dual goals of both art and science. The debt was as much to Ruskin as to the Pre-Raphaelites, and, as has been pointed out, "The *New Path*'s prototypes and models for landscape were located in the realm of site-specific documentation and properly recorded natural history, with 'the photograph' and the 'topographical report' as standards of accuracy."[81] As modern historians have elucidated, the 1860s were the acme and the period of maturity for the American Pre-Raphaelites, during which time they created their own genres of landscape—particularly of rock vignettes and Ruskinian studies of weeds, leaves, mosses, and ferns. They forged new categories for their medium and their message, nonetheless synthesizing Ruskinian preferences for wildflowers in fields, flowering branches, and birds and their nests, all of these expressing a plainness and humility which reflected an everyday, unglorified nature.[82]

In addition to these watercolor and wildflower close-ups, however, there were aspects of English Pre-Raphaelite landscape painting that were also grafted onto what is now called American luminism. While English Pre-Raphaelite landscapes constituted a radical change from the prevailing landscape tradition, they, too, were part of a seemingly international phenomenon. As recent scholarship has suggested, this development was not a uniquely American trait, and the English were also concerned with light, atmosphere, and air as well as

with a generally smooth, static effect of surfaces within expansive vistas or sweeping coastal views. For example, John Brett's *Massa, Bay of Naples* of 1854 predated Kensett's *The Upper Mississippi* by nearly a decade, and William Dyce's *Pegwell Bay, Kent* of 1860 and William Bell Scott's *View of Ailsa Craig and the Isle of Arran* (fig. 113) of the same year were other British precedents.[83] In the 1850s and 1860s in America, FitzHugh Lane, Heade, and others were producing dazzling horizontal canvases filled with water and light, but English luminism did not fully emerge until the late 1860s and 1870s (and continuing into the 1880s), with Brett's *British Channel Seen From the Dorsetshire Cliffs* of 1871 a classic example of this "band of water . . . and band of sky . . . empty foreground, and its concern with evanescent light effects."[84]

The crisp style, ultra-clarity, and bright colors were also not particularly new in either country, being traits which American artists like Church, Durand, Bierstadt, Cropsey, Kensett, Gifford, Heade, and others all shared to some degree in their art. However, as one modern writer succinctly expressed the difference, "whereas the Pre-Raphaelites were concerned with meticulous and tactile detail, the luminists sought to evoke a state of mind through delicate tonal variations and an almost mirrorlike painting surface."[85] It is arguable that generally these Americans, whether consciously or not, incorporated some Pre-Raphaelite principles into their paintings, although it is often difficult to distinguish Hudson River School degrees of high finish and vivid color from similar Pre-Raphaelite idiosyncrasies. Ultimately, the luminist aesthetic of the 1860s may have owed at least a partial debt to British painters like J. M. W. Turner, F. M. Brown, John Inchbold, and John Brett, although artists on both sides of the Atlantic were exploring some similar artistic territories. Sanford Gifford, for example, whose

Figure 113. William Bell Scott, *View of Ailsa Craig and the Isle of Arran*, 1860. Oil on canvas, 12¹³⁄₁₆ × 19¼ inches. *(Courtesy of the Yale Center for British Art.)*

primary inspiration was Turner, produced luminist landscapes which have been characterized by a modern scholar as uniting "Ruskin's two loves in a way that few English painters did, literally combining the tightly realistic technique of the Pre-Raphaelites with the atmospheric effects and palette of Turner."[86] Many of Kensett's woodland interiors also qualified as reforgings of American Pre-Raphaelitism. In fact, Henry Tuckerman in 1867 chose to describe the differences between English and American manifestations of this style by focusing on Kensett as a case study: "In some of his pictures the dense growth on a rocky ledge, with the dripping stones and mouldy lichens, are rendered with the literal minuteness of the old Flemish painters. It is on this account that Kensett enjoys an exceptional reputation among the extreme advocates of the Pre-Raphaelite school, who praise him while ignoring the claims of other American landscape artists. But this fidelity to detail is but a single element of his success. His best pictures exhibit a rare purity of feeling, an accuracy and delicacy, and especially a harmonious treatment, perfectly adapted to the subject."[87] Furthermore, in the case of Cropsey, who was in England in the 1860s and exhibited landscapes at the Royal Academy, a Pre-Raphaelite influence may be discerned in such works as *Autumn on the Hudson* of 1860, which when seen in England was enthusiastically received and earned him presentation to Queen Victoria. Another example is *Starruca Viaduct* of 1865, which combines Pre-Raphaelite foreground detail with the typically strong autumnal hues of Cropsey's palette. Parallels might be drawn with F. M. Brown's *English Autumn Afternoon* (see fig. 20), with its archetypal Pre-Raphaelite spatial device of a foreground plateau or ledge with sharply delineated foreground and a horizontal format.

Frederic Edwin Church, whose *Niagara* was shown in London and several other English cities in 1857–58, was one major Hudson River painter whose landscapes were not only appreciated by the British press but were also sometimes compared with the Pre-Raphaelites. Church's keen interest in science and geology struck a responsive chord with pro-Ruskinians, and, in the summer of 1859, his *Heart of the Andes* was honored with a private showing to Queen Victoria and Prince Albert.[88] The breadth and finish of this vision of mountain solitude were embraced by most English reviewers, and the *Art-Journal* congratulated the artist for achieving ". . . a grand and graceful unity and harmony. . . . The picture combines, more than any other we know, the minute and literal truth at which the Pre-Raphaelites aim imperfectly with Turner's greatness and grace of conception. On this American more than any other . . . does the mantle of our greatest painter appear to us to have fallen."[89] Ruskin also admired Church, and the artist seems to have been well aware of Ruskinian doctrines of natural history and botany, resulting in a kind of landscape that blended well with the British taste for the sublime, for example. Another painting that was received with awe as well as respect was Church's herculean *The Icebergs,* which went on view in London in 1863; the specificity of its arctic theme and subject struck a particularly resonant note with British audiences, and even William Michael Rossetti joined the many reviewers who showered attention on this painting. This member of the Pre-Raphaelite Brotherhood wrote that Church ". . . produced by resolute and steady work a picture of amazing natural phenomena. The painting is truly a genuine and surprising success, worthy of being seen and studied if not for its artistic attainment than for the new and marvelous world with which it brings us face to face."[90]

While Church achieved almost Olympian heights of fame in England and may well have "bridged the gulf between the exactitudes of the pre-Raphaelites and the breadth of the post-Raphaelites," there were other Americans whose landscapes of the 1860s also seem to have blended Hudson River School tightness of detail with the Pre-Raphaelite palette and aesthetic.[91] Among these was Martin Johnson Heade, who actually exhibited a painting at the Royal Academy during the 1860s. As has been noted, Heade's *Rhode Island Shore* of 1859 in its minute finish may have been indebted to the American, not the English, Pre-Raphaelites.[92] Another example is *Lake George* (fig. 114) of 1862 with its veined rocks and strong foreground

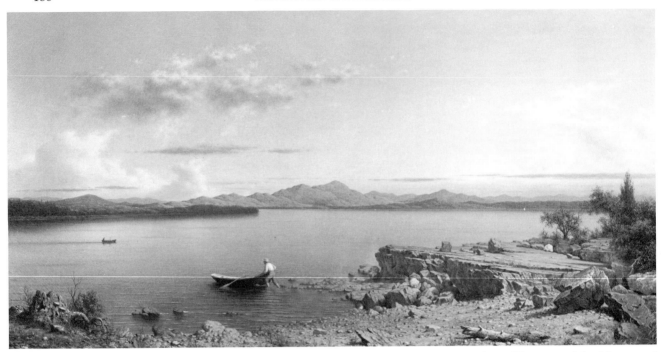

Figure 114. Martin Johnson Heade, *Lake George*, 1862. Oil on canvas, 26 × 49¾ inches. (*Courtesy of the Museum of Fine Arts, Boston. Bequest of Maxim Karolik for the M. and M. Karolik Collection of American Paintings, 1815–65.*)

gradient texture, a work in which technique may have surpassed that "of the American Pre-Raphaelites, or of Church in the 1850s, and specifically recalls the brighter, more detailed technique of the English Pre-Raphaelites and their contemporaries, which . . . was doubtless known to Heade through the exhibition of British art of 1857–8."[93] Pehaps it even drew its virtuoso realism of water and rock from works like Brett's *Glacier at Rosenlaui*, which was included in the New York *venue* of that monumental exhibition. Brett's glacier (or Ruskin's *Fragment of the Alps*) may have also inspired Heade's meticulous rock study, *The Lookout, Burlington, Vermont* of 1862, a geological portrait done in the manner advocated in *Modern Painters*.

In a somewhat different vein, Heade's *Sheep in a Landscape* of about 1863, a collaboration done with F. O. C. Darley painting the animals, may have been a deliberate allusion to Holman Hunt's *Our English Coasts: Strayed Sheep* in its general composition and subject. Perhaps his *Two Owls at Sunset* of ca. 1860 may have been inspired by the bird images of Ruskin or, on home turf, by the Hills, mixing botanical precision of the grasses with ornithological accuracy for a dramatic effect. Moreover, it is plausible that Heade's floral still lifes and even his Brazilian forest scenes may have borrowed both from Asher B. Durand's natural nooks and from American Pre-Raphaelite crammed recesses of nature.

Initially, then, a number of American artists were attracted by the extreme detail and finish of Pre-Raphaelite paintings and by the quasi-scientific botanical and geological specifity of such landscapes and their expressive qualities of light. For a short period these and other painters mixed their styles of realism with foreign and native influences alike, absorbing and amalgamating Pre-Raphaelitism in varying degrees in their vistas and views. But such obsession, whether phrased in a luminist vocabulary or not, proved fleeting as well as hard to sustain and remains elusive to analyze even today.

Nonetheless, in spite of what the American Pre-Raphaelites had achieved in their own paintings and in their impact on other artists, by the late 1860s, the Pre-Raphaelites—both

English and American—were losing critical ground in the United States. As early as 1859 (after Stillman resigned as editor of the *Crayon)* that journal complained that "Pre-Raphaelitism had done much mischief by giving undue importance to manipulation and to insignificant details; the result is to smother the artist's individuality, or, in other words, the subjective element of Art."[94] By 1861 Jarves began what was to become a constant crusade of finding fault with the group's premises, and this pattern was repeated, in varying degrees, in all three of his books from that decade. In *The Art-Idea* of 1864, for example, he scathingly attacked the use of the term Pre-Raphaelitism, which ". . . is ued to cover up so much dry mediocrity, and barren imitation of the natural and common by a close of painters whom the Greeks . . . would have called mere dirt painters. . . ."[95] Moreover, Jarves downplayed the impact that these English artists had upon Americans and thus rather exaggeratedly wrote that "The English school has ceased to exercise any influence over ours, unless a crude interpretation of its Pre-Raphaelitism by a few young men may be considered as such. Some, like Mr. Richards and his followers, show decided talent in imitative design, and are earnest in their narrow, external treatment of nature. We do not believe, however, that their principles and manner will become firmly rooted here. . . ."[96]

Moreover, the American Pre-Raphaelites consciously began to exhibit less at the National Academy of Design and even to withdraw from it at times. As has been suggested by a modern expert, "Pre-Raphaelite dissatisfaction with the National Academy may well have been justified, but the Academy at the time may have reflected the uneasiness of many outsiders."[97] By 1865, for example, Cook remarked that his colleague Moore's *Study in the Catskill Valley* at the Academy was "an admirable illustration and a powerful defense of that method of study which is much sneered at and ridiculed . . . under the name of 'Pre-Raphaelite'. . . ."[98] Yet ironically this was being maintained in a year that was "the only one in which Pre-Raphaelite principles held sway in three of the principal critical journals in New York—the *New Path*, the *Tribune*, and the newly founded *Nation*."[99] The year that marked the end of the Civil War was also a banner one at the Academy for Farrer, Moore, Newman, and others, and some of these entries were owned by Sturgis, Norton, and John E. Lauer, the latter a major Pre-Raphaelite patron.

The Civil War and its aftermath may have also subtly influenced these painters in other ways by the year 1865, and it has been suggested that in turning away from the classic English Pre-Raphaelite figural dramas, Americans chose "a more limited territory that confined the 'truth of emotion' to carefully controlled and socially limited areas." Their landscapes thus might be considered as an unconscious "evasive strategy, an avoidance of the social conflict of these years—the war itself and the turbulence associated with the commercial and industrial transfor-mation of American society."[100] In this respect these allied artists could be seen as producing art that attempted to stabilize values by creating views of domestic harmony and beauty which paradoxically screened out unpleasant external realities and substituted instead an unbloodied, scientifically correct corner or grove in nature that brought with it spiritual values for the spectator to ponder.

In 1866 all the major American Pre-Raphaelites contributed to the important Artists' Fund Society Exhibition, to which Norton also lent his Rossetti watercolor of *Dante Meeting Beatrice*. This exhibition became a great triumph and gained the "widest New York exposure" for the group, but it proved a hollow victory given the future course of events.[101] (The same artists dominated the Water Color Society exhibition of 1868–69, but they did so with a narrower majority of works and with far less critical acceptance.) Conversely, that year the Hills, Farrer, and Moore did not exhibit at the Academy, and their actions were explained by Clarence Cook as a boycott by "a small body of earnest, hard-working students of nature . . . who have this year withdrawn, nearly in a body, from the Academy."[102]

In 1866 there were presages of the collapse of the "movement" and descriptions of the alleged "internecine war which is raging in the metropolitan world of art" among the supporters and

detractors of the American brethren by the editor of *Harper's Magazine*.[103] Obviously biased against the new breed, the editor (George Curtis) lambasted this clique of the so-called Myopian Club, "near-sighted young men, most students of weeds, briers, leaves, blades of grass, straws, dead sticks, warts, hairs, nose-pimples, and cheek-freckles. . . , disciples of a well-known Champion of the Ring of Art in England." In spite of his railings against "this nest of juvenile gods,". . . fanatical young men with one idea . . . to spend a whole summer or a whole winter over a small canvas, producing a so-called painting of nature, which a photographer might have saved them all the labor of," Curtis offered an excellent insight into how the group gained a foothold on American soil. He cites how pre-Raphaelite doctrines were initially "for a long time merely theoretically and doubtfully entertained in this country" until a body of young men accepted the canon and "within two or three years both the painters and the professors of the new school . . . have taken the field with an audacity and enthusiasm which are making the dust fly in every direction." To Curtis the Sanitary Fair in New York in 1864 had been one signal occasion for advancement of these artists, but the reformers were also favored by a series of articles in the *Tribune*. The allusion to Cook's contributions to the *Tribune* is quite pointed, Curtis viewing this advantage to the new sect as gaining "the critical chair" and voice of a very important New York newspaper. Sarcastically he speaks of the "oracular utterances" of Cook, and also how the *New Path* and critics in the *Round Table* and the *Nation* advanced the cause of the brethren, allowing them to be "seated upon the new thrones with their weapons sharper than ever, and driving them up to the bloody hilt in every direction." Most accounts were not so sharp in tone, yet they offer an interesting insight into how these "microscopic imitators" and "the gospel of the apotheosis of the microcosm" were apparently a matter of heated debate among cosmopolitan art circles in the 1860s.

The year 1867 was a very good one for the Pre-Raphaelites and their unknowing swan song, combining success with imminent demise, for it was this year that all of the artists except the Hills "returned in force for the last time to the National Academy annual."[104] While earlier in the decade both the *New York Times* and the *New York Daily Tribune* reserved some praise or sympathy for Pre-Raphaelitism, by 1867 these attitudes had dramatically shifted, perhaps partly in response to the jibes of Curtis in *Harper's Magazine*. Accordingly, even Clarence Cook charged Farrer with being an inferior artist, and the *Tribune* remarked that "The Pre-Raphaelites are well represented in numbers, and their pictures are all excellently hung. We are sorry that this is all we can say in their favor, every one being just as bad as a false theory of art put into worse practice can make it."[105] Similarly, the *New York Times* the same year castigated Farrer on four separate occasions, repudiating the American followers in general but firm tones: "We confess that the more we study their work the less we like it. It seems to be constrained, laborious, affected, and wholly unlike nature, both in drawing and color."[106] Besides these slurs against the movement, Tuckerman's 1867 *Book of the Artists* pronounced the Pre-Raphaelite principles of Richards and others to be false and mechanical; moreover, doubting "the ultimate triumph of a literalness so purely imitative."[107]

A similarly hostile reception awaited in the pages of the *New York Times* for the 1867 inaugural exhibition of the Trumbull Gallery at Yale, in which nearly thirty American Pre-Raphaelite works were included in what bcame the last "group appearance" of the key artists.[108] Nearly a quarter of the entries were by Society members, Farrer dominating the show with a total of twenty works in various media. In addition, Newman sent four works, John W. Hill five, his son two, and Moore nine oils; less well-known adherents like Robert Pattison contributed five objects, Henry Farrer eleven drawings and watercolors, and Mary Mcdonald six works. As had been the case with the 1857–58 exhibition of English art in New York, local critics chose to focus on the Pre-Raphaelite contingent, a correspondent for the *New Haven Daily Morning Journal and Courier* astutely commenting that "The Pre-Raphaelites have an abundant representation, the largest they have ever had in this country, and a fair opportunity is afforded to compare their

school with that of the more popular, if less conscientious, artists of the day. . . ."[109] Another reporter maintained that the pictures "look at first repulsive, so hard and harsh, and real are their every feature, but after an half an hour's study, say of T. C. Farrer's book scene, or of Moore's exquisitely delicate Catskill view, I begin to wonder whether . . . these men and this school have not a future, and whether revolutions in art are not as necessary as revolutions in politics."[110] A writer for the *New Haven Daily Palladium* was also intrigued by the pictures, saying that "the marvellous finish and the almost painful minuteness of detail can only be appreciated after long and close study. Whether admired or not they must not be lightly condemned because they seem strange. The more they are examined, the less likely will any one be to dismiss them with a shrug of ignorance."[111] In addition, Russell Sturgis reviewed the show rather favorably in the *Nation*, while Cook in the *New York Daily Tribune* unequivocally stated that in this exhibition "It is now, for the first time, possible to see and judge what has been accomplished by this coterie of young men and women. Heretofore, they have been rather snubbed than welcomed when seeking for an opportunity to meet the public on equal ground with the older, and better-known artists."[112] His public remarks were decidedly optimistic, including the statement that ". . . with time, whatever prejudices, ignorance, and interest may have excited against them have been softened, if they have not wholly disappeared, and the example of our own Academy of Design at its last exhibition, has been followed by the committee here, albeit not without some wry faces."

Obviously some of the negative criticism irked Charles Moore, who responded to an attack in *The Yale College Courant* of the exhibition by writing a letter to the editor. In it he particularly defended Farrer's *Mount Washington,* which had been criticized for being too Pre-Raphaelite in its crisp detail and prismatic brilliance. Moore countered that this was not the case, maintaining that "in Mr. Farrer's picture . . . you can see no veins in the leaves." While he admitted that realism in American hands was still imperfect, he believed that his colleagues were striving to create "real" landscapes which were faithful records of geological and botanical truths. He also asserted the superiority of the preferred palette of clear, enameled hues, nonetheless realizing that "persons who prefer the leaden and snuffy tone of the popular pictures to the comparatively bright and pure color of the realistic work would not be changed in their liking by anything and I could say." Moreover, he interestingly sensed the possible encroachment of photography into the domain of Pre-Raphaelite painting, although he doubted that the mechanical tendencies of artistic followers would ever go too far. For him, then, the best of American Pre-Raphaelite canvases achieved a self-conscious verisimilitude as well a kind of Turneresque "obscurity and mystery," and he concluded with the pronouncement that "there is already more poetry in the Realistic work than the public have learned to understand."[113]

Thus, in spite of some flag-waving by Sturgis and others, increasingly the American Pre-Raphaelites were viewed with impatience and disfavor, if not downright intolerance, and the characteristics that had once earned them accolades now consistently repelled critics, making them the victims of both their previous successes and their alleged failures. After 1867 there was not even the iconoclastic *New Path* to defend Pre-Raphaelitism to an American audience; its writers had become somewhat disillusioned with Ruskin, or at least confounded by the many aesthetic ambiguities and contradictions (including that between objectivity and divine inspiration and between science and art) in his writings. Rejection of Ruskinian aesthetics went hand in hand with the spurning of Pre-Raphaelite art and its bold tenets, and as early as 1859 other approaches—including references to Hegel's *Aesthetik*—were being offered as alternatives to the Ruskinian ideology.[114]

Many of the artists mentioned in this chapter had already begun to shed their Pre-Raphaelite style in the 1860s, perhaps in response to public criticism and taste. However, it should also be remembered that nearly all the major English practitioners of Pre-Raphaelite landscape had also moved away from this style after the late 1850s and 1860s. And in America, as in England, this

halt did not totally preclude an impact from the "intervention" of Pre-Raphaelitism. In both countries, as a modern historian has pointed out, "when . . . artists began to realize that painting highly finished pictures directly from nature was an impractical way of working, they did not stop painting highly finished pictures, but stopped painting directly from nature," thus bringing Pre-Raphaelitism into the studio and diluting it with other goals and styles.[115]

As early as 1864, the *Round Table* critic wrote that Shattuck and less eminent American followers Samuel Colman and William Hart had already abandoned their new creed, and by 1869 none except John Henry Hill still supported the earnest doctrines originally espoused by the Association. In about 1870 an article on the Hills and Farrer (and his brother Henry) spelled out the denouement of the new school, referring both to their earlier boycott of the Academy and also to the divergent paths that now led the band away from one another into idiosyncratic corners and therfore no longer towards the same goal: "There no longer exists between the artists . . . the obvious similarity which enabled the most cursory critic to recognize them as belonging to one school, and which consisted in qualities unmercifully, and not always unjustly, denounced by the older painters, as might naturally have been expected from the central principles of fidelity in study and practice from nature, professed by the Pre-raphaelites, their work has grown more and more unlike in result, the longer each pursued and adhered to the patient and close use of his own eyes."[116] Thus, within little more than ten years from its inception even the galvanizing leadership of Farrer was defunct, and the disenchanted artist— probably disgusted with the attacks on his band from critics who initially dismissed Pre-Raphaelitism as radical and later execrated it for being outdated and passé—returned to Europe. Newman, the Hills, Fidelia Bridges, and a few others carried on the tradition tentatively for a while longer, but the peak was definitely past and the halcyon days of the 1850s and 1860s became only a formidable memory.

It is perhaps fitting to conclude with Cook's assessment in 1867 of what his fellow Pre-Raphaelites had achieved in their brief but intense period of activity and impact. The Yale show, the last collective statement of the group, was not singlehandedly able to ". . . convert people all at once from the error of thinking that the same mass of pictures that have thus far stood as representative of American art are worthy of the extraordinary admiration, sincere and insincere, that has been lavished upon them. To accomplish this, it would require a much greater display of talent than is to be found in this collection. . . ."[117] However, like many previous critics, he nonetheless saluted the sincerity and commitment of the band, saying that "what is wanting in talent is made up by a religious earnestness, and hard work." Believing that the strong individuality of the various artists fostered a stylistic divergence and diversity which doomed the movement, Cook ended his appraisal with a moving hymn to his comrades' noble aims and selfless toil, genuine traits of their English brethren:

> Say what the opponents of these men may, ridicule and find fault to their hearts' content, this remains: that here, for the first time, is a movement in American Art, not merely original and peculiar, but springing from an enthusiasm, a belief in something higher than the mercantile spirit that has thus far animated us; an independent movement clear of the Old World, whether that be right or wrong; building its own road as it has gone along; careless of criticism, careless of applause, and only bent on solving its own problems in its own way. This movement has not been the work of giants, intellectual or technically skillful; it is, all of it, interesting, and valuable, and much of it is beautiful, but it is none of it great; and yet, it has the precious element of everlastingness in it, that it springs from the soul. . . . These men do not work by recipe; they have no 'way of doing it,' but every fresh drawing is as if it were the first. This mode of working has been their strength thus far, for it has not been possible to predict from one picture what the next would be, and the thinking portion of the public has been impressed by this absence of routine, this emancipation from the hackneyed ways that prevail so widely among our artists. Every new drawing that Henry Newman makes, or new one by Charles Moore, by Miss McDonald, by Henry Farrer, is interesting in itself; it

is not like the tenth or twentieth book of a popular writer which sells because the rest have sold, it is the work of a young writer who throws all that he is into the new effort, and who holds the public by the magnetism of his own enthusiasm.[118]

In the end, as the *Atlantic Monthly* had remarked nearly a decade earlier in a discussion of how "Pre-Raphaelitism colonizes," American artists had absorbed and transformed the English version to evolve their own naturalistic recipe for landscape. What was unusual was that in spite of the dearth of real objects and examples, the effects of English Pre-Raphaelitism lingered for a few years in American art. Toward the last years of its period of ascendancy the *Nation* reconfirmed its earlier judgment that Americans had produced virtually no Pre-Raphaelite art, and the author offered a fitting metaphor on which to conclude this book. To him, ". . . Pre-Raphaelite pictures, like a small edition of a costly book which has never been reprinted, are every year more and more hard to come at; there will never be any more of them, and the original issue was 'very limited.' "[119] With inspiration and guidance only from Ruskin's writings (and, occasionally, of his own watercolors), from engravings and secondhand descriptions and accounts, and from an infrequent glimpse of a real Pre-Raphaelite work of art, the American contingent somehow managed to fuel their own commitments and to forge their own synthetic (and primarily landscape) statement of Pre-Raphaelitism in the years between 1855 and 1869, precisely the years when their idols Millais, Hunt, and Rossetti enjoyed their greatest share of fame on foreign shores.

Notes

Chapter 1. Ruskin, His Champions, and His Challengers

1. Roger B. Stein, *John Ruskin and Aesthetic Thought in America 1840–1900* (Cambridge: Harvard University Press, 1967), passim.

2. "Fine Arts," *Knickerbocker, or New-York Monthly Magazine* 30 (October 1847): 346.

3. "Fine Arts," *Literary World* 1 (24 July 1847): 591.

4. "Sketchings," *Crayon* 2 (2 May 1855): 283.

5. John Ruskin, letter of 28 March 1855, as reprinted in *Crayon* 2 (2 May 1855): 283.

6. "Fine Arts. The Athenaeum Exhibition," *Dwight's Journal of Music* 13 (24 April 1858): 26.

7. "Fine Arts," *North American Review* 66 (January 1848): 112.

8. "Sketchings," *Crayon* 2 (2 May 1855): 283.

9. Brownlee Brown, "Fine Arts," *Independent* 9 (22 October 1857): 1.

10. "Art Matters," *New York Times*, 3 April 1867, p. 4.

11. William J. Stillman, "Modern Painters," *Atlantic Monthly* 6 (August 1860): 239.

12. William J. Stillman, *The Autobiography of a Journalist* (New York and Boston: Houghton Mifflin, 1901), 1: 111.

13. Ibid., 139.

14. Ibid., 139–40.

15. Ibid., 177.

16. "Fine Art. The National Academy," *Putnam's Monthly Magazine*, 4 (May 1854): 567.

17. As quoted in Edward W. Emerson, *Early Years of the Saturday Club 1855–70* (Boston and New York, 1898), 129.

18. Stillman, *Autobiography*, 1: 222 and 227.

19. The works listed in the 1860 exhibition were *Seranac Lake* and *Aderondur Wilds*, both misspellings of *Saranac Lake* and *Adirondack Wilds*. These are cited in Jane Johnson, comp., *Works Exhibited at the Royal Society of British Artists 1824–1893* (Woodbridge, Suffolk: Antique Collectors' Club, 1978), 2: 444.

20. William J. Stillman, *The Old Rome and the New and Other Studies* (Boston: Houghton Mifflin, 1898), 118.

21. W. J. Stillman letter of May 1860 to Charles Eliot Norton, Collection of the Houghton Library, Harvard University.

22. W. J. Stillman letter of 22 March 1861 to Charles Eliot Norton, Collection of the Houghton Library, Harvard University.

23. "Fine Arts," *North American Review* 81 (October 1855): 439.

24. "Reviews. Art Hints," *Crayon* 2 (15 August 1855): 101.

25. As quoted in "Review. Art Hints," *Crayon* 2 (15 August 1855): 103.

26. James Jackson Jarves, *The Art-Idea: Part Second of Confessions of an Inquirer* (New York and Boston: Hurd and Houghton, 1864), xii.

27. Stein, *John Ruskin*, 124–5.

28. James Jackson Jarves, *Art Studies: The 'Old Masters' of Italy: Painting* (New York: Derby & Jackson, 1861), 29–30.

29. Charles Moore, "Fallacies of the Present School," *New Path* (October 1863), 61–64 passim.

30. Jarves, *The Art-Idea*, 161–63 passim.

31. As cited in Charles Moore, "Fallacies of the Present School," *New Path* (October 1863): 62–63.

32. James Jackson Jarves, *Art Thoughts* (New York: Hurd and Houghton, 1869), 212.

33. See, for example, Francis G. Townsend, "The American Estimate of Ruskin, 1847–1860," *Philological Quarterly* 32 (January 1953): 69–82.

34. As quoted in Sara Norton and M. A. DeWolfe Howe, eds., *Letters of Charles Eliot Norton* (Boston and New York: Houghton Mifflin, 1913), 1: 207.

35. Henry Wadsworth Longfellow also promised to contribute, see Stein, *John Ruskin*, 105.

36. See Jane Whitehill, ed., *The Letters of Mrs. Gaskell and Charles Eliot Norton* (London: Oxford University Press, 1932), 42.

37. Norton—and also Charles Moore—were later also to be mocked as obsessed by the battle cry "To Ruskin and Rossetti!" in such publications as Frederick Gunnison Hall's and Edward R. Little's *Harvard Celebri-*

ties: *A Book of Caricatures and Decorative Drawings* (Cambridge: Harvard University Press, 1901), n.p. I thank Professor Betsy Fahlman for bringing this book to my attention.

38. "The Art Electives," *Crimson,* 1 (30 September 1875): 7.

39. Henry James, *The Painter's Eye: Notes and Essays on the Pictorial Arts by Henry James* (London: Rupert Hart-Davis, 1956), 27.

Chapter 2. The Stiff, the Eccentric, and the Ugly

1. "Pre-Raphaelitism," *Nation* 1 (August 1865): 273.

2. "Reviews. 2. Pre-Raphaelitism," *North American Review* 74 (1852): 251.

3. See, for example, John Simoni, *Art Critics and Criticism in Nineteenth-Century America* (Ph.D. diss., Ohio State University, 1952).

4. "A.Y.-R.S.," "Pre-Raphaelitism from Different Points of View," *Fraser's Magazine* (1856): 686–93.

5. "Pre-Raphaelitism," *Crayon* 1 (4 April 1855): 219.

6. "Pre-Raphaelitism and Its Lessons," *Crayon* 1 (18 April 1855): 241.

7. "The English Pre-Raphaelites," *Crayon* 3 (March 1856): 96.

8. "Sketchings. Pre-Raphaelitism," *Crayon* 5 (March 1858): 85.

9. Review from *Eclectic Magazine* as cited in "The English Pre-Raphaelites," *Crayon* 3 (March 1856): 96.

10. *The Times,* May 1851, as cited in Holman Hunt, *Pre-Raphaelitism and the Pre-Raphaelite Movement* (London: Macmillan, 1905), 1: 249.

11. See, for example, Julie Codell, "Expression over Beauty: Facial Expression, Body Language and Circumstantiality in the Paintings of the Pre-Raphaelite Brotherhood," *Victorian Studies* 29 (Winter 1986): 255–90. This subject is also discussed in Stephanie J. Grilli, *Pre-Raphaelite Portraiture, 1848–1854* (Ph.D. diss., Yale University, 1980).

12. "The Athenaeum Exhibition. II. Oil Paintings," *Dwight's Journal of Music* 13 (8 May 1858): 46.

13. As quoted in a 7 May 1858 letter from "T.T.S" to the Editor, *Boston Daily Evening Transcript,* 11 May 1858, p. 4.

14. "The American Exhibition of British Art," *Evening Post,* 20 October 1857, p. 2.

15. "The Hope of Art," *Crayon* 2 (18 July 1855): 31.

16. "Sketchings: Pre-Raphaelitism," *Crayon* 5 (March 1858): 84.

17. "The American Exhibition of British Art," *Evening Post,* 20 October 1857, p. 2.

18. "Art. The British Gallery in New York," *Atlantic Monthly* (February 1858): 501.

19. "Exhibition of British Art," *Boston Daily Courier,* (15 May 1858, p. 2.

20. "Correspondence. Art News from London, No. 1," *Crayon* 1 (15 April 1855): 26.

21. "The British Gallery," *Christian Register,* 17 April 1858, p. 3.

22. "Foreign Correspondence, Items, etc.," *Crayon* 6 (June 1859): 183.

23. "Pre-Raphaelitism," *Nation* (August 1865): 273.

24. "The Fine Arts," *Nation* 3 (1866): 501.

25. "The American Exhibition of British Art," *Evening Post,* (20 October 1857, p. 2.

26. William J. Stillman, "Pre-Raphaelitism and Its Lessons," *Crayon* 1 (15 April 1855): 1.

27. Ibid.

28. "British and French Art in New-York," *Knickerbocker, or New-York Monthly Magazine* 51 (January 1858): 53.

29. "Art. The British Gallery in New York," *Atlantic Monthly* 1 (February 1858): 503.

30. As quoted in "Gleanings and Items," *Crayon* 5 (October 1858): 297.

31. T. C. Farrer, "A Few Questions Answered," *New Path* 1 (June 1863): 14.

32. "Pre-Raphaelitism," *Nation* 2 (August 1865): 274.

33. "The Limits of Medieval Guidance," *New Path* 2 (April 1864): 159.

34. On the English aspects of this subject, see, for example, Alastair Grieve, "The Pre-Raphaelite Brotherhood and the Anglican High Church," *The Burlington Magazine* 111 (May 1969): 294–99.

35. "Pre-Raphaelitism," *Nation* 1 (August 1865): 273.

36. "British Art," *North American and United States Gazette,* 3 February 1858, p. 2.

37. "British and French Art in New-York," *Knickerbocker, or New-York Monthly Magazine* 51 (January 1858): 54.

38. "Pre-Raphaelitism," *Nation* 1 (August 1865): 274.

39. "Foreign Art. The Exhibition of the British and French Pictures in New-York," *New York Times,* 7 November 1857, p. 1.

40. Ibid.

41. "Fine Art. The Athenaeum Exhibition, IX. Water Colors," *Dwight's Journal of Music* 13 (13 July 1858): 128.

42. Adam Badeau, *The Vagabond* (New York: Rudd & Carleton, 1859), 236–41 passim.

43. This is one of the articles of incorporation cited in "Association for the Advancement of Truth in Art," *New Path* (May 1863): 12.

44. T. C. Farrer, "A Few Questions Answered," *New Path* 1 (June 1863): 15.

45. "J. S.", "Art as a Record," *New Path* 1 (August 1863): 43.

46. "Sketchings," *Crayon* 2 (2 May 1855): 284.

47. "Art. The British Gallery in New York," *Atlantic Monthly* 1 (February 1858): 505–6.

48. "The British Gallery," *Christian Register,* 17 April 1858, p. 3.

49. "Recent Art Criticism," *Round Table* 1 (January 1864): 42.

50. "Pre-Raphaelitism," *Nation* (August 1865): 274.

51. Clarence Cook, *Art and Artists of Our Time* (New York: Selmar Hess, 1888), 3: 128, 130.

Chapter 3. The 1857–1858 Exhibition of English Art in America

1. "The American Exhibition of British Art," *Evening Post*, 21 October 1857, p. 2.

2. Ibid.

3. This research was assisted by a grant from the American Council of Learned Societies under a program funded by the National Endowment for the Humanities. This chapter also appeared in somewhat different form as an essay in Linda S. Ferber and William H. Gerdts, *The New Path: Ruskin and the American Pre-Raphaelites* (New York: Schocken Books, 1974), 109–33. I am grateful to the Brooklyn Museum and Schocken Books for allowing me to reprint portions of this essay in this chapter.

4. William Michael Rossetti, *Some Reminiscences* (New York: Scribner's Sons, 1906), 1: 264.

5. Ibid.

6. A 13 February 1855 letter from John Ruskin to W. M. Rossetti, as quoted in *The Works of John Ruskin*, ed. E. T. Cook & Alexander Wedderburn (London: George Allen, 1905), 13:188.

7. As quoted in "Fine Arts Gossip," *Athenaeum* 30 (20 June 1857): 796.

8. Ibid.

9. Ibid.

10. "Proposed New York Exhibition of British Art," *Builder* 15 (27 July 1857): 362.

11. "Minor Topics of the Month," *Art-Journal* 19 (June 1857): 294.

12. "Minor Topics of the Month," *Art-Journal* 19 (July 1857): 326.

13. Rossetti, *Some Reminiscences*, 265.

14. A 5 July 1857 letter from Gambart to William Michael Rossetti, Special Collections Division of the University of British Columbia.

15. A 21 July 1857 letter from Gambart to W. M. Rossetti, Special Collections Division of the University of British Columbia.

16. Rossetti, *Some Reminiscences*, 265.

17. Virginia Surtees, *The Diary of Ford Madox Brown* (New Haven and London: Yale University Press, 1981), 199.

18. A 29 July 1857 letter from John Everett Millais to W. M. Rossetti, Special Collections Division of the University of British Columbia.

19. A 13 August 1857 letter from J. E. Millais to W. M. Rossetti, Special Collections Division of the University of British Columbia.

20. A 3 September 1857 letter from J. E. Millais to W. M. Rossetti, Special Collections Division of the University of British Columbia.

21. A 22 June 1859 letter from J. E. Millais to Charles Warren, Special Collections Division of the University of British Columbia.

22. "Sketchings. An Exhibition of English Art," *Crayon* 4 (August 1857): 251.

23. A 23 September 1857 letter from J. Ruskin to W. M. Rossetti, as quoted in William Michael Rossetti, ed., *Ruskin: Rossetti: Pre-Raphaelitism, Papers 1854 to 1862* (London: George Allen, 1899), 178–79. Ruskin's letter to Stillman turning down the offer to write for *Crayon* was written on 28 March 1855 and is quoted in E. T. Cook and Alexander Wedderburn, eds. *The Works of John Ruskin* (London: George Allen, 1905), 13:194–95.

24. Rossetti, *Some Reminiscences*, 266.

25. Ibid.

26. A 29 September 1857 letter from Augustus A. Ruxton to W. M. Rossetti, as quoted in Rossetti, *Ruskin: Rossetti: Pre-Raphaelitism*, 180.

27. Ibid.

28. A 10 October 1857 letter from A. A. Ruxton to W. M. Rossetti, as quoted in ibid., 181–82.

29. A 20 October 1857 letter from A. A. Ruxton to W. M. Rossetti, as quoted in ibid., pp. 185–86. Turner's *Whalers* is now in the collection of the Metropolitan Museum of Art.

30. Thomas S. Cummings, *Historic Annals of the National Academy of Design Drawing Association, Etc., with Occasional Dottings by the Way-Side, from 1825 to the Present Times* (Philadelphia, 1865), 267.

31. "The American Exhibition of British Art," *Evening Post*, 20 October 1857, p. 2.

32. "The Fine Arts in New York," *New York Herald* 20 October 1857, p. 4.

33. "Foreign Art: The Exhibition of the British and French Paintings in New-York," *New York Times*, 7 November 1857, p. 2.

34. A 3 November 1857 letter from Gambart to W. M. Rossetti, Special Collections Division of the University of British Columbia.

35. Ibid.

36. Rossetti, *Some Reminiscences*, 266.

37. Ibid.

38. A 15 November 1857 letter from William J. Stillman to W. M. Rossetti as quoted in Rossetti, *Ruskin: Rossetti: Pre-Raphaelitism*, 187–88.

39. Holograph abstract of an untitled memorandum by William Michael Rossetti, Beinecke Rare Book and Manuscript Library, Yale University.

40. The 11 January 1858 Council Minutes, National Academy of Design 1848–62 archives.

41. The 25 January 1858 Council Minutes, National Academy of Design 1848–62 archives.

42. The 11 January 1858 Minutes of the Board of Directors, Pennsylvania Academy of the Fine Arts archives.

43. The 22 February 1858 Minutes of the Board of Directors, Pennsylvania Academy of the Fine Arts archives.

44. The 24 March 1858 Minutes of the Board of Directors, Pennsylvania Academy of the Fine Arts archives.

45. "Amusements," *Pennsylvania Inquirer*, 3 February 1858, p. 2.

46. "British Pictures on Exhibition at the Academy of Fine Arts," *Press*, 5 February 1858, p. 1.

47. "English Pictures at the Academy of the Fine Arts," *Philadelphia Sunday Dispatch*, 14 February 1858, p. 1.

48. I am grateful to Jonathan Harding of the Library of the Boston Athenaeum for his assistance in researching the trustees' records on this matter.

49. "Sketchings," *Crayon* 5 (May 1858): 148–49.

50. "Athenaeum Gallery," *Boston Post*, 14 April 1858, p. 1.

51. "Gallery of British Art," *Boston Daily Advertiser*, 28 April 1858, p. 2.

52. "Fine Arts: The Athenaeum Exhibition, I," *Dwight's Journal of Music* 13 (14 April 1858): 26.

53. A 7 May 1858 letter from "T. T. S." to the Editor, *Boston Daily Evening Transcript*, 11 May 1858, p. 4.

54. "Fine Arts: The Athenaeum Exhibition, I," *Dwight's Journal of Music* 13 (14 April 1858): 26.

55. "Gallery of British Art," *Boston Daily Advertiser* 28 April 1858, p. 2.

56. "Sketchings. American Exhibition of British Art," *Crayon* 4 (November 1857): 343.

57. "Foreign Art: The Exhibition of the British and French Paintings in New-York," *New York Times* 7 November 1857, p. 1.

58. "Amusements," *The Pennsylvania Inquirer*, 3 February 1858, p. 2.

59. According to a letter Leighton wrote to his mother, Rossetti was unaware of the censorship: "Rossetti answers me (as indeed I did not doubt) that he had not the remotest notion of the fate of "Pan" and "Venus." He has written on my request to beg they may be sent back at once to Europe." As quoted in Mrs. Russell Barrington, *Life, Letters, & Work of Frederic Leighton* (London: George Allen, 1906), 2:46.

60. Letter dated only "Friday 26th" and quoted in ibid., 45.

61. "Foreign Art: The Exhibition of the British and French Paintings in New-York," *New York Times*, 7 November 1857, p. 1.

62. "Fine Arts: The Athenaeum Exhibition, VII," *Dwight's Journal of Music* 13 (19 June 1858): 92.

63. "Sketchings. American Exhibition of British Art," *Crayon* 4 (November 1857): 343.

64. "British and French Art in New-York," *Knickerbocker, or New-York Monthly Magazine* 51 (January 1858): 57.

65. "Foreign Art: The Exhibition of the British and French Paintings in New-York," *New York Times*, 7 November 1857: p. 1.

66. "English Pictures at the Academy of Fine Art," *Philadelphia Sunday Dispatch*, 14 February 1858, p. 1.

67. "Exhibition of British Art," *Boston Daily Courier*, 15 May 1858, p. 2.

68. "Fine Arts: The Athenaeum Exhibition, IX" *Dwight's Journal of Music* 13 (13 July 1858): 127.

69. A 7 May 1858 letter from "T. T. S." to the Editor, *Boston Daily Evening Transcript*, 11 May 1858, p. 4.

70. "Sketchings. American Exhibition of British Art," *Crayon* 4 (November 1857): 343.

71. "The English and French Exhibitions," *Evening Post*, 14 November 1857, p. 2.

72. "British and French Art in New-York," *Knickerbocker, or New-York Monthly Magazine* 51 (January 1858): 54.

73. "Foreign Art: The Exhibition of the British and French Paintings in New-York," *New York Times*, 7 November 1857, p. 1.

74. "The British Gallery," *Christian Register*, 17 April 1858, p. 3.

75. "British and French Art in New-York," *Knickerbocker, or New-York Monthly Magazine* 51 (January 1858): 54.

76. "English Pictures at the Academy of Fine Art," *The Philadelphia Sunday Dispatch*, 14 February 1858, p. 1.

77. "Sketchings. American Exhibition of British Art," *Crayon* 4 (November 1857): 343.

78. Ibid.

79. "Gallery of British Art," *Boston Daily Advertiser*, 28 April 1858, p. 2.

80. "The English and French Exhibitions," *Evening Post*, 14 November 1857, p. 2.

81. This abstract and all subsequent references are to Rossetti's abstract/memorandum in the Beinecke Rare Book and Manuscript Library, Yale University.

82. "Foreign Art: The Exhibitions of the British and French Paintings in New-York," *New York Times*, 7 November 1857, p. 2.

83. As quoted in Rossetti, *Ruskin: Rossetti: Pre-Raphaelitism*, 182.

84. "Foreign Art: The Exhibitions of the British and French Paintings in New-York," *New York Times*, 7 November 1857, p. 2.

85. "British Art," *North American and United States Gazette*, 3 February 1858, p. 2.

86. "English Pictures at the Academy of Fine Art," *Philadelphia Sunday Dispatch*, 14 February 1858, p. 1.

87. "The British Gallery," *Christian Register*, 17 April 1858, p. 3.

88. Ibid.

89. "Exhibition of British Art," *Boston Daily Courier*, 15 May 1858, p. 2.

90. A 15 November 1857 letter from W. J. Stillman to W. M. Rossetti, as quoted in Rossetti in *Ruskin: Rossetti: Pre-Raphaelitism*, 188.

91. "Art: The British Gallery in New York," *Atlantic Monthly* 1 (February 1858): 503.

92. "Sketchings. American Exhibition of British Art," *Crayon* 4 (November 1857): 343.

93. "Exhibition of British Art," *Boston Daily Courier*, 15 May 1858, p. 2.

94. "Foreign Art: The Exhibition of the British and French Paintings in New-York," *New York Times*, 7 November 1857, p. 2.

95. "Exhibition of British Art," *Boston Daily Courier*, 15 May 1858, p. 2.

96. Ibid.

97. "Fine Art. The Athenaeum Exhibition, VII. Oil Pictures," *Dwight's Journal of Music* 13 (19 June 1858): 93.

98. "Exhibition of British Art," *Boston Daily Courier*, 15 May 1858, p. 2.

99. "British Pictures on Exhibition at the Academy of the Fine Arts," *Philadelphia Press*, 5 February 1858, p. 1.

100. "Fine Art. The Athenaeum Exhibition, VII," *Dwight's Journal of Music* 13 (19 June 1858): 93.

101. "Exhibition of British Art," *Boston Daily Courier*, 15 May 1858, p. 2.

102. Ibid.

103. "English Pictures at the Academy of the Fine Arts," *Philadelphia Sunday Dispatch*, 14 February 1858, p. 1.

104. "Exhibition of British Art," *Boston Daily Evening Transcript*, 13 April 1858, p. 2.

105. "Fine Art. The Athenaeum Exhibition, IX," *Dwight's Journal of Music* 13 (17 July 1858): 128.

106. An 11 February 1858 letter from A. A. Ruxton to W. M. Rossetti as quoted in Rossetti, *Ruskin: Rossetti: Pre-Raphaelitism*, 195.

107. As quoted in Jeremy Maas, *Holman Hunt and The Light of the World* (London: Scolar Press, 1984), 71.

108. "Sketchings," *Crayon* 5 (March 1858): 89.

109. Cummings, *Historic Annals*, 267.

110. An 11 February 1858 letter from A. A. Ruxton to

W. M. Rossetti as quoted in Rossetti, *Ruskin: Rossetti: Pre-Raphaelitism*, 195.

111. "Sketchings," *Crayon* 5 (March 1858): 89. *The Crayon* also remarked in a footnote in this piece that Fales had "lately acquired one of Turner's finest drawings, . . . a landscape gem, and probably the most satisfactory expression of the artist's genius in this country."

112. An 11 February 1858 letter from A. A. Ruxton to W. M. Rossetti as quoted in Rossetti, *Ruskin: Rossetti: Pre-Raphaelitism*, 195–96.

113. "Sketchings," *Crayon* 5 (May 1858): 148.

114. Stillman had written in a November 1857 piece for *Crayon* (p. 344) that the previous year the English

novelist William Thackeray had also purchased one of Steers' watercolor landscapes.

115. Mabel Munson Swan, *The Athenaeum Gallery 1827–1893. The Boston Athenaeum as an Early Patron of Boston* (Boston: The Boston Athenaeum, 1940), 104.

116. An 11 February 1858 letter from A. A. Ruxton to W. M. Rossetti as quoted in Rossetti, *Ruskin: Rossetti: Pre-Raphaelitism*, 195.

117. "The Fine Arts in New York," *New York Herald*, 20 October 1857, p. 4.

118. "Art. The British Gallery in New York," *Atlantic Monthly* 1 (February 1858): 505–6.

Chapter 4. John Everett Millais

1. "London Art News," *Photographic and Fine Art Journal* 7 (July 1854): 216.

2. [W. M. Rossetti], "Correspondence. Art News from England," *Crayon* 1 (20 March 1855): 265.

3. William J. Stillman, *The Autobiography of a Journalist*, 2 vols. (Boston and New York: Houghton, Mifflin, 1901), 1: 138.

4. [W. J. Stillman], "Pre-Raphaelitism and Its Lessons," *Crayon* 1 (April 1855): 241.

5. As quoted in Mary Bennett, *John Everett Millais* (Liverpool: Walker Art Gallery, 1967), 29.

6. Stillman, "Pre-Raphaelitism," 241.

7. [F. G. Stephens], "The Two Pre-Raphaelitisms. Third Article. The Modern Pre-Raphaelites," *Crayon* 3 (November 1856): 323.

8. [W. M. Rossetti], "Correspondence. Art News from England," *Crayon* 2 (23 August 1855): 196.

9. [W. M. Rossetti], "Correspondence. Art News from England," *Crayon* 2 (23 August 1855): 328.

10. "Fine Arts—Royal Academy," *Athenaeum* 27 (1854): 581.

11. "Exhibition of the Royal Academy," *Illustrated London News*, 31 8 May 1852, pp. 368–69.

12. Stephens, "The Two Pre-Raphaelitisms," 323.

13. C. P. Cranch, "Letter to the Editor," *Crayon* 2 (31 October 1855): 343.

14. "Exhibition of the Royal Academy," *Illustrated London News*, 17 May 1853, p. 379.

15. "Millais and the Pre-Raphaelites," *National Magazine* 1 (1854): 212.

16. William Michael Rossetti, *Fine Art, Chiefly Contemporary Notices Re-printed, with Revisions* (1867, reprints, New York: AMS Press, 1970), 212.

17. [W. M. Rossetti], "Correspondence. Art News from England," *Crayon* 2 (23 August 1855): 196.

18. C. P. Cranch, "Letter to the Editor," *Crayon* 2 (31 October 1855): 343.

19. "Gleanings & Items," *Crayon* 3 (July 1856): 321.

20. Stephens, "The Two Pre-Raphaelitisms," 232.

21. Henry James, *A Small Boy and Others* (New York: Charles Scribner's Sons, 1913), 297.

22. [W. M. Rossetti], "Correspondence. Art News from England," *Crayon* 1 (23 April 1955): 238.

23. Cranch, "Letter to the Editor," 343.

24. "Exhibition of the Royal Academy," *Illustrated London News*, 14 May 1853, p. 384.

25. Stephens, "The Two Pre-Raphaelitisms," 323–24.

26. Stillman, *Autobiography*, 1: 141.

27. "Millais and the Pre-Raphaelites," *National Magazine* 1 (1854): 195.

28. John Ruskin, "Notes on Some of the Principal Pictures Exhibited in the Rooms of the Royal Academy Exhibitions, 1855, *Crayon* 2 (15 August 1855): 100.

29. [F. G. Stephens], "The Idea of a Picture," *Crayon* 5 (February 1858): 64.

30. Ibid.

31. Rossetti, *Fine Art*, 219.

32. Henry James, *A Small Boy and Others*, 315.

33. Stephens, "The Two Pre-Raphaelitisms," 324.

34. [W. M. Rossetti], "Correspondence. Art News from England," *Crayon* 2 (20 April 1856): 182.

35. Rossetti, *Fine Art*, 217.

36. [W. M. Rossetti], "Correspondence. Art News from England," *Crayon* 2 (20 April 1856): 182.

37. Stephens, "The Two Pre-Raphaelitisms," 324.

38. "The Royal Academy," *Art Journal* 18 (1856): 171.

39. [W. M. Rossetti], "Correspondence. Art News from England," *Crayon* 2 (20 April 1856): 182.

40. Stephens, "The Two Pre-Raphaelitisms," 324.

41. F. G. Stephens Papers, British Library. I am grateful to Malcolm Warner for bringing this letter to my attention.

42. As quoted in Bennett, *John Everett Millais*, 31.

43. Stephens, "The Two Pre-Raphaelitisms," 323.

44. Rossetti, *Fine Art*, 208.

45. "Fine Art—The Royal Academy Exhibition," *Spectator* (May 1852): 472.

46. As quoted in Rossetti, *Fine Art*, 208.

47. John Ruskin, *From Some Notes on the Principal Pictures of Sir John Everett Millais* (London: William Reeves, 1886), 6–7.

48. See Susan P. Casteras, "John Everett Millais' 'Secret-Looking Garden Wall' and the Courtship Barrier in Victorian Art," *Browning Institute Studies: An Annual of Victorian Literary and Cultural History* 13 (1985): 70–98.

49. As quoted in "Studies among the Leaves," *Crayon* 4 (September 1857): 286.

50. [F. G. Stephens], "The Idea of a Picture," *Crayon* 5 (February 1858): 64–5.

51. Stephens, "The Two Pre-Raphaelitisms," 324.

52. "The Athenaeum Exhibition, IX. The Water Colors," *Dwight's Journal of Music* 13 (17 July 1858): 128.

53. "A Letter from Mr. Ruskin," *New Path* (May 1863): 9–10.

54. Charles H. Moore, "Fallacies of the Present School," *New Path* (October 1863): 63.

55. "J. S.", "Naturalism and Genius," *New Path* (October 1863): 67–68.

56. "Art. Three Representative Pictures," *Round Table* (16 July 1864): 74.

57. "Fine Arts—The Royal Academy," *Athenaeum* 33 (5 May 1860): 620.

58. "P.," "Foreign Correspondence, Items, Etc.," *Crayon* 7 (September 1860): 262.

59. "Art. Art Notes at Home & Abroad," *Round Table* 3 (30 September 1865): 60.

60. "Foreign Correspondence, Items, Etc.," *Crayon* 7 (July 1860): 202.

61. A similar point is made in Roger B. Stein, "A Flower's Saving Grace: The American Pre-Raphaelites," *Artnews* 85 (April 1985): 89–90.

62. "Sketchings. American Exhibition of British Art," *Crayon* 4 (November 1857): 343.

63. "The American Exhibition of British Art," *Evening Post*, 20 October 1857, p. 2.

64. "Another Exhibition of French and English Paintings," *New York Times*, 10 September 1859, p. 4.

65. I am indebted to Millais scholar Malcolm Warner for suggesting that these two pictures were the ones exhibited.

66. "Art. Exhibition of Foreign Pictures," *Round Table*, 3 (16 December 1865): 239.

67. This provenance was offered by Malcolm Warner.

68. "Foreign Correspondence, Items, Etc.," *Crayon* 6 (June 1859): 183.

69. "Art. Wanted—Artists Who Can Draw," *Round Table* 4 (7 July 1866): 423.

70. "The Artists Fund Society, Fourth Annual Exhibition," *New Path* (December 1863): 96.

71. "Millais' 'Parables,'" *New Path* (March 1864): 149.

72. James Jackson Jarves, *Art Thoughts* (New York: Hurd & Houghton, 1869), 212.

73. Eugene Benson, "Three Parables Illustrated by Millais," *The Spirit of the Fair* (7 April 1864): 32.

74. "Art. The British Gallery in New York," *Atlantic Monthly* 1 (February 1858): 506.

75. "Art News at Home & Abroad," *Round Table* (23 September 1865): 37.

76. "The Fifth Exhibition of French, English, and Flemish Pictures," *Nation* (29 November 1866): 435.

77. Ion Perdicaris, "The Opening of the Royal Academy," *The Galaxy: An Illustrated Magazine* 4 (May–December 1867): 362.

78. "Concerning Prae-Raphaelitism, Its Art, Literature, & Professors," *Littell's Living Age* 5 (4 April 1868): 443–46 passim.

79. J. D. Champlin, "John Everett Millais," *Appleton's Journal* 12 (24 October 1874): 513–15 passim.

80. Once again I thank Malcolm Warner for identifying the painting in question.

81. J. D. McCabe, *The Illustrated History of the Centennial Exhibition* (Philadelphia: National Publishing Co., 1876), 78.

82. Henry James, *The Painter's Eye*, 143.

83. Ibid., 151.

84. Ibid., 168–70 passim.

85. Ibid., 165–66.

86. Ibid., 182.

87. Ibid., 211, 215.

88. Ibid., 252–53.

89. "London Letter: Royal Academy Exhibition," *Art Interchange* 2 (30 April 1879): 68.

90. "Summer Exhibition—Grosvenor Gallery," *Art Interchange* 4 (26 May 1880): 86.

91. Montague Marks, "My Notebook," *Art Amateur* (June 1882): 25.

92. [Montezuma], "My Notebook," *Art Amateur* 4 (October 1883): 94.

93. Clark S. Marlor, *A History of the Brooklyn Art Association with an Index of Exhibitions* (New York: James F. Carr, 1980), 276.

94. Helen Bigelow Merriman, "The English Pre-Raphaelite and Poetical School of Painters," *The Andover Review* 1 (June 1884): 605.

95. M. G. Van Rensselaer, "Notes from England. III. Modern Painters—I," *The American Architect and Building News* 18 (28 November 1885): 258–59.

96. "London Letter—Royal Academy for 1885," *The Art Interchange* 14 (4 June 1885): 1.

97. Clarence Cook, *Art and Artists of Our Time* (New York: Selmar Hess, 1888), 3:130–31.

98. "The London Exhibitions," *Art Interchange* 22 (25 May 1889): 1.

99. [Montezuma], "My Notebook," *Art Amateur* (January 1886): 28.

100. [Montezuma], "My Notebook," *Art Amateur* (July 1895): 22.

101. [Montezuma], "My Notebook," *Art Amateur* (September 1888): 75.

102. Esther Wood, *Dante Rossetti and the Pre-Raphaelite Movement* (New York: Charles Scribner's Sons, 1894), 123.

103. Russell Sturgis, "The Pre-Raphaelites and Their Influence," *The Independent* 52 (18 January 1900): 182.

104. Kenyon Cox, *Old Masters and New. Essays in Art Criticism* (New York: Fox, Duffield, & Co., 1905), 165–75 passim.

105. Millais's apparent "threats" to go off to America were pointed out to me by Malcolm Warner.

Chapter 5. Holman Hunt

1. "A Gallery of British Art," *Boston Daily Advertiser*, 28 April 1858, p. 2.

2. James Jackson Jarves, "Art in America. Its Conditions and Prospects." *Fine Arts Quarterly Review* 1 (October 1863): 393.

3. "London Art News," *Photographic and Fine Arts Journal* 7 (July 1854): 216.

4. [F. G. Stephens], "The Two Pre-Raphaelites. Third Article," *Crayon* 3 (December 1856): 353.

5. As quoted in Mary Bennett, *William Holman Hunt*

(Liverpool: Walker Art Gallery, 1969), 30.

6. "The Fine Arts—Royal Academy," *Athenaeum* 25 (22 May 1852): 58.

7. Stephens, "The Two Pre-Raphaelites. Third Article," 353.

8. "The Fine Arts—Royal Academy." *Athenaeum* 26 (7 May 1852): 58.

9. Stephens, "The Two Pre-Raphaelites. Third Article," 354.

10. Ibid.

11. John Ruskin, "Academy Notes," in *The Works of John Ruskin* ed. E. T. Cook and Alexander Wedderburn, (London: George Allen, 1905), 14: 61–63 passim.

12. "The Fine Arts—Royal Academy," *Athenaeum* 29 (10 May 1856): 589.

13. Stephens, "The Two Pre-Raphaelites. Third Article," 354.

14. Henry James, *A Small Boy and Others*, 316.

15. As quoted in Bennett, *William Holman Hunt*, 36.

16. Stephens, "The Two Pre-Raphaelites. Third Article," 354–55.

17. "London Art News," *Photographic and Fine Arts Journal* 7 (July 1854): 216.

18. "The Fine Arts—Royal Academy," *Anthenaeum* 37 (6 May 1854): 561.

19. Stephens, "The Two Pre-Raphaelites. Third Article," 354.

20. Untitled Rossetti memorandum, Beinecke Rare Book and Manuscript Collection, Yale University.

21. "British and French Art in New-York," *Knickerbocker, or New-York Monthly Magazine* 51 (January 1858): 54.

22. "Foreign Art: The Exhibitions of the British and French Paintings in New-York," *New York Times*, 7 November 1857, p. 2.

23. As quoted in Jeremy Maas, *Holman Hunt and The Light of the World*, 71.

24. "British Art," *North American and United States Gazette*, 3 February 1858, p. 2.

25. "English Pictures at the Academy of Fine Art," *Philadelphia Sunday Dispatch*, 14 February 1858, p. 1.

26. "Cicerone," "American Art Galleries, V. Collection of Mr. John Wolfe," *Art Amateur* 3 (June 1880): 5.

27. "Fine Art. The Athenaeum Exhibition," *Dwight's Journal of Music* 13 (24 April 1858): 26.

28. "The British Gallery," *Christian Register* 17 April 1858, p. 3.

29. Adam Badeau, *The Vagabond* (New York: Rudd & Carleton, 1859), 240.

30. [F. G. Stephens], "The Idea of a Picture," *Crayon* 5 (February 1858): 65.

31. "The Work of the True and the False Schools," *New Path* (November 1863): 87.

32. "Art: Three Representative Pictures," *Round Table* (16 July 1864): 74.

33. James Jackson Jarves, *Art Thoughts* (New York: Hurd & Houghton, 1869), 214.

34. John F. Weir letter of 19 February 1871 letter to Prof. Salisbury. Manuscripts and Archives Collection, Yale University Library.

35. Linda S. Ferber, "The Determined Realists: The American Pre-Raphaelites and the Association for the Advancement of Truth in Art," in Linda S. Ferber and William H. Gerdts, *The New Path*, 32.

36. "British Art," *North American and United States Gazette*, 3 February 1858, p. 2.

37. "English Pictures at the Academy of Fine Art," *Philadelphia Sunday Dispatch*, 14 February 1858, p. 1.

38. "Fine Art. The Athenaeum Exhibition. Oil Paintings," *Dwight's Journal of Music* 13 (19 June 1858): 93.

39. I am indebted to Hunt scholar Judith Bronkhurst for kindly sharing this material with me and speculating on the circumstances of this painting's exhibition.

40. "Fine Arts News," *Cosmopolitan Art Journal* (December 1859): 12.

41. "Foreign Correspondence, Items, Etc.," *Crayon* 6 (July 1860): 202.

42. "Art. Foreign Notes," *Round Table* (18 June 1864): 10.

43. "Another English Letter," *New Path* (August 1865): 127–28.

44. Henry James, *The Painter's Eye* (London: Rupert Hart-Davis, 1956), 143.

45. "Another English Letter," *New Path* (August 1865): 128.

46. "Art. Foreign Notes," *Round Table* (18 June 1864): 10.

47. "Art Notes," *Round Table* (25 August 1866): 60.

48. "The Fifth Exhibition of French, English, and Flemish Pictures," *Nation* (29 November 1866): 435.

49. J. D. McCabe, *The Illustrated History of the Centennial Exhibition* (Philadelphia: National Publishing Co., 1876), 526.

50. As quoted in ibid., 76.

51. "Current Exhibitions of Art," *New York Tribune*, 25 November 1876, p. 4. I am grateful to Lucy Oakley in the European Paintings Department of the Metropolitan Museum of Art for this and other information about the provenance and exhibition history of this painting.

52. As quoted from a draft in the John Ferguson Weir Memoirs, John Ferguson Weir Papers, Manuscripts and Archives Collection, Yale University Library.

53. I am once again grateful to Judith Bronkhurst for her very useful insights on this painting.

54. As quoted in Bennett, *William Holman Hunt*, 50.

55. Williams and Everett Gallery, *Mr. Holman Hunt's "The Shadow of Death"* (Boston: Williams and Everett, ca. 1879), n.p.

56. "Art: Holman Hunt's "Shadow of Death": A Picture to Fight Over," *Aldine* 7 (November 1879): 227.

57. Henry James, *The Painter's Eye*, 209.

58. Helen Bigelow Merriman, "The English Pre-Raphaelite and Poetical School of Painters," *Andover Review*, 1 (June 1884): 604.

59. [Montezuma], "My Notebook," *Art Amateur* (January 1886): 29.

60. Clarence Cook, *Art and Artists of Our Time* (New York: Selmar Hess, 1888), 3: 132.

61. Russell Sturgis, "The Pre-Raphaelites and Their Influence," *The Independent* 52 (18 January 1900): 182.

Chapter 6. Dante Gabriel Rossetti

1. [F. G. Stephens], "The Two Pre-Raphaelitisms. Third Article. The Modern Pre-Raphaelites," *Crayon* 3 (November 1856): 355.

2. [F. G. Stephens], "The Two Pre-Raphaelitisms. Article Fourth," *Crayon* 4 (September 1856): 298.

3. Ibid., 262.

4. "Art. The British Gallery in New York," *Atlantic Monthly* 1 (February 1858): 507.

5. Charles Eliot Norton letter of 22 July 1869 to G. W. Curtis, as quoted in *Letters of Charles Eliot Norton* ed. Sara Norton & M. A. DeWolfe Howe (Boston and New York: Houghton Mifflin, 1913), 1: 356.

6. Charles Eliot Norton letter of 2 July 1857 to Mrs. Andrews Norton, as quoted in ibid., 174.

7. Dante Gabriel Rossetti, July 1858 letter to Charles Eliot Norton, as quoted in *Letters of Dante Gabriel Rossetti. Vol. 1, 1835–1860*, ed. Oswald Doughty and John R. Wahl (Oxford: Clarendon Press, 1965), 340.

8. Norton and DeWolfe Howe, *Letters of Charles Eliot Norton*, pp. 206–7.

9. As quoted in Oswald Doughty, *A Victorian Romantic. Dante Gabriel Rossetti* (London: Oxford University Press, 1966), 507.

10. William J. Stillman, *The Autobiography of a Journalist* (New York and Boston: Houghton, Mifflin, 1901), 1: 79.

11. William J. Stillman, *The Old Rome and the New and Other Studies* (Boston: Houghton, Mifflin, 1898), 194.

12. Stillman, *Autobiography*, 1: 473.

13. "A Letter from Mr. Ruskin," *New Path* (May 1863): 10.

14. This occurred at a 5 March 1863 meeting and is noted in the Minutes of the Society for the Advancement of Truth in Art, Chicago Public Library manuscript collection.

15. Clarence Cook letter of 21 August 1864 to Thomas C. Farrer. Gordon L. Ford Collection, New York Public Library.

16. Russell Sturgis letter of 4 September 1863 to Thomas C. Farrer. Gordon L. Ford Collection, New York Public Library.

17. "Pre-Raphaelitism," *Nation* 1 (1865): 274.

18. "Art. The Artists' Fund Society," *Round Table* 4 (17 November 1866): 260.

19. "Fine Arts. Two Drawings by Rossetti," *Nation* 3 (20 December 1866): 501.

20. Stillman S. Conant, "The Exhibition of Water Colors," *Galaxy* 3 (1867): 57–58.

21. James Jackson Jarves, *Art Thoughts* (New York: Hurd & Houghton, 1869), 212.

22. Henry James, *The Painter's Eye*, 90.

23. Edmund W. Gosse, "Dante Gabriel Rossetti," *Century Illustrated Magazine* 24 (1882): 718–25 *passim*.

24. Mary Robinson, "Dante Gabriel Rossetti," *Harper's New Monthly Magazine* 65 (1882): 693.

25. Anon., "Memorials of Rossetti," *Atlantic Monthly* 51 (April 1883): 553.

26. On this subject, see Alastair Grieve, "Rossetti's Illustrations to Poe," *Apollo* 97 (February 1973): 142.

27. Helen Bigelow Merriman, "The English Pre-Raphaelite and Poetical School of Painters," *Andover Review* 1 (June 1884): 603–7 passim.

28. Priscilla M. Thompson, "Samuel Bancroft, Jr.: Wilmington's Quaker Industrialist and Art Collector," in *The Samuel and Mary R. Bancroft, Jr. and Related Pre-Raphaelite Collections* (Wilmington: Delaware Art Museum, 1978), 12.

29. Ibid., 14.

30. Ibid., 16.

31. Theodore Child, "A Pre-Raphaelite Mansion," *Harper's Monthly Magazine* 82 (December 1890): 93.

32. Kenyon Cox, *Concerning Painting: Considerations Theoretical and Historical* (New York: Charles Scribner's Sons, 1917), 171.

33. Kenyon Cox, *Old Masters and New: Essays in Art Criticism* (New York: Duffield & Co. 1908), 141.

34. Mariana Griswold Van Rensselaer, preface to Dante Gabriel Rossetti, *The Blessed Damozel* (New York: Dodd, Mead and Co., 1886), n.p. I am grateful to Kathleen Walsh Rossetti for bringing this and other reactions to Cox's illustrations to my attention.

35. I am grateful to Richard Brettell, former Searle Curator of European Painting at the Art Institute of Chicago, for his information on the provenance and exhibition history of this picture. Moreover, I thank Kathleen A. Foster, Director of Curatorial Publications at the Pennsylvania Academy of the Fine Arts, for giving me a photocopy of the 1892 catalogue.

36. "A Pre-Raphaelite Exhibition," *Art Amateur* 31 (February 1893): 74.

37. Esther Wood, *Dante Rossetti and the Pre-Raphaelite Movement* (New York: Charles Scribner's Sons, 1894).

38. Sidney T. Whiteford, "Dante Gabriel Rossetti," *Art Amateur* 33 (September 1895): 66–69.

39. Herbert H. Gilchrist, "Recollections of Rossetti," *Lippincott's* 68 (1901): 571–76.

40. Russell Sturgis, "The Pre-Raphaelites and Their Influence," *The Independent* 52 (18 January 1900): 182.

41. Stillman, *The Old Rome and the New*, 194–95.

42. William J. Stillman, *Autobiography*, pp. 472–73.

43. Ibid., 473.

44. As quoted in Norton and DeWolfe Howe, *Letters of Charles Eliot Norton*, 267.

Chapter 7. The American Pre-Raphaelites

1. "Art. The British Gallery in New York," *Atlantic Monthly* 1 (February 1858): 506.

2. "National Academy of Design, The Thirty-Ninth Exhibition," *New York Daily Tribune*, 21 May 1864, p. 3.

3. [Russell Sturgis?], "Pre-Raphaelitism," *Nation* 1 (31 August 1865): 273–74.

4. "A Letter to a New Subscriber," *New Path* 2 (January 1864): 114.

5. Charles H. Moore, "The Fallacies of the Present School," *New Path* 1 (October 1863): 63.

6. Thomas C. Farrer, "A Few Questions Answered," *New Path* 1 (June 1863): 13.

7. J.S., "Art as a Record," *New Path* 1 (August 1863): 47.

8. "The Office of the Imagination," *New Path* 1 (August 1863): 79.

9. "Recent Art Criticism," *Round Table* 1 (January 1864): 42.

10. William H. Gerdts, "Through a Glass Brightly," in Ferber and Gerdts, *The New Path*, 39.

11. This point was made by Linda Ferber in a lecture at the American Pre-Raphaelite symposium held in April 1985.

12. Linda S. Ferber entry on this painting in Ferber and Gerdts, *The New Path*, 277–78.

13. Russell Sturgis, "Some American Pre-Raphaelites, A Reminiscence," *Scrip* 3 (October 1906): 5.

14. Charles Cook, "The National Academy of Design," *New York Daily Tribune*, 14 June 1867, p.2.

15. Gerdts, "Through a Glass Brightly," 57.

16. "Sketchings. National Academy of Design," *Crayon* 4 (July 1857): 222.

17. William H. Gerdts and Russell Burke, *American Still Life Painting* (New York: Praeger Books, 1971), 117.

18. "Letter from J.H.H.," *New Path* (May 1865): 73.

19. Ibid., 73–74.

20. "Sketchings," *Crayon* 4 (July 1857): 221.

21. "The National Academy of Design," *New York Times*, 22 December 1860, supplement.

22. Charles Moore to Thomas Farrer, letter of 4 March 1860, Gordon L. Ford Collection, New York Public Library.

23. May Brawley Hill catalogue entry for this painting in Ferber and Gerdts, *The New Path*, 170.

24. John H. Hill, *Sketches from Nature* (New York: privately printed, 1867), n.p.

25. John H. Hill to Thomas Farrer, Gordon L. Ford Collection, New York Public Library.

26. John H. Hill letter to Thomas Farrer, Gordon L. Ford Collection, New York Public Library.

27. Clarence Cook, "The National Academy of Design," *New York Daily Tribune*, 14 June 1867, p. 2.

28. "National Academy of Design," *New York Times* 24 April 1867, p. 3.

29. See May Brawley Hill catalogue entry in Ferber and Gerdts, *The New Path*, 166.

30. As quoted in Linda S. Ferber, "Determined Realists," in Ferber and Gerdts, *The New Path*, 21.

31. "Sketchings. National Academy of Design," *Crayon* 8 (April 1861): 94.

32. "Pictures and Studies," *New Path* 2 (July 1864): 47.

33. See May Brawley Hill catalogue entry in Ferber and Gerdts, *The New Path*, 157.

34. James Jackson Jarves, "Art in America, Its Conditions and Prospects," *Fine Arts Quarterly Review* 1 (October 1863): 393.

35. "National Academy of Design," *New York Daily Tribune*, 23 June 1865, p. 6.

36. John H. Hill to Thomas Farrer, Gordon L. Ford Collection, New York Public Library.

37. Mrs. L. C. Lillie, "Two Phases of American Art," *Harper's New Monthly Magazine* 80 (January 1890): 214.

38. As quoted in Frank Jewett Mather, Jr., *Charles Herbert Moore: Landscape Painter* (Princeton: Princeton University Press, 1957), 45–46.

39. "Sketchings. American Exhibition of British Art," *Crayon* 7 (November 1857): 343.

40. "Naturalism and Genius," *New Path* 1 (October 1863): 66.

41. "The Artists' Fund Society," *New Path* (December 1865): 192.

42. "A Word with 'X'—A Known Quantity," *New Path* (August 1863): 134–35.

43. James Jackson Jarves, *Art Thoughts*, 294–95.

44. James Jackson Jarves, *The Art-Idea* (New York: Hurd & Houghton, 1864), 199.

45. Gerdts, "Through a Glass Brightly," p. 59.

46. Linda S. Ferber catalogue entry in Ferber and Gerdts, *The New Path*, 216.

47. "Art Items," *New York Daily Tribune* 3 March 1862, p. 8.

48. John Ruskin, excerpt from *Modern Painters*, as quoted in Linda S. Ferber, *William Trost Richards* (Brooklyn: The Brooklyn Museum, 1973), 24.

49. Henry S. Tuckerman, *The Book of the Artists* (New York: G. P. Putnam's Sons, 1867), 524.

50. Ibid.

51. "The Work of the True and False Schools," *New Path* 1 (November 1863): 86.

52. "Domestic Art Gossip," *Crayon* 2 (21 November 1855): 330.

53. Ferber, "Determined Realists," 29.

54. Henry Newman letter of 13 October 1860 to Thomas Farrer, Gordon L. Ford Collection, New York Public Library.

55. As quoted in Ferber, "Determined Realists," 28.

56. As quoted in Tuckerman, *The Book of the Artists*, 568.

57. Henry Newman letter of 15 September 1864 to Thomas Farrer, Gordon L. Ford Collection, New York Public Library.

58. Gerdts, "Through a Glass Brightly," 69.

59. Kathleen A. Foster, "The Pre-Raphaelite Medium: Ruskin, Turner, and American Watercolor," in Ferber and Gerdts, *The New Path*, 79–80.

60. As quoted in ibid., 56.

61. "The Artists' Fund Society, Fourth Annual Exhibition," *New Path* 1 (December 1863): 101.

62. "National Academy of Design—Fortieth Annual Exhibition," *New Path* 2 (June 1865): 103.

63. See, for example, "The Artists' Fund Society, Fourth Annual Exhibition," *New Path* 1 (December 1863): 95–96 on Homer or "The National Academy of Design—Fortieth Annual Exhibition," *New Path* 2 (June 1865): 98–102 on Johnson.

64. As quoted in The Arts Council of Great Britain, *Landscape in Britain 1850–1950* (London: The Hillingdon Press, 1983), 72.

65. As quoted in Royal Cortissoz, *John LaFarge. A Memoir and a Study* (Boston and New York: Houghton Mifflin, 1911), 109.

66. Ibid., 98.

67. As quoted in Cecilia Waern, "John LaFarge, Artist and Writer," *Portfolio* (April 1896): 12–13.

68. Ibid., 13.

69. See Kathleen A. Foster, "The Still-Life Paintings of John LaFarge," *American Art Journal* 11 (Summer 1979): 14–16.

70. Jarves, *The Art-Idea*, 185.

71. H. Barbara Weinberg, "John LaFarge: The Rela-

tion of His Illustrations to His Ideal Art," *American Art Journal* 5 (1979): 65.

72. Cortissoz, *John LaFarge*, 138.

73. As quoted in ibid., 137.

74. Ibid., 38.

75. John LaFarge, *Considerations in Painting* (New York: Macmillan, 1895), 74–75.

76. "National Academy of Design: Fortieth Annual Exhibition," *New Path* 2 (June 1865): 98.

77. H. C. Brunner, "The Society of American Artists," *Puck* 3 (27 March 1878): 3.

78. The best examination of this connection is found in Susan Hobbs, "Thomas Wilmer Dewing: The Early Years, 1851–1885," *American Art Journal* 3 (Spring 1981): passim.

79. Judith E. Lyczko, "Thomas Wilmer Dewing's Sources: Women in Interiors," *Arts Magazine* 54 (November 1979): 156.

80. "Greta," "Boston Correspondence," *Art Amateur* 2 (March 1880): 75.

81. Ferber, "Determined Realists," 13.

82. See especially Gerdts, "Through a Glass Brightly," 42–46 on these themes.

83. William H. Gerdts, "On the Nature of Luminism," in *American Luminism* (New York: Coe Kerr Gallery, 1978), n.p.

84. Theodore E. Stebbins, Jr., "Luminism in Context: A New View," in John Wilmerding, et al., *American Light. The Luminist Movement 1850–1875* (Washington, D.C.: The National Gallery, 1980), 219.

85. Joseph S. Czestochowski, *The American Landscape Tradition: A Study and Gallery of Paintings* (New York: E. P. Dutton, 1982), 24.

86. Stebbins, "Luminism in Context," 213.

87. Henry Tuckerman, *The Book of the Artists* (1867; reprint, New York: James F. Carr, 1966), 11.

88. Gerald Carr, *The Icebergs of Frederic Edwin Church* (Dallas: Dallas Museum of Art, 1980), 28. An excellent analysis of *The Heart of the Andes* in this context is Gerald Carr, "American Art in Great Britain: The National Gallery Watercolor of the Heart of the Andes," *Studies in the History of Art* 12 (1982): 81–100.

89. "The Heart of the Andes," *Art-Journal* 21 (October 1859): 297.

90. William Michael Rossetti, "Art Exhibitions in London," *The Fine Arts Quarterly Review* 1 (October 1863): 343.

91. As quoted in Albert Ten Eyck Gardener, "Scientific Sources of the Full-length Landscape: 1850," *The Metropolitan Museum of Art Bulletin* 4 (1945–46): 62.

92. Theodore E. Stebbins, Jr., *Martin Johnson Heade* (New Haven and London: Yale University Press, 1975), 32.

93. Ibid., 39.

94. "The National Academy of Design," *Crayon* 6 (June 1859): 191.

95. Jarves, *The Art-Idea*, 161.

96. Ibid., 214.

97. Gerdts, "Through a Glass Brightly," p. 66.

98. "National Academy of Design," *New York Daily Tribune*, 23 June 1865, p. 6.

99. Gerdts, "Through a Glass Brightly," p. 64.

100. Roger B. Stein, "A Flower's Saving Grace: The American Pre-Raphaelites," *Artnews* 85 (April 1985): 90.

101. Gerdts, "Through a Glass Brightly," p. 66.

102. [Clarence Cook], "The National Academy of Design," *Christian Examiner* 81 (July 1866): 107.

103. [George Curtis], "The Editor's Easy Chair," *Harper's New Monthly Magazine* 32 (March 1866): 521–23 passim.

104. Gerdts, "Through a Glass Brightly," p. 68.

105. "The National Academy of Design," *New York Daily Tribune*, 21 May 1867, p. 3.

106. "The National Academy of Design," *New York Times*, 24 April 1867, p. 4.

107. Tuckerman, *The Book of the Artists*, 524.

108. "Fine Arts. The Exhibition at Yale College," *New York Times*, 22 July 1867, p. 3.

109. "The Opening of the Yale Exhibition," *New Haven Daily Morning Journal and Courier*, 12 July 1867, p. 2.

110. "Art in New Haven at Yale," *Hartford Daily Courant*, 12 July 1867, p. 4.

111. "The Yale Inaugural Exhibition," *New Haven Daily Palladium*, 12 July 1867, p. 2.

112. [Clarence Cook], "Fine Art in New Haven," *New York Daily Tribune*, 14 August 1867, p. 2.

113. "The Pre-Raphaelite School," *Yale College Courant*, 11 September 1867, pp. 25–26.

114. "The National Academy of Design," *Crayon* 6 (June 1859): 190.

115. Allen Staley, *The Pre-Raphaelite Landscape* (Oxford: Clarendon Press, 1973), 176.

116. "Four Pre-Raphaelites," as quoted in Gerdts, "Through a Glass Brightly," 72.

117. [Clarence Cook], "Fine Art in New Haven," *New York Daily Tribune*, 14 August 1867, p. 2.

118. Ibid.

119. [Russell Sturgis], "Fine Arts. Two Drawings by Rossetti," *Nation* 3 (20 December 1866): 501.

Select Bibliography

Because the notes contain so many references to specific articles in contemporary magazines and newspapers like the *Crayon,* the *New Path,* the *Evening Post,* the *New York Daily Tribune,* the *Nation,* and others, readers are referred to individual chapters for this information. As a result, this bibliography is limited primarily to a list of general nineteenth- and twentieth-century books and articles, some of which are mentioned in the notes and others that were useful and relevant to my research.

Adams, Steven. *The Arts & Crafts Movement.* London: Quintet Publishing Ltd., 1987.

Ahrens, Kent. "Pioneer Abroad, Henry R. Newman (1843–1917): Watercolorist and Friend of Ruskin." *American Art Journal* 7 (November 1976): 85–98.

Ashbee, Charles R. "The Pre-Raphaelites and Their Influence upon Life." *House Beautiful* 27 (1910): 75–77, 101–4, 112.

Badeau, Adam. *The Vagabond.* New York: Rudd & Carleton, 1859.

Barrington, Emilie Isabel. "The Painted Poetry of Watts and Rossetti." *Nineteenth Century* 13 (1883): 950–70.

Bristol, Frank M. "The Poet-Painter." In *The Ministry of Art.* Cincinnati: Curts and Jennings, 1897.

Burke, Doreen Bolger, et al. *In Pursuit of Beauty. Americans and the Aesthetic Movement.* New York: The Metropolitan Museum of Art and Rizzoli, Inc., 1987.

Cary, Edward. "Some American Pre-Raphaelites: A Reminiscence," *Scrip* 2 (October 1906): 1–7.

Cary, Elisabeth Luther. "Holman Hunt's Pre-Raphaelitism." *The Critic* 48 (June 1906): 529–31.

———. "The New Rossetti Water Colour in the Metropolitan Museum." *International Studio* 35 (1908): cxxv–cxxx.

———. "Rossetti as Illustrator." *Lamp [Bookbuyer]* 27 (1903): 321–28.

———. *The Rossettis: Dante Gabriel and Christina.* New York: G. P. Putnam's Sons, 1900.

Casteras, Susan P. "John Everett Millais and the Courting Wall Motif." In *Victorian Men and Women,* edited by Adrienne Munich, 71–98. New York: The Browning Institute, 1985.

———. "Rossetti's Embowered Females in Art, or Love Enthroned and 'The Lamp's Shine,'" *Nineteenth Century Studies* 2 (1988): 27–56.

Chesneau, Ernest. *The English School of Painting.* Translated by L. N. Etherington. London and New York: Cassell, 1885.

Coe Kerr Gallery. *American Luminism.* Introductory essay by William H. Gerdts. New York: Coe Kerr Gallery, 1978.

Cook, Clarence. *Art and Artists of Our Time.* 3 vols. New York: Selmar Hess, 1888.

Cortissoz, Royal. *John LaFarge. A Memoir and Study.* Boston and New York: Houghton Mifflin, 1911.

Cox, Kenyon. *Concerning Painting: Considerations Theoretical and Historical.* New York: Charles Scribner's Sons, 1917.

Dickason, David H. *Those Daring Young Men—The Story of the American Pre-Raphaelites.* Bloomington: Indiana University Press, 1953.

Doughty, Oswald. *A Victorian Romantic. Dante Gabriel Rossetti.* London: Oxford University Press, 1966.

Doughty, Oswald, and John R. Wahl, eds. *The Letters of Dante Gabriel Rossetti.* Oxford: Clarendon Press, 1965.

Everson, Ida. G. "William J. Stillman: Emerson's 'Galant Artist.' " *The New England Quarterly* 31 (March 1958): 32–46.

Fennell, Francis L. *Dante Gabriel Rossetti: An Annotated Bibliography.* New York: Garland Publishing, 1982.

Ferber, Linda S. "Ripe for Revival: Forgotten American Artists." *Artnews* 79 (December 1980): 68–73.

———. *William Trost Richards (1833–1905): American Landscape and Marine Painter.* Ph.D. diss., Columbia University, 1980.

Ferber, Linda S., and William H. Gerdts, *The New Path and the American Ruskinians.* New York: Schocken Books, 1985.

Foshay, Ella M. *Reflections of Nature: Flowers in American Art.* New York: Alfred A. Knopf, 1984.

Foster, Kathleen Adair. *Makers of the American Watercolor Movement, 1860–1890.* Ph.D. diss., Yale University, 1982.

———. "The Still-Life Paintings of John LaFarge." *American Art Journal* 11 (Summer 1979): 4–37.

Fredeman, William E. *Pre-Raphaelitism, A Bibliocritical Study.* Cambridge: Harvard University Press, 1965.

Gerdts, William H. *Down Garden Paths.* Rutherford, N.J.: Fairleigh Dickinson University Press, 1983.

———. "The Influence of Ruskin and Pre-Raphaelitism on American Still-Life Painting." *American Art Journal* 1 (Fall 1969): 80–97.

———. *Painters of the Humble Truth: Masterpieces of American Still-Life, 1801–1939.* Columbia: University of Missouri Press, 1981.

Gilchrist, Herbert. "Recollections of Rossetti." *Lippincott's Magazine* 68 (1901): 571–76.

Gosse, Edmund. "Dante Gabriel Rossetti." *Century Magazine* 24 (1882): 718–25.

Grilli, Stephanie. "Pre-Raphaelitism and Phrenology." In *The Pre-Raphaelite Papers,* edited by Leslie Parris. London: The Tate Gallery, 1984.

Hamill, Alfred E. "Dante Gabriel Rossetti in America." *Notes and Queries* 165 (1933): 358–59.

Hobbs, Susan. "Thomas Wilmer Dewing: The Early Years, 1851–1885." *American Art Journal* 13 (Spring 1981): 5–35.

Hoppin, James M. "Dante Gabriel Rossetti." In *Great Epochs in Art History,* 210–19. Boston: Houghton Mifflin, 1901.

Hunt, William Holman. "The Pre-Raphaelite Brotherhood: A Fight for Art." *Contemporary Review* 49 (1886): 471–78. 737–50, 820–33.

———. *Pre-Raphaelitism and the Pre-Raphaelite Movement.* London: Macmillan, 1905.

James, Henry. *The Painter's Eye. Notes and Essays on the Pictorial Arts by Henry James.* Edited by John L. Sweeney. London: Rupert Hart-Davis, 1956.

Jarves, James Jackson. *The Art-Idea: Part Second of Confessions of an Inquirer.* New York and Boston: Hurd & Houghton, 1864.

———. *Art Studies: The Old Masters of Italy; Painting.* New York: Derby & Jackson, 1861.

———. *Art Thoughts.* New York: Hurd & Houghton, 1869.

Jump, J. D. "Ruskin's Reputation in the Eighteen-Fifties: The Evidence of the Three Principal Weeklies." *PMLA* 63 (1948): 678–85.

Landau, Sarah B., and John Zukowsky. *P. W. Wight: Architect, Contractor, and Critic, 1838–1925.* Chicago: The Art Institute of Chicago, exhibition catalogue, 1981.

Landow, George. *The Aesthetic and Critical Theories of John Ruskin.* Princeton: Princeton University Press, 1971.

Lillie, Lucy Cecil White. "Two Phases of American Art." *Harper's Magazine* 80 (January 1890): 206–16.

Lindquist-Cock, Elizabeth. "Stillman, Ruskin, and Rossetti: The Struggle between Nature and Art." *History of Photography* 3 (January 1979): 1–14.

Livingston, L. S. "First Books of Some English Authors. III. Dante Gabriel and Christina G. Rossetti." *Bookman* (New York) 10 (1899): 245–47.

Low, Will H. "A Century of Painting," *McClure's Magazine* 7 (1896): 65–72.

Maas, Jeremy. *Gambart. Prince of the Victorian Art World.* London: Barrie & Jenkins, 1975.

———. *Holman Hunt and The Light of the World.* London: Scolar Press, 1984.

Mather, Frank Jewett, Jr. *Charles Herbert Moore, Landscape Painter.* Princeton: Princeton University Press, 1957.

"Memorials of Rossetti," *Atlantic Monthly* 51 (1883): 549–55.

Moore, Charles H. "John Ruskin as an Art Critic." *Atlantic Monthly* 86 (October 1900): 438–50.

Myers, Kenneth, and Margaret Favretti. "In Most *Extreme Need*": Correspondence of C. H. Moore with J. F. Kensett." *Archives of American Art Journal* 26 (1986): 11–17.

Neiswander, Judith A. "Imaginative Beauty and Decorative Delight: Two American Collectors of the Pre-Raphaelites." *Apollo* (March 1984): 198–205.

Noble, James Ashcroft. "At the Grave of Rossetti." *Bookman* (New York) 1 (1895): 170–73.

Norton, Sara, and M. S. DeWolfe Howe, eds. *Letters of Charles Eliot Norton.* London and Boston: Houghton Mifflin, 1913.

Pennell, Joseph. "A Golden Decade in English Art." *Savoy* 1 (1896): 112–24.

Phythian, John E. "The Pre-Raphaelite Brotherhood" and "The Course of Pre-Raphaelitism." In *Fifty Years of Modern Painting, Corot to Sargent,* 16–51, 129–89. New York: Dutton, 1908.

Robinson, Mary. "Dante Gabriel Rossetti." *Harper's* 65 (1882): 691–701.

Rossetti, Dante Gabriel. *The Blessed Damozel.* Introduction by Mariana G. Van Rensselaer. New York: Dodd, Mead, and Co., 1886.

Rossetti, William Michael. *Ruskin: Rossetti: Pre-Raphaelitism. Papers 1854 to 1862.* London: George Allen, 1899.

———. *Some Reminiscences.* New York: Charles Scribner's Sons, 1906.

Scott, William Bell. *Autobiographical Notes.* 2 vols. Edited by W. Minto. New York: Harper, 1892.

Simoni, John Peter. *Art and Art Criticism in Nineteenth-Century America.* Ph.D. diss., Ohio State University, 1952.

Smyser, William E. "Romanticism in Tennyson and His Pre-Raphaelite Illustrators." *North American Review* 192 (1910): 504–15.

Soria, Regina. *Elihu Vedder. American Visionary Artist in Rome (1836–1923).* Rutherford, N.J.: Fairleigh Dickinson University Press, 1970.

Staley, Allen. *The Pre-Raphaelite Landscape.* Oxford: Clarendon Press, 1973.

Stebbins, Theodore E., Jr. *The Life and Works of Martin Johnson Heade.* New Haven and London: Yale University Press, 1975.

Stein, Roger B. "A Flower's Saving Grace: The American Pre-Raphaelites." *Artnews* 85 (April 1985): 85–90.

———. *John Ruskin and Aesthetic Thought in America, 1840–1900.* Cambridge: Harvard University Press, 1967.

Stevens, W. Bertrand. "*Ecce Ancilla Domini!* (Behold the Haindmaiden of the Lord)." *Chautauquan* 46 (1907): 103–4.

Stillman, William James. *The Autobiography of a Journalist.* New York and Boston: Houghton Mifflin, 1901.

———. "Modern Painters." *Atlantic Monthly* 5 (August 1860): 239–42.

———. *The Old Rome and the New and Other Studies.* New York and Boston: Houghton Mifflin, 1898.

Surtees, Virginia. *The Paintings and Drawings of Dante Gabriel Rossetti, 1828–1882. A Catalogue Raisonné.* Oxford: Clarendon Press, 1971.

Swinburne, Louis J. *Rossetti and the Pre-Raphaelites.* New Haven: privately printed, 1885.

Tate Gallery. *The Pre-Raphaelites.* London: The Tate Gallery and Penguin Books, 1984.

Townsend, Francis G. "The American Estimate of Ruskin 1847–1860." *Philological Quarterly* 32 (January 1953): 69–82.

Tuckerman, Henry T. *The Book of the Artists.* New York: G. P. Putnam's Sons, 1867.

Waern, Cecilia. *John LaFarge. Artist and Writer.* London: Seeley, 1896.

Walker Art Gallery. *John Everett Millais.* Liverpool: Walker Art Gallery, 1967.

———. *William Holman Hunt.* Liverpool: Walker Art Gallery, 1969.

Warner, Malcolm. "John Everett Millais's 'Autumn Leaves': 'A Picture Full of Beauty and without Subject.'" In *The Pre-Raphaelite Papers,* edited by Leslie Parris. London: The Tate Gallery, 1984.

Weinberg, H. Barbara. *The Decorative Work of John LaFarge.* Ph.D. diss., Columbia University, 1972.

———. "John LaFarge. The Relation of His Illustrations to His Ideal Art." *American Art Journal* 5 (1973): 54–73.

Wiley, Edwin. "Dante Gabriel Rossetti and the Pre-Raphaelites." In *The Old and the New Renaissance: A Group of Studies in Art and Letters,* 117–68. Nashville, Tenn.: M. E. Church, 1903.

Wilmerding, John, et al. *American Light. The Luminist Movement.* Washington, D.C.: The National Gallery, 1980.

Wodehouse, Lawrence. "The 'New Path' and the American Pre-Raphaelites." *College Art Journal* 25 (Summer 1966): 351–54.

Wood, Esther. *Dante Rossetti and the Pre-Raphaelite Movement.* New York: Charles Scribner's Sons, 1894.

Wren, Linnea Holmer. *The Animated Prism: A Study of John LaFarge as Author, Critic, and Aesthetician.* Ph.D. diss., University of Minnesota, 1978.

Zueblin, Rho Fisk. "Pre-Raphaelites: The Beginnings of the Arts and Crafts Movement." *Chautauquan* 36 (1902): 57–61.

Index

Individual works of art are listed under artists' names; some titles of paintings have been shortened in the index. Page numbers on which illustrations appear are in boldface.